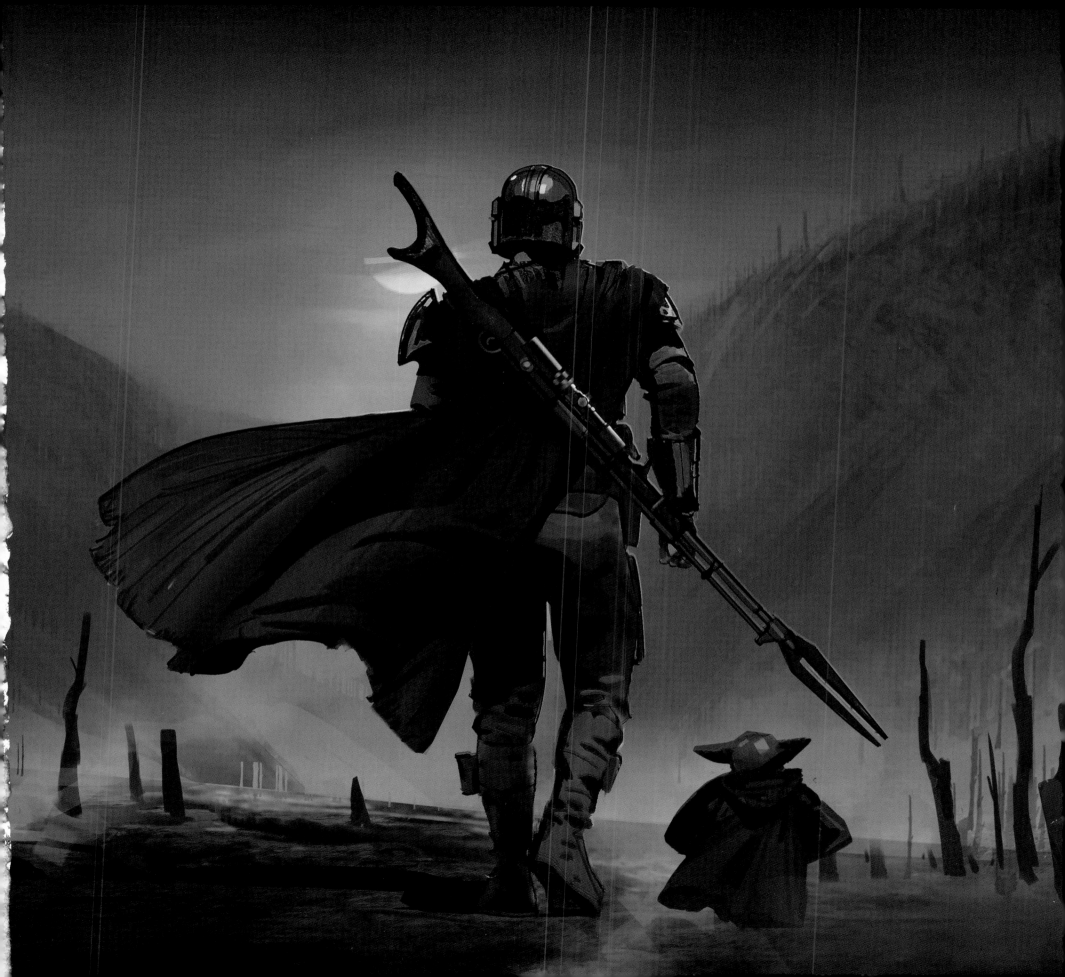

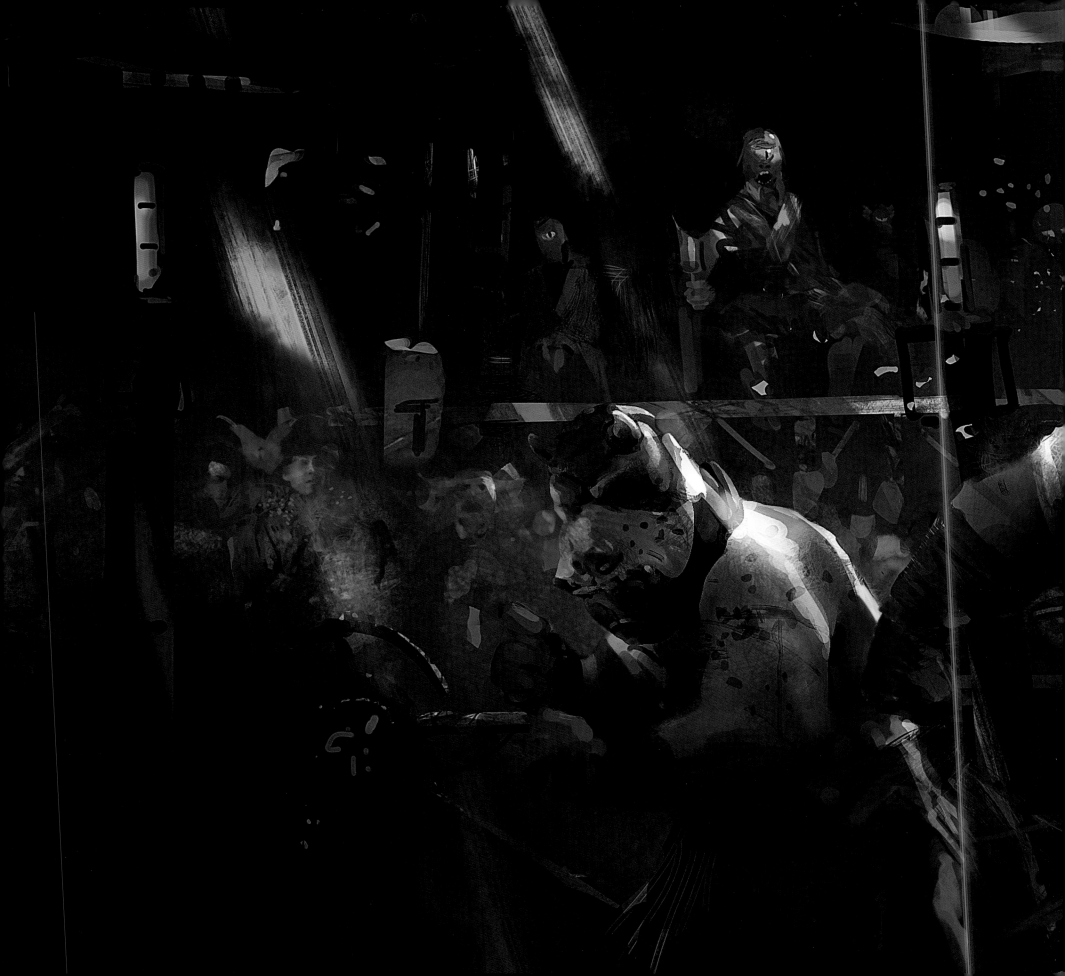

THE ART OF

STAR WARS™

THE

MANDALORIAN

Written by Phil Szostak
Foreword by Doug Chiang

ABRAMS, NEW YORK

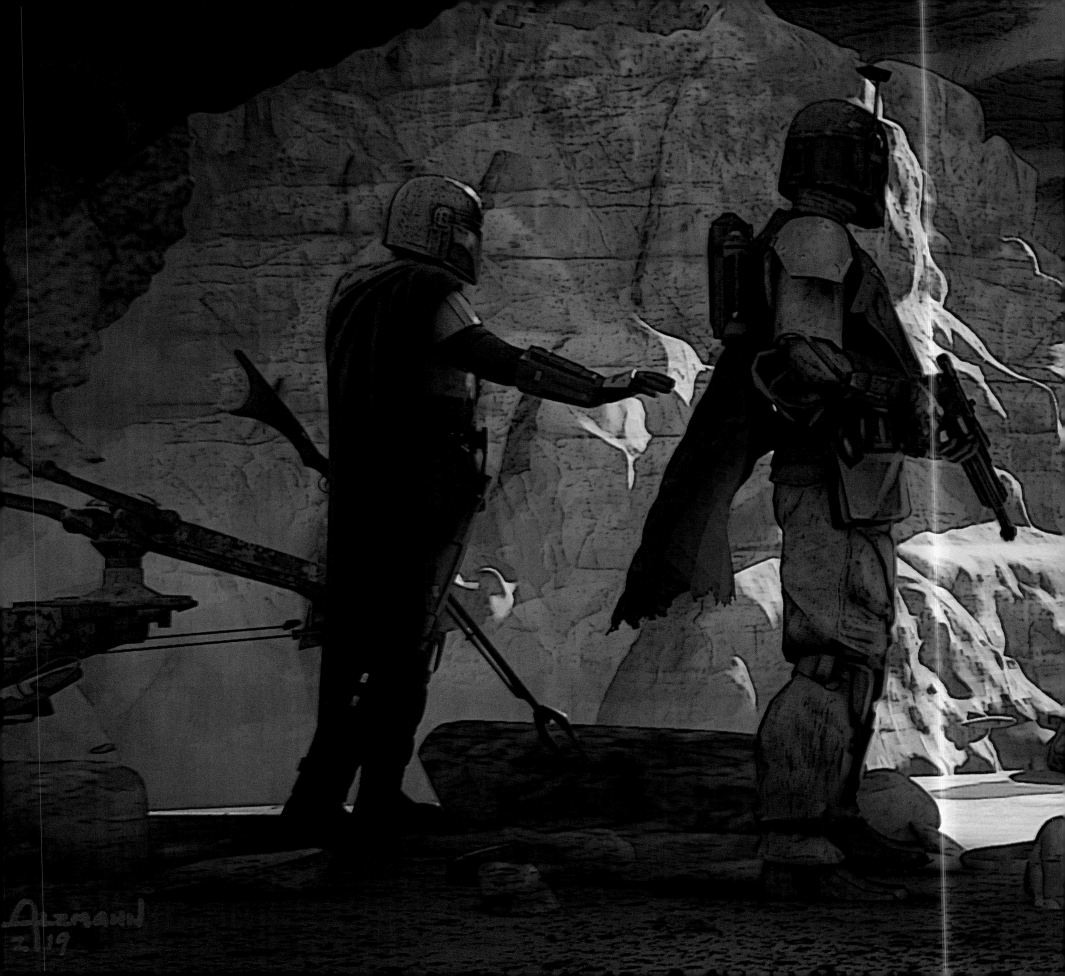

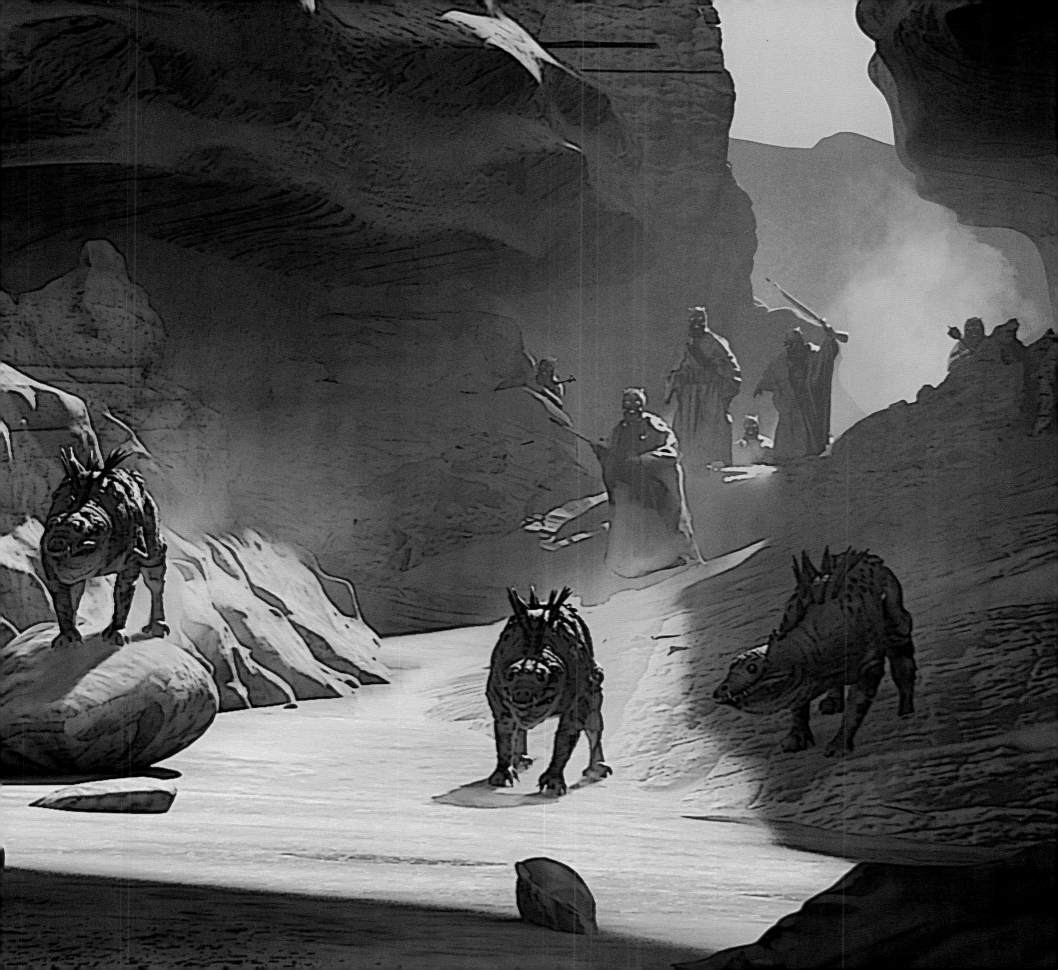

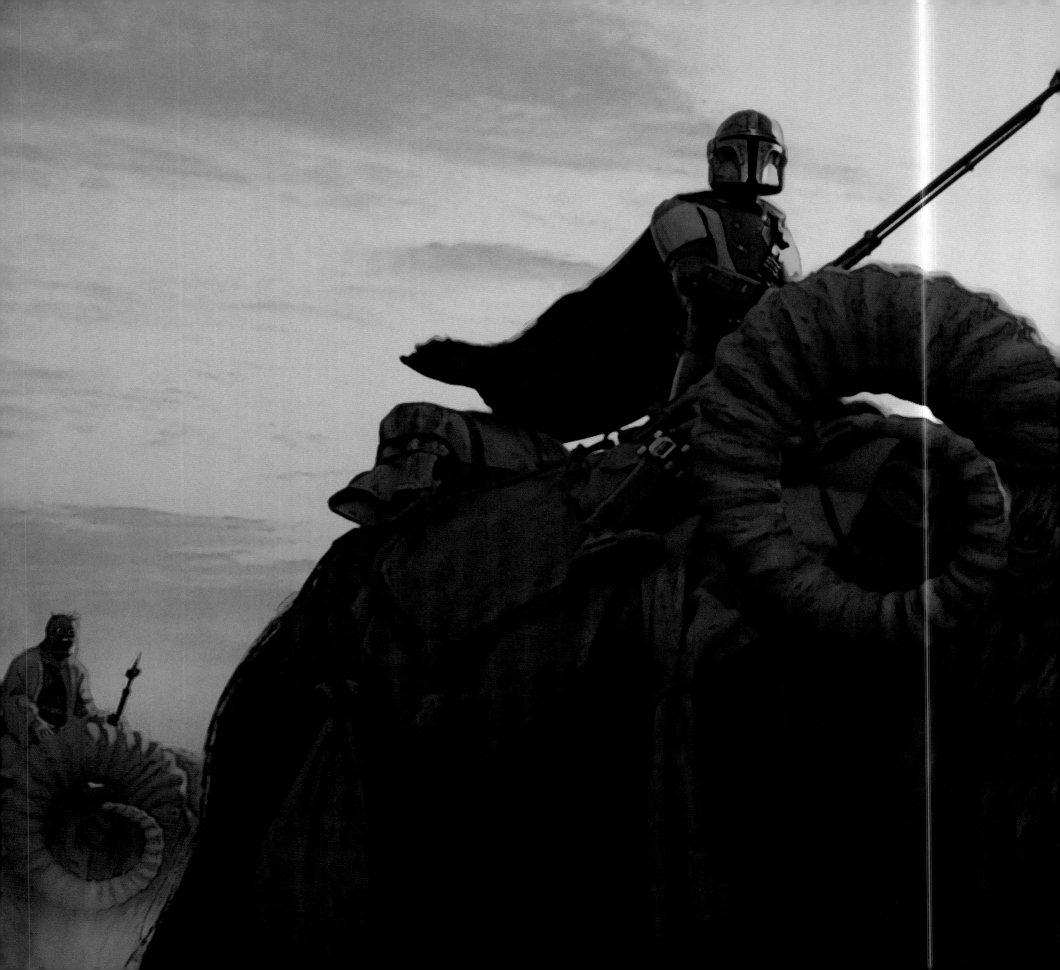

CONTENTS

FOREWORD BY DOUG CHIANG

Season 2 of *The Mandalorian* marks my sixteenth year of designing for *Star Wars*. I'm often asked if I ever get tired of it, and my answer, in short, is always "no"—my curiosity for creating distinctive imagery from the galaxy conceived by George Lucas remains strong. There are still many unexplored ideas, and *The Mandalorian* offers us the unique opportunity to continue this creative discovery. Many of us in the Lucasfilm art department grew up with the original trilogy, and collectively, there are multiple decades of *Star Wars* design knowledge between us. Yet even as first-generation fans, designing for *Star Wars* is an instinct developed with time and experience. *The Art of Star Wars: The Mandalorian (Season Two)* offers an in-depth look at what we've learned over the years. It reveals how sets and characters are developed; showcases the thoughtful process of invention and research behind each image; and highlights the design process that sometimes begins even before the first words are written, and continues long after principal photography has ended. Under Jon Favreau and Dave Filoni's assured direction, we won't tire of *Star Wars* for many decades to come.

It all starts with story: The story informs the art, and the art defines the story. Designing more than 320 minutes of content—enough for two or three feature films—in a third of the time and half the budget continues to be one of our biggest challenges. But we embrace the limitations, and we use them to our advantage. In art, the amount of time you spend on a piece doesn't determine how good it is; often the opposite is true. Time, therefore, forces us to focus and be concise.

New cross-disciplinary art and filmmaking tools like virtual scouting, where we don VR goggles to virtually walk our sets months before physical construction, allow us to design more efficiently and effectively. Moreover, our design process has become more fluid and now encompasses many other disciplines, including the virtual art department, costume design, creatures, visual effects, and lighting.

There are four stages to the design process. The first stage determines the philosophical foundation that anchors and unifies the look of the series. Good production design mirrors and reinforces the emotional story and character arcs. This may be as complicated as imagining a character history and tying the visual form language of the worlds to reflect the character's personality—or as simple as creating a color progression that reflects the emotional arc of the character.

The second stage is where the design process really begins: the concept design phase. This stage is where we establish the vision, and there are two components. The first part is blue sky exploration, where we go for the bold vision; we set the aspirational bar as high as possible, knowing that it'll be reduced once we go into production. The second part is where we refine the design to align with the script. The script pages determine how much effort we put into a particular set. For example, the greater the page count (and thus greater time spent on that set), the bigger the construction budget, and the more elaborate the design.

The third stage is the actual "production" of production design. This is where the designs become physical or virtual sets, or a combination of both. It involves all the departments: art, construction, set decoration, props, pre-vis, cinematography, visual effects, costumes, and creature effects. As the vision of the story is translated to physical reality, this phase can be fraught with challenges and compromises—or creative solutions.

The fourth and final stage is post-production, or visual effects design. In a standard film, the design process typically ends after principal photography. However, for *The Mandalorian*, art and design continue well into the post-production and editing phases, where the story is fully realized in its final iteration.

So, what makes a strong *Star Wars* design? The guidelines established by George Lucas are simple: Design as if a child could draw it. Design for the silhouette. Design for the iconic logo. Keep it simple. Give it personality and make it believable. When audiences see a design, they perceive the shape first. And they need to understand what they're looking at in seconds, so the silhouette is critical. Color and details come next, and they complete the design but don't define it. Additionally, it's crucial to use research. Don't be afraid to use references. It's a matter of looking at ordinary objects from a new point of view. Mix and match to turn the ordinary into the extraordinary. Remember, it is the choices we make that determine talent. Design is like archaeology; you dig into the past to uncover ideas and make them your own.

These guidelines are easy to understand and repeat but very hard to execute well. My team and I are still learning today, even after sixteen years of designing for *Star Wars*. Take, for example, the town of Mos Pelgo on Tatooine, where Mando finds Cobb Vanth and his extraordinary armor. This new location could have easily resembled the established cities of Mos Eisley or Mos Espa. To make it fresh and original, we turned it into a classic Western town with a single main street and then raised the buildings on stilts to give it a distinct characteristic that we hadn't seen before. The result is something familiar yet unique.

Jon Favreau continues to challenge us to take risks and bend the rules—breaking them when needed. When confronted with something new, it's tempting to play it safe, to repeat what has been done before. We resisted that urge and pushed the design needle forward. After all, *Star Wars* design is not about copying what we've seen before.

In my career, I was told you could be one of three things: the first, the only, or the best. The Lucasfilm art department obviously isn't the first, and definitely not the only, but we can strive to be one of the best. *The Art of Star Wars: The Mandalorian (Season Two)* celebrates the incredible artists bringing Din Djarin's second chapter to life with their designs. In these pages, you'll hear about what each of them brought forward to achieve the best memorable designs possible. I hope you enjoy their brilliance as much as we've enjoyed continuing to fulfill Jon and Dave's vision of a warrior and the foundling in his care.

"We always try to frame these shots so that they're very Western, like horseback riders. You could replace the banthas with horses. This is that classic Western shot." **Doug Chiang**

INTRODUCTION

In early 2019, many months out from the launch of the Walt Disney Company's streaming service Disney+, on which the series would debut, *The Mandalorian* creator Jon Favreau (*Iron Man*, *Chef*) and executive producer Dave Filoni (*Star Wars: The Clone Wars*, *Star Wars Rebels*) began to reassemble their teams for a second season. That season would widen the scope of the show, in both the sheer number of characters and the scale of the worlds to be designed and fabricated, some familiar to *Star Wars* fans and many others brand-new. But, as the hundreds of pieces of concept art, and the stories behind their creation, in the following pages clearly demonstrate, the challenge that expansion presented was met with both aplomb and the excellence typified by Favreau and Filoni's world-class crew.

Every episode of *The Mandalorian* begins with a spark, the germ of an idea that grows page-by-page as the screenplays are written. Lifelong *Star Wars* fans themselves, these writers dreamt big for the series's second run, folding in saga favorites like Ahsoka Tano, Bo-Katan Kryze (from Filoni's time on *The Clone Wars*, co-conceived with *Star Wars* creator George Lucas, and *Star Wars Rebels*), a return to Tatooine and the live-action debut of Marshal Cobb Vanth, original trilogy lead hero Luke Skywalker, as well as Boba Fett, the fearsome bounty hunter who metaphorically birthed every Mandalorian who followed, including the eponymous Din Djarin.

But it would be the newly introduced elements, such as the legendary krayt dragon, the rain-soaked world of Trask, Nevarro's Imperial base, the Kurosawa samurai film—inspired city of Calodan, and the menacing mechanical dark troopers, that would present some of the greatest design challenges for the *Mandalorian* crew.

The Lucasfilm art department was the first part of the team reassembled to turn those ideas into images, in this case pre-production concept art. Vice president and executive creative director Doug Chiang's squad rolled continuously and seamlessly from one season to the other, bringing with them an even more refined understanding of the preferred design language and aesthetic of filmmakers Favreau and Filoni.

The core of Chiang's team, design supervisors Ryan Church, Erik Tiemens (both concept design supervisors on *Star Wars Episode III: Revenge of the Sith*), and Christian Alzmann (who, along with Legacy Effects, designed the adorable Grogu for the series's debut season) were the first to reprise their roles for the second season, soon joined by fellow *Mandalorian* veterans Rene Garcia, Brian Matyas, Anton Grandert, and Tony McVey.

As design work continued, concept artists Khang Le, Benjamin Last, and Amy Beth Christenson bolstered the Lucasfilm art department's ranks, contributing key designs to the ever-growing list of production needs. Throughout, the group would draw inspiration, and sometimes unused designs, from *Star Wars* original trilogy design legends like Ralph McQuarrie, Joe Johnston, and Nilo Rodis-Jamero. Some of their indelible work is reproduced in this volume. McVey himself would carry more than four decades of design experience into Season 2 of *The Mandalorian*; his *Star Wars* career kicked off with creature sculpture and fabrication for 1983's *Return of the Jedi*.

The Lucasfilm art department's pre-production set and environment designs were then taken by co-production designer Andrew L. Jones and his production and virtual art department (or VAD) teams to be translated into not only physical assets to be put before the camera, but virtual ones added to the Stagecraft "volume" LED screens, a ground-breaking technology pioneered for *The Mandalorian*'s first season and advanced for the second.

For that very reason, VFX supervisor Richard Bluff (later joined by fellow VFX supervisors Joe Bauer and Jason Porter) was, as with Season 1, brought on very early to oversee the asset creation and implementation side of the Stagecraft technology, supplemented by Landis Fields's virtual production art. That asset creation includes the capturing of photogrammetry from dramatic real-world landscapes, supervised by Enrico Damm. Normally, the work of Industrial Light & Magic (or ILM, the visual effects company that George Lucas founded) is completed toward the tail end of the filmmaking schedule. But with Stagecraft enabling real-time in-camera visual effects, photoreal digital assets have to be front-loaded, resulting in a flipped VFX workflow more closely resembling the one found in animation.

Deciding where the line between real and virtual sets lies (and which sets are appropriate for the "volume" soundstage) is one of Jones's paramount tasks. Aiding him in that endeavor were returning set decorator Amanda Serino, prop master Josh Roth, and Legacy Effects supervisor John Rosengrant, as well as new to *The Mandalorian* costume designer Shawna Trpcic, primarily creating the physical assets needed for the real-world side of that fuzzy line. But Serino's team also provided assets to be scanned and included in the content load for the Stagecraft screens. Supplementing the costume and prop designs provided by Chiang's team with production-specific concept art were costume illustrator Michael Uwandi and property illustrator Paul Ozzimo, under Trpcic and Roth, respectively.

Simultaneous with the early design process, head of storyboards Dave Lowery and storyboard artist Phill Norwood began transforming Favreau's scripted words into sequential art consisting of shots, camera movement, and action. Favreau worked hand-in-hand with Lowery on nearly all of his films, from 2008's *Iron Man* to 2019's *The Lion King*, and one of Lowery's first professional gigs was storyboarding *Willow* at ILM for director Ron Howard, father of *Mandalorian* director Bryce Dallas Howard.

"This story is about coming together," Favreau said. "And I think *Star Wars* was always about that, families forming." And as the artists and artisans listed above moved from one season to the next, reuniting with old comrades, and now having worked together for more than three years, that story of coming together, a family forming, extends from within the narrative of the show to without. A production family of hundreds of the very best craftspeople in the film and television industry has been formed under the guidance of Favreau and Filoni. The work in *The Art of Star Wars: The Mandalorian* (Season 2) represents but a fraction of the total art created for the series, showcasing one of the first, but perhaps most vital, steps in bringing the story of Din Djarin and Grogu to life.

→ **DUNE VILLAGE LAYOUT** Erik Tiemens

→→ **KRAYT HEAD VERSION 02** "The horns created too much visual conflict with traditional dragons, so, ultimately, we decide to eliminate the horns and do more of a triceratops shield." **Chiang**

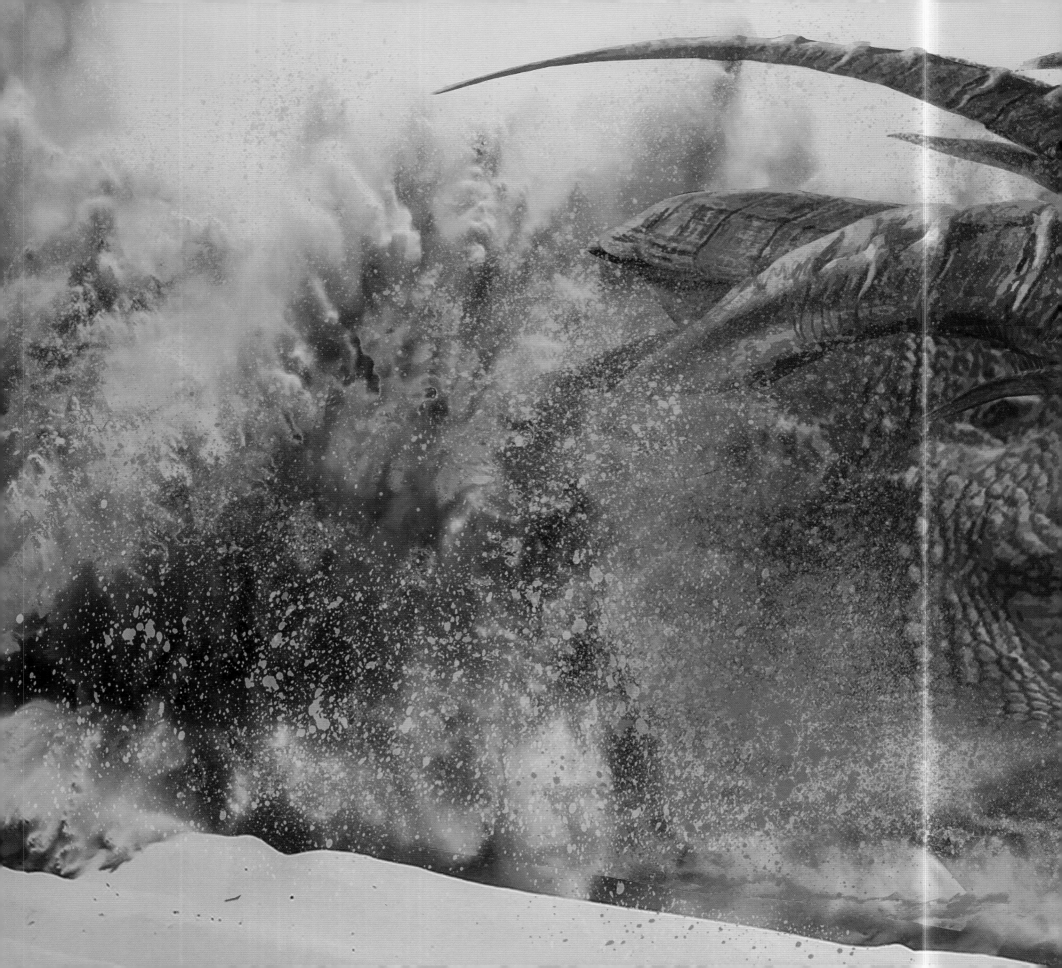

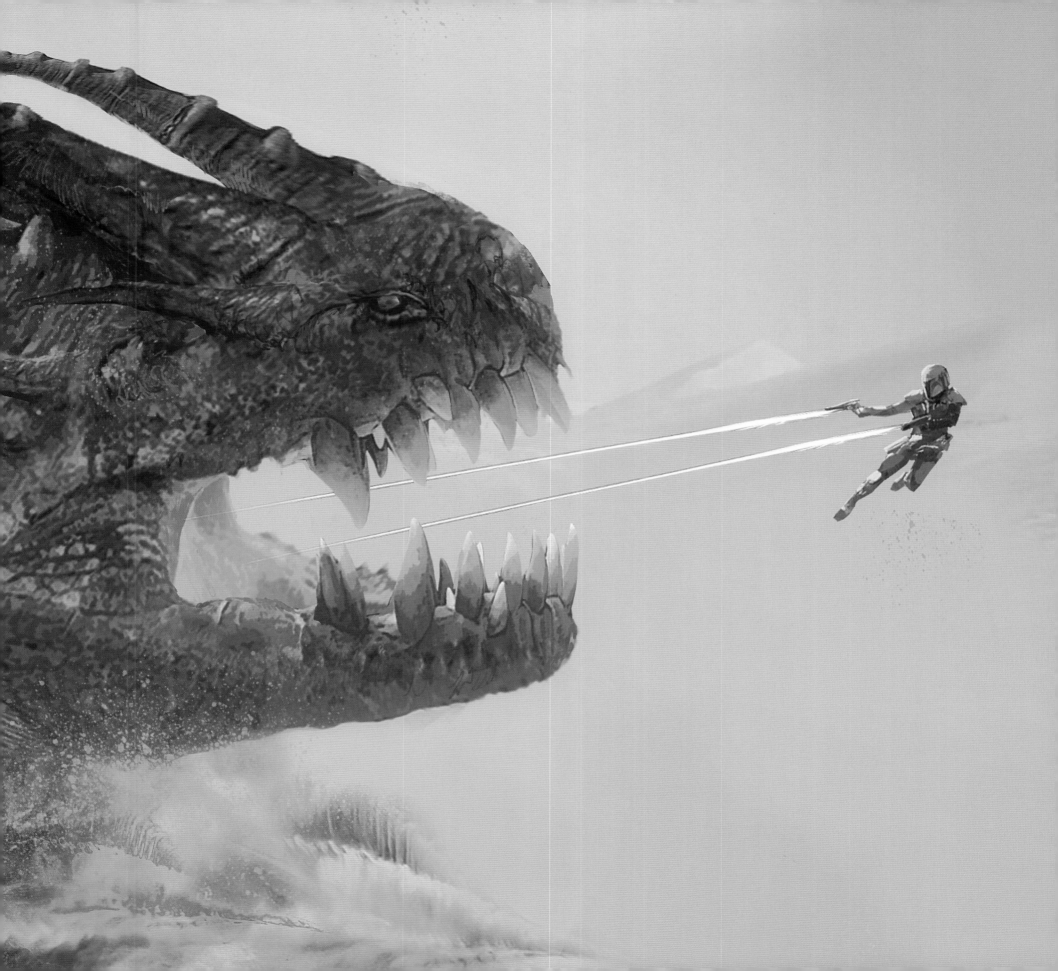

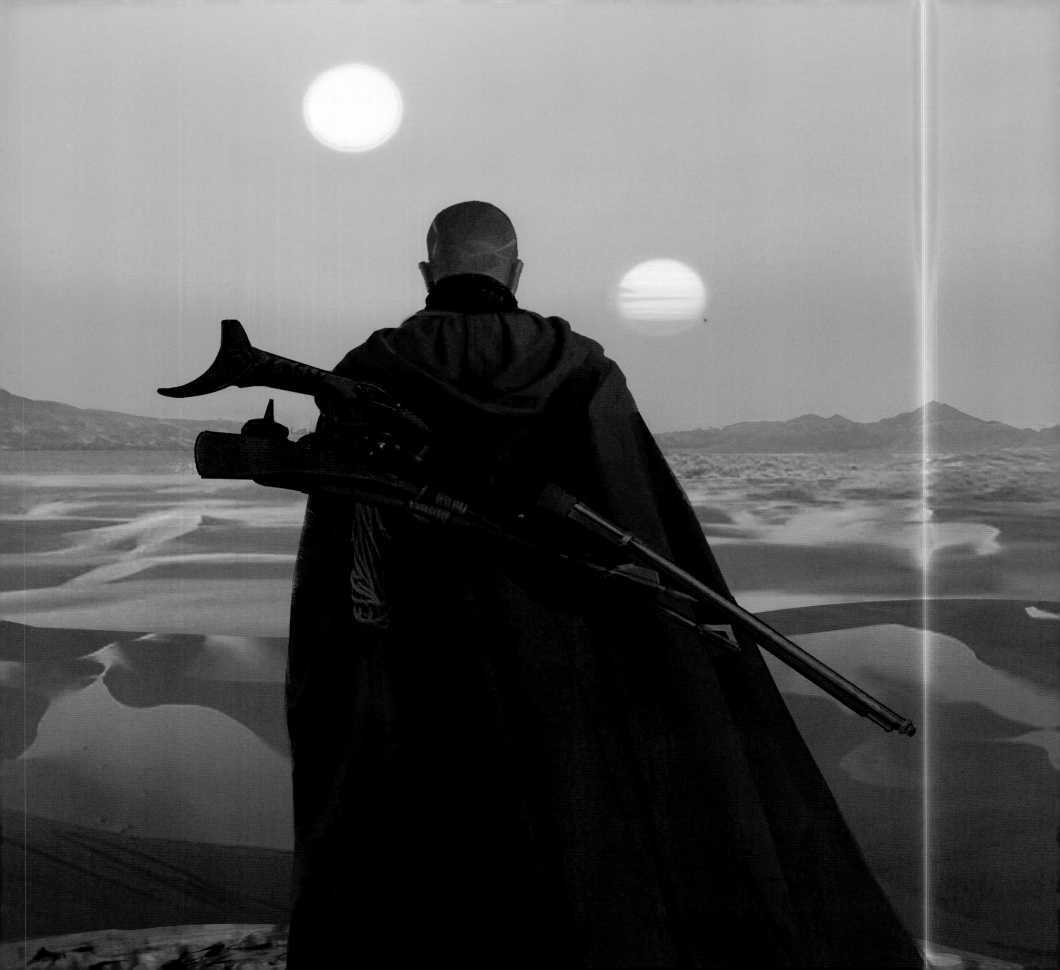

↑ **AHSOKA CAPE** Michael
Uwandi and Shawna Trpcic

← **BOBA FETT DUNE SEA
VERSION 1A** Matyas

WHO'S WHO

CHRISTIAN ALZMANN
Concept supervisor

JOHN BARTNICKI
Producer

JOE BAUER
VFX supervisor

CARRIE BECK
Co-executive producer/
Lucasfilm VP live action
development & production

STACY BISSELL
ILM VFX producer

RICHARD BLUFF
Consulting VFX supervisor/
VFX supervisor

ROY K. CANCINO
Special effects supervisor

DOUG CHIANG
Production designer/Design
supervisor/Lucasfilm VP/
Executive creative director

DAVID CHOE
Graffiti artist/actor

AMY BETH CHRISTENSON
Concept artist

RYAN CHURCH
Concept supervisor

ENRICO DAMM
Environments VFX
supervisor

MICHAEL EPSTEIN
Graphic designer

RICK FAMUYIWA
Director/Screenwriter

JON FAVREAU
Creator/Executive
producer/Director/
Screenwriter

LANDIS FIELDS
Virtual production
visualization supervisor

DAVE FILONI
Executive producer/
Director/Screenwriter

RENE GARCIA
Concept model supervisor

KAREN GILCHRIST
Co-executive producer

JOHN GOODSON
Concept model maker/
Miniatures team

ANTON GRANDERT
Concept artist

JOHN HAMPIAN
Co-producer

HAL HICKEL
Animation supervisor

PABLO HIDALGO
Lucasfilm senior
creative executive

BRYCE DALLAS HOWARD
Director

BAZ IDOINE
Director of photography

MATTHEW JENSEN
Director of photography

JOE JOHNSTON
Star Wars original trilogy
ILM art director

ANDREW L. JONES
Production designer

ABBIGAIL KELLER
VFX producer

KATHLEEN KENNEDY
Executive producer/
Lucasfilm president

DAVID KLEIN
Director of photography

JOHN KNOLL
ILM VFX supervisor

BENJAMIN LAST
Concept artist

DAVID LAZAN
Supervising art director

KHANG LE
Concept artist

JANET LEWIN
Co-producer/Lucasfilm
VP production

DAVE LOWERY
Head of storyboards

GEORGE LUCAS
Star Wars creator

BRIAN MATYAS
Concept artist

JASON McGATLIN
Co-producer/Lucasfilm
senior VP of physical
production

RALPH McQUARRIE
Star Wars original trilogy
production illustrator/
Concept artist

TONY McVEY
Concept sculptor

PHILL NORWOOD
Storyboard artist

PAUL OZZIMO
Property illustrator

DAN PATRASCU
Miniatures team

JASON PORTER
VFX supervisor

PEYTON REED
Director

JULIE ROBAR
Costume supervisor

NILO RODIS-JAMERO
Star Wars original trilogy
ILM assistant art director/
Costume designer

ROBERT RODRIGUEZ
Director

JOHN ROSENGRANT
Legacy Effects supervisor

JOSH ROTH
Prop master

AMANDA SERINO
Set decorator

THOM TENERY
*Rogue One: A Star Wars
Story* concept artist

ERIK TIEMENS
Concept supervisor

SHAWNA TRPCIC
Costume designer

MICHAEL UWANDI
Costume illustrator

CARL WEATHERS
Director/Actor

COLIN WILSON
Executive producer/
Unit production manager

THE MARSHAL

Given the runaway success of the first season of *The Mandalorian*, which garnered multiple Emmy nominations and awards and fueled the worldwide growth of Disney+, a sophomore season might seem like an inevitability. But the behind-the-scenes story of *The Mandalorian's* second run begins long before that success (and long before the countless adorable "Baby Yoda" memes and animated GIFs), stretching all the way back to 2018, when the first season was still being shot.

"As I was first pitching the *Mandalorian* story [in November 2017] and figuring out what I wanted the show to look like, I gave myself the freedom to tell the story I wanted to tell," Favreau said. "And, to his credit Dave never said, 'Oh, you can't have [Mandalorians not removing their helmets] be the rule; we've already established that [they can remove their helmets].' I even played a Mandalorian character [*The Clone Wars'* Pre Vizsla] whose helmet was off most of the time. But there were a few things that I wanted to explore. One was why we didn't see a lot of Mandalorians in the original trilogy and sequels. You see them so much in *Clone Wars*, but you don't see any of them now. The other was, how do you get back to what George did, which was treat the characters almost like action figures? How do you get back to how young kids interact with *Star Wars*, the colors and shapes and characters? By keeping [Mando's] helmet on all the time. It's not about the face under it, it's about the helmet. Same with Boba Fett; you don't think about what's under the helmet, you think about that mysterious silhouette. I wanted to preserve the magic of that, or return it to that, knowing full well that we would get complex later, that there are some groups that stick to the old rules and other groups that have evolved, like Bo-Katan's group, that are dealing more with the politics of the moment. Having those two meet each other and contend with one another was a way to address that." Bo-Katan Kryze is the Mandalorian warrior and leader co-created with George Lucas for the animated series *Star Wars: The Clone Wars*.

Executive producer and writer/director Dave Filoni recalled, "Early on I had also been considering ways of working Ahsoka Tano (Anakin Skywalker's Jedi apprentice, who also has origins in *The Clone Wars* and *Rebels*) into the story. There were a lot of things that I wanted to do with her character. But how can I do it, make sure I'm getting it right, and have as much control over the situation as possible?"

After a full nine months of intensive concept design work (detailed in Abrams Books' *The Art of Star Wars: The Mandalorian* Season 1), executive creative director Doug Chiang's San Francisco–based Lucasfilm art department wrapped pre-production on Season 1 of *The Mandalorian*.

Two months later, after more than four years of work, the Lucasfilm art department completed design work on the *Star Wars*: Galaxy's Edge lands at Disneyland Resort in Anaheim, California, and Walt Disney World Resort in Orlando, Florida. Hitting that milestone freed design supervisor Erik Tiemens to commit to *The Mandalorian* full-time for its second season. "There was some overlap there," Tiemens recalled. "I was happily busy with notes for the parks, but at the same time I was feeling like, oh, it would be so fun to work on *The Mandalorian*!"

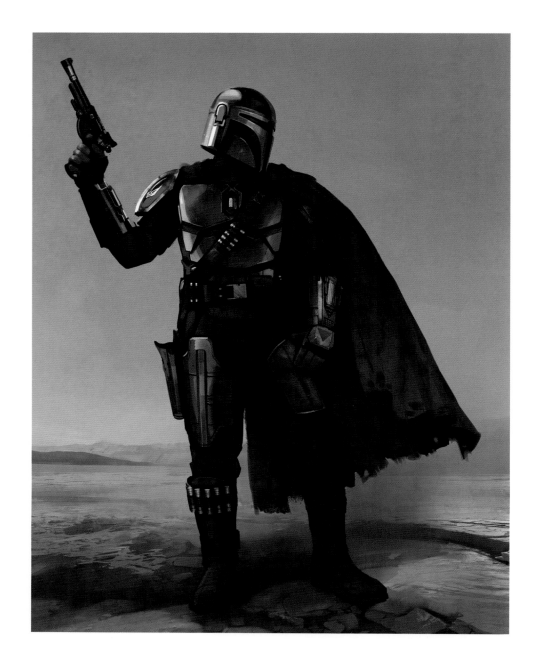

Then, prior to the crew's customary two-week holiday break, Favreau began sharing some early Season 2 story ideas with Chiang. "I started before Christmas because Jon gave me a sneak peek—he wanted to explore the krayt dragon," Chiang said. "I didn't know what the context was, but I started doing some paintings while on set."

As he did one year prior with the screenplay for Chapter 1, Jon Favreau completed his first draft of the first episode of Season 2, titled "Chapter 9: The Marshal," over the holiday break. The core team of Lucasfilm art department concept supervisors—Christian Alzmann, Ryan Church, and Erik Tiemens—plus concept model supervisor Rene Garcia, all under Chiang's supervision, began designing Chapter 9's aforementioned krayt dragon and dusty Tatooine backwater Mos Pelgo

↑ **WAREHOUSE DISTRICT VERSION 03**
"The challenge was, how can we build a set that is not too big and can show this industrial, seedier part of town? With the distant towers, I wanted to allude to something that goes beyond just that street level, like you're nestled into this canyon of establishments." **Tiemens**

↖ **MANDO STAGE 6 VERSION 175** Matyas

almost immediately thereafter, on January 10. They were joined by returning Season 1 concept artists Anton Grandert, Brian Matyas, Tony McVey, and John Park (all worked remotely, except McVey, as freelance concept artists often do), plus series newcomer Khang Le, in the second week of February.

In that first Chapter 9 draft, Favreau introduced titular Mos Pelgo marshal Cobb Vanth to *The Mandalorian*. Vanth is the first character ever to make the leap from the pages of a *Star Wars* novel, in this case author Chuck Wendig's *Star Wars: Aftermath* trilogy released from 2015 to 2017, to live-action. "I happened upon Cobb Vanth as I was investigating what was out there about Boba Fett and figuring out the best way to bring that character in," Favreau remembered. "Cobb Vanth's is a story told

within the [*Aftermath*] story. It felt like a Western. When you dig into the deep lore, you want to make sure that you're not excluding fans who don't know about it. But looking for inspiration in every corner of the *Star Wars* canon and Expanded Universe is a good way to acknowledge that people have spent a lot of time with these stories."

Despite his having penned twelve of the sixteen *Mandalorian* scripts over both seasons, Chapter 9 was the first episode that veteran filmmaker Jon Favreau also directed.

"Chapter 9: The Marshal" was the third of the eight Season 2 episodes filmed. In the middle of its thirteen-day shoot, the Disney+ streaming service launched, and the first episode of Season 1 of *The Mandalorian* premiered.

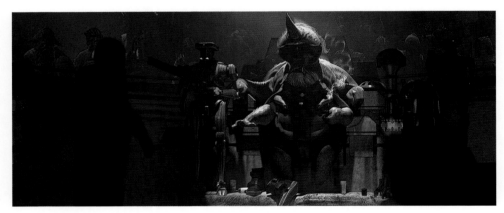

↑ **GOR KORESH VERSION 03** Alzmann

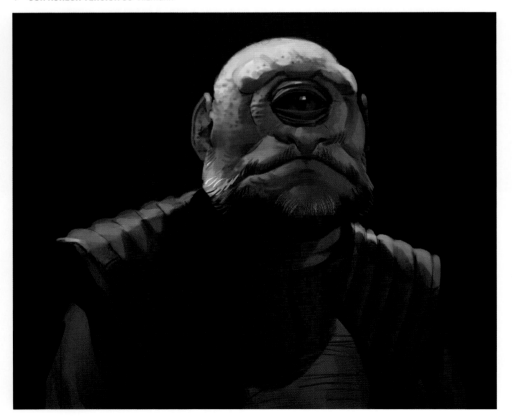

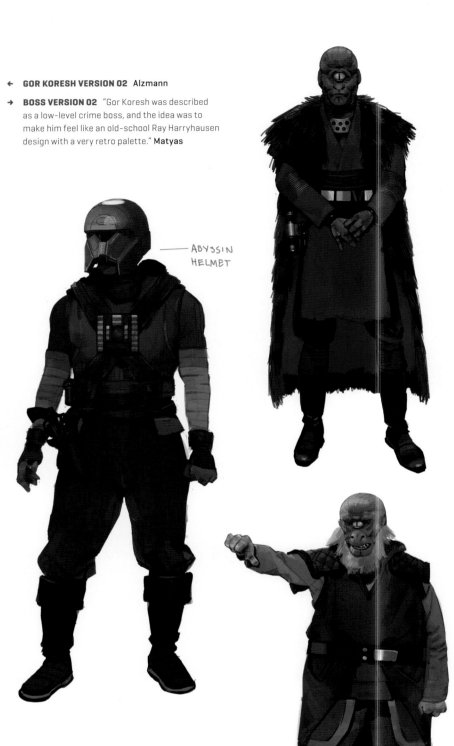

← **GOR KORESH VERSION 02** Alzmann

→ **BOSS VERSION 02** "Gor Koresh was described as a low-level crime boss, and the idea was to make him feel like an old-school Ray Harryhausen design with a very retro palette." Matyas

— ABYSSIN HELMET

↑ **BODYGUARD VERSION 01** "I thought it would be interesting to explore the idea of an Abyssin assassin-hitman-henchman with a helmet, which would have a monocle to compensate for their giant eyeball." Matyas

← **VERSION 253** Matyas

→ **BOSS VERSION 4A** "Doug described Gor Koresh as being almost like an emperor of the Colosseum who gets to decide the fates of the Gamorreans, so I tried the half thumb, yea-or-nay, to riff off of that idea. A really simple costume." Matyas

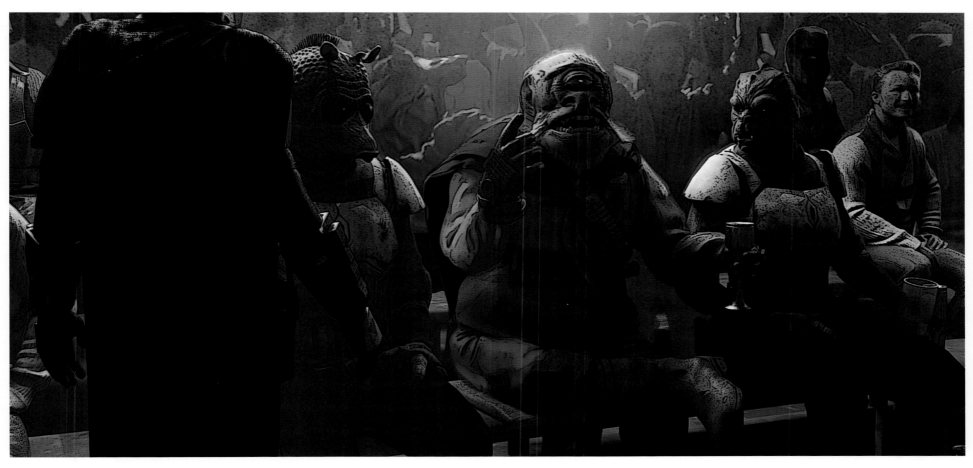

↑ **CYCLOPS GANG BOSS VERSION 06**
Alzmann

"Jon's idea was that the arena should have simple bench seating. Gor Koresh is not a distant spectator or sitting on a throne. He's just one of the guys, obviously surrounded by his bodyguards." **Chiang**

← **GOR KORESH HAIR OPTIONS VERSION 02** Legacy Effects

In Jon Favreau's first draft script of "Chapter 9: The Marshal," Gor Koresh is simply described as "a foul cyclops with two earrings and a nose ring."

→ **ABYSSIN BOSS VERSION 06** "Once I did a few of those, we decided to 'make him more like a classic mob boss.' So I went full Tony Soprano. And that's the one that stuck." **Matyas**

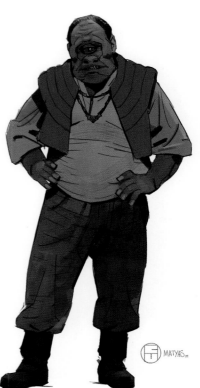

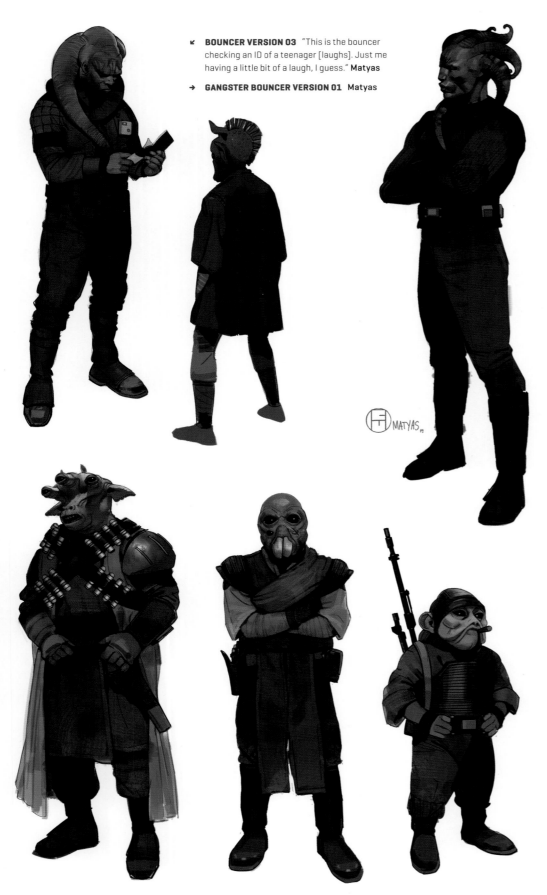

↖ **BOUNCER VERSION 03** "This is the bouncer checking an ID of a teenager [laughs]. Just me having a little bit of a laugh, I guess." **Matyas**

→ **GANGSTER BOUNCER VERSION 01** Matyas

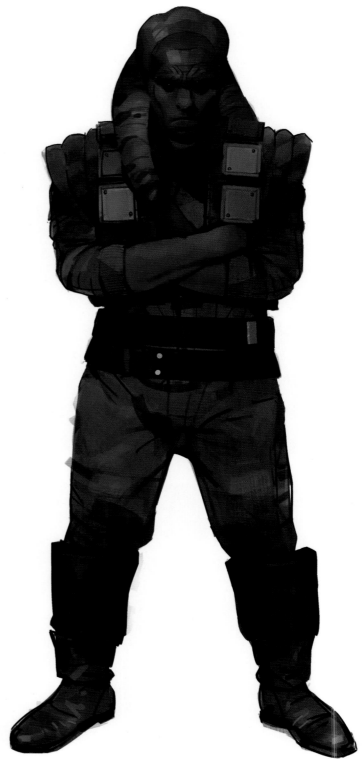

↑ **GANGSTER BOUNCER VERSION 02** Matyas

"This scene was really our grittier, seedier version of the Mos Eisley cantina, populated with as many interesting characters as possible, but making it feel very dangerous at the same time." **Chiang**

← **GANGSTER GUARDS VERSION 03** Matyas

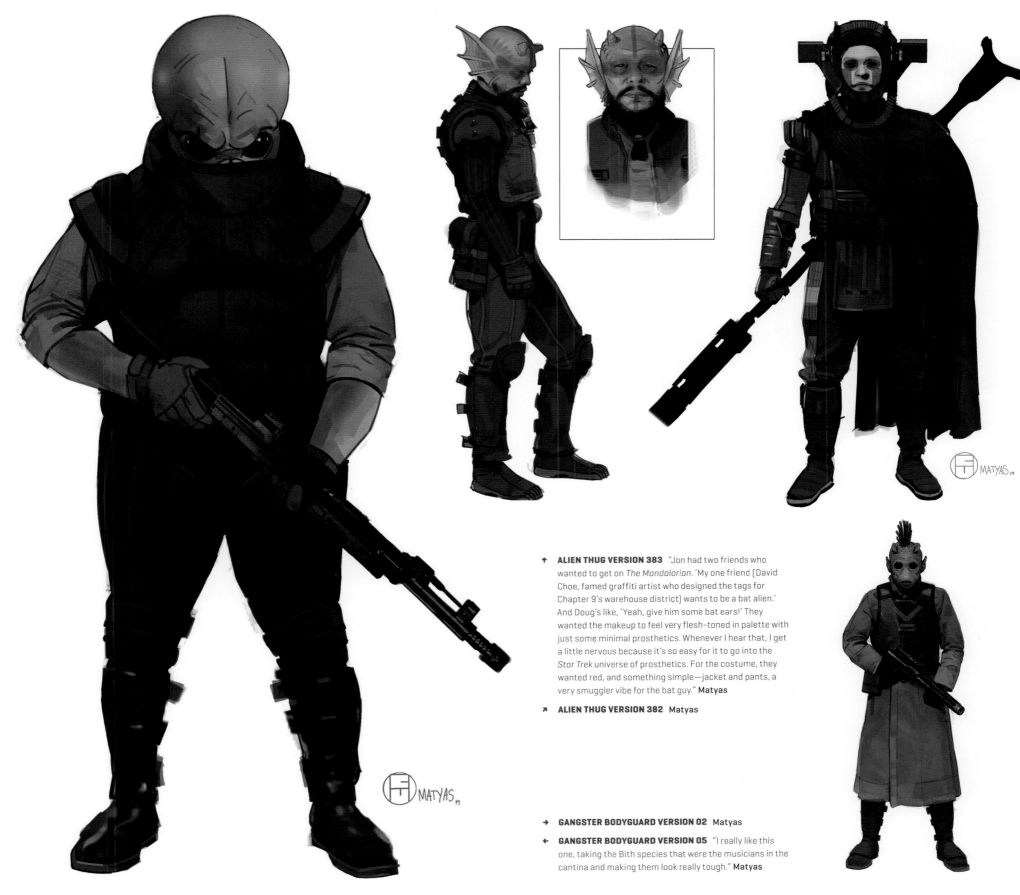

ALIEN THUG VERSION 383 "Jon had two friends who wanted to get on *The Mandalorian.* 'My one friend (David Choe, famed graffiti artist who designed the tags for Chapter 9's warehouse district) wants to be a bat alien.' And Doug's like, 'Yeah, give him some bat ears!' They wanted the makeup to feel very flesh-toned in palette with just some minimal prosthetics. Whenever I hear that, I get a little nervous because it's so easy for it to go into the *Star Trek* universe of prosthetics. For the costume, they wanted red, and something simple—jacket and pants, a very smuggler vibe for the bat guy." **Matyas**

↗ **ALIEN THUG VERSION 382** Matyas

→ **GANGSTER BODYGUARD VERSION 02** Matyas

← **GANGSTER BODYGUARD VERSION 05** "I really like this one, taking the Bith species that were the musicians in the cantina and making them look really tough." **Matyas**

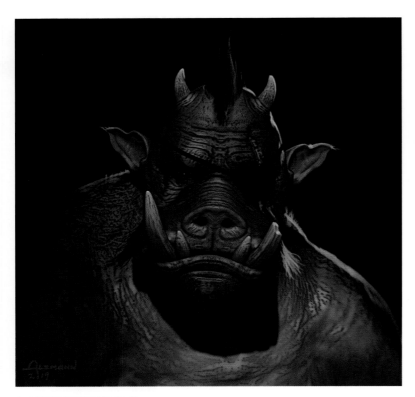

↑ **EYEPATCH VERSION 02** Alzmann

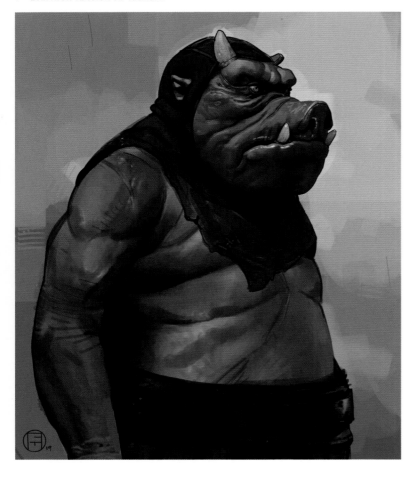

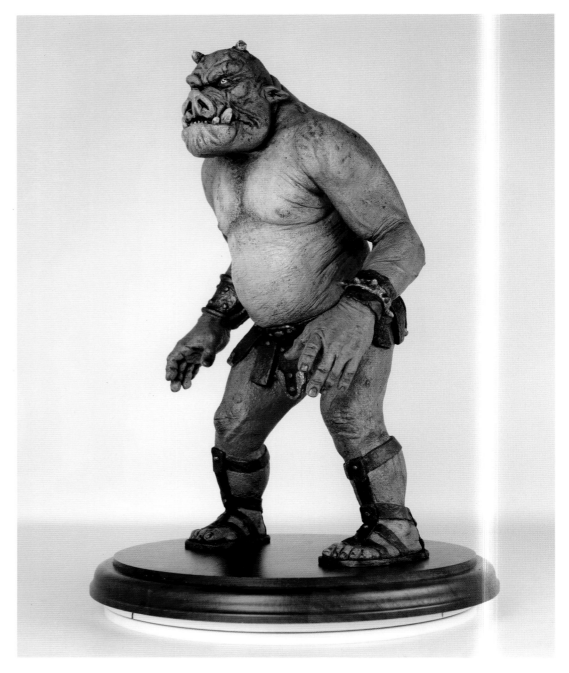

"This is the first time we we've brought the Gamorreans back to live-action, so I wanted to update the original *Return of the Jedi* designs. We deliberately made them very strong, with a lot of presence." **Chiang**

← **GAMORREAN PORTRAIT VERSION 156**

"We were going very gladiatorial in the costuming, which is the Gamorreans' vibe from *Return of the Jedi*, for the most part, and a bit of a barbarian vibe, as well. So, riffing off of what you already know with Gamorrean guards and updating them for how they're going to shoot them for the show." **Matyas**

↑ **PAINTED GAMORREAN SCULPT VERSION 04** Tony McVey

Jon Favreau shared a photo of this Gamorrean fighter maquette, sculpted by veteran *Star Wars* creature sculptor Tony McVey, on his Instagram account. It was the second teaser image from Season 2 and Chapter 9 that Favreau shared, following a snapshot of the Mandalorian's helmet on a pillar in the Mos Pelgo backlot set posted a month earlier.

"I made the foam built-up bodies for the *Return of the Jedi* Gamorreans, while the head, hands, and feet were sculpted by Dave Carson, and to be honest, I always thought they could have used a little more character. I thought the little full-body pig guard maquette looked much more interesting, loosely rendered and craggy and more intense-looking than the final costumed versions." **McVey**

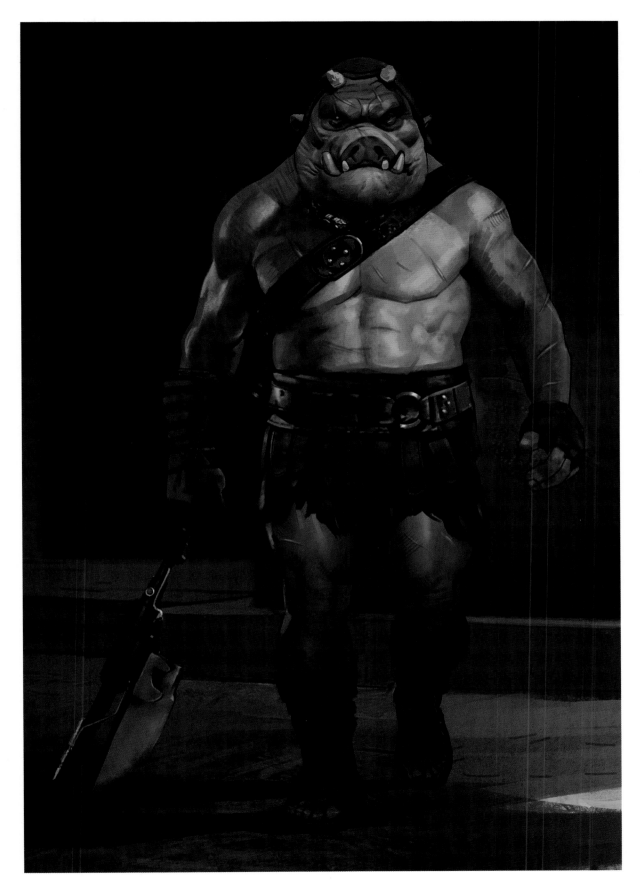

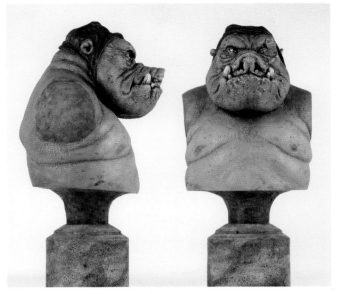

↑ **PAINTED GAMORREAN BUST VERSION 4A** McVey

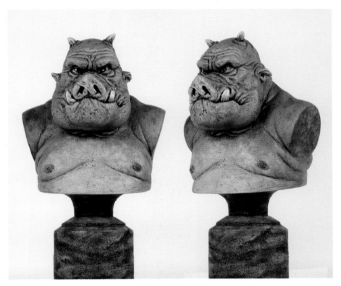

↑ **PAINTED GAMORREAN BUST VERSION 4B** McVey

← **GAMORREAN FIGHTER VERSION 3A** Matyas

"The challenge was that they were going to be bare-chested. We really can't hide much, and they have to do a lot of fighting, so they couldn't be full-on rubber bodysuits. This was our ideal version of our muscular gladiator Gamorrean." **Chiang**

→→ **MANDO ENTRY VERSION 02** Alzmann

"Jon's idea was to open the season on an Outer Rim planet that's very rough, like a warehouse district at the edge of town. Because we're only going to see this location at night, we had to figure out how to create distinct architecture that would give us really strong silhouettes. Maybe the buildings are almost like cylindrical water containers, old structures that have been converted into this sort of underground fight club. For the foreground, we really leaned into the idea that this is a cobbled-together industrial area, with a lot of cables and strong lights to give it a very seedy feel." **Chiang**

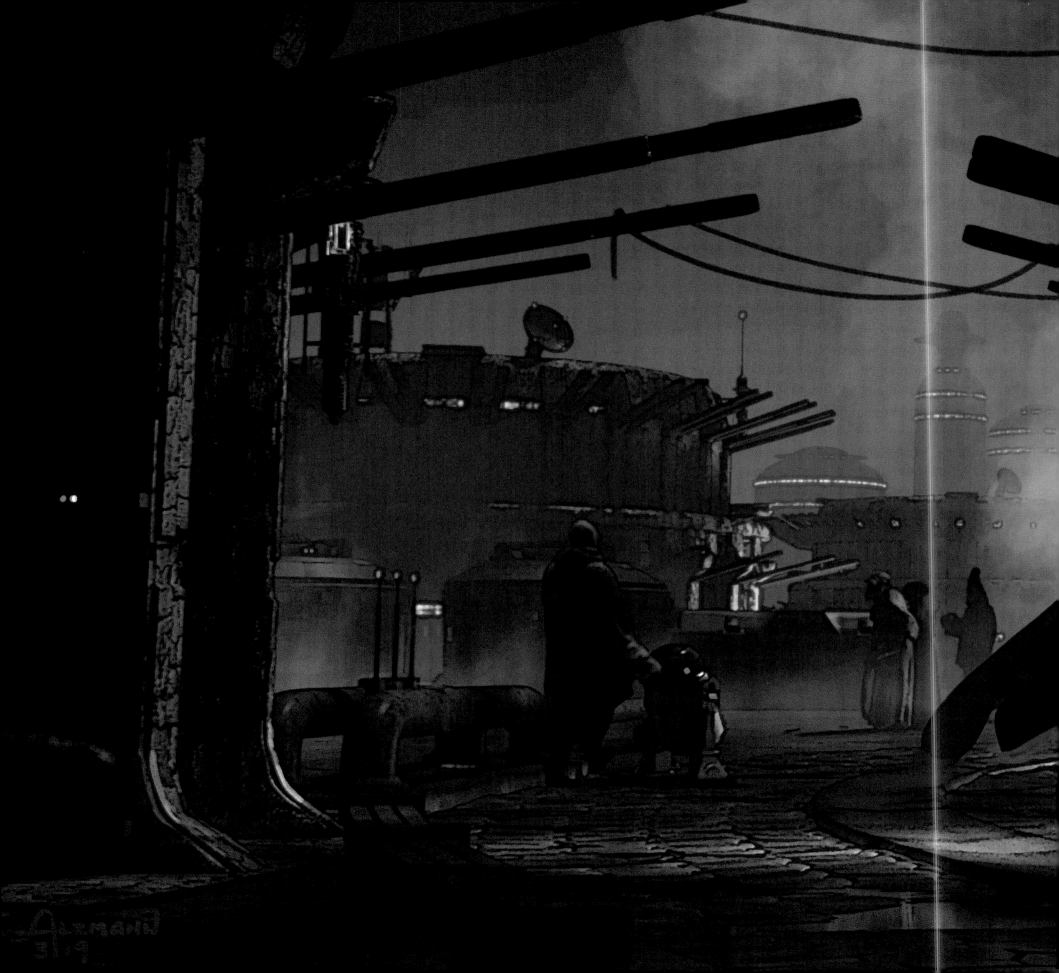

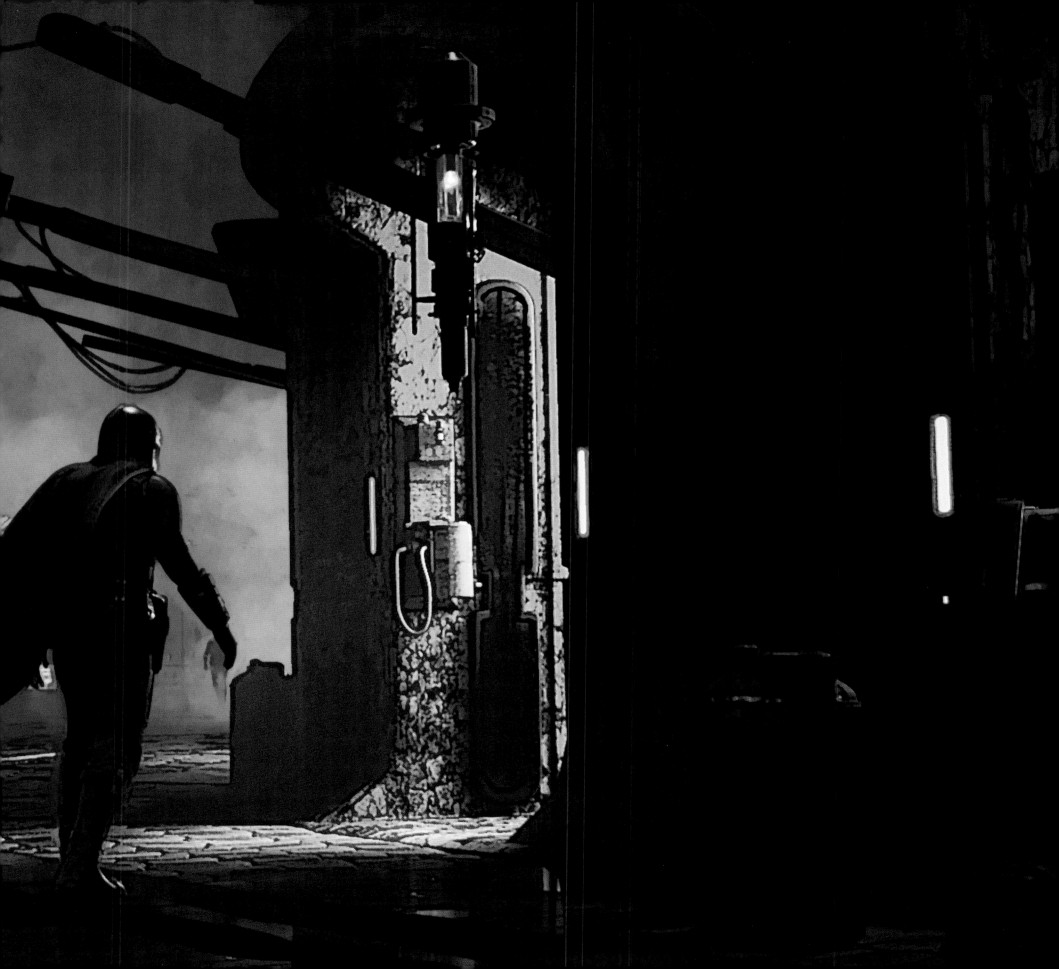

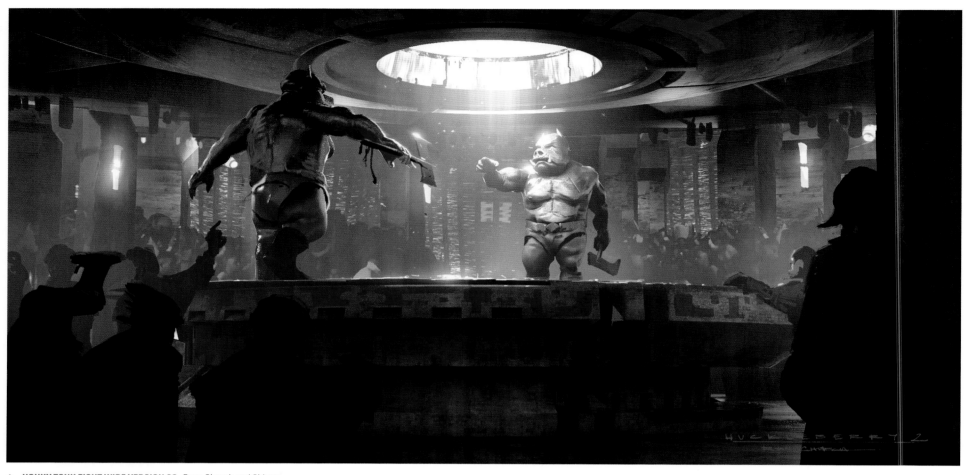

↑ **HONKY TONK FIGHT WIDE VERSION 02** Ryan Church and Chiang

↓ **CARNITA ARENA VERSION 07** Alzmann

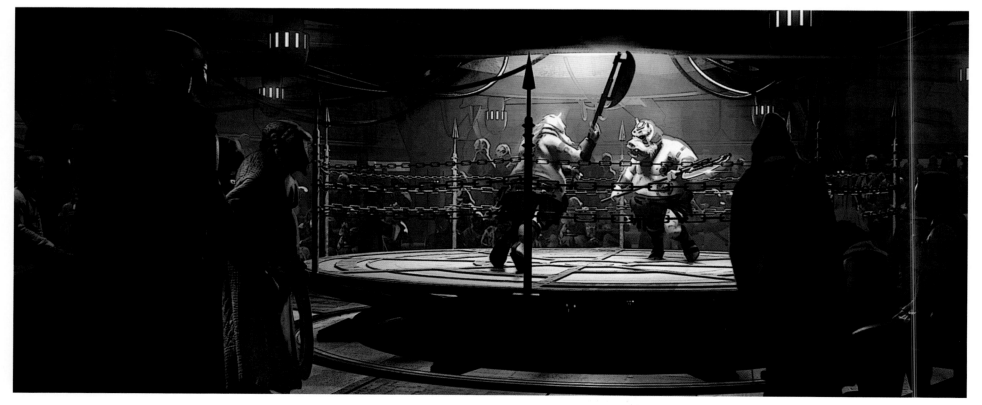

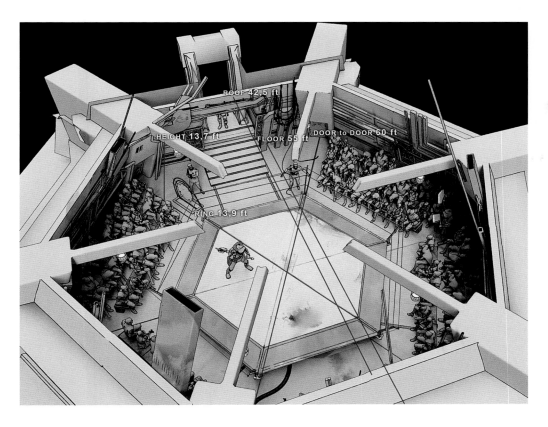

Roof 42.5 ft

HEIGHT 13.7 ft FLOOR 55 ft DOOR to DOOR 60 ft

RING 13.9 ft

← **CARNITA ARENA 02 VERSION 07** Anton Grandert

"The inspiration for this is Muay Thai fighting
arenas, going really down and dirty, very smoky.
We designed it as an ideal volume set, meaning
that the diameter of this actually fit and matched
the LED walls. All we had to build was the
centerpiece, the floor and the fight pit, and then
the entrance where Mando comes down. The set
itself was pretty simple." **Chiang**

↓ **CARNITA ARENA VERSION 01** "This was the
first painting I did for the show, and it's one of my
favorites." **Grandert**

↑ **CARNITA ARENA 06 VERSION 6B**

"When I got this assignment, Doug
showed me Christian's version of the
arena, and I freaked out because his
was so good, and I didn't feel really
confident that I could do anything
better. I looked at some real fighting
arenas, like UFC, Thai boxing, and
kickboxing, and thought it would
be fun to have some flags hanging
from above, like trophies of previous
winners. I even put a gong in there, as
a reference to boxing." **Grandert**

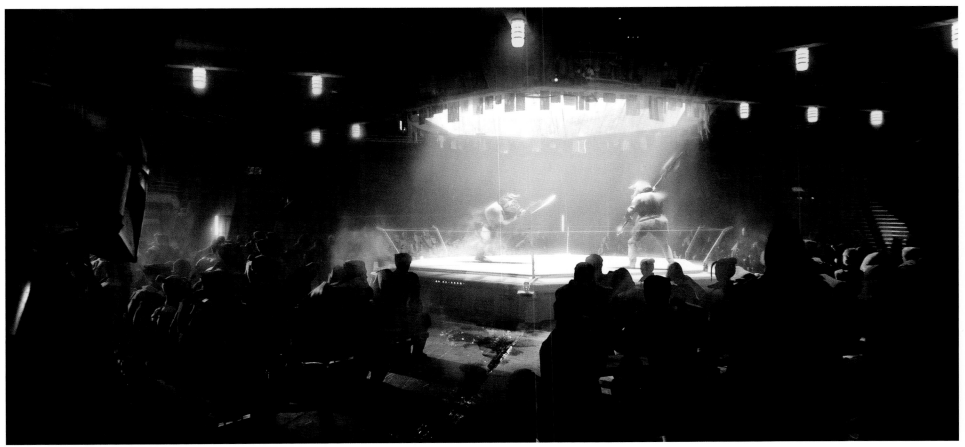

↑ **HONKY TONK EXTERIOR VERSION 04** "It's the classic language of the cinematographer, when they're smoking the sets and playing with light and shadow and silhouette. The more you can suggest, the more your brain fills in all the little details and expands it. I think we get more production value than a set lit at noon where you see every little square inch." **Tiemens**

← **WILD DOG VERSION 309** Matyas

→ **WILD DOG VERSION 306** "The design prompt was for these creatures to be a quadruped that is essentially a dog in personality. Hard surface designs [sets, vehicles, droids] and creatures, to me, are fun, but they're challenging." **Matyas**

← **WILD DOG VERSION 311** Matyas

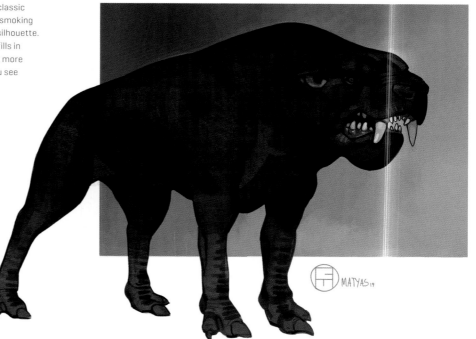

"We knew we were going to Tatooine, which has a really bright yellow, orange palette, later in the episode, so we deliberately leaned into a cooler palette for this, going much darker." **Chiang**

↑ **ALLEY GOR VERSION 1A** Alzmann

↑ **GOR KORESH HANGING SKETCH VERSION 01** Matyas

→ **HUNG CYCLOPS VERSION 2A** Le

→→ **KRAYT AERIAL VERSION 02** "This painting was my early attempt to show the scale of this beast. You can see the alligator scales, implying that this is a giant serpent underneath the sand." **Chiang**

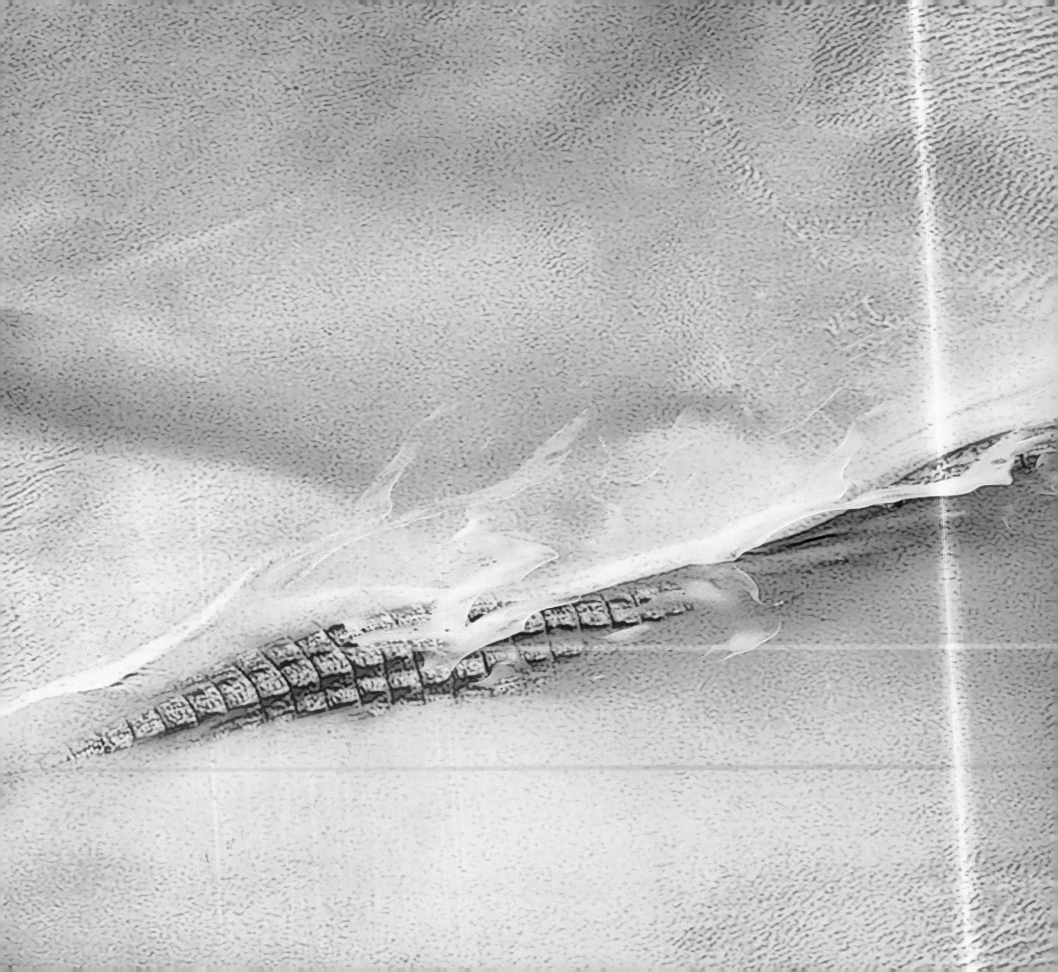

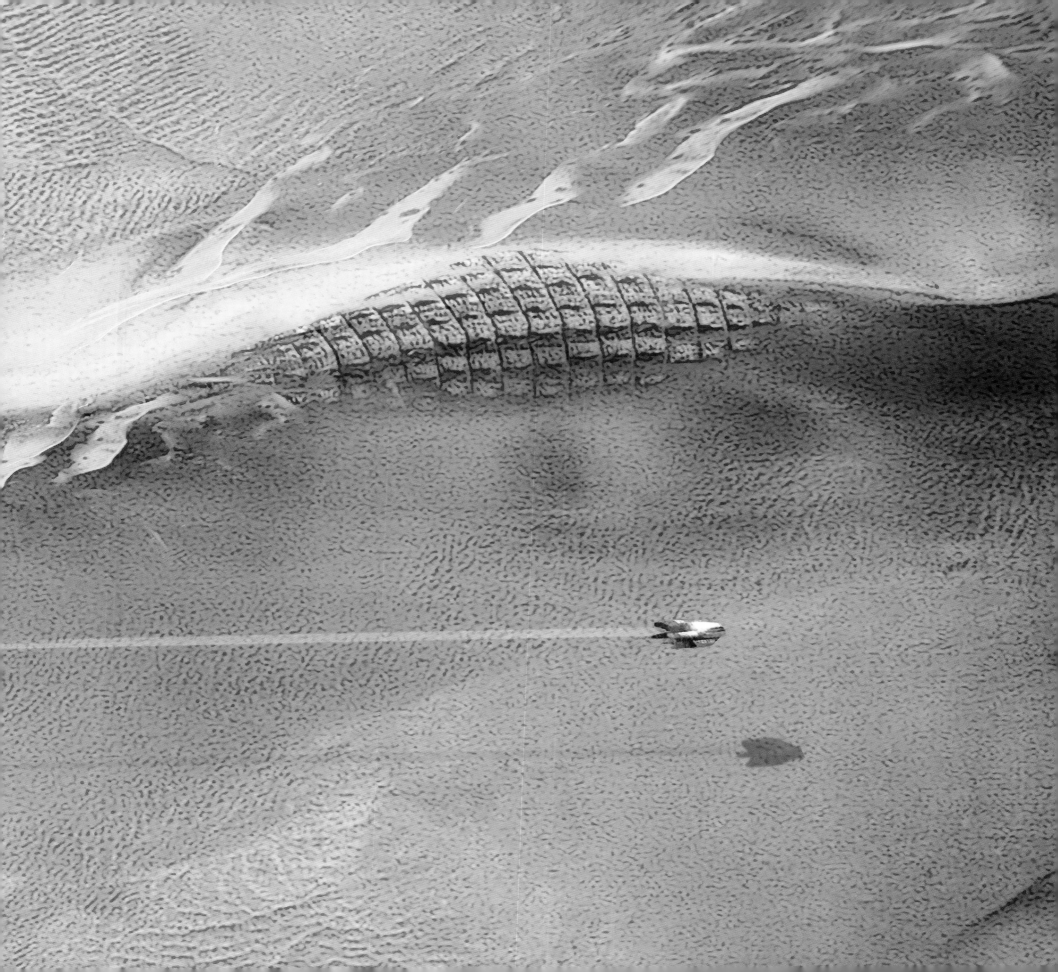

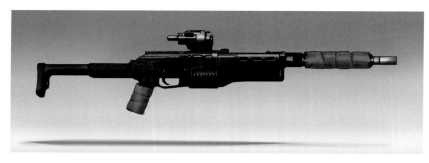

↑ **MARSHAL RIFLE VERSION 01** Matyas

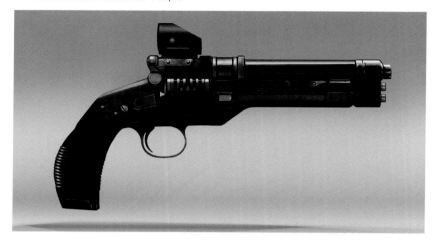

↑ **MARSHAL PISTOL VERSION 01** Matyas

"These were designed by Brian [Matyas] but were passed to Josh Roth, the prop master, who then found real-world pistol equivalents and augmented them." **Chiang**

→ **COBB VANTH HELMET** Uwandi and Trpcic

"The idea was taking Boba Fett's armor and refitting it a little bit, so that when you first see Cobb Vanth, you think he's Boba Fett, but he's actually not. We left just enough paint for the fans to know that it's Boba Fett, and we kept his helmet the same, dents and all." **Chiang**

↓ **FINAL JETPACK** Paul Ozzimo

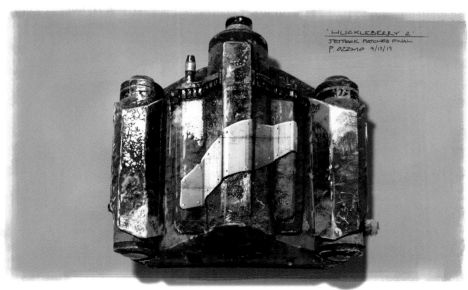

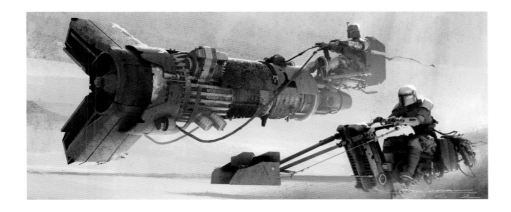

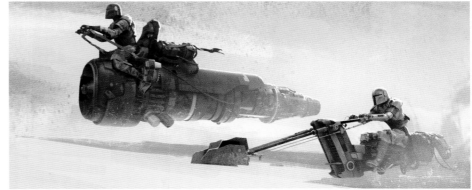

↑ **POD ENGINE SPEEDER VERSION 2A** Church and Chiang

↑ **POD ENGINE SPEEDER VERSION 01** "Lots of funny ideas here. Cobb Vanth could be riding Sebulba's podracer engine [from *Star Wars* Episode I *The Phantom Menace*]." **Church**

→ **MARSHAL SPEEDER VERSION 107** Rene Garcia

↓ **MARSHAL SPEEDER VERSION 07** Grandert

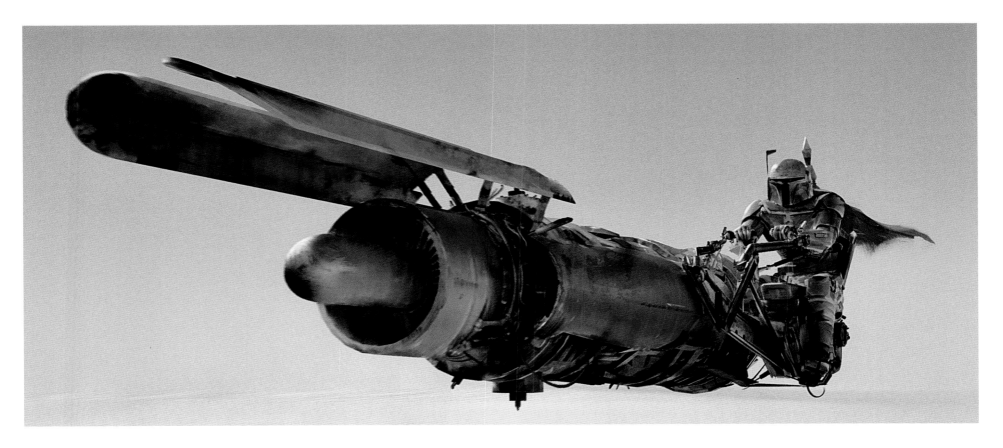

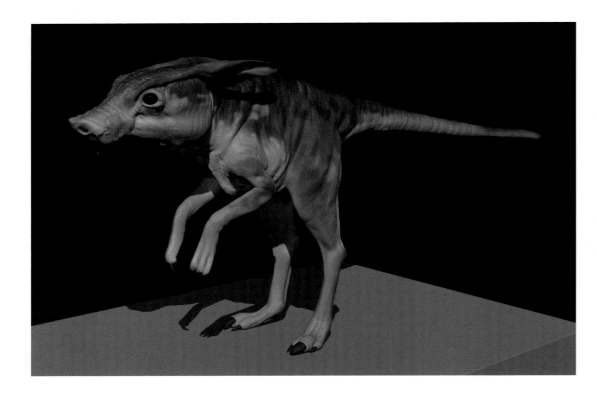

↓ BABY AND SCURRIER VERSION 336 Alzmann

"This is our Child and scurrier moment. The scurrier got refined, taking the best of everything that we've seen previously of the scurrier and updating it for our show." **Chiang**

The scurrier, a creature designed by TyRuben Ellingson, was first seen in the *Star Wars*: Episode IV *A New Hope* Special Edition, released theatrically in 1997.

↑ TATOOINE SCURRIER VERSION 334 Alzmann

→ WEEQUAY BARTENDER VERSION 01 Matyas

Marshal Cobb Vanth was played by Timothy Olyphant, best known for playing Deputy U.S. Marshal Raylan Givens in *Justified* and Sheriff Seth Bullock in *Deadwood*. Olyphant was joined in Chapter 9 by his *Deadwood* co-star W. Earl Brown as Mos Pelgo's Weequay bartender.

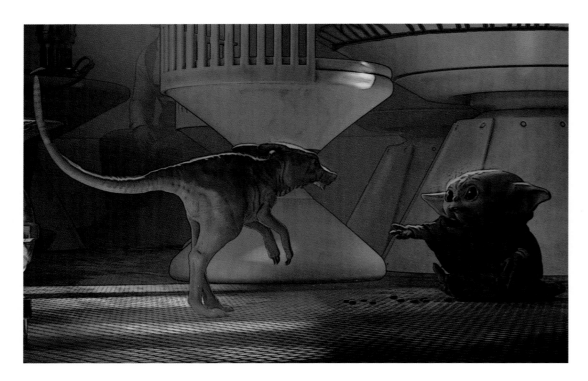

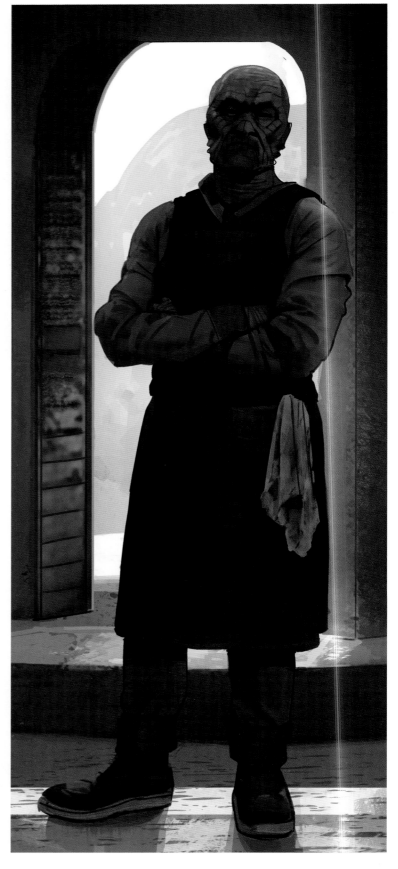

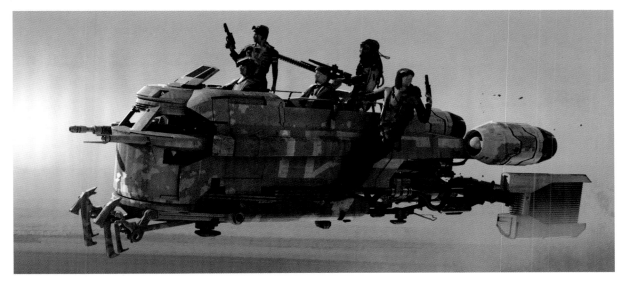

↑ **MINING SPEEDER VERSION 01** Church

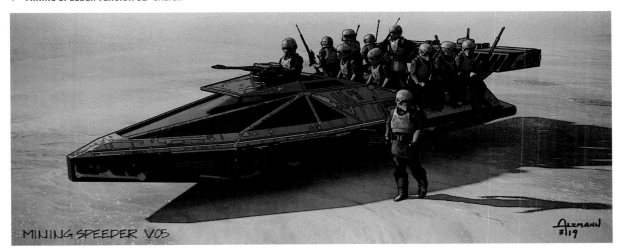

MINING SPEEDER V05

↑ **MINING SPEEDER VERSION 05**

"For the mining speeder, I pretty much took [the Lars family landspeeder] that's in Luke's garage and that we see riding around Tatooine and added Brian Matyas's mining guards." **Alzmann**

→ **MINING COLLECTIVE SOLDIERS VERSIONS 02, 03, AND 05**

"I wanted them to feel like an improvised combat militia, with a military kind of look that derived from whatever they might mine. I was thinking very padded. Even their helmets riff on a mining look or at least something that's subterranean, like these guys don't come out in the sun very often." **Matyas**

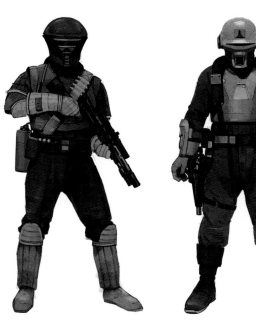

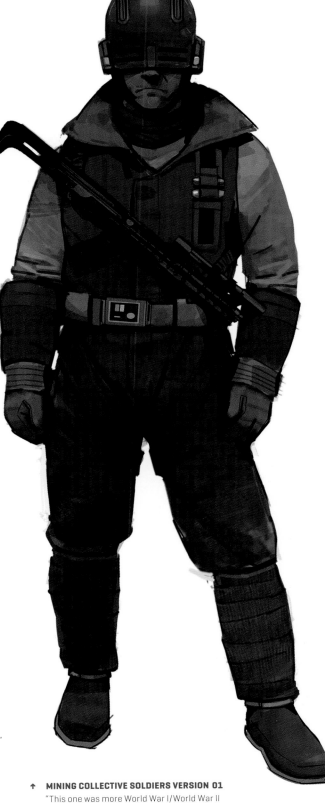

↑ **MINING COLLECTIVE SOLDIERS VERSION 01**

"This one was more World War I/World War II aviation, in look." **Matyas**

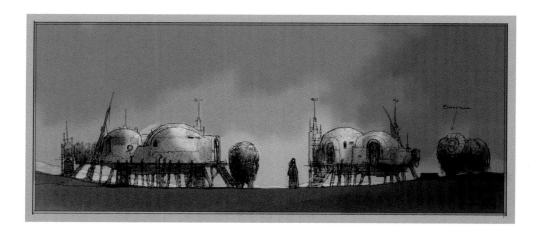

↑ MOS PELGO SKETCH VERSION 03 Tiemens

"Jon wanted to create a new Tatooine backwater town and wanted to make it very Western. The reason this old mining town was built up on stilts is to avoid vibrations that would alert the krayt dragon. That gave us a very distinct look for these Tatooine buildings, and it also helped to make it look more Western, the decks and platforms outside." **Chiang**

↗ MOS PELGO EXTERIOR VERSION 01 Le

→ LAYOUT SKETCH VERSION 1B Tiemens

↓ MOS PELGO AERIAL VERSION 01
Church and Chiang

"We've got these wooden walkways here [on Tatooine] and it makes no sense (due to the lack of trees on the desert world). But you have to have the sound of feet on the wood to really make it a Western." **Church**

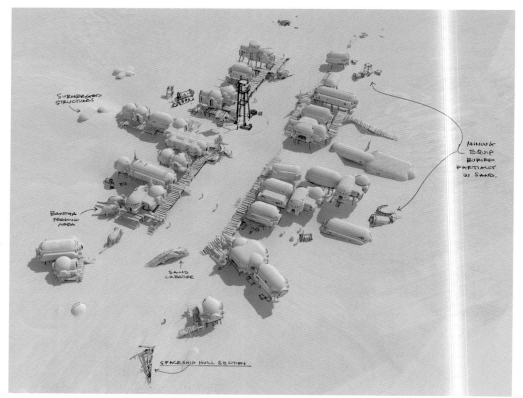

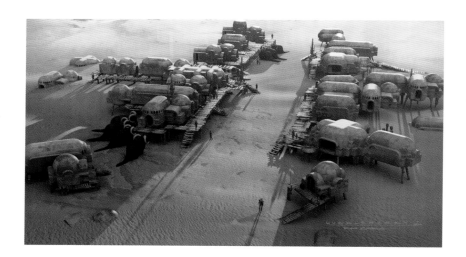

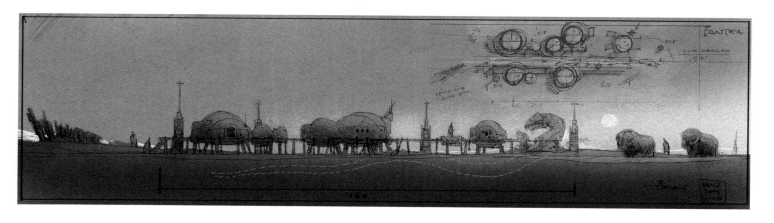

← MOS PELGO SKETCH VERSION 04 Tiemens

"Literally, the inspiration for this was taking the town from *High Plains Drifter* and turning it into our Tatooine version. We really wanted to have high sand dunes, again to hint at the idea that the sand was dangerous." **Chiang**

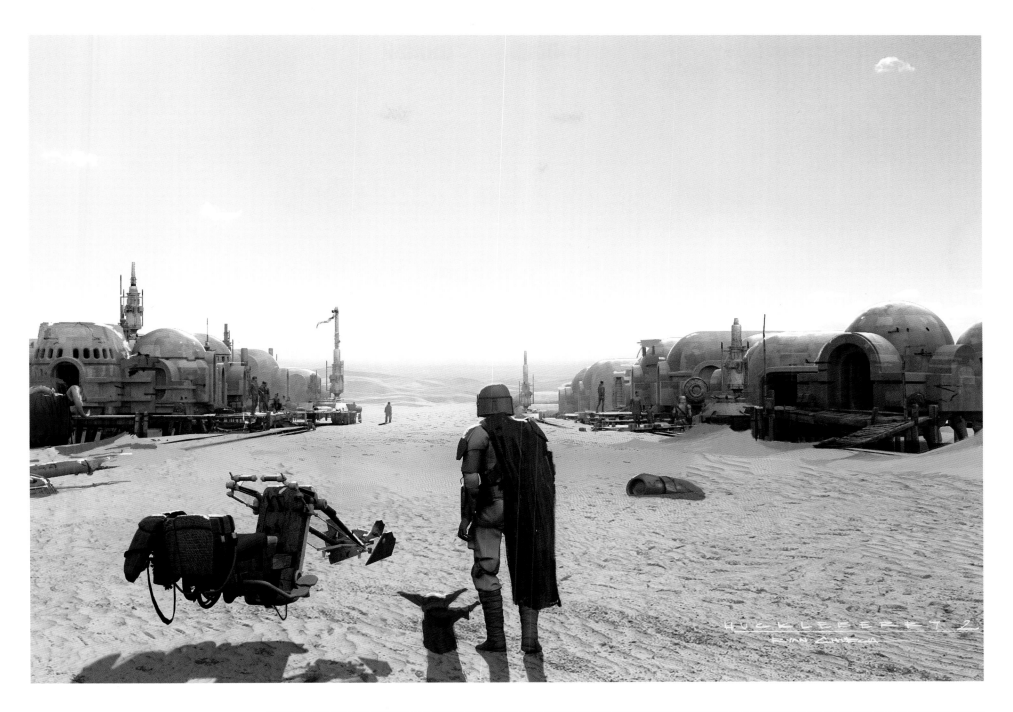

↑ TATOOINE TOWN ESTABLISHING 1A

"The struts [holding up the buildings and walk-ways] are mechanical. I was thinking, 'Well, the sands must shift over a range of twenty, fifty, one hundred feet here.' I always use the *Millennium Falcon* boarding ramp hydraulic legs, because they are very cool-looking." **Church**

"It was very important to Jon that in a shot like this, we see some daylight underneath." **Chiang**

→ MOS PELGO STREET SCENE VERSION 01
Tiemens

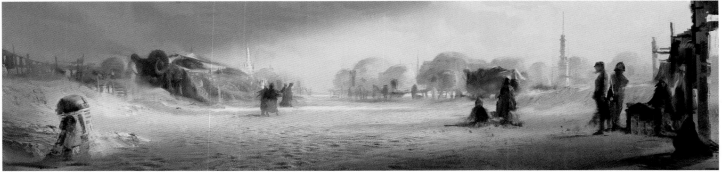

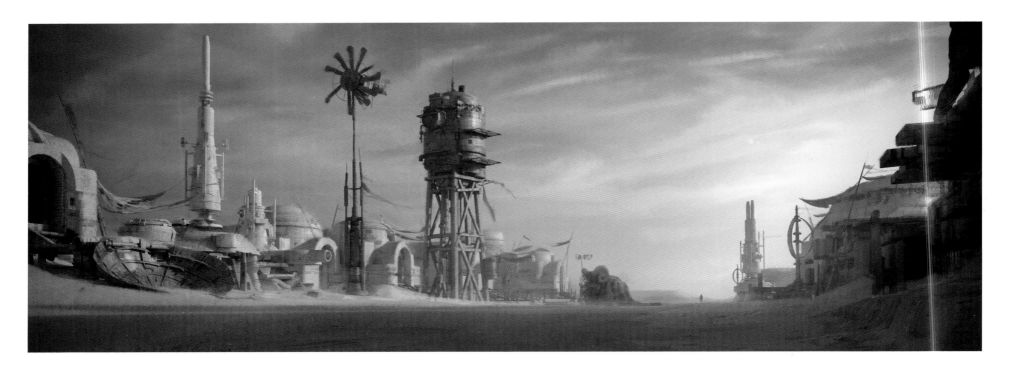

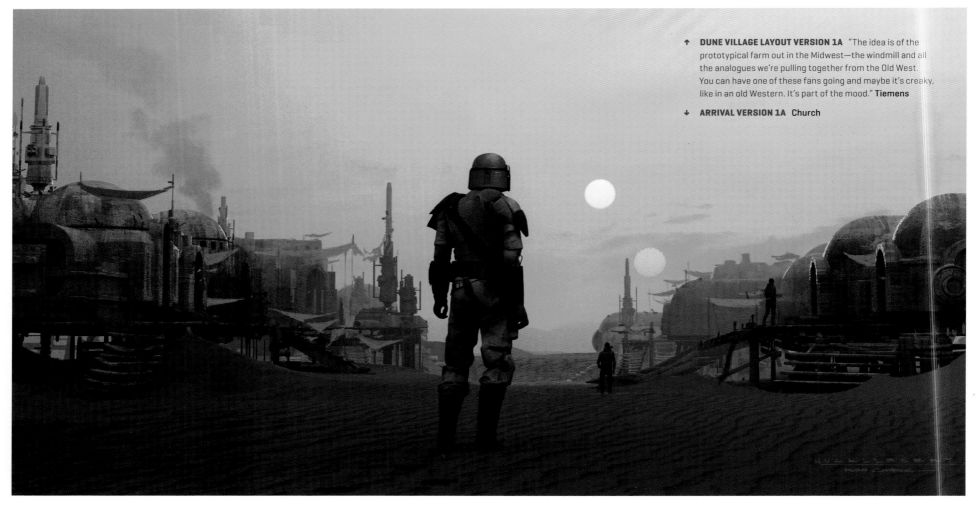

↑ **DUNE VILLAGE LAYOUT VERSION 1A** "The idea is of the prototypical farm out in the Midwest—the windmill and all the analogues we're pulling together from the Old West. You can have one of these fans going and maybe it's creaky, like in an old Western. It's part of the mood." **Tiemens**

↓ **ARRIVAL VERSION 1A** Church

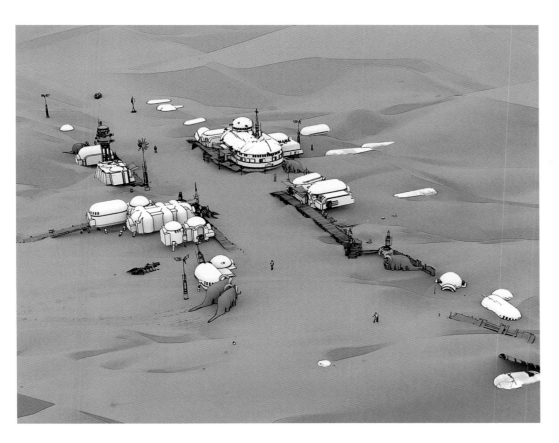

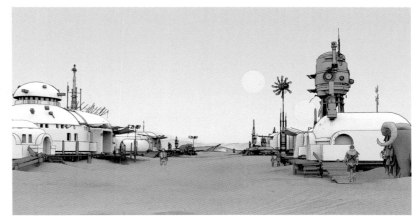

↑ **TATOOINE STILT TOWN VERSION 06**
Grandert

← **TATOOINE STILT TOWN VERSION 04**
Grandert

"The town started off about twice the size
of this and shrank. There was a moment
where the dragon needs to swim in the sand
through the main street. And that dictated
this layout. On the outskirts of town, we can
see remnants of old homes that have been
destroyed by the krayt dragon, to give this
place some history." **Chiang**

→→ **MARSHAL MISSILE ATTACK VERSION 01**
"I always thought that you could use the
jetpack rocket more as a mortar, firing it
up and using the rangefinder." **Alzmann**

↓ **TATOOINE STILT TOWN RENDERED
VERSION 04** "I took over the city layout
from Ryan Church and Erik Tiemens
and continued working on it. I got really
excited hearing about the krayt dragon.
It made this assignment so much more
fun to work with, adding that story
element to it." **Grandert**

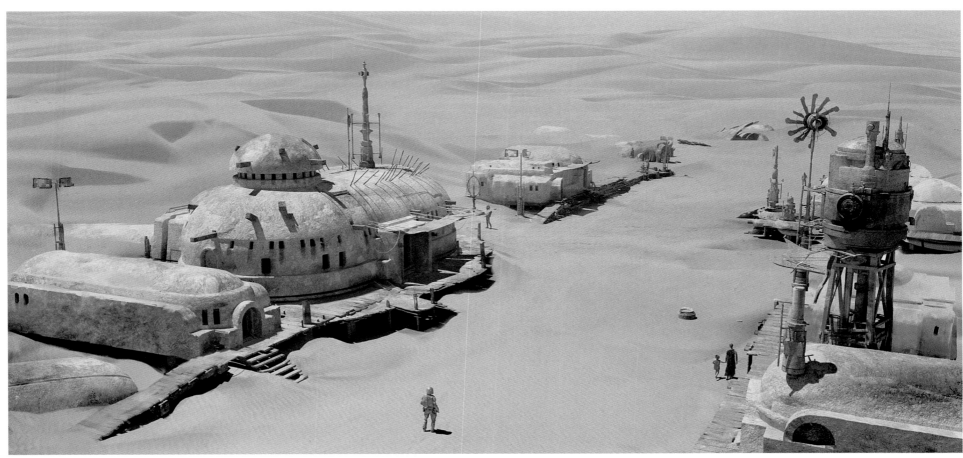

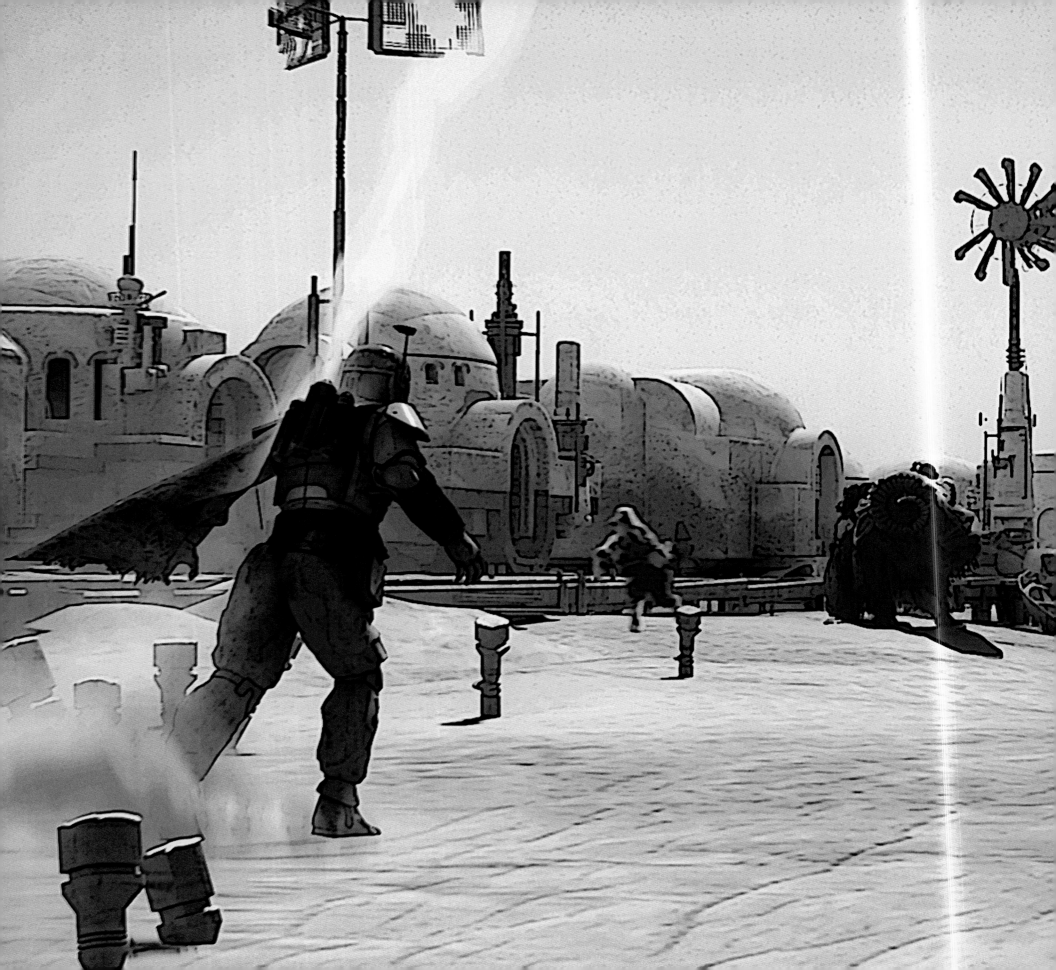

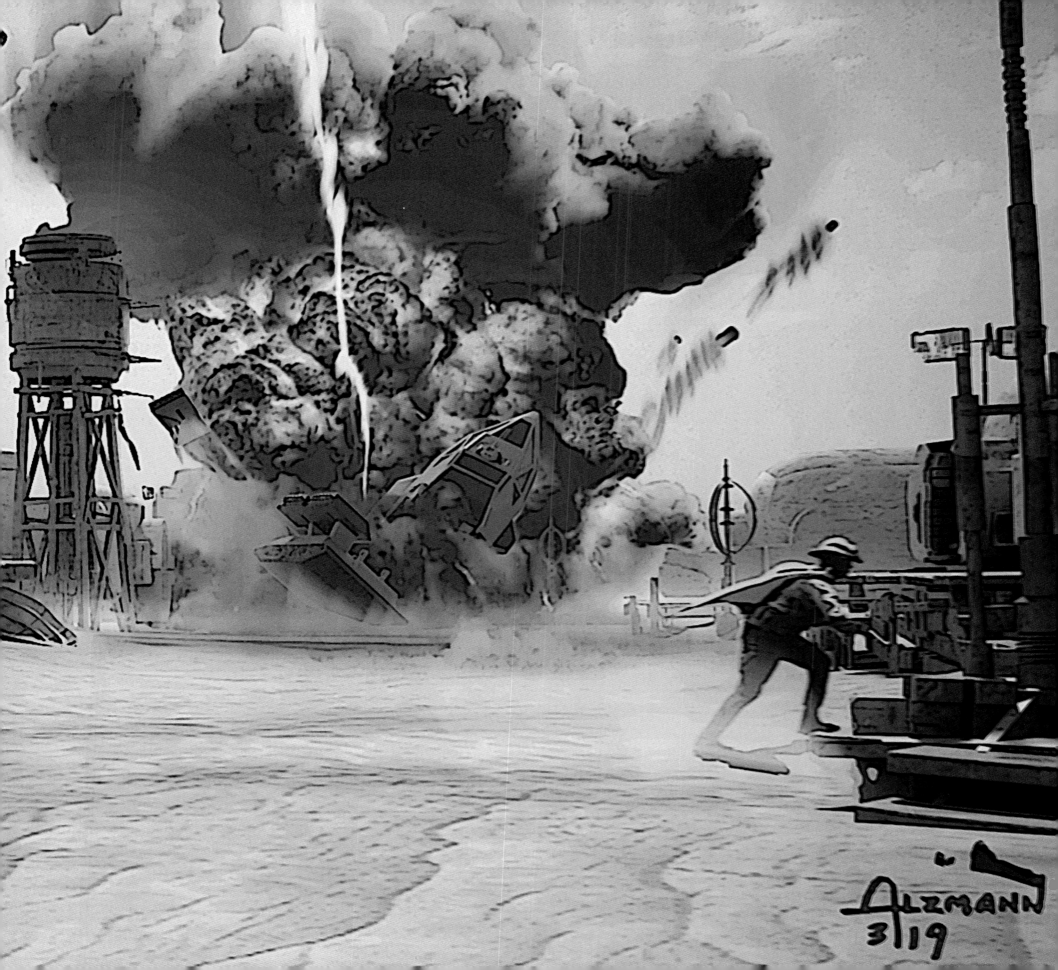

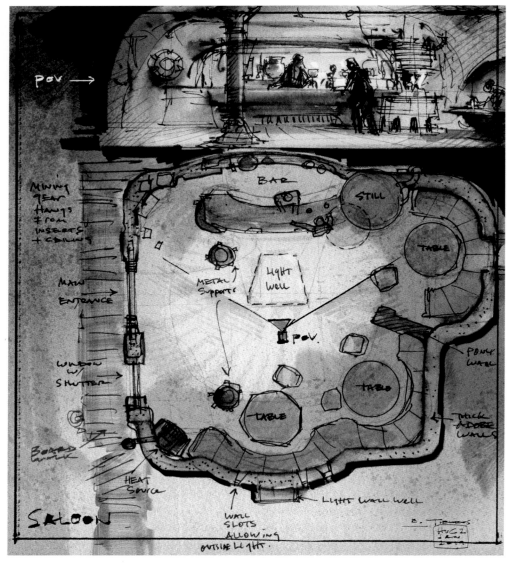

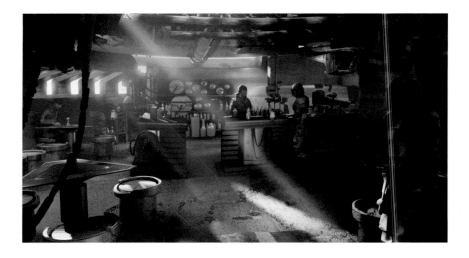

↑ **MOS PELGO SALOON VERSION 02** "I put the ceiling of one of my favorite movie sets ever, the *Once Upon a Time in the West* roadhouse where Cheyenne meets Harmonica, right in there. I wanted to get the same quality of light coming through." **Church**

↓ **MOS PELGO SALOON VERSION 02** Le

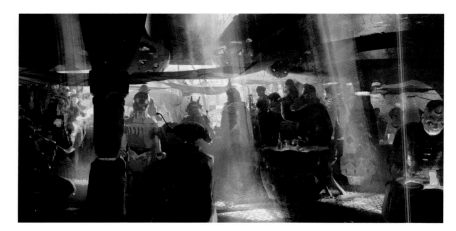

↑ **SALOON LAYOUT SKETCH VERSION 01** Tiemens

↓ **SALOON SKETCH VERSION 02** Tiemens

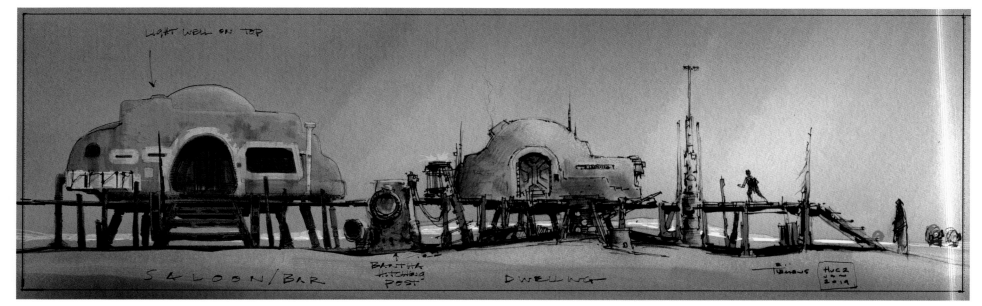

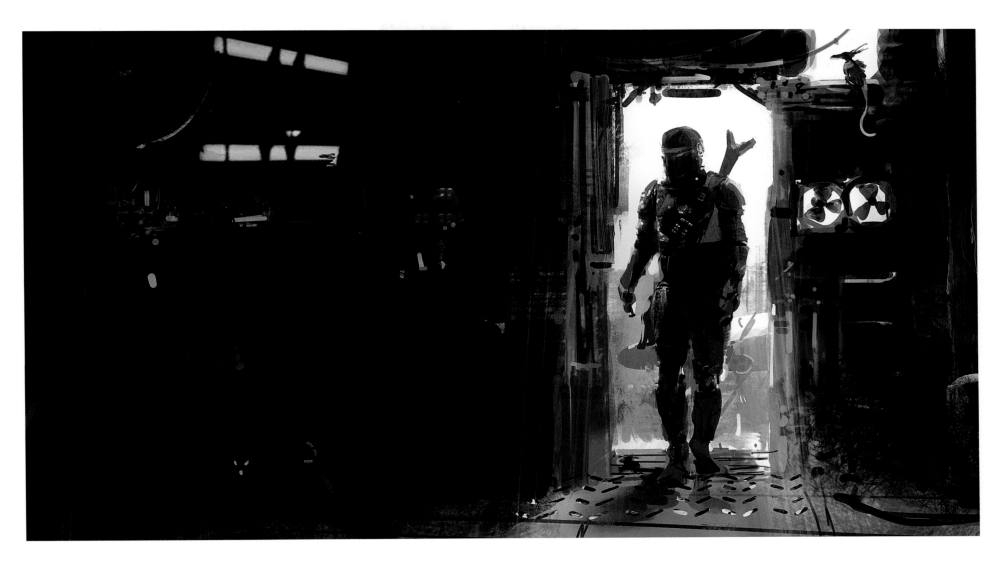

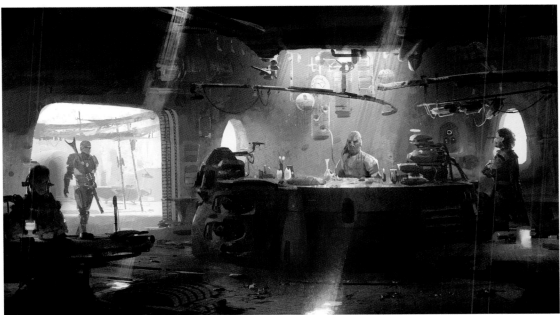

← **MANDO ENTRY VERSION 04**
Le and Chiang

"You'll notice the bar counter looks very much like Watto's table in Mos Espa (from *The Phantom Menace*). That was, again, trying to bridge and connect all of the design language for Tatooine." **Chiang**

↑ **SALOON ENTRY VERSION 01** Le

"We went back and forth, deciding if we should have saloon doors. Ultimately, we didn't need them." Chiang

↓ **MANDO AND COBB DRINKING VERSION 1A** Le

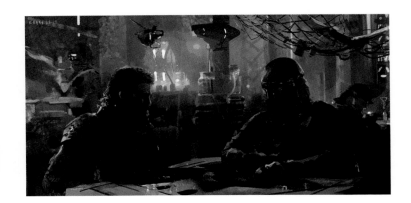

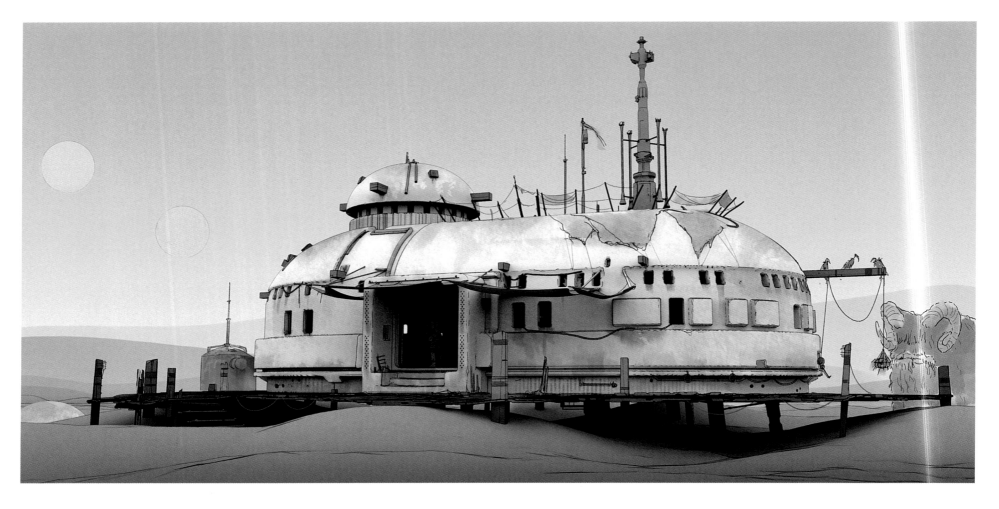

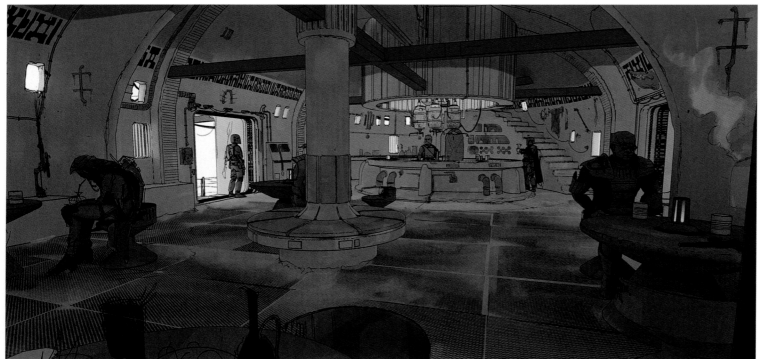

↑ **TATOOINE STILT TOWN VERSION 03**
"I did a rough block-out [basic geometry representing the set] in 3D, then I drew in all the prop dressing, characters, and details by hand. It was a good process for these images, adding story elements and details, like stuff found in the desert that was put on the walls for decoration. I also had some Western church-like buildings in mind, to make it stand out from the rest of the buildings, maybe inspired by [Sergio Leone's] Dollars Trilogy." **Grandert**

← **TATOOINE STILT TOWN VERSION 02**
Grandert

"We added wood beams to the interior, which we really haven't used before, but the coloration of the roof, the Ralph McQuarrie graphic that goes along the perimeter of the roofline, were all very specifically designed to lean into Star Wars motifs." **Chiang**

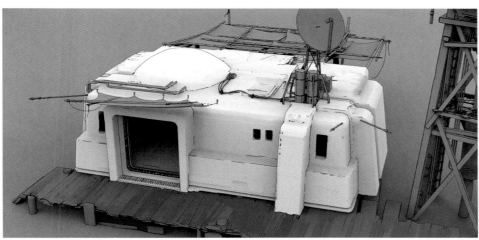
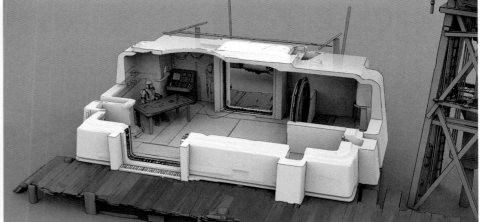

↑ **STILT TOWN JAIL VERSIONS 05 AND 5A** Grandert

→ **STILT TOWN JAIL VERSION 06** Grandert

"Jon wanted to have a small sheriff's office that was away from the cantina. Keeping it very simple, so that it was just a room with a desk and a jail cell. What does a Tatooine Western-inspired jail cell look like? We came up with this circular door that rotated [like the 'bank vault' New Republic prison doors in Chapter 6]." **Chiang**

↓ **STILT TOWN JAIL VERSION 03** "I wanted the back side of the jail to have an area where the marshal could repair his speeder and do other maintenance jobs." **Grandert**

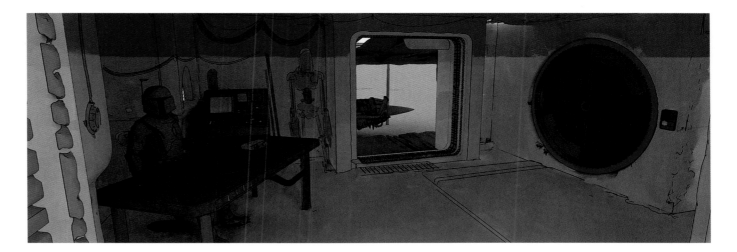

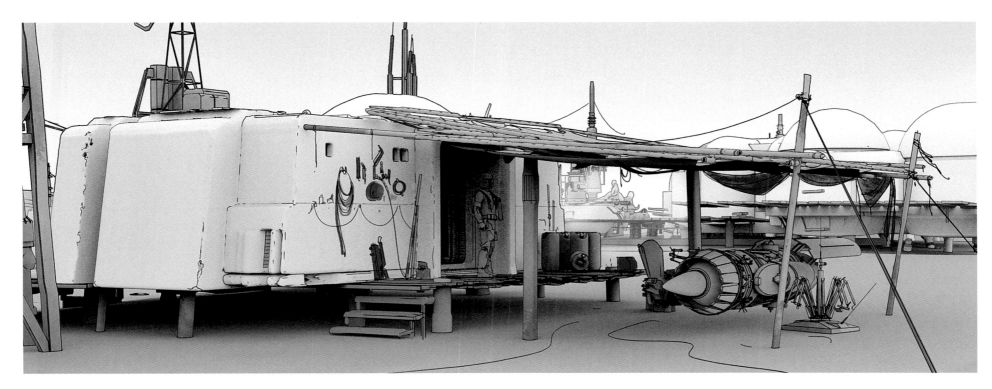

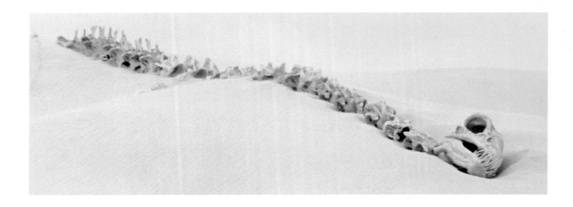

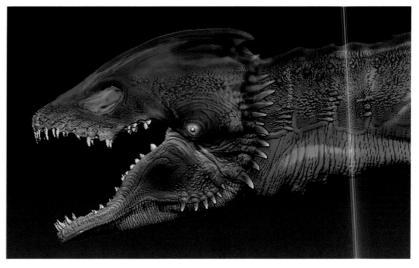

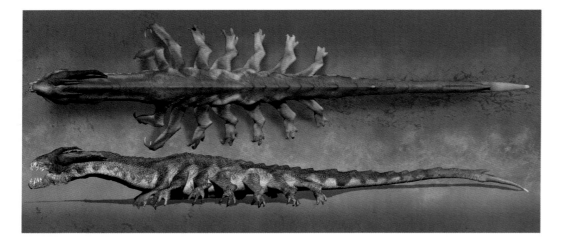

↑ **KRAYT HEAD VERSION 7A** Alzmann

↖ The krayt dragon skeleton seen in 1977's Episode IV *A New Hope* was a Diplodocus skeleton prop from the 1975 Disney comedy *One of Our Dinosaurs Is Missing*, salvaged by set decorator Roger Christian and subsequently taken to and left behind in the Tunisian desert by the *Star Wars* crew.

← **KRAYT SHORT HEAD VERSION 1A** Church

"We saw the [krayt dragon] skeleton in *A New Hope*, and Terryl Whitlatch [*Star Wars*

creature designer] did some beautiful drawings. These early explorations were really trying to figure out, 'What is the design of the head so that it doesn't conflict too much with the skull that we saw in the desert?' But then we realized, because this is the mature version of the creature in our storytelling, we should make it more interesting, more dangerous. So, it was kind of a reverse evolutionary process. Is that a female? Is that a young one?" Church

↓ **KRAYT COMP VERSION 10** Alzmann

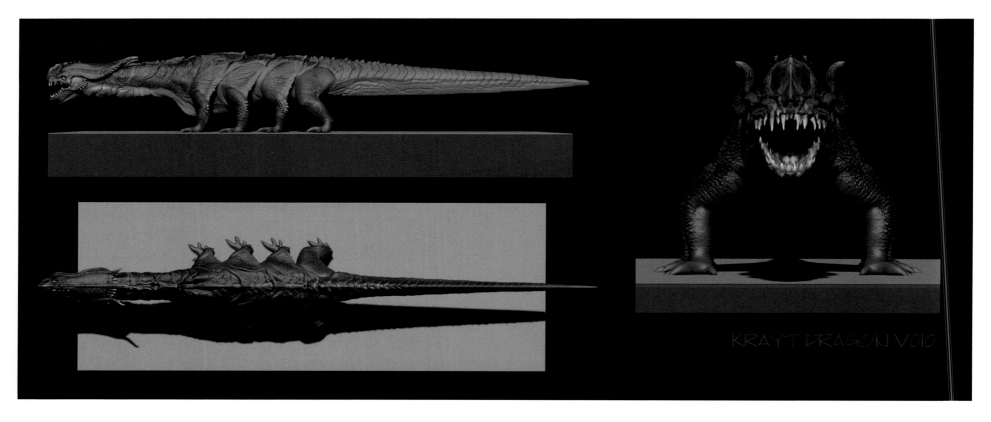

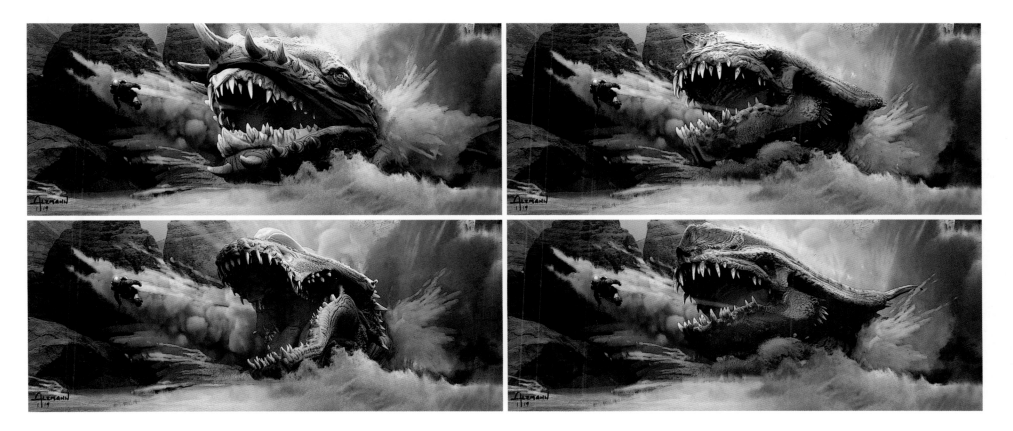

↑ **COBB VANTH ATTACK VERSIONS 2A, 3A, 4A, AND 8A** "I was trying different types of jaws and different types of bites. This one [at bottom left] almost has an alligator/crocodile vibe. It ultimately ended up being a lot more like this one [at bottom right], especially when I pushed it toward feeling like a shark head. I'll never be able to get that *Jaws* poster out of my head, so, I was probably vibing off that." **Alzmann**

↓ **KRAYT VERSION 16** "The skull shape is almost like a helmet, in a way. I was thinking that it would be really neat if it had kind of a fan to it; the way it would kick the sand off, almost spray it, and make him look that much bigger. I know Doug always likes dinosaurs, so I went [with a kind of Triceratops head ridge]. For something like this, you want to give it a memorable shape, that makes it stand out. And then it's not just an existing animal." **Alzmann**

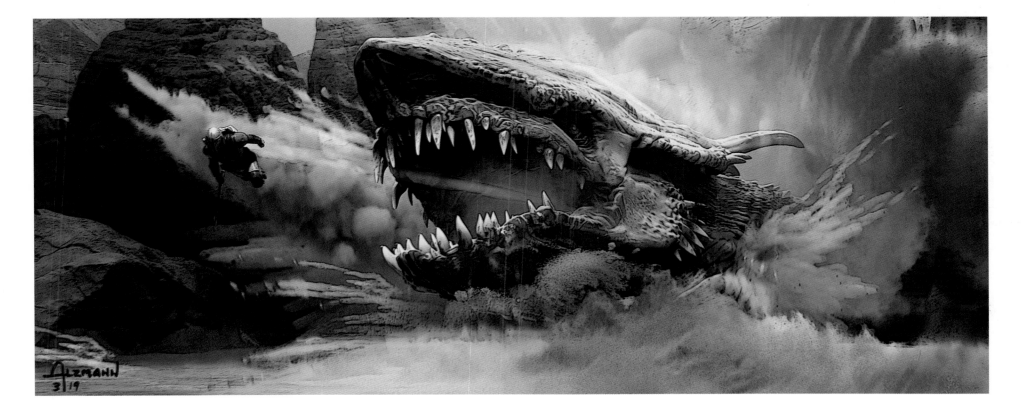

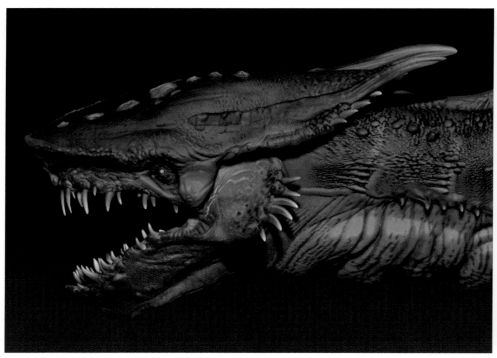

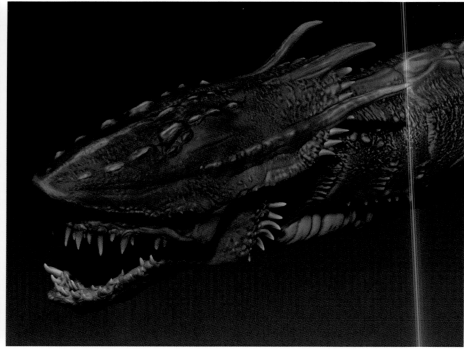

↑ **KRAYT VERSION 15A** Alzmann

151' KRAYT DRAGON

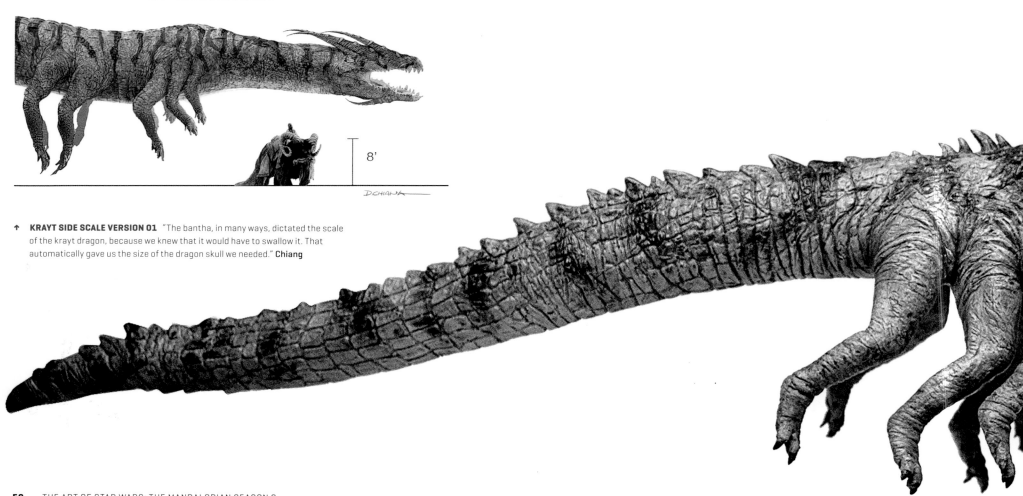

8'

↑ **KRAYT SIDE SCALE VERSION 01** "The bantha, in many ways, dictated the scale of the krayt dragon, because we knew that it would have to swallow it. That automatically gave us the size of the dragon skull we needed." **Chiang**

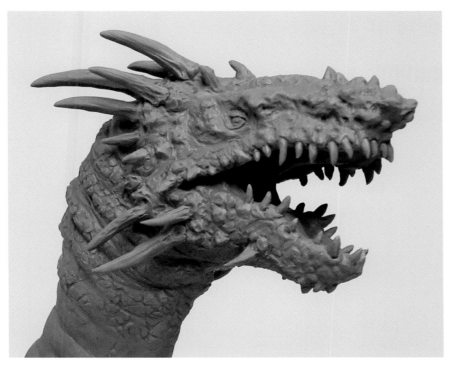

↑ **KRAYT DRAGON VERSION 03** McVey

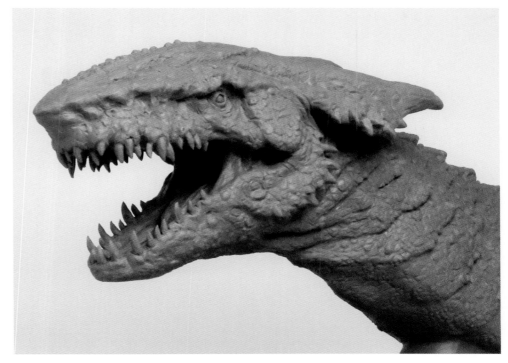

↑ **KRAYT DRAGON VERSION 5A** McVey

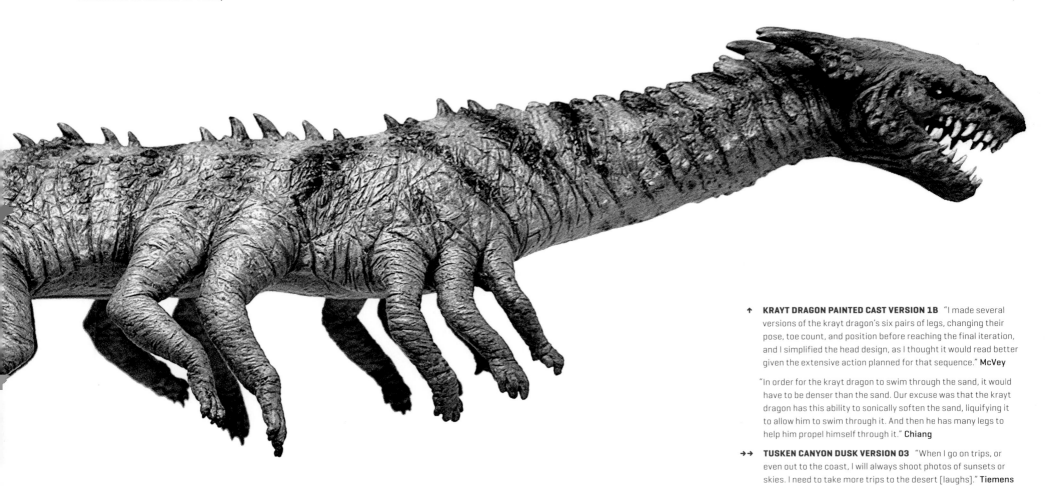

↑ **KRAYT DRAGON PAINTED CAST VERSION 1B** "I made several versions of the krayt dragon's six pairs of legs, changing their pose, toe count, and position before reaching the final iteration, and I simplified the head design, as I thought it would read better given the extensive action planned for that sequence." **McVey**

"In order for the krayt dragon to swim through the sand, it would have to be denser than the sand. Our excuse was that the krayt dragon has this ability to sonically soften the sand, liquifying it to allow him to swim through it. And then he has many legs to help him propel himself through it." **Chiang**

→→ **TUSKEN CANYON DUSK VERSION 03** "When I go on trips, or even out to the coast, I will always shoot photos of sunsets or skies. I need to take more trips to the desert [laughs]." **Tiemens**

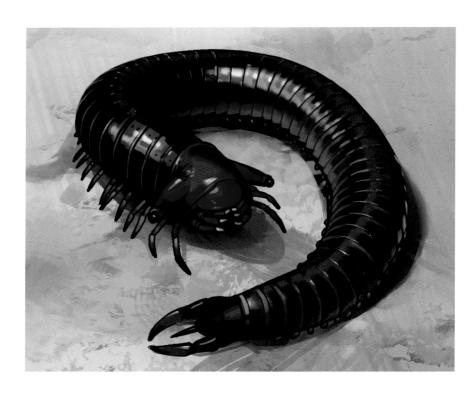

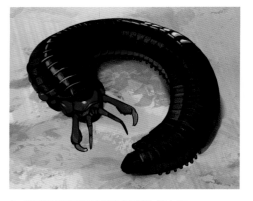

↑ **TUSKEN DELIGHT VERSION 337** Matyas

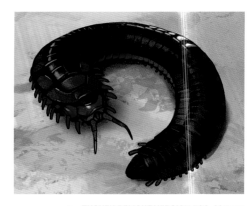

↑ **TUSKEN DELIGHT VERSION 338** Matyas

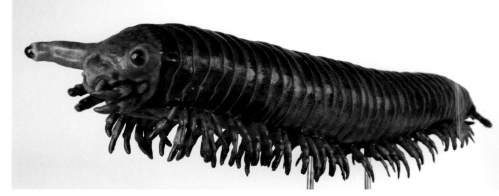

↑ **TUSKEN DELIGHT VERSION 336** "I designed some weird little creepy crawlies for them to eat, essentially a millipede." **Matyas**

→ **TUSKEN DELIGHT SCULPT VERSION 1B** McVey

↓ **BANTHA BUILD BREAKDOWN A** Landis Fields

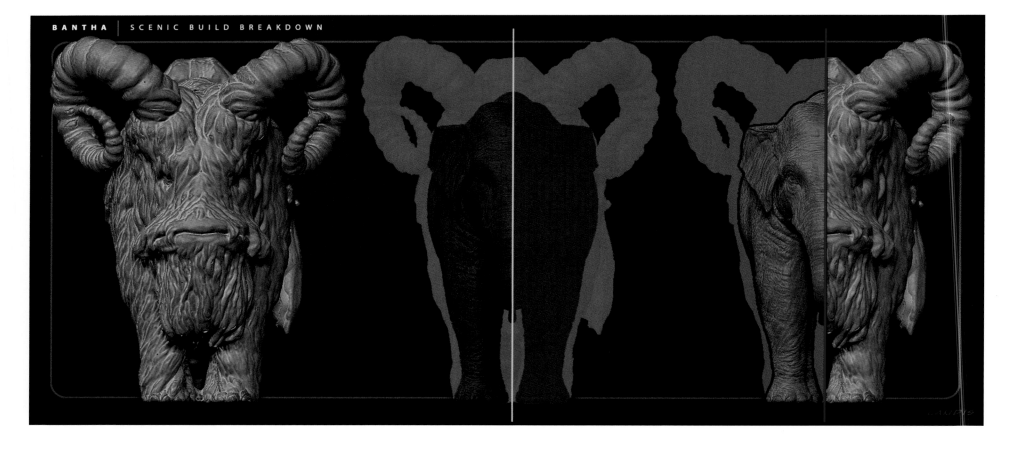

BANTHA | SCENIC BUILD BREAKDOWN

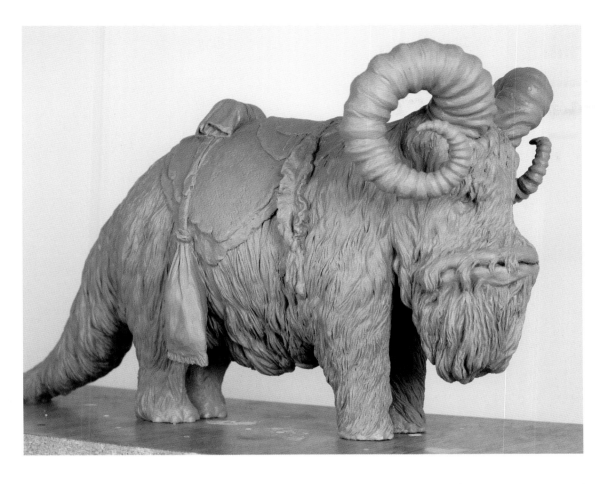

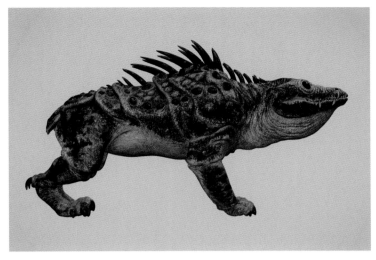

↑ **MASSIFF VERSION 01** "Like with the scurriers, I just tweaked the proportions of the massiff. Literally everything else about it is dead on [to the original design]." **Alzmann**

Massiffs first appeared in 2002's Episode II *Attack of the Clones*, intended to attack Obi-Wan Kenobi on the planet Geonosis. When that scene was cut, the massiffs were moved over to Tatooine to act as guard dogs for the Tusken Raider camp.

← **BANTHA SCULPT VERSION 03** "The bantha was sculpted over a 3-D-print of an Asian elephant [the banthas seen in 1977's *A New Hope* were played by a female Asian elephant named Mardji], which turned out to be a real time saver and helped reduce the weight of the clay model. It remained in its clay form, and multiple photos were shot as reference for the eventual physical prop and CG versions." **McVey**

↓ **MASSIFF CONTACT SHEET** Fields

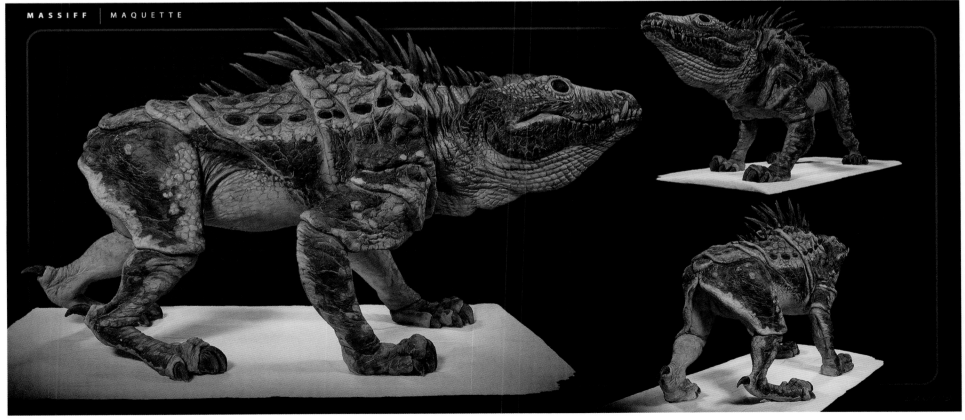

MASSIFF | MAQUETTE

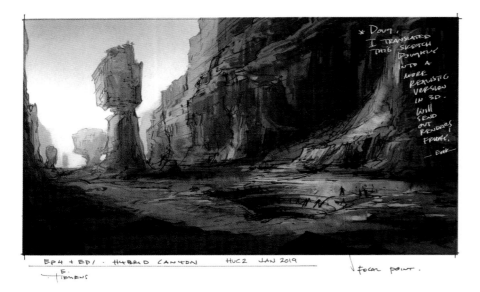

EP4 + EP1 · HYBRID CANYON HUC2 JAN 2019
E. Tiemens

↓ focal point.

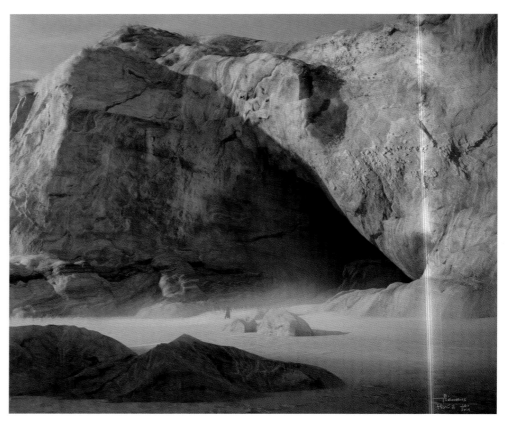

↑ **CANYON ROUGH SKETCH VERSION 01** "This Tatooine canyon is not too dissimilar to Beggar's Canyon from *The Phantom Menace*. There're hoodoos, or almost mushroom-like rock structures, a little bit of that. We ultimately didn't quite go there." **Tiemens**

↓ **KRAYT BANTHA VERSION 01** "The idea was to make the krayt dragon very mysterious. Jon wanted to keep it very peekaboo, like *Jaws*, where the shark is more hidden. We never really see the full length of it. We only hint." **Chiang**

→ **CLIFF CAVE VERSION 2C** Tiemens

"Where would the krayt dragon live? Early on, the script mentioned that the krayt dragon had occupied an old sarlacc pit because it had eaten it. Jon wanted to go a little bit more Ray Harryhausen, so the inspiration was, of course, the cave from *The 7th Voyage of Sinbad*." **Chiang**

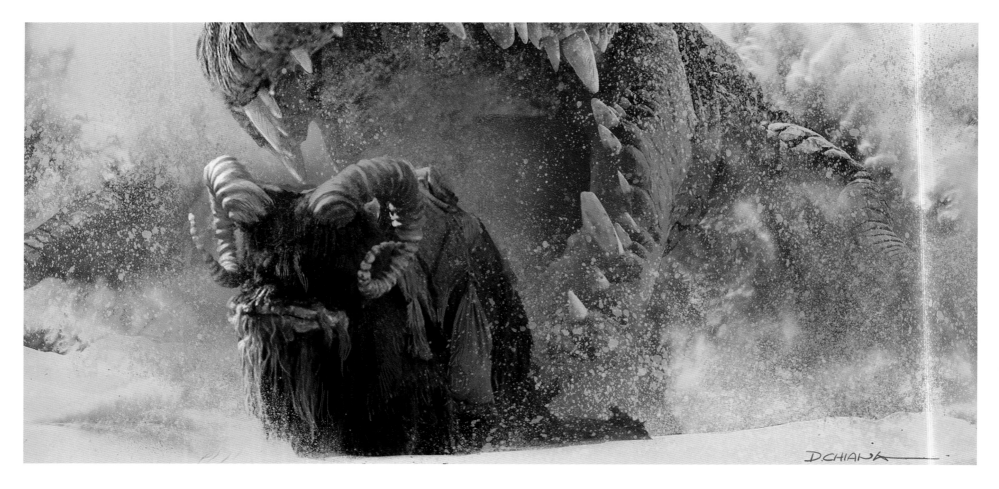

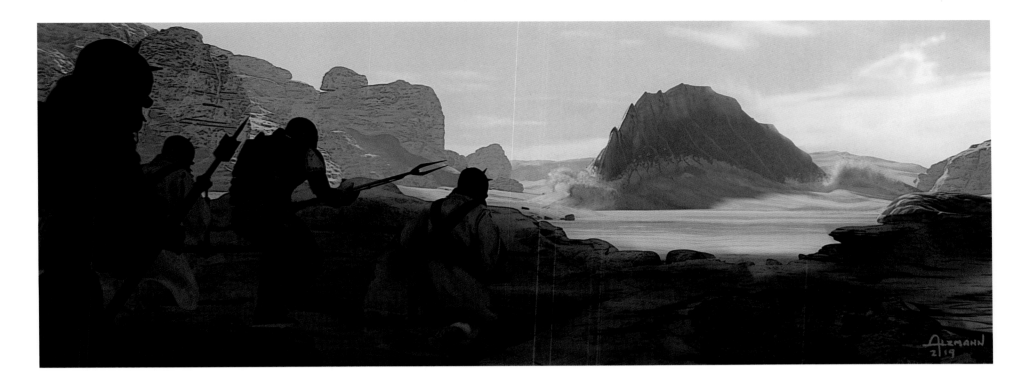

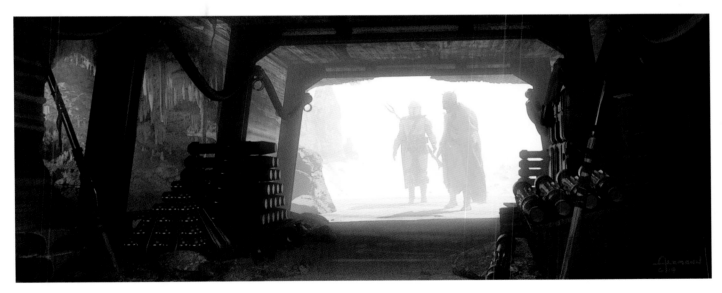

↑ **CHARGING KRAYT VERSION 03** "This shows just how vast the scale is, while trying to get that shark-fin vibe. It's pretty similar to the dragonsnake we see in Dagobah that was shot in George Lucas's [unfinished] swimming pool (which stood in for the swamp during *The Empire Strikes Back* pickup shots in early 1980). I wanted to emphasize the scale of this dragon charging and was referencing *Tremors* and *Dune*." **Alzmann**

← **MINE SHAFT VERSION 129** Alzmann

"Because the history of Mos Pelgo was that it was a mining town, we thought they would use old mine shafts to store their explosives." **Chiang**

↓ **DETONATOR PACK VERSION 01** Tiemens

"Our inspiration for [the explosive-laden bantha] was [the Western trope of] a mule with backpacks of dynamite on it." **Chiang**

↓ **MINE SHAFT VERSION 128** Alzmann

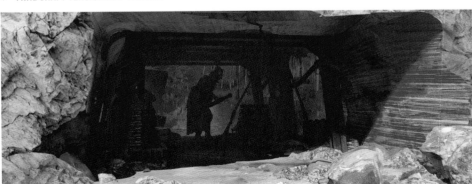

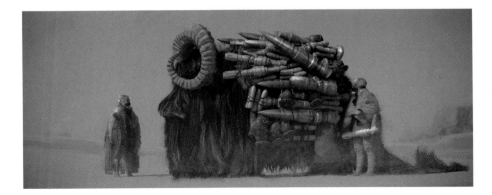

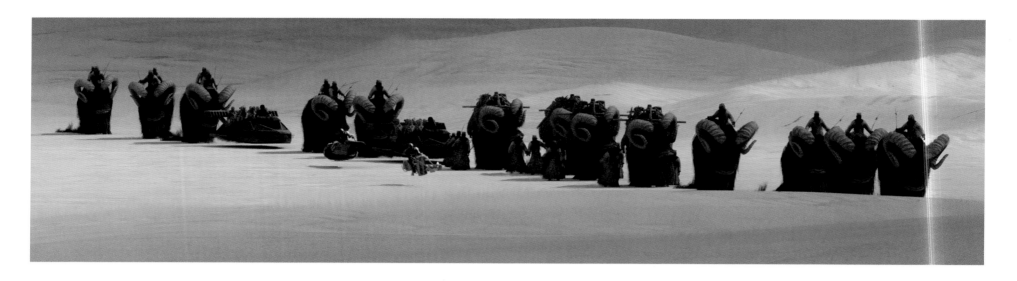

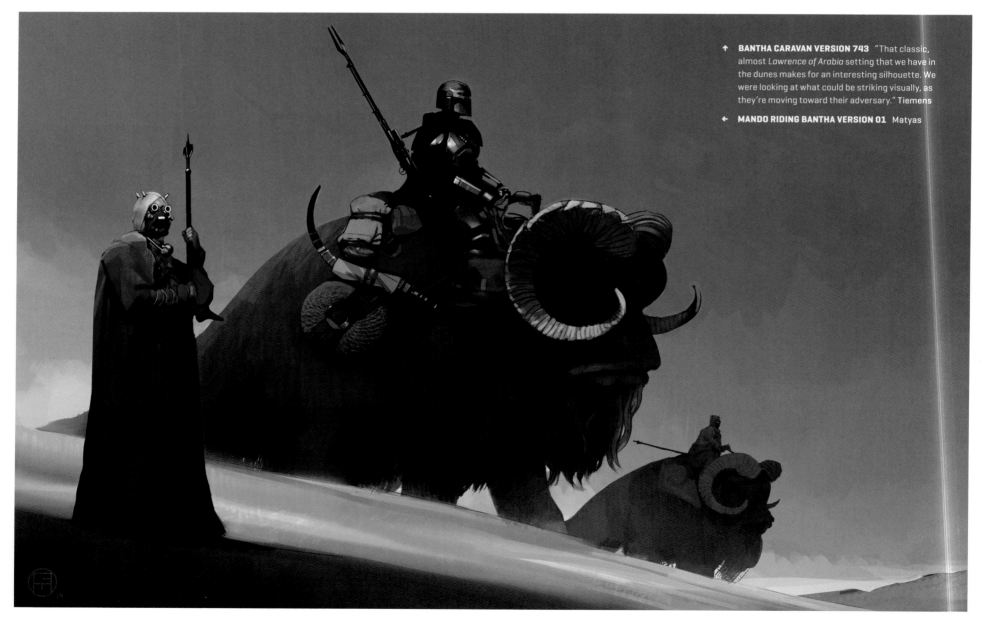

↑ **BANTHA CARAVAN VERSION 743** "That classic, almost *Lawrence of Arabia* setting that we have in the dunes makes for an interesting silhouette. We were looking at what could be striking visually, as they're moving toward their adversary." Tiemens

← **MANDO RIDING BANTHA VERSION 01** Matyas

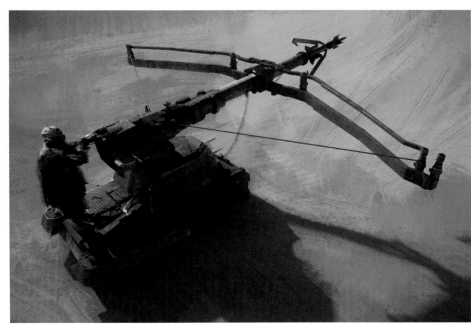

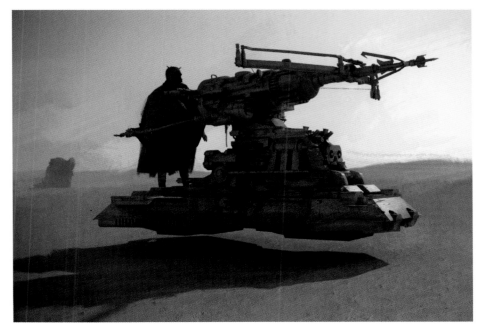

↑ **BALLISTA VERSION 5A** "In order for it to look like a credible threat to the krayt dragon, we had to figure out how to make the ballista really menacing, while maintaining a nod to Tusken technology. I'm glad we actually went more Old World and medieval in the final design that we came up with." **Tiemens**

→ **TUSKEN BALLISTA VERSION 05** "I didn't want this to look like a regular crossbow, so I tried some different ideas. I wanted it to look powerful, so I added lots of notches and other things, making it a bit more complex. But in the end, we simplified it to find good balance, and it actually looked like a regular crossbow/ballista. But, as they say, 'Less is more, only if you know what more is.'" **Grandert**

"We used the E-Web tripod base as the platform for the crossbow. It was a cost-saving measure, but also aesthetically, since the Tuskens are scavengers, they might have found some E-Web blasters." **Chiang**

↓ **TUSKEN BALLISTA** Ozzimo

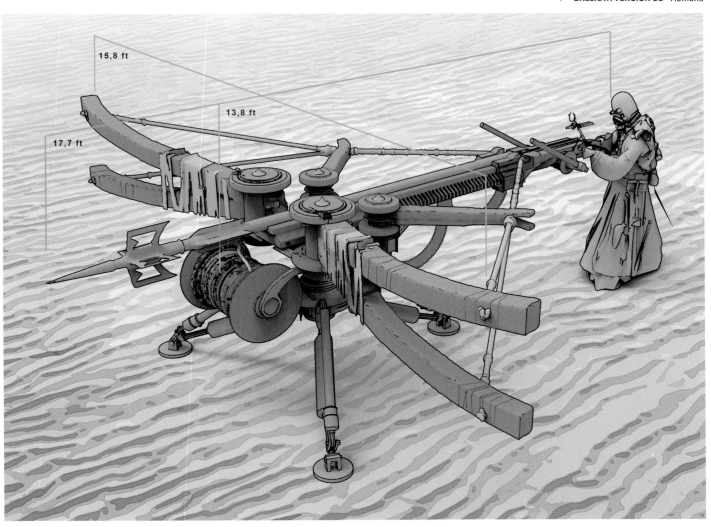

15,8 ft

13,8 ft

17,7 ft

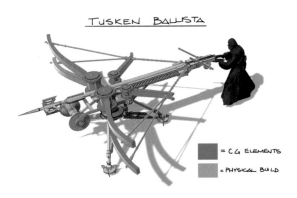

TUSKEN BALLISTA

■ = C.G ELEMENTS

■ = PHYSICAL BUILD

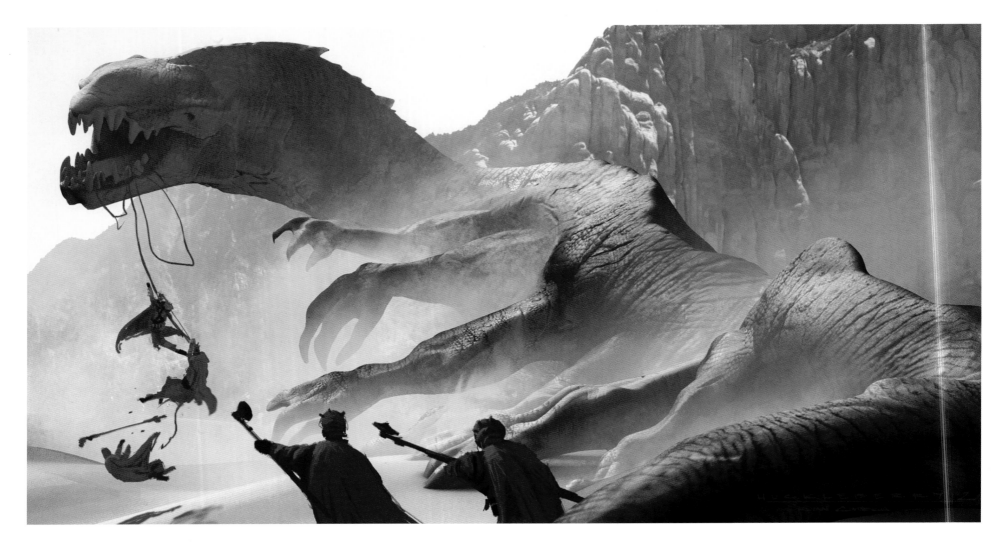

↑ **CANYON ATTACK REAR VERSION 02** "The thing I remember most about the krayt dragon was that, in the script, it specifically said, 'tombstone-sized teeth.' Because Jon is such a specific guy, I kept drawing krayt dragons with tombstone-sized teeth. I remember always starting a design with that, but I probably should have opened myself up a bit more [laughs], because it makes the thing look smaller overall when you make the teeth that big." **Church**

→ **CANYON ATTACK CLOSEUP VERSION 1A** Church

↓ **CANYON ATTACK SIDE VERSION 01** Church and Chiang

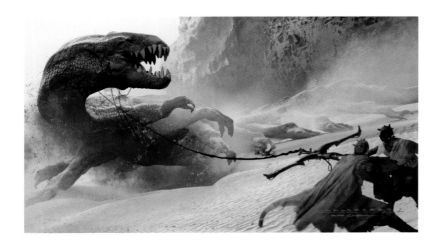

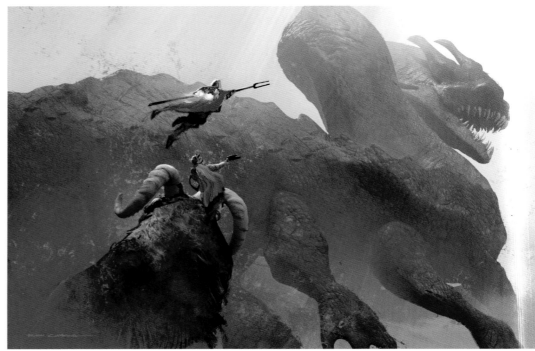

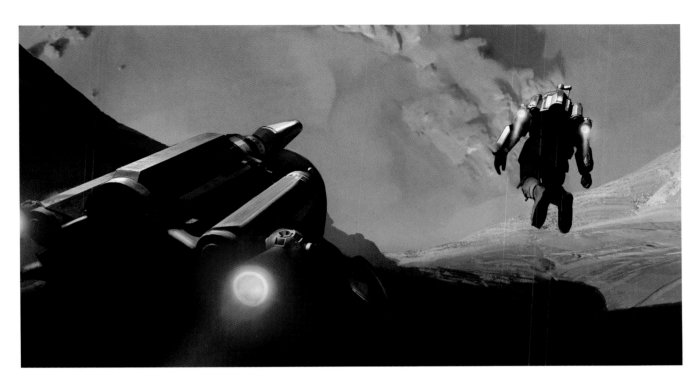

↑ **TUSKEN RAIDERS VERSION 05** Grandert and Matyas

← **CANYON RUN VERSION 02** Matyas

↓ **ACID TUSKEN VERSION 02** "They didn't want it to be too graphic, disgusting, or disturbing, so I had to be really careful with the mounds of meaty flesh. Which is good. I didn't want to have to go do that research [laughs]." **Matyas**

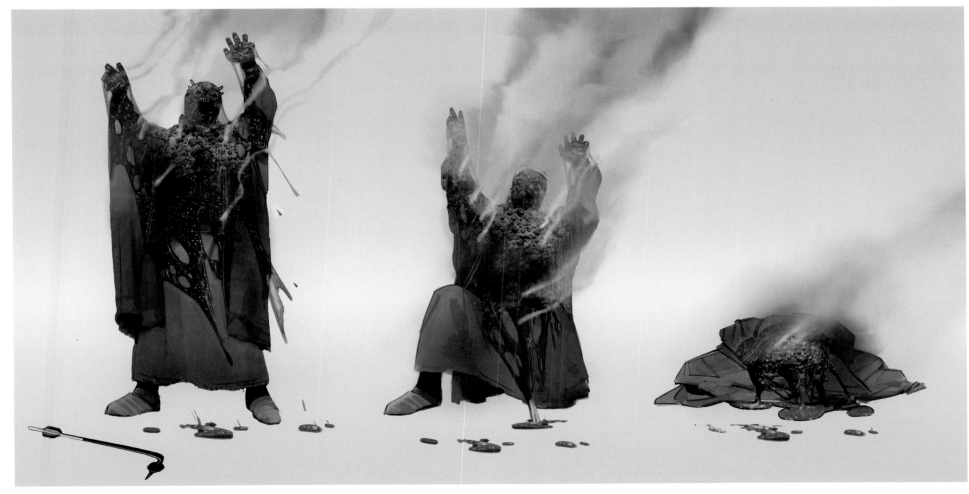

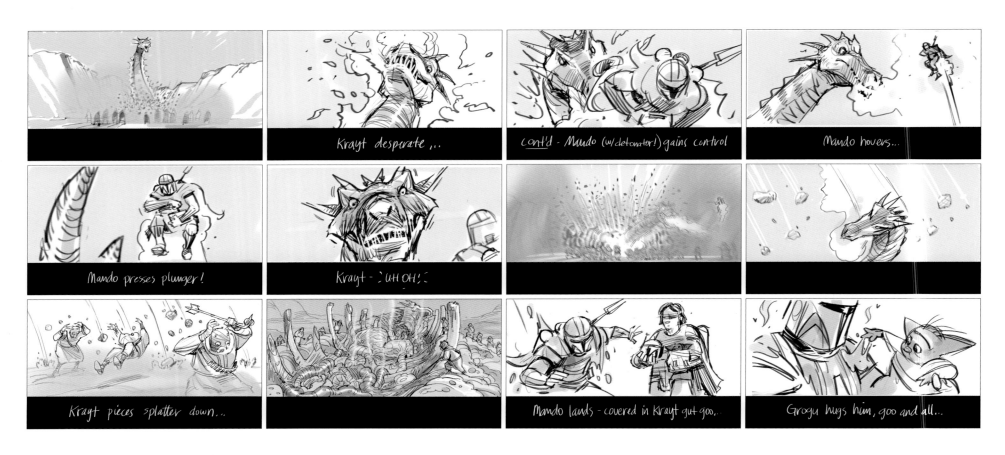

Krayt desperate ,..

cont'd - Mando (w/detonator!) gains control

Mando hovers...

Mando presses plunger!

Krayt - ¡UH OH!¡

Krayt pieces splatter down...

Mando lands - covered in Krayt gut goo,..

Grogu hugs him, goo and all...

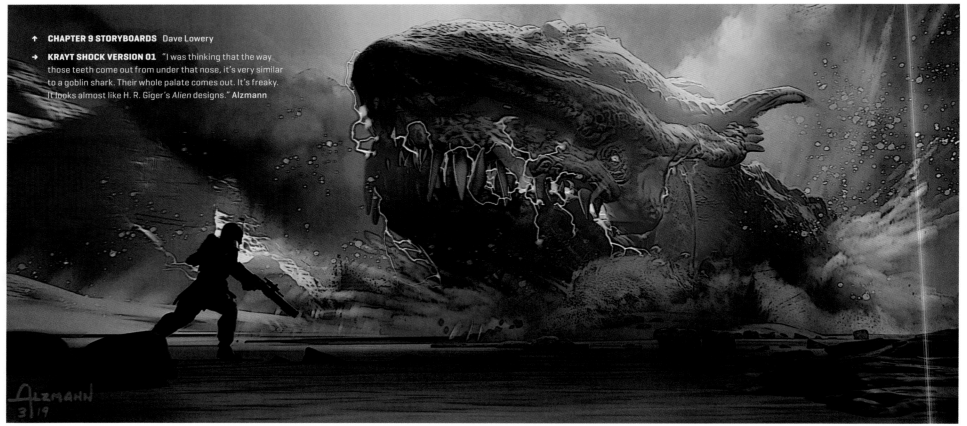

→ **CHAPTER 9 STORYBOARDS** Dave Lowery

→ **KRAYT SHOCK VERSION 01** "I was thinking that the way those teeth come out from under that nose, it's very similar to a goblin shark. Their whole palate comes out. It's freaky. It looks almost like H. R. Giger's *Alien* designs." Alzmann

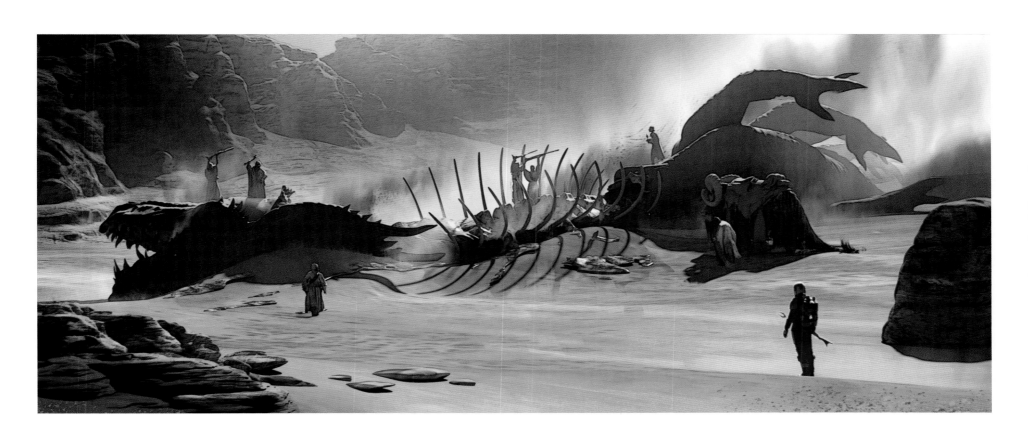

↑ **DEAD KRAYT VERSION 01** "Nilo Rodis-Jamero [*Star Wars* original trilogy designer] said, 'The best concept artists are the people who have the best memories of their childhood.' Basically, if you can remember the stuff that made you geek out as a kid and pull that into what you're doing, then it ends up being a great design. I mean, you can just look at this shot and I'm clearly all over the end of *Dragonslayer*, the Vermithrax Pejorative. You could smell it [laughs]." **Alzmann**

↓ **KRAYT CRATER VERSION 366** "It was fun doing all the layers of frothy wet sand [laughs], chunks, blood. What would all the stuff inside a krayt be? This will ensure that people don't think of me just as 'the Child designer' [laughs]." **Alzmann**

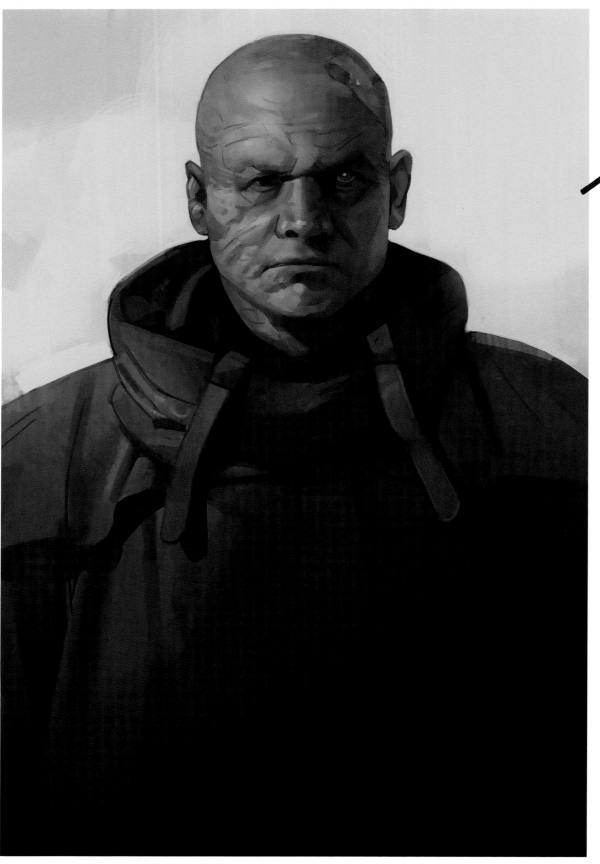

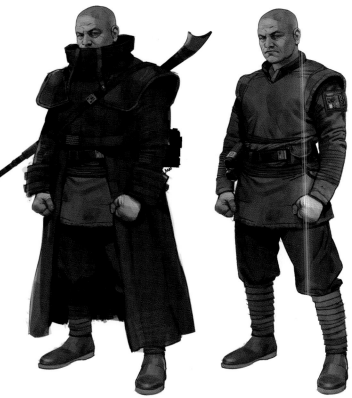

← **BOBA FETT PORTRAIT VERSION 02** Matyas

↓ **BOBA NOMAD VERSION 190** "This was a little too close to Obi-Wan's tunic, just in terms of the palette, the tone, and the construction." Matyas

↑ **BOBA FETT VERSION 178** "Playing with something a little more *Mad Max* for Boba Fett's cloak here. Giving him a fighter look, at his core posture, and even just the wrapped gloves, where he could fight off Tusken Raiders with his bare hands, if he had to." Matyas

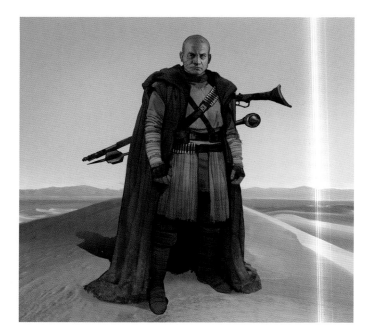

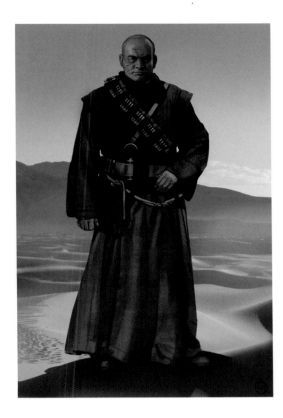

↑ **BOBA NOMAD VERSION 220** Matyas

"The inspiration for this was Omar Sharif's costume from *Lawrence of Arabia*, that dark-cloth nomadic look along with the gun belts and so forth." **Chiang**

↓ **BOBA NOMAD VERSION 225** Matyas

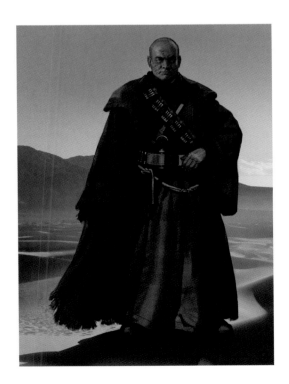

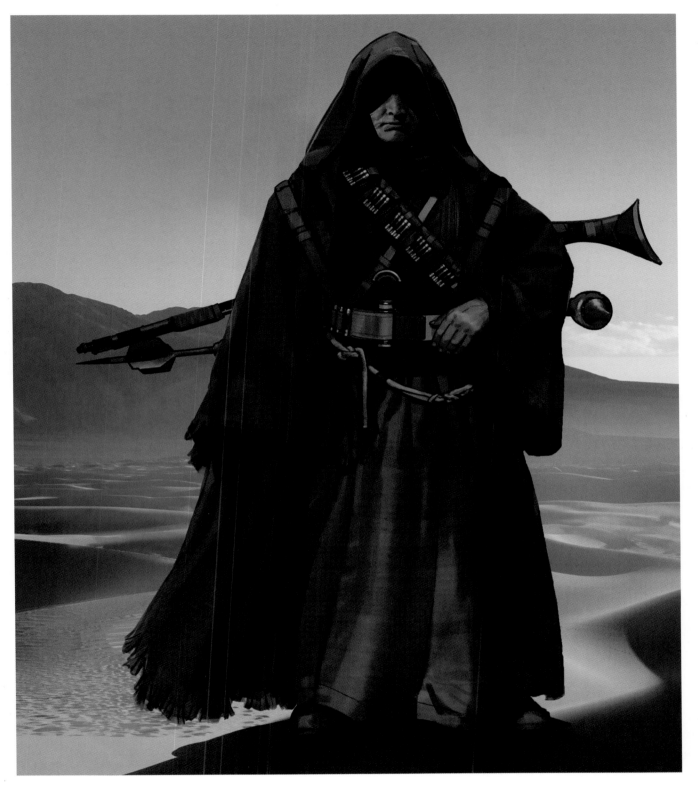

↑ **BOBA NOMAD VERSION 233** "If I'm remembering correctly, the Tusken Raider bandolier is a Swedish bandolier from World War I. And it has a very similar vibe to the Middle Eastern and even the African Theater of World War I and World War II. I played off of that and gave a strong nod to *Lawrence of Arabia*. I was also really inspired by the Sideshow Collectibles Ben Kenobi Mythos statue, the collection of items on his back and not concealing what you're collecting." **Matyas**

→→ **TEMUERA BOBA VERSION 1A** "We asked ourselves, what kind of prosthetics are we going to have to do for Temuera Morrison, since he's been affected by the acid of the sarlacc pit? So that was some exploration for him, for his makeup but also his mysteriousness." **Matyas**

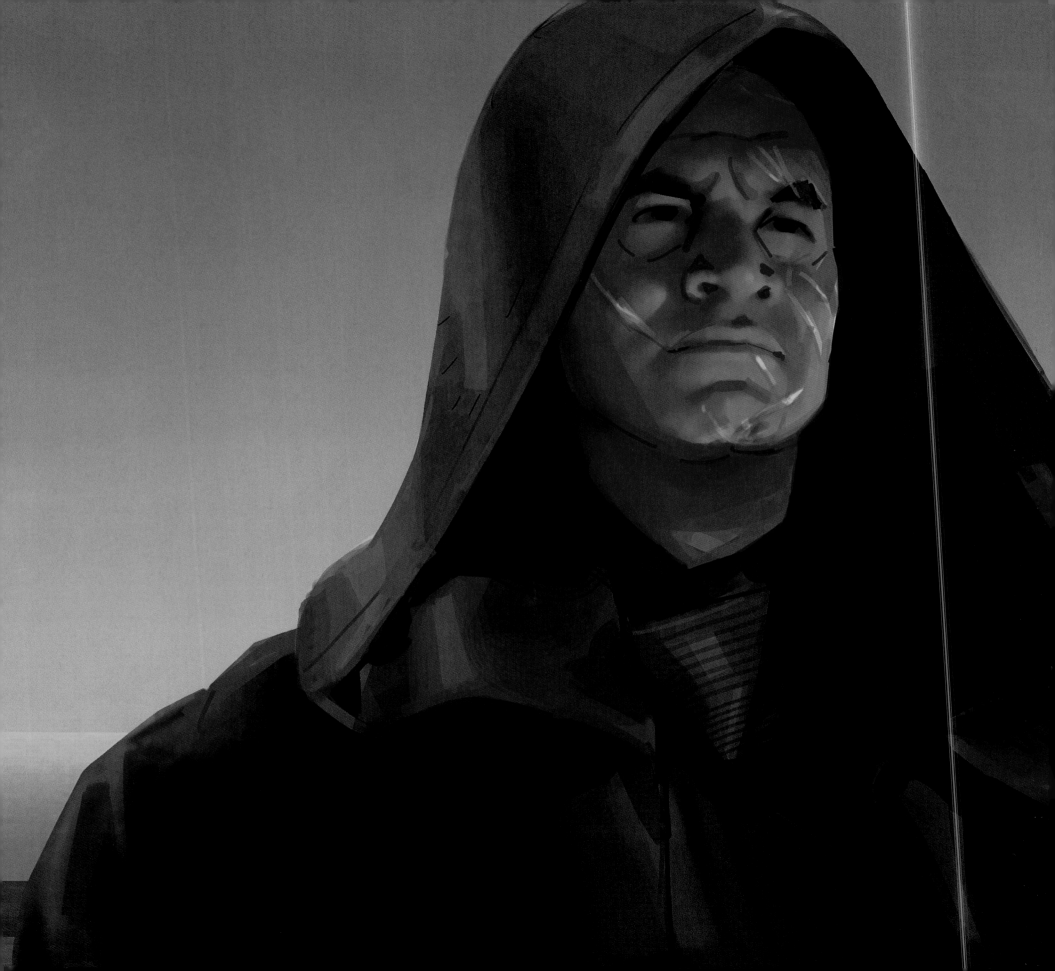

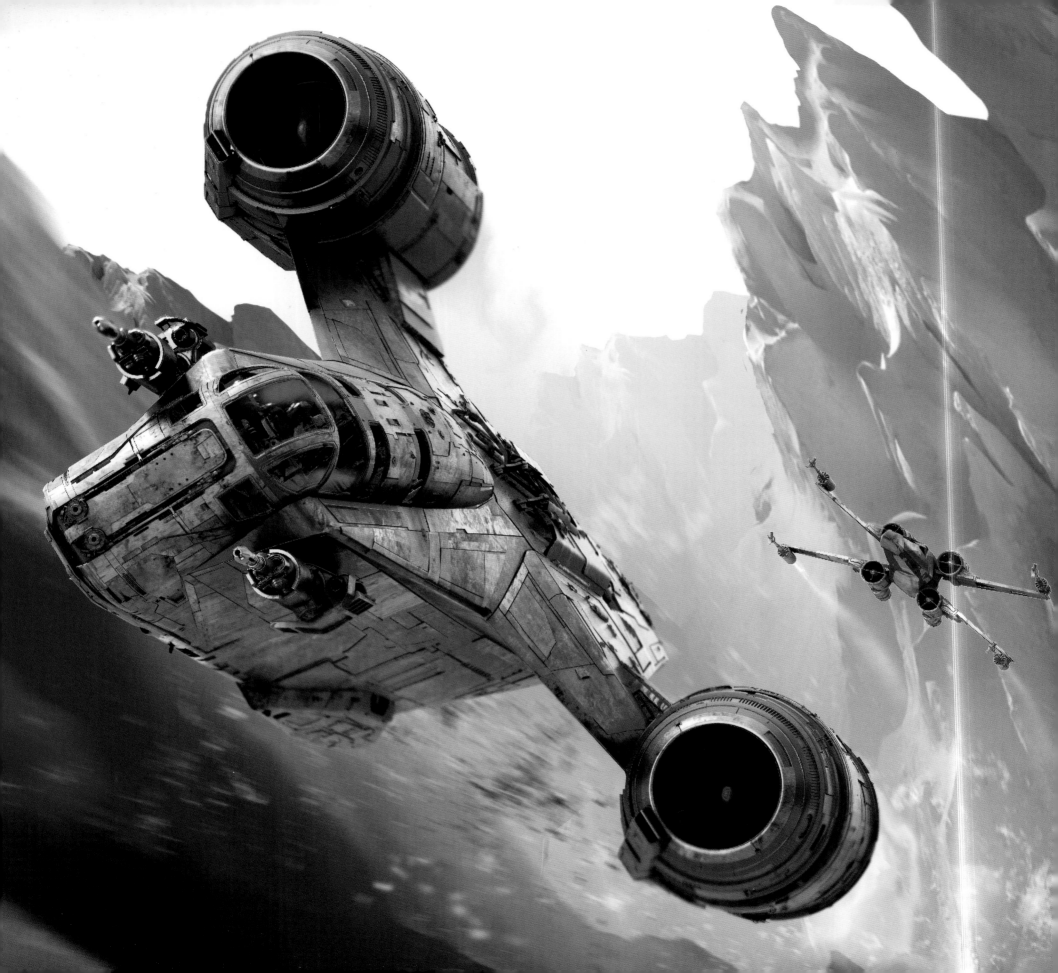

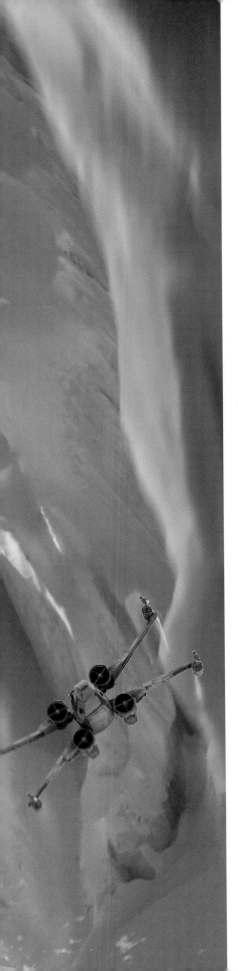

THE PASSENGER

As *Thor: Ragnarok* director Taika Waititi neared completion of "Chapter 8: Redemption," he and Jon Favreau reunited with their fellow Marvel Cinematic Universe (MCU) directors Anthony and Joseph Russo (the latter Captain America films, *Avengers: Infinity War, Avengers: Endgame*) and Peyton Reed (*Ant-Man, Ant-Man and the Wasp*) on the set of *The Mandalorian*.

"We were down in the [Nevarro Mandalorian] covert set and some of our Marvel friends came by," Favreau recalled. "And you could tell that it meant a lot to Peyton. He was a fan from childhood. It was like when I visited the set of *The Force Awakens*. When it's your first time on a set seeing stormtroopers and X-wings, it hits you on a deep level. Sometimes, it takes a while for actors to settle down, because it feels like you're hitting something that's bigger than just a normal movie set. I knew Peyton was into it and excited, so when it was time to pull in a list of directors for Season 2, we reached out to him."

Favreau fed early location and story ideas to Doug Chiang so that his team could proceed with Chapters 10 and 11. Filoni would do the same for his episode "Chapter 13: The Jedi." "I've leaned on the art department since the beginning [of the series]," Favreau affirmed. "As I would write, I would show Dave. Dave would sketch, and then we'd start sending Dave's sketches over to Doug. [The art department] started doing fully formed versions of [those sketches], and that would get me writing more. Sometimes I would even say to Doug, 'Hey, I haven't written this yet, but I'm thinking of a location like this, and this is what's going to happen there,' and then let the drawing inspire the scene. They make it more exciting for me to write it. Or I'll get ideas from the visuals that I'll use in the script.

"The thing that's cool about Doug and the art department is, I might write a scene, but when I see it rendered in a *Star Wars* style, with all the details, all of a sudden it feels like a real *Star Wars* thing. It goes from just an idea on my laptop to something I can look at, that looks like a frame out of the show. It's like being able to look into the future. And now I

understand the scene better. Then, it's like a game of telephone, where each idea gets built upon, except in a positive sense. Everybody changes it a little bit, and if there's ever anything that doesn't feel right for the story, you can give notes. More often than not, the new ideas are inspiring." This back-and-forth, symbiotic approach between screenwriter and art department, where story ideas feed concept art and vice versa, was precisely how creator George Lucas worked with concept artists for his *Star Wars* films, particularly on the prequel Episodes I through III.

With Favreau's notes and Filoni's sketches in hand, the Lucasfilm art department began work on Chapter 10 and continued their efforts on the episode for five months in total. "We were trying to create a new ice planet that didn't look like Hoth," Chiang said. "Obviously, if you have an ice planet, people could easily think that it's Hoth, so our thinking was that [Maldo Kreis] is more like Greenland, where you see glaciers and fissures in the ice."

Almost a year after his fortuitous set visit, Peyton Reed kicked off production of the second season with "Chapter 10: The Passenger," one of the more straightforward episodes of the eight, with a small cast (including the return of actor Misty Rosas—who previously performed Kuiil the Ugnaught on set—to *The Mandalorian*, playing the unnamed Frog Lady passenger, and Dave Filoni's second turn as New Republic X-wing pilot Trapper Wolf, alongside actor Paul Sun-Hyung Lee's Captain Carson Teva) and minimal new set builds, namely the spider egg chamber, constructed in the LED volume stage, and ice tunnels of Maldo Kreis.

Said Favreau, "We want to make sure that [the people we hire] are either fans already or excited by it, because there's a tremendous amount of work that has to be accomplished in a very short amount of time. It *can't* feel like work, it has to feel fun, otherwise, you will never get it done. You're surrounded by other people who feel the same way. And Peyton is that kind of guy."

← **RAZOR CREST CHASE VERSION 128** Church

→ **ICEHORN VERSION 04** Alzmann

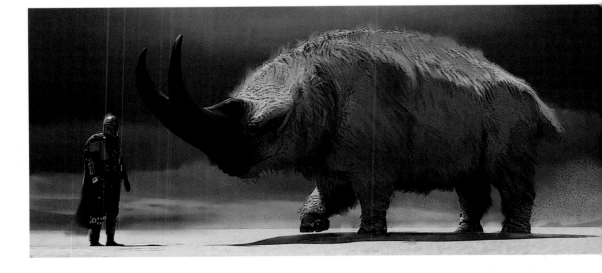

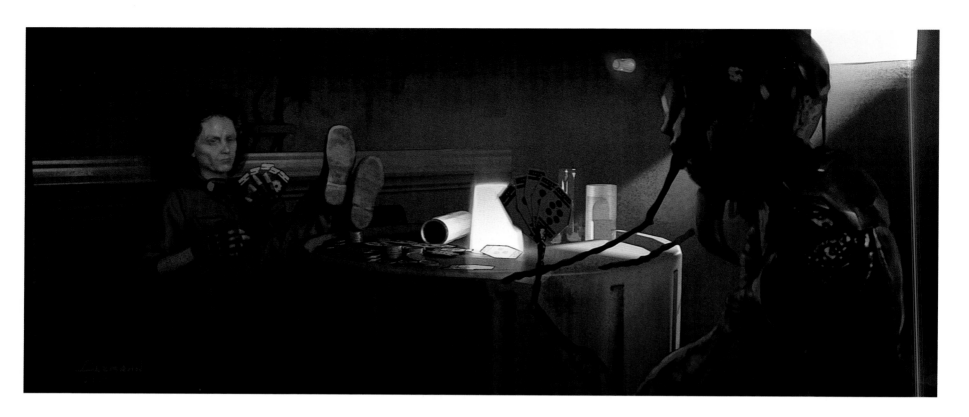

↑ **PELI AT CARDS VERSION 1A**
Alzmann

Both Dr. Mandible, the giant ant-like alien playing cards with Peli Motto, and Frog Lady, the eponymous passenger, appeared in the Mos Eisley cantina as background characters in "Chapter 5: The Gunslinger."

← **PELI GRILL VERSION 105**
Alzmann

→ **BAR ALIEN VERSION 257**
Alzmann

"At one point we were going to bring back the Yuzzum, an early design for the Ewoks, as a background character." Chiang

↓ **PELI GRILL VERSION 141**
Alzman

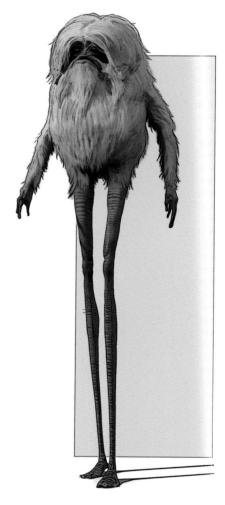

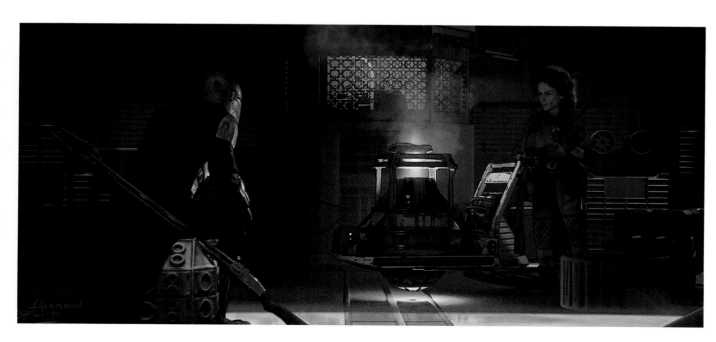

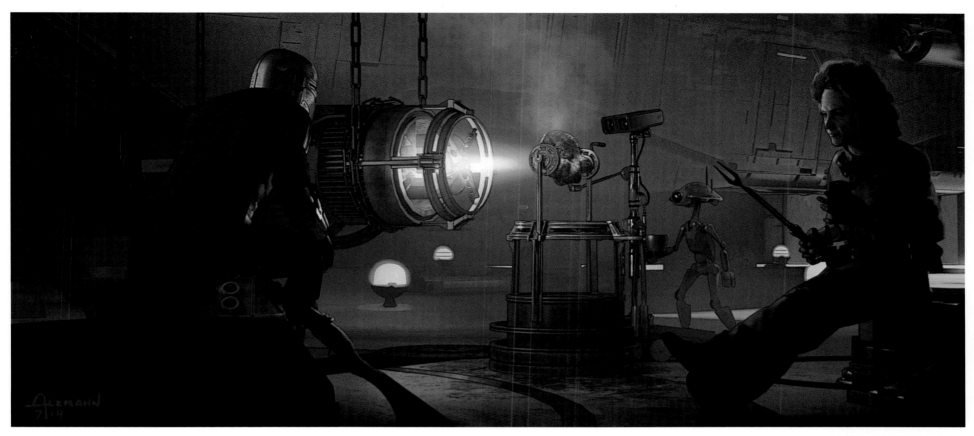

↓ **FROG EGG CYLINDER** Ozzimo

↑ **PELI GRILL VERSION 155** Alzmann

→ **FROGMAN VERSION 180** "I had this assignment to do a frog alien [not knowing that she had appeared in the first season]. Well, what kind of frog? Do you want a poison dart frog? And then I got the actual story that it's a mother with her babies, essentially, on her back. That's when we explored some more specific looks." **Matyas**

↘ **FROG LADY VERSION 135** Matyas and Chiang

↓ **FROGMAN VERSION 181** Matyas

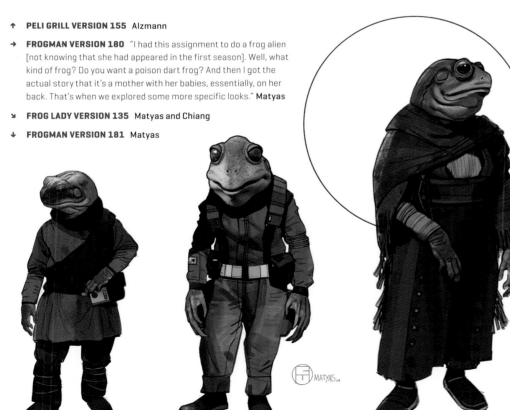

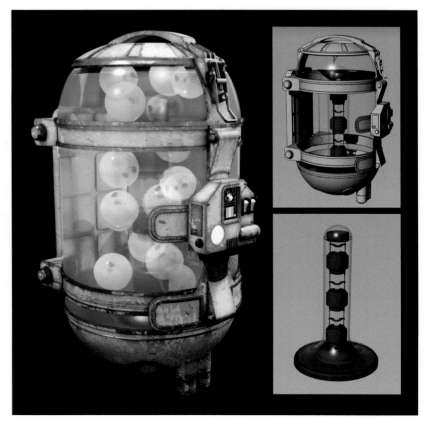

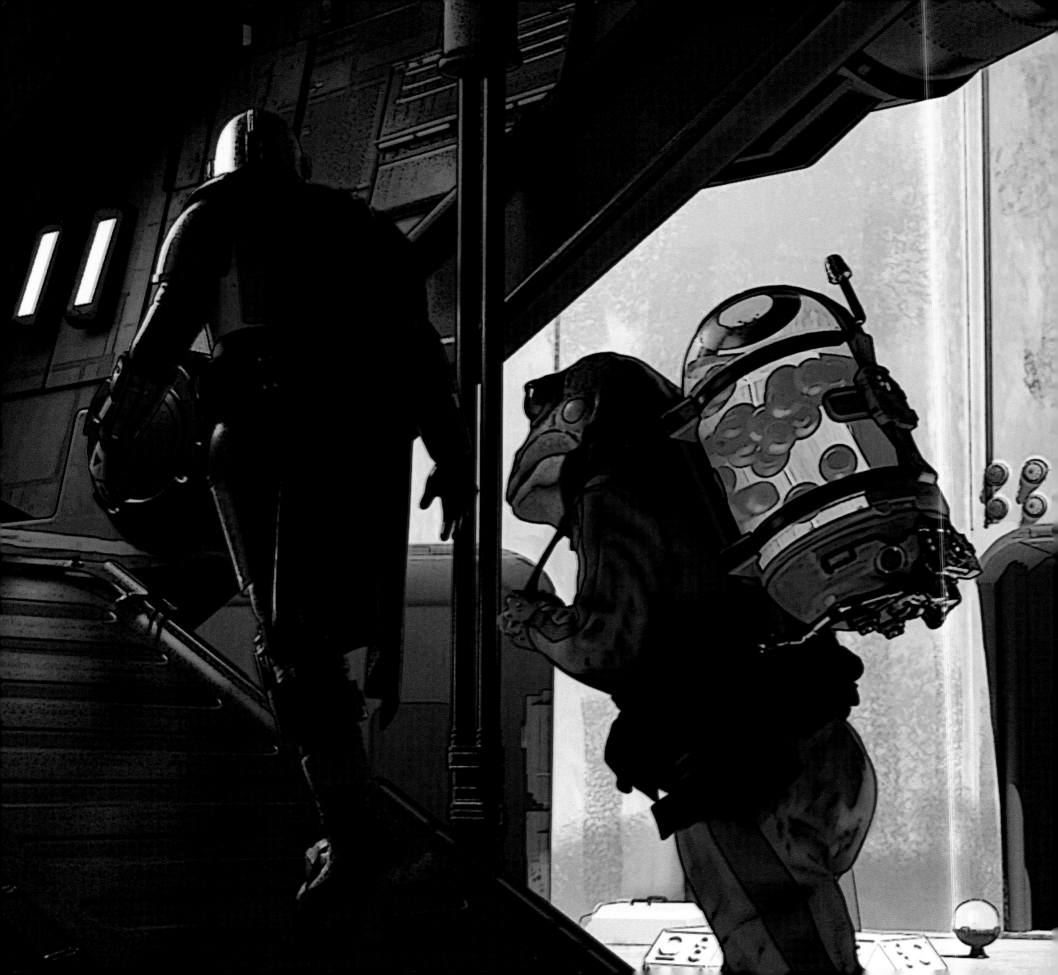

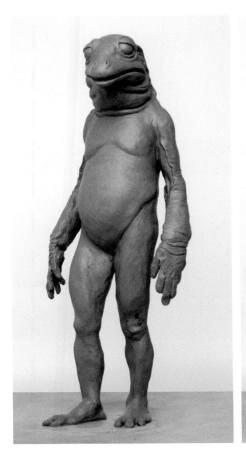

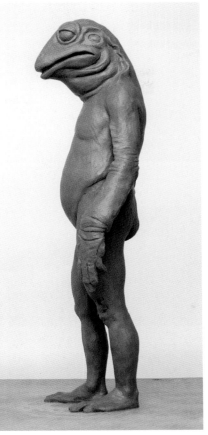

↑ FROG BODY SCULPT VERSION 1A McVey

"We knew Frog Lady was going to be performed by a live actor, but I always like to figure out what the alien would look like if it were real. This is her anatomy without the clothing to see if it logically makes sense." **Chiang**

← TADPOLE CONTAINER VERSION 03 "That egg container was one of the most amazing prop builds I had ever seen." **Alzmann**

→ FROG LADY VERSION 191 Matyas

"We basically wanted to turn Frog Lady into a more fully realized character [than her brief Mos Eisley cantina appearance in the first season], but keep the original design." **Chiang**

↓ FROG LADY VERSION 107 Alzmann

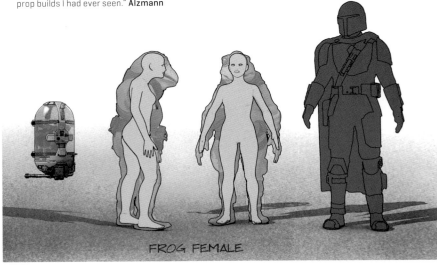

FROG FEMALE

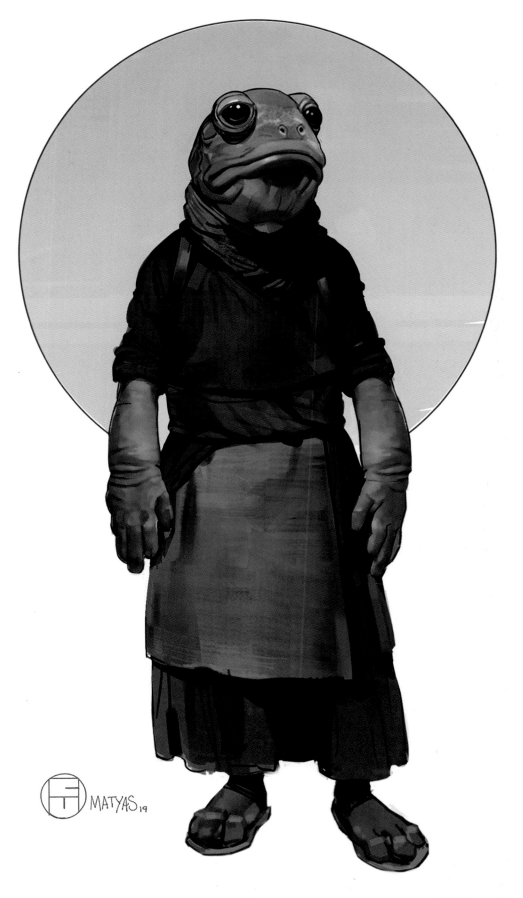

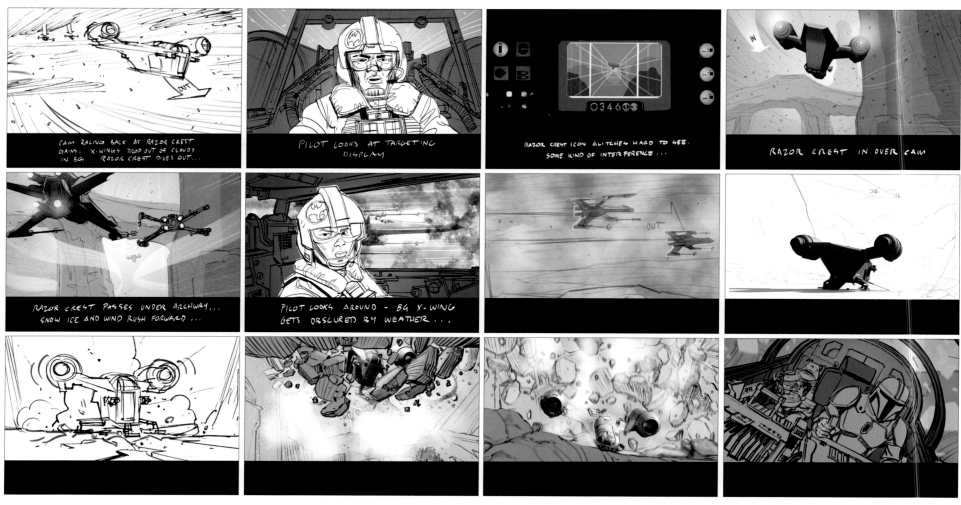

CAM RACING BACK AT RAZOR CREST GAINS. X-WINGS DROP OUT OF CLOUDS IN BG. RAZOR CREST DIVES OUT...

PILOT LOOKS AT TARGETING DISPLAY

RAZOR CREST ICON GLITCHES HARD TO SEE. SOME KIND OF INTERFERENCE...

RAZOR CREST IN OVER CAM

RAZOR CREST PASSES UNDER ARCHWAY... SNOW ICE AND WIND RUSH FORWARD...

PILOT LOOKS AROUND - BG X-WING GETS OBSCURED BY WEATHER...

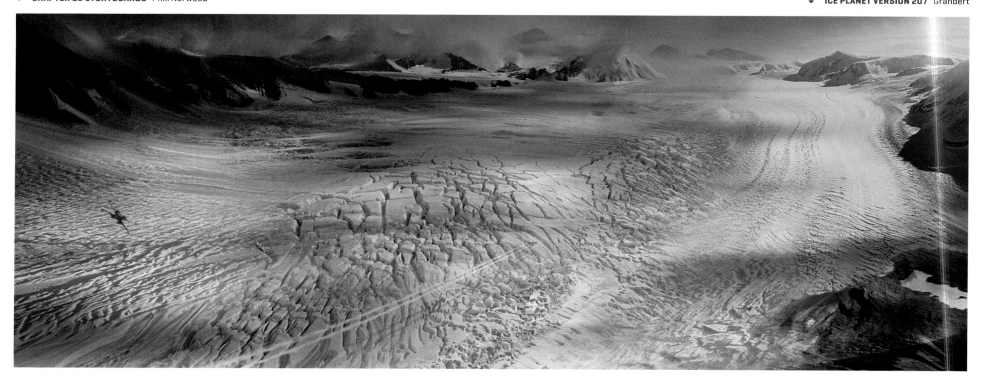

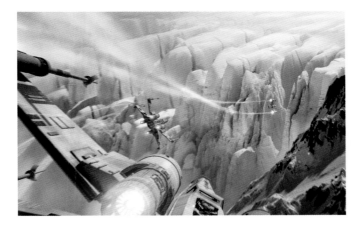

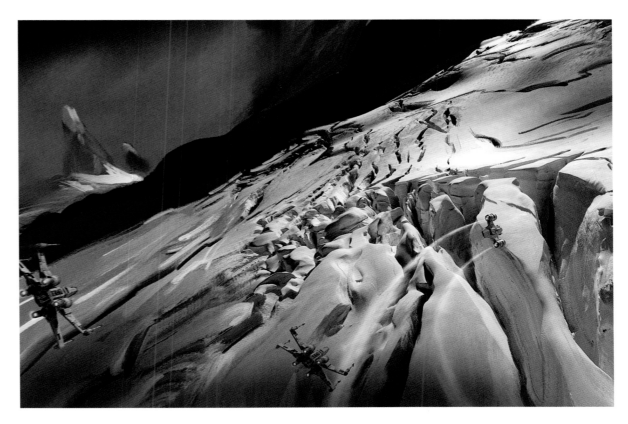

↑ *RAZOR CREST* CHASE VERSION 201 "These were super fun to do, and a much-needed break after design work on Calodan [the walled city from Chapter 13, which went into design prior to Chapter 10]. I really enjoy making concepts with lots of action, speed, emotion, and story. And here I got the chance to fully explore that, designing an epic ice glacial landscape with fast action taking place." **Grandert**

→ ICE PLANET VERSION 210 Grandert

↓ *RAZOR CREST* CHASE VERSION 212 Grandert

"This is almost taken right out of *The Empire Strikes Back*, in the asteroid crater. I thought it would be really fun to play with that so that, subliminally, it matches that shot, but texturally, it's very different." **Chiang**

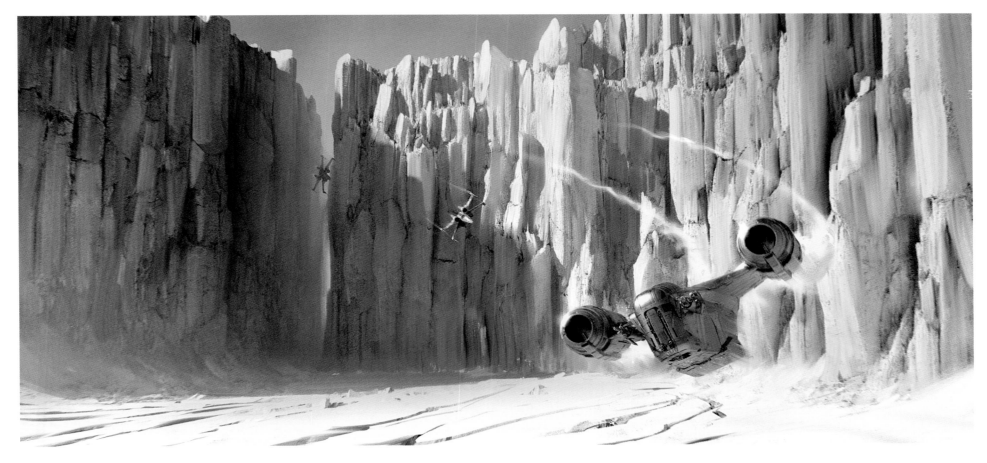

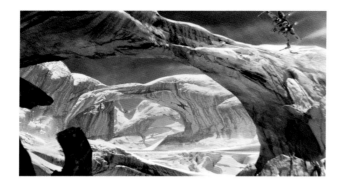

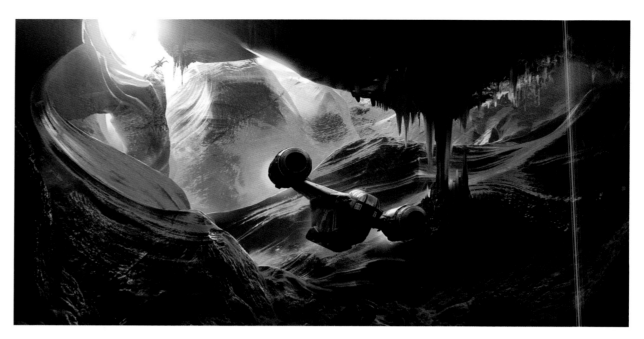

↑ **ARCHES VERSION 217** "The arches were based on photos of actual locations in the US, like Arches National Park [in Utah]. I reworked those locations, making them a bit more complex, and changing the red rock into ice." Grandert

→ **ICE CAVERN VERSION 220** "The challenge here was to find the right style of the landscape, since we have seen quite a lot of similar locations before in *Star Wars*." Grandert

↓ *RAZOR CREST* **LAND VERSION 128** Church

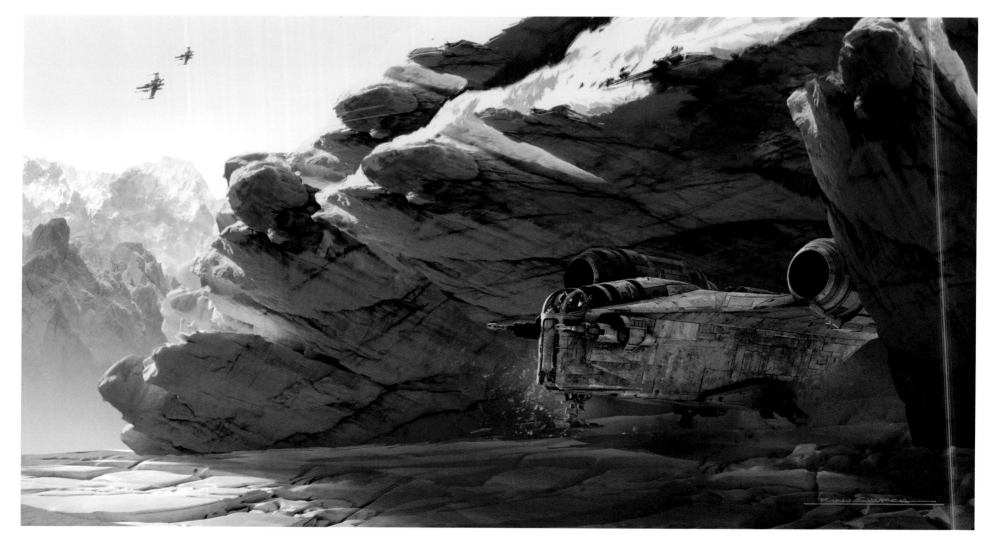

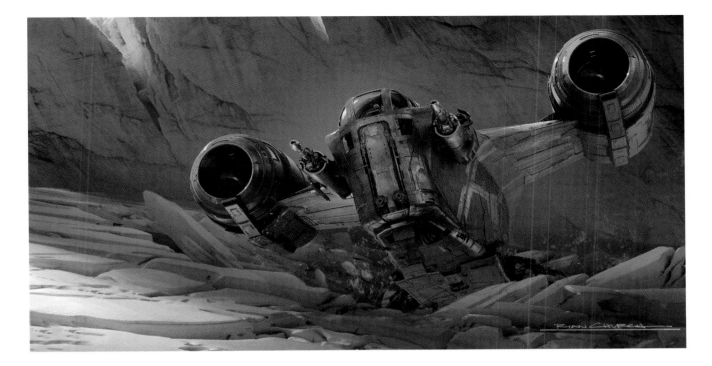

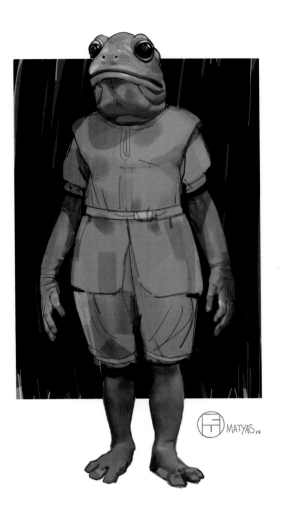

↓ **HOT SPRING VERSION 108** Alzmann

"I remembered an old Ralph McQuarrie painting for the *Illustrated Star Wars Universe* book where he painted these hot springs underneath Hoth, with grass growing and tauntauns. And I thought, 'Well, wouldn't it be fun to do that here, to create a hot spring?' And you could have life down here because it's warm." **Chiang**

Initially sketched in February 1979 for *The Empire Strikes Back*, several of Ralph McQuarrie's "bog planet" landscapes included white bulbs of fungus that the creatures of Dagobah ate. For *The Mandalorian*, those bulbs were reimagined as spider eggs, reminiscent of the H. R. Giger–designed Xenomorph eggs from 1979's *Alien* and its subsequent sequels.

↑ *RAZOR CREST* **ICE CRASH VERSION 132** Church

→ **FROG LADY SWIMSUIT VERSION 192** "For this design I looked at nineteenth-century-style swimsuits for inspiration." **Matyas**

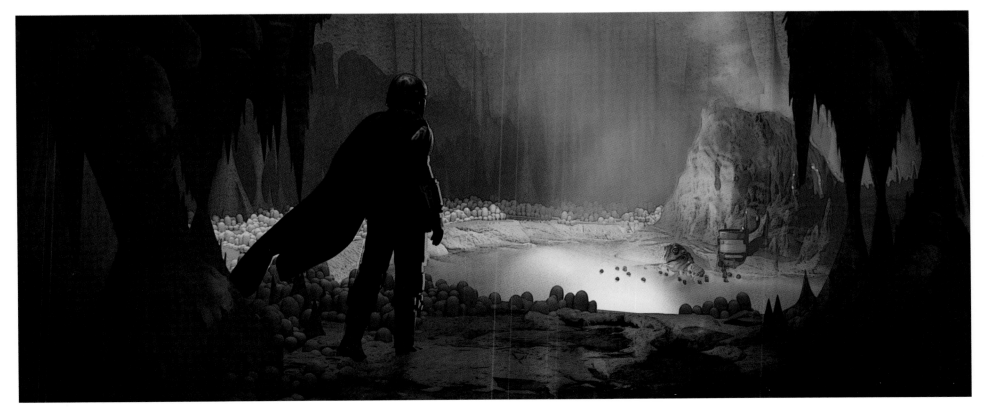

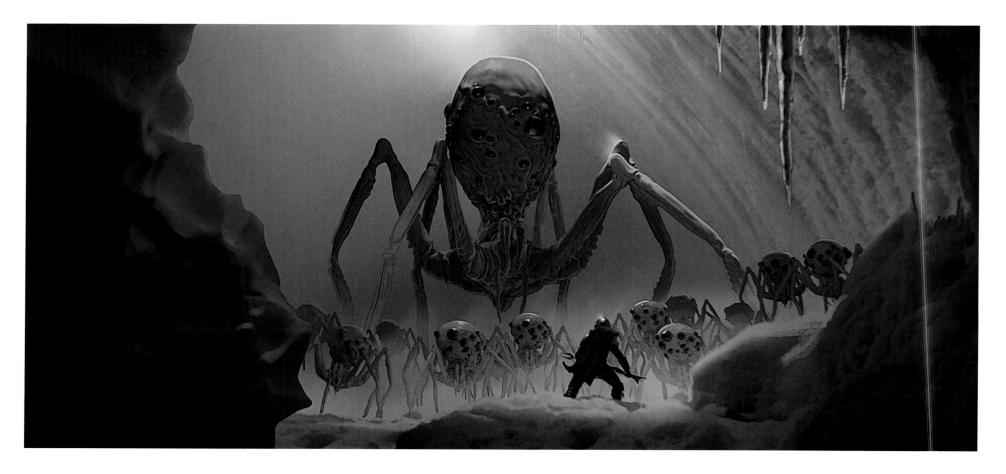

↑ ICE SPIDER VERSION 2 "The ice spider is, of course, based on the McQuarrie design, but I thought I'd do a different spin and add a bunch of red eyes. It looks grosser that way." **Alzmann**

↓ DAGOBAH—WHITE SPIDER
Ralph McQuarrie

Ralph McQuarrie completed his "bog planet tree creature" painting in 1993, based on a 1979 sketch, for *The Illustrated Star Wars Universe*, later inspiring both the krykna for *Star Wars Rebels* and the ice spiders for Chapter 10 of *The Mandalorian*.

→ ICE SPIDER SCULPT VERSION 2A "The McQuarrie spider was a challenge mainly because of all those legs. I cast and painted two copies from the rubber molds I made, and the version that was intended as the scanning model had removable legs held in place in their sockets with magnets, a little extra that proved to be quite time-consuming to complete, so I hope it was actually useful when the time came." **McVey**

"This is our generic version of the ice spider. And [in visual effects] we built a baby version from this, along with a three-foot and a six-foot [digital model], and then ultimately used this as a model for our giant mother spider." **Chiang**

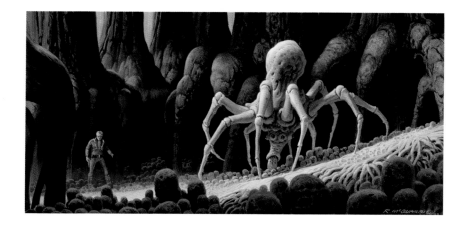

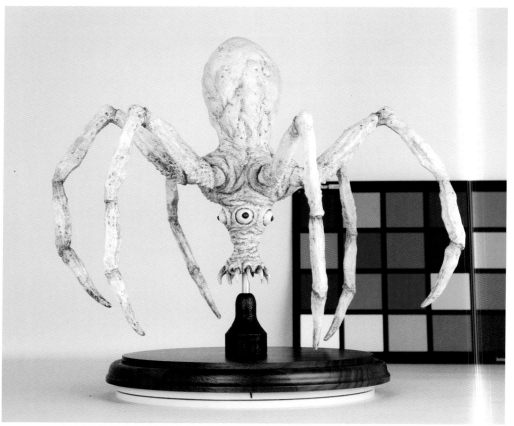

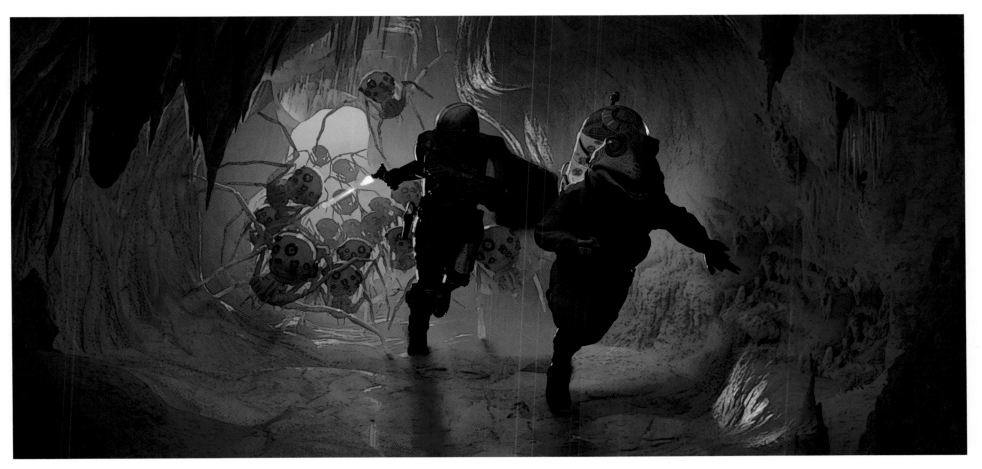

↑ **CHASE CAVE VERSION 112** Alzmann

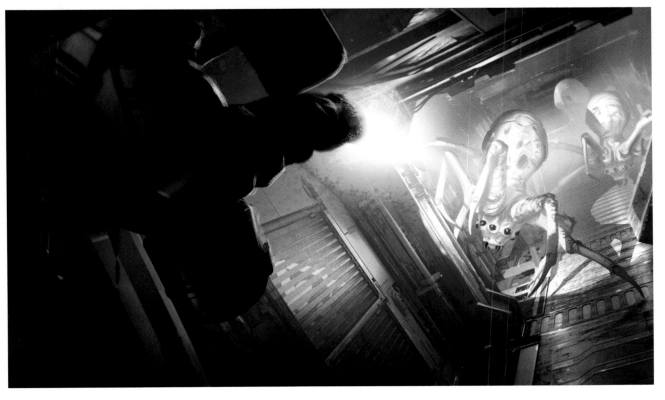

↑ **FROG LADY WEAPON** Ozzimo

← **SPIDER ATTACK VERSION 114** Church

⇥ **CRASH SPIDER VERSION 105** "When you read [about the spider] in the script, it's just a no-brainer. Although wrapping your head around the fact that the spider is not living in a humid, warm environment but in an ice environment, that was a bit of a stretch. But with the coloration and thickness of the skin and everything, it kind of works." **Church**

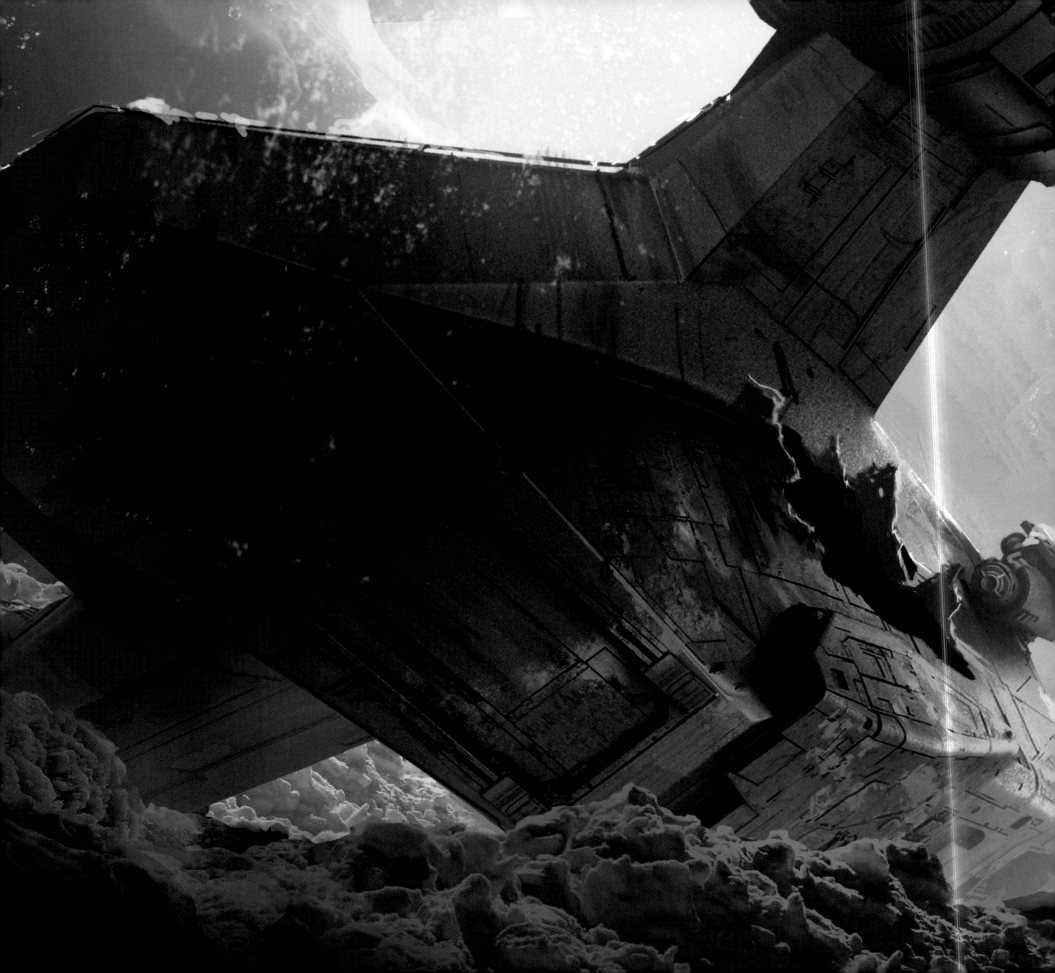

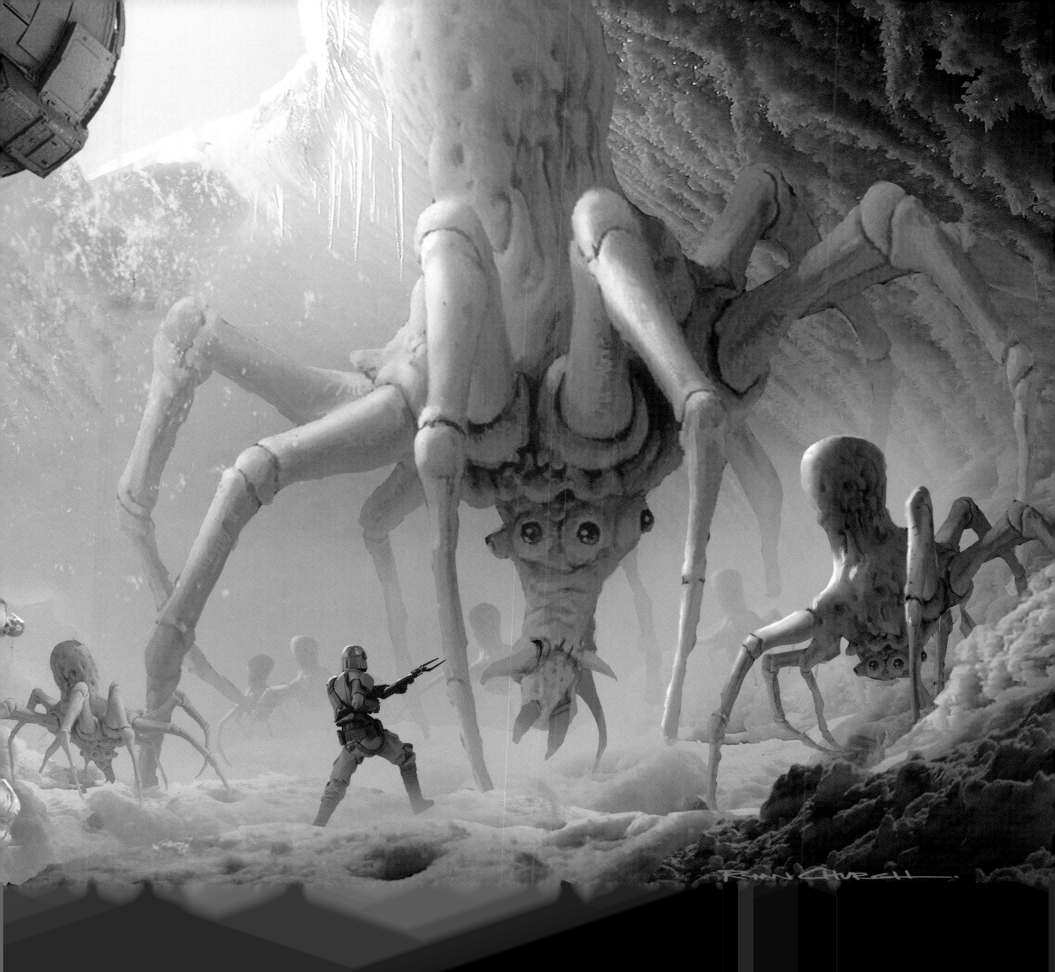

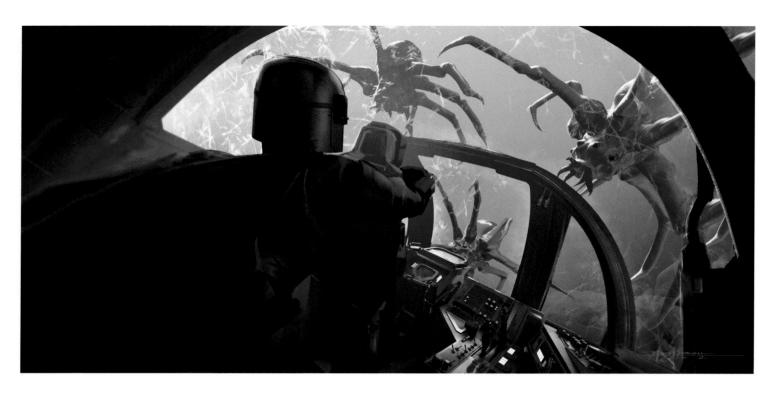

← RAZOR CREST COCKPIT VERSION 114

"More *Alien* moments. This is actually more of a Jim Cameron type of a moment, when these things are breaking through." **Church**

→ "I remember talking to Doug about the hangar at Hoth. I still don't know what they did with that interior. There's just so much blue light flooding that entire set, but you don't see the source or anything. It's amazingly well done. And it doesn't look at all overcooked or DI-ed [the digital intermediate post-production process in which the color of a shot can be altered]. It's just nailed." **Church**

↓ ICE CAVE VERSION 145 Alzmann

"Early on, there was a plan for the spiders to spin an ice web to cocoon the *Razor Crest*. This idea ultimately fell away." **Chiang**

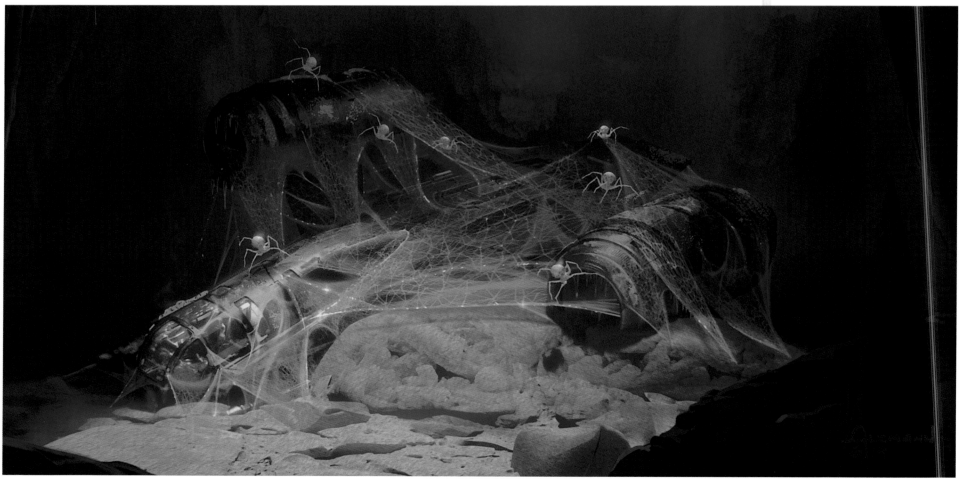

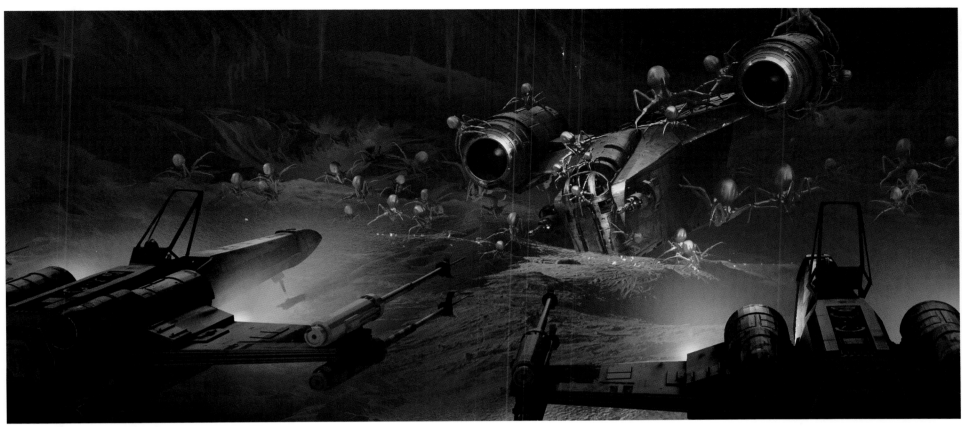

↑ *RAZOR CREST* SPIDERS VERSION 115 Church

↓ X-WING SAVE VERSION 113 Church

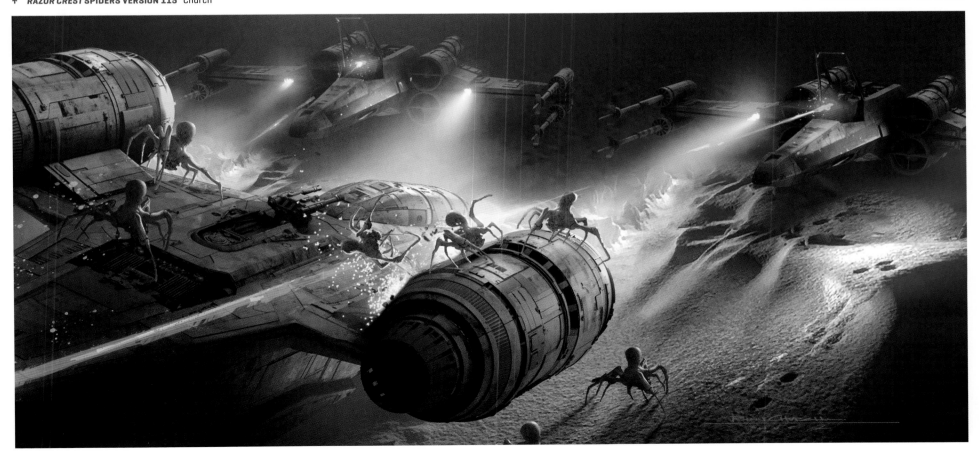

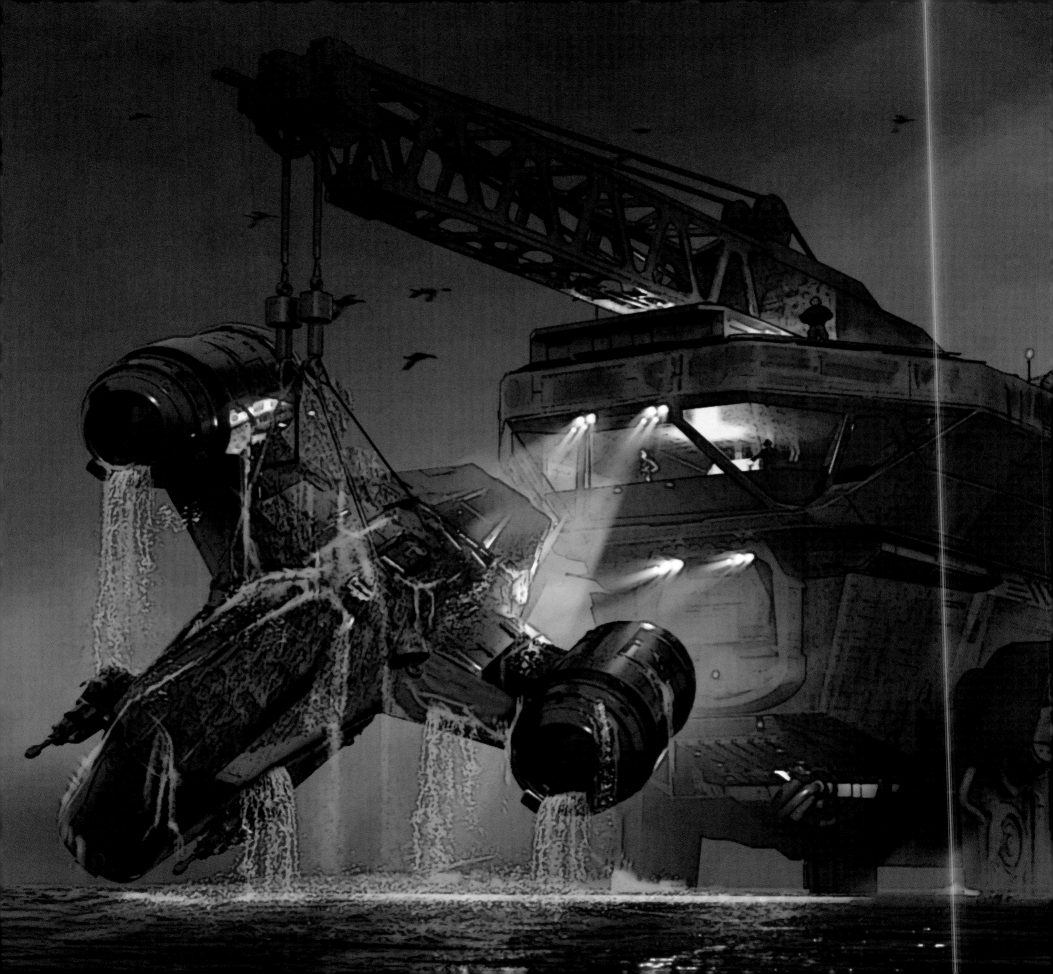

THE HEIRESS

Both Jon Favreau and Dave Filoni had rough outlines and many ideas for each of their episodes, some of which they had already been sharing with Chiang and his team, including a brief mention of an idea for a "train robbery" episode, showcasing combat aboard an Imperial vessel, seeds for both Bo-Katan Kryze and her compatriots' invasion of it in Chapter 11, and the rescue mission on Moff Gideon's Imperial light cruiser in Chapter 16.

Chapter 11 would be the episode set on Trask, and Filoni stated his desire to include Bo-Katan Kryze and her Mandalorian cohort in multiple episodes of the season, but a definitive connection between the locale and characters had not yet been made. The conflict between Bo-Katan's and Din Djarin's perspectives on what it means to be a Mandalorian due to their wildly divergent upbringings was discussed, Djarin being "from the zealots," in Bo-Katan's eyes, and Kryze from "royalty, remnants of the bigger houses and clans." A scene where Bo-Katan and her companions remove their helmets, but Djarin doesn't, was mentioned. "His story is about becoming," a shift made apparent in the second season's later episodes.

"I told Katee Sackhoff [voice actor for Bo-Katan Kryze in *The Clone Wars* and *Star Wars Rebels*, made famous by her role of Kara "Starbuck" Thrace on *Battlestar Galactica* (2004)] years ago that, if this works out, maybe Bo-Katan could return in live-action," Filoni said. "And she was like, 'Oh, sure. Like, c'mon.' Because [a character making the jump from animation to live-action] so rarely happens. And I think even more rare is the idea that the person, like me, who created these characters actually carries them all the way into live-action and continues writing them and directing and designing them. Usually, it gets handed off to a different group who may or may not actually know the characters."

Filoni continued, "Katee's armor, the helmet, and the shape of that, I went over in great detail. Same with Ahsoka's costume. With those two costumes, I knew how much scrutiny they'd get from fans. I really wanted to make them in a way that I felt I could never achieve in the animation. I loved what I did in the animation, but now it's real cloth and materials. Having one year of experience working with costume designers, I had an idea of what I wanted to do."

"The most interesting [characters] are the ones that are complicated and strong, good at what they do, are flawed and overcome obstacles that are presented in interesting ways," Favreau mused. "We're fortunate that we have this whole garden of mature characters to choose from, because of all the creative people who have been involved. To tell a story about Mandalorians, at some point you're going to be curious about Bo-Katan and the Darksaber, so it was very organic storytelling. Now that we can draw from other storylines in other *Star Wars*, why not pull the coolest characters in, like Ahsoka and Bo-Katan?"

Actor and director Bryce Dallas Howard returned for Season 2 of *The Mandalorian*, three days before her Season 1 episode, "Chapter 4: Sanctuary," debuted, to helm the Favreau-penned "Chapter 11: The Heiress," guest-starring Sackhoff as Bo-Katan Kryze.

"Katee's been the character forever," Filoni said. "And I felt so good about her having the opportunity to play Bo-Katan again. She was over the moon about it. We used to just geek out on the side, like, 'Can you believe we actually made this happen?' It's almost like somehow we tricked everybody into making it happen."

← **RAZOR CREST DREDGE VERSION 281** Alzmann

→ **GAUNTLET BLADE VERSION 2D** Ozzimo

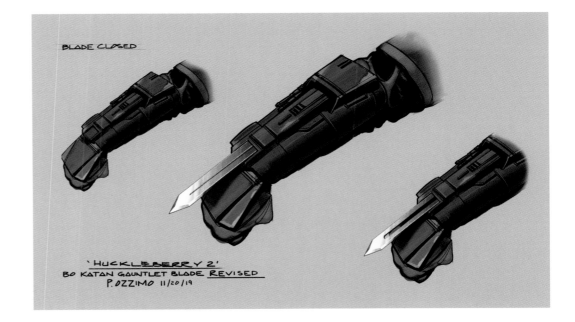

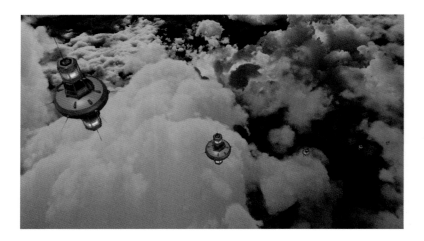

PORT CITY VERSION 110 Church

"We were trying to find a new look for a planet, because after a while, you end up repeating the same things. Jon had this great idea that Trask should be a port town, so, I started to research New England whaling towns and how that could inform the design." **Chiang**

TRASK BUOY VERSION 443 Alzmann

TRASK AERIAL VERSION 142 Church

"We decided that this planet was going to be heavily overcast, because we knew that lighting condition works really well in the volume, allowing us to put most of the content on the LED walls." **Chiang**

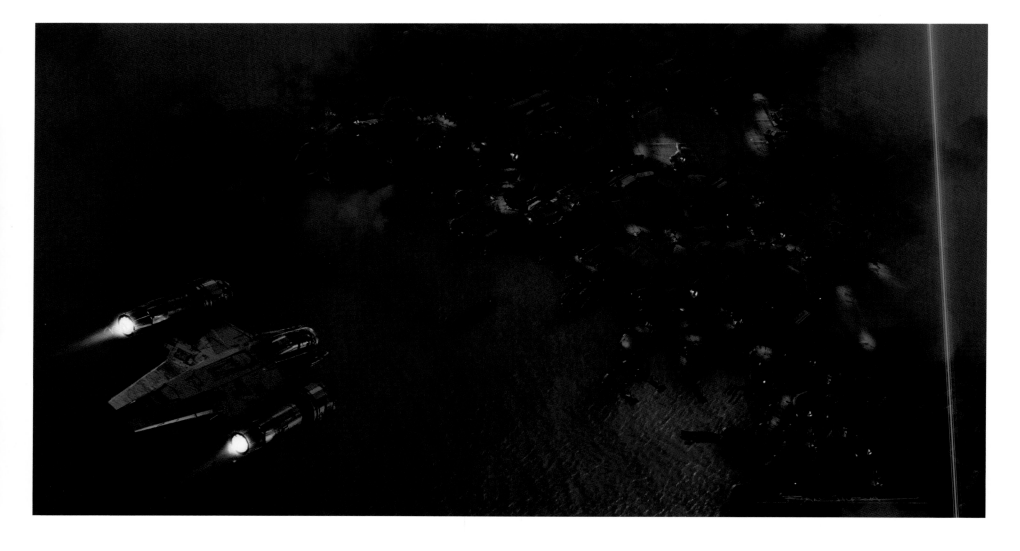

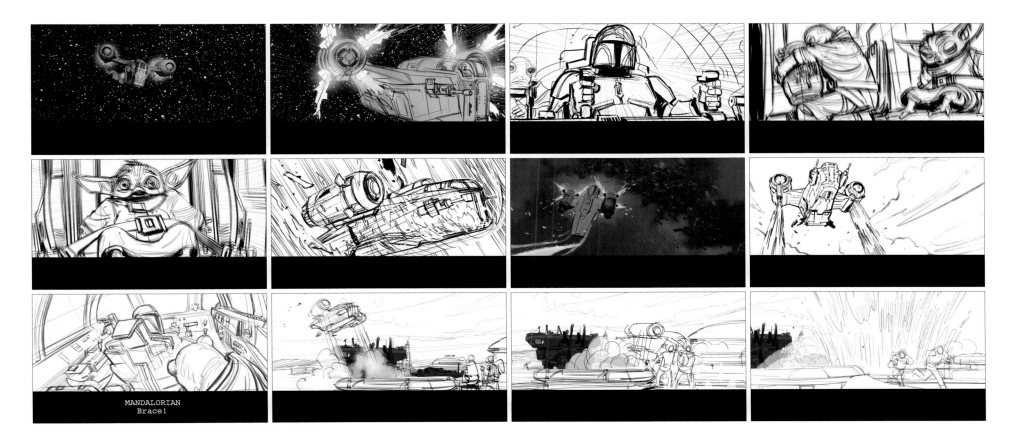

↑ **CHAPTER 11 STORYBOARDS** Norwood

→ **SINKING VERSION 236** Church

↓ ***RAZOR CREST* LANDING VERSION 02** "I had taken a drive out with a friend of mine from London to the east coast [of England], where the Thames River meets the ocean. It was a dark, overcast day, and it was *that* day that I was trying to get into all of these illustrations. Evocative. And I never changed the illustration style, the time of day, ever, in any of these illustrations." **Church**

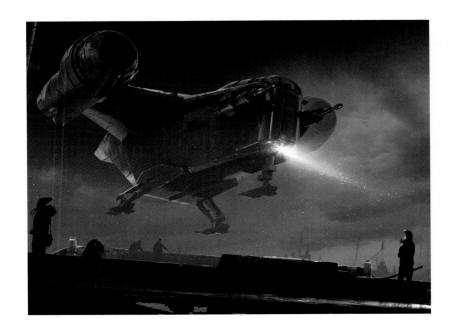

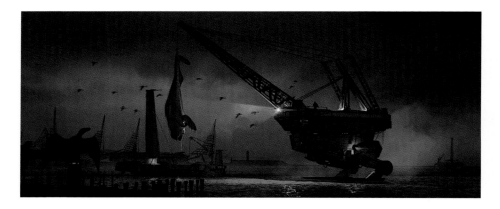

↑ *RAZOR CREST DREDGE VERSION 269* Alzmann

↑ **FISHING VERSION 01** "I love that walkers can be combat vehicles, but also just utility vehicles. They almost make more sense as utility vehicles. No one is trying to hamstring one of these (as the Rebels did with the Imperial walkers in the Battle of Hoth). I'm just thinking, 'What's an interesting sandcrawler type of rusty, utilitarian shape that could walk on four legs?'" **Alzmann**

→ **TRASK WALKER VERSION 296** "I threw the AT-AT legs onto the bottom because I figured that we'd never see them. Now everyone will think, 'Well, it's a refurbished AT-AT walker.'" **Alzmann**

↓ **TRASK DOCK WALKER VERSION 03** Alzmann

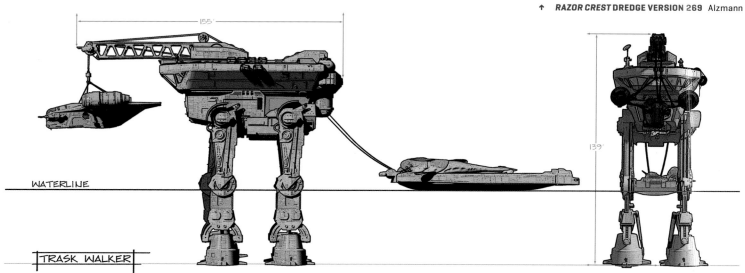

WATERLINE

TRASK WALKER

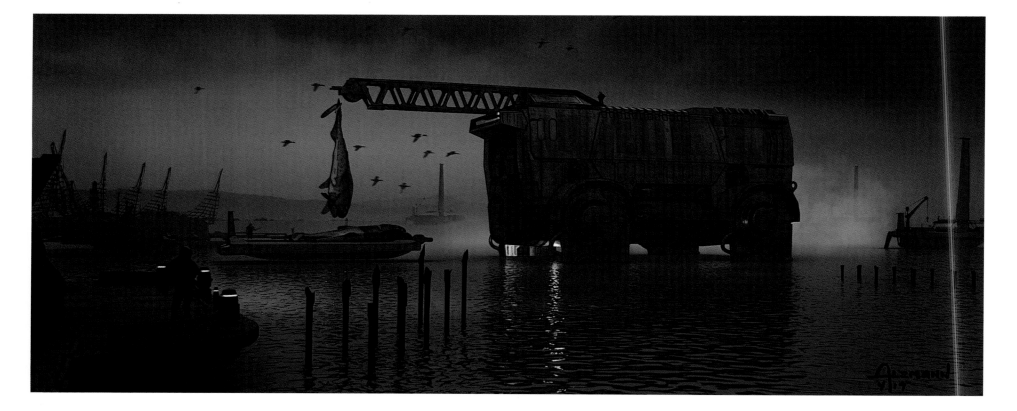

→ **CALAMARI COOK
VERSION 01**
Matyas

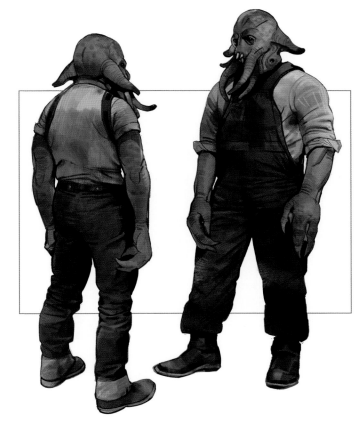

↑ **QUARREN DOCK WORKERS VERSION 02** Matyas

← **QUARREN SAILOR VERSION 01** "I was thinking that this would be the Captain Ahab of the boat that they rent." **Matyas**

→→ **FISHING DOCK VERSION 02** Le

↓ **QUARREN DOCK WORKERS VERSION 01** "I remember seeing the concept art for the fishing town and thinking, 'Quarren dockworkers and fishermen'? Of course! [Laughs] Of course they are. I was thinking that maybe, to shield themselves from rain, the fishermen are like hermit crabs [laughs] in silhouette, where you get just the tendrils from their beards under this big basket shell shape." **Matyas**

↑ WHARF STUDY VERSION 02 "I took an early pass at this space whaling port, where a bunch of trawlers are tied up, rough geometry, sketching over them. And then I started doing more refined modeling. I think it got a bit too busy, versus something that was more repeated and regimented, but in a way that's easier for set builds. But all of this stuff's so fun to explore and play around with and see what it might be like." **Tiemens**

→ TRASK WHARF ROUGH VERSION 08 Tiemens and Chiang

↓ FISHING DOCK VERSION 01 Le

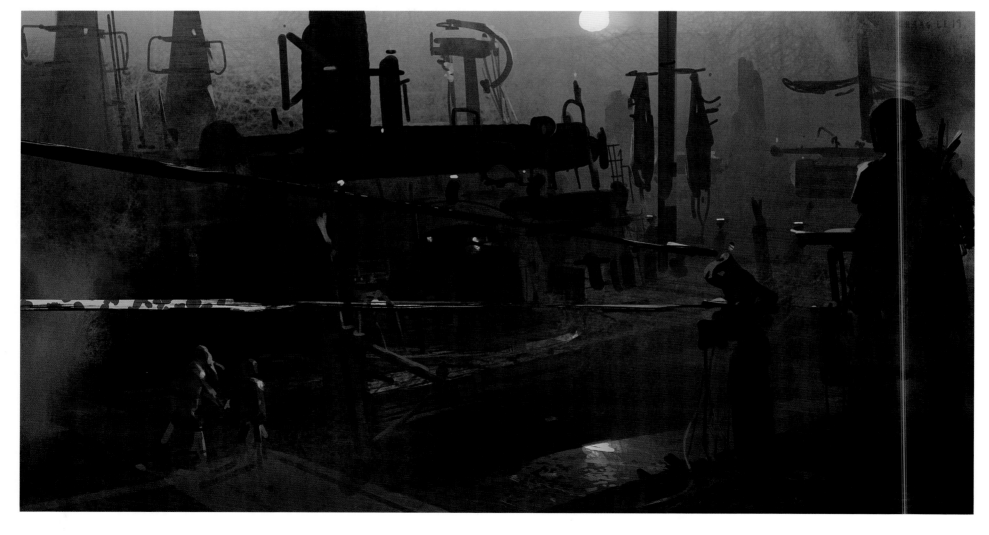

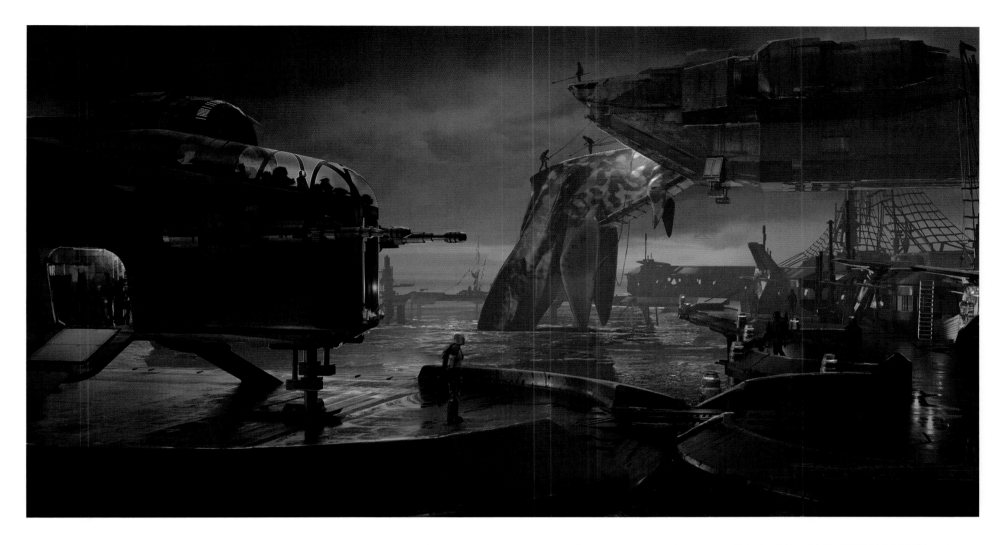

↑ **TRASK WHALE WIDE VERSION 01** Church

"I had an early conversation with Dave about designing these landing platforms to be concrete and streamlined, so that we can reskin them for a different planet later on. So the platform's our cleaner element. And then on the deck itself, we have more cobbled-together buildings. The idea is that old shipping containers had been dropped here and have now been turned into bars and restaurants and storage buildings." **Chiang**

→ **TRASK STREET REVERSE VERSION 01** Church

↓ **TRASK STREET AERIAL VERSION 01** Church

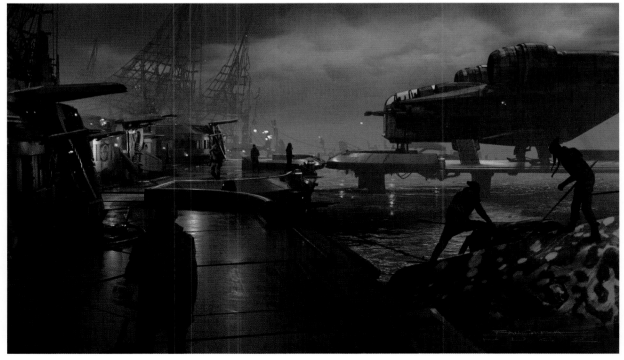

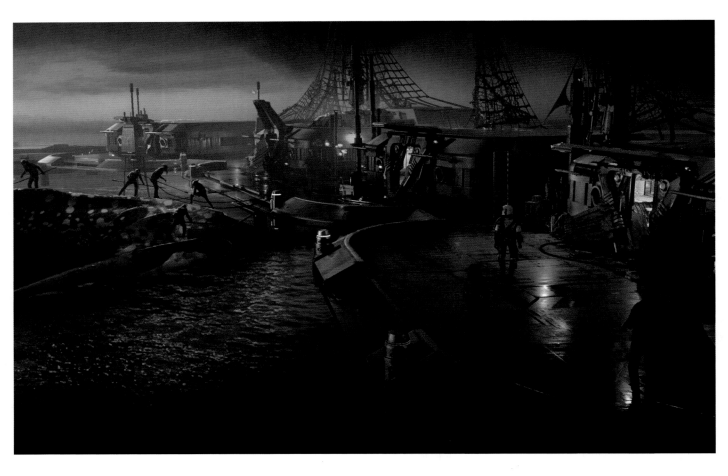

TRASK STREET WIDE VERSION 01 "Every Trask image was so much fun. You can just smell the seaweed, fish, and mussels. This vertical net design that I kept doing, it makes no sense. What, are we catching flying fish or something? Maybe they're drying the nets. But when you see nets silhouetted against the sky, you get that it's a fishing village. If you put it on the ground, you're not going to see it. If you put it as a door covering, it's going to look a little hokey. But putting it as a silhouette element means you're really making a huge statement like, 'This is where they go fishing.'" **Church**

"This is quite ramshackle, and doesn't look very *Star Wars*, and I totally get it. But I wanted it to look like the *Popeye* [1980] set, which is one of the best sets ever, built in Malta. That set combined with that day in East Britain, when it was totally 'Everyday Is Like Sunday,' the Morrissey song. Just dark and post-nuclear winter, that was the combination for Trask." **Church**

FISH PROCESSING VERSION 01 Alzmann

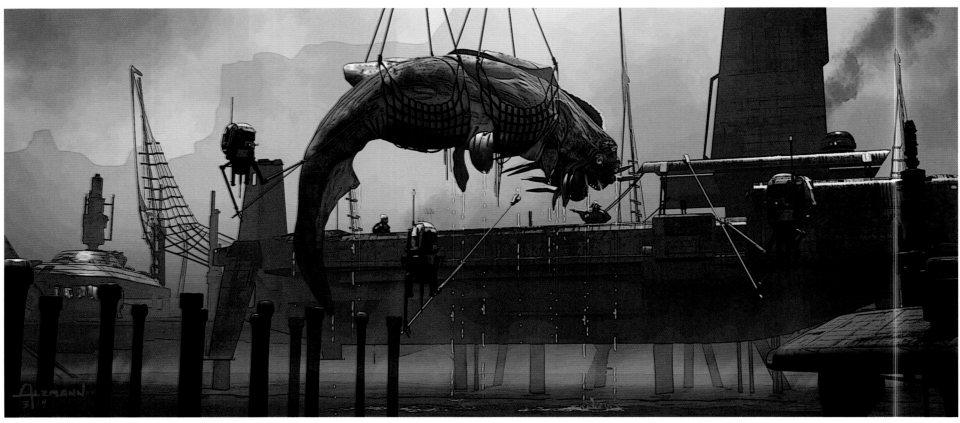

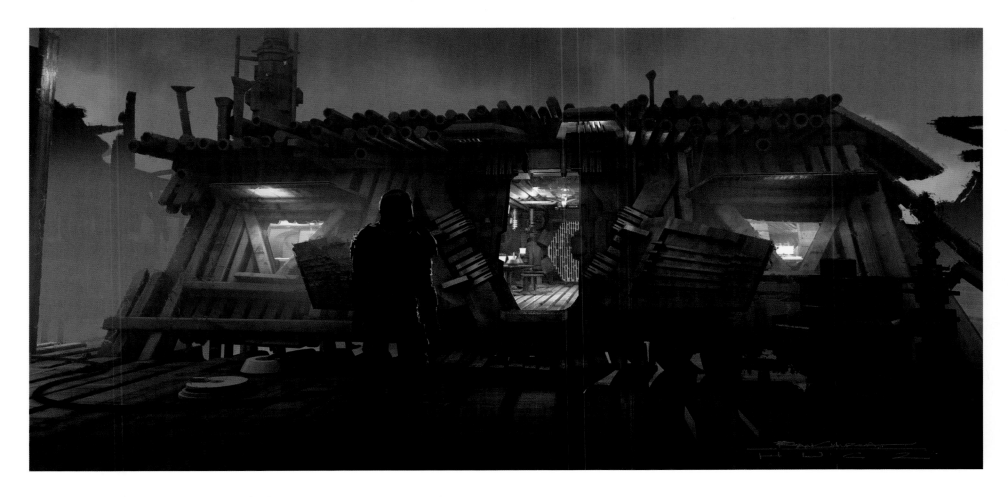

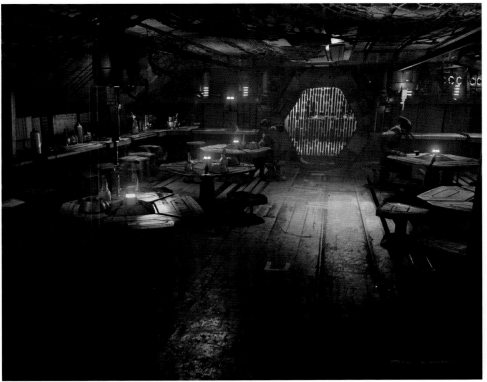

← **TRASK RESTAURANT INTERIOR VERSION 01**
"I popped the inn into more of a shipping container, which was definitely the right call. It seems like the kind of prefabricated pod that they might create." **Church**

"We made the inn very much like Quint's shack from *Jaws*, set decorating with a lot of fishing paraphernalia, nets and traps and things like that, keeping the furnishings all very simple and rustic. The floor is the floor of the metal container, the chairs and the tables perhaps cobbled together from old pieces." **Chiang**

↑ **TRASK RESTAURANT ENTRANCE VERSION 01**
Church

→→ **TENTACLE SOUP VERSION 01** Alzmann

↓ **TRASK RESTAURANT VERSION 01** "I absolutely love that door, because an upside-down triangle, you can chop the corners off and it makes it a hexagonal door. So you could look out from the interiors and it's kind of a hex door. I've been trying to get that door in. And it looks like a real, heavy door, like it could really hold something back, like it was meant for a ship and it got repurposed." **Church**

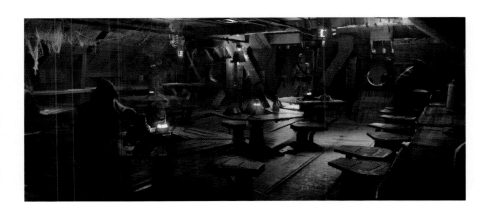

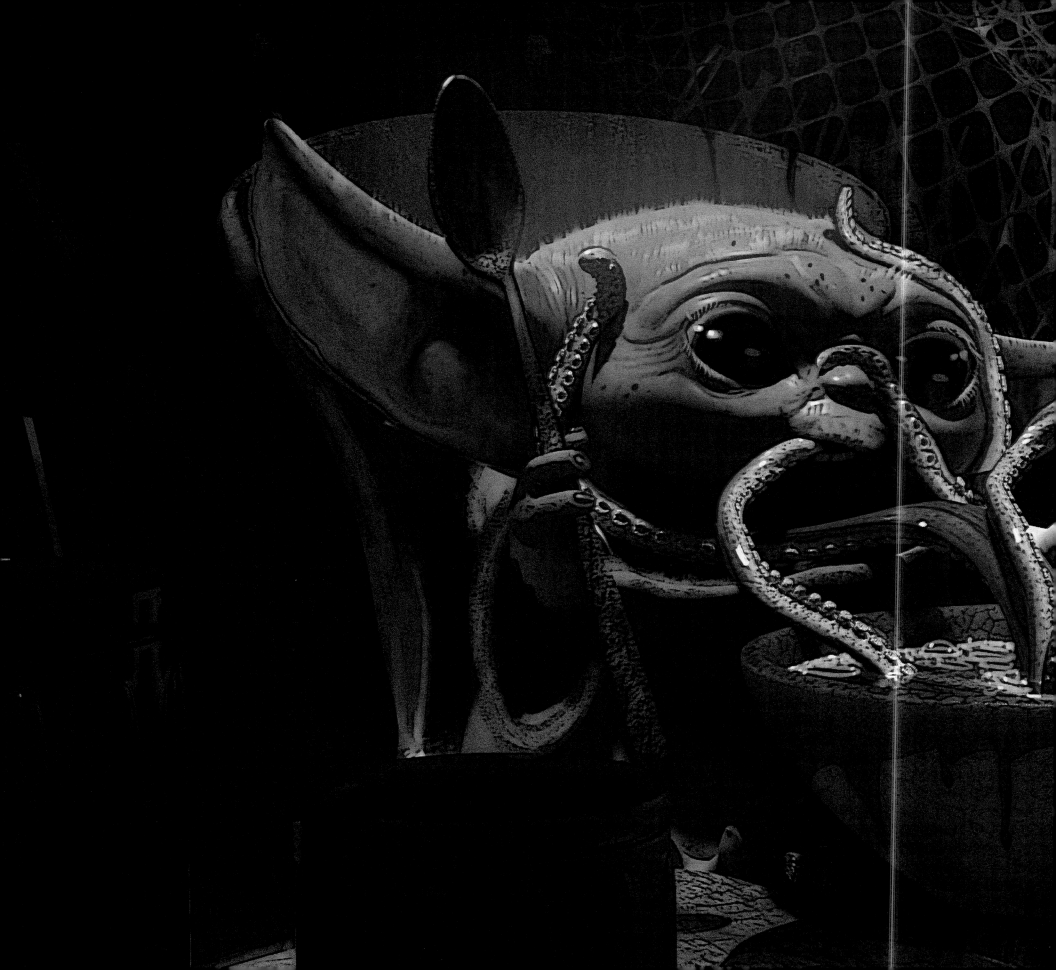

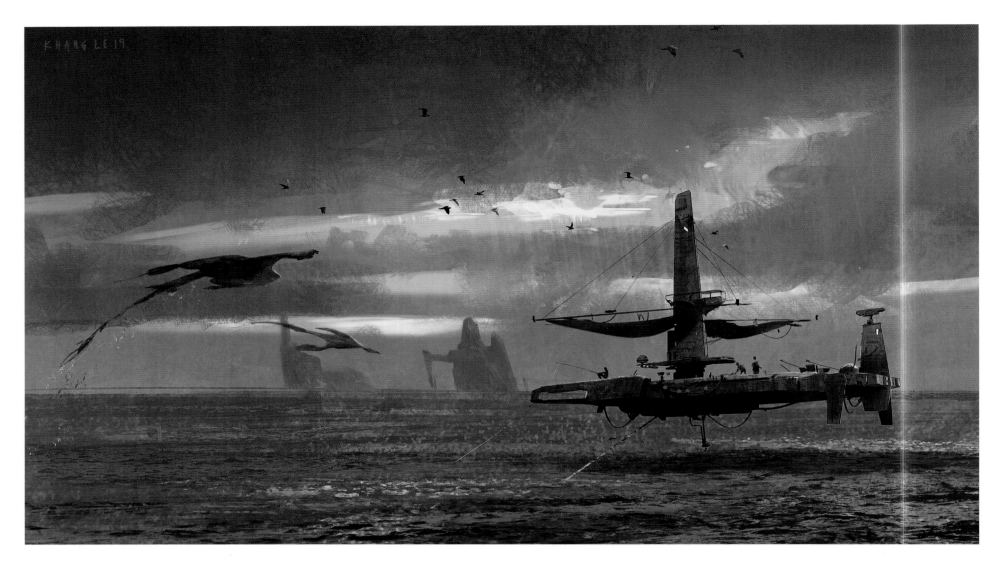

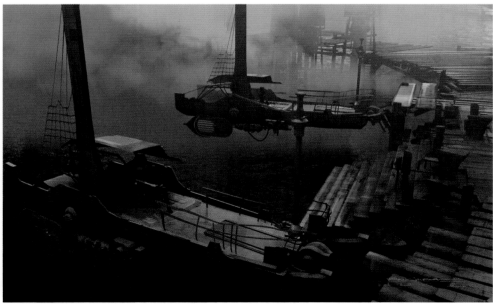

↑ **FISHING TRAWLER VERSION 02** Le

← **FISHING VESSEL VERSION 02**
"For these, I referenced the boat models I did for *Rogue One*." **Church**

↓ **HOVER BOAT VERSION 1A** Thom Tenery

"We took an old design that we had developed for *Rogue One*, for the river journey [where Jyn Erso was initially going to find Saw Gerrera, as seen in the teaser trailer shown at *Star Wars* Celebration Anaheim 2015], and basically scaled it up to be this fishing trawler. We needed a big cargo hold in the center, where this sea creature was going to be." **Chiang**

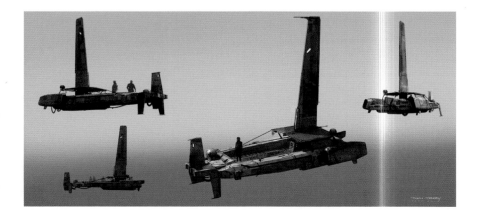

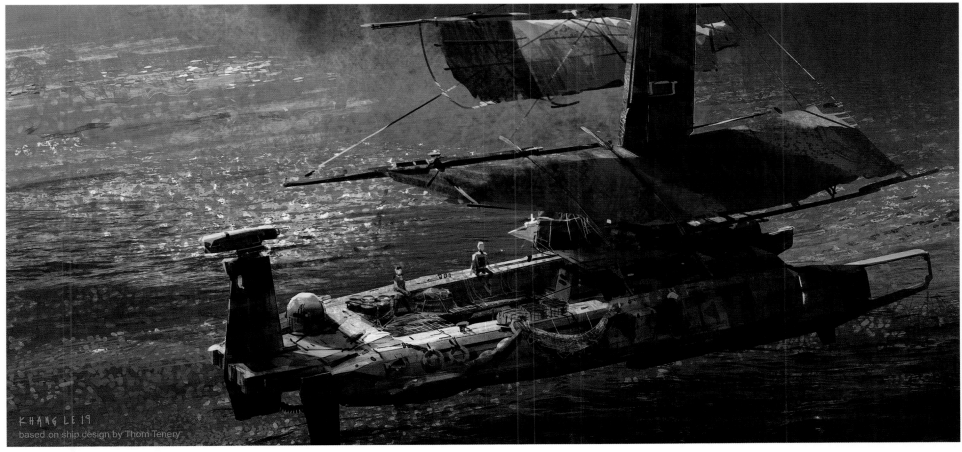

KHANG LE 19
based on ship design by Thom Tenery

↑ **FISHING TRAWLER CLOSE UP VERSION 02** Le

↓ **TRASK BOAT VERSION 06** Alzmann

↑ **TRASK BOAT VERSION 07** Alzmann

↓ **TRASK BOAT VERSION 05** "This started from a Thom Tenery [*Rogue One* concept artist] design, which I then slightly modified, mostly for story and some minor changes. But the final boat is mostly Thom's." **Alzmann**

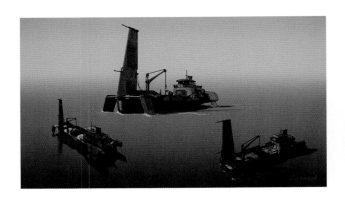

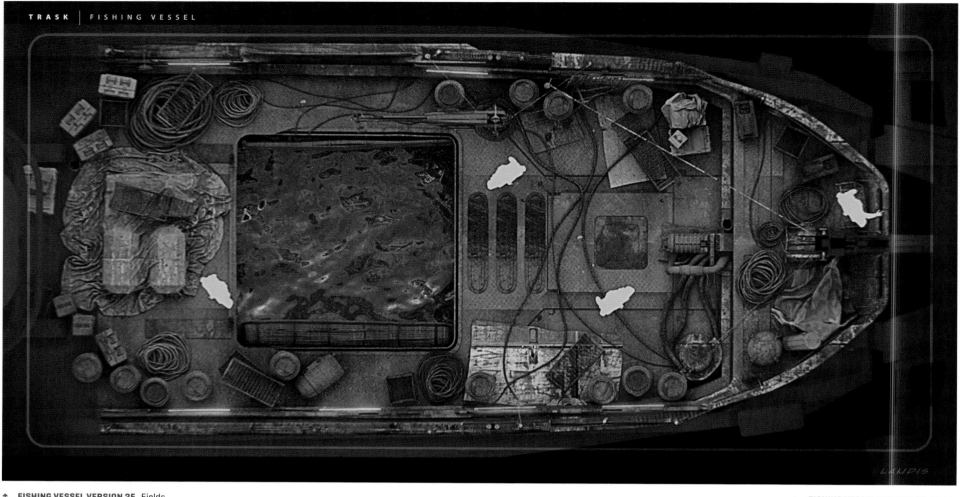

↑ **FISHING VESSEL VERSION 2F** Fields

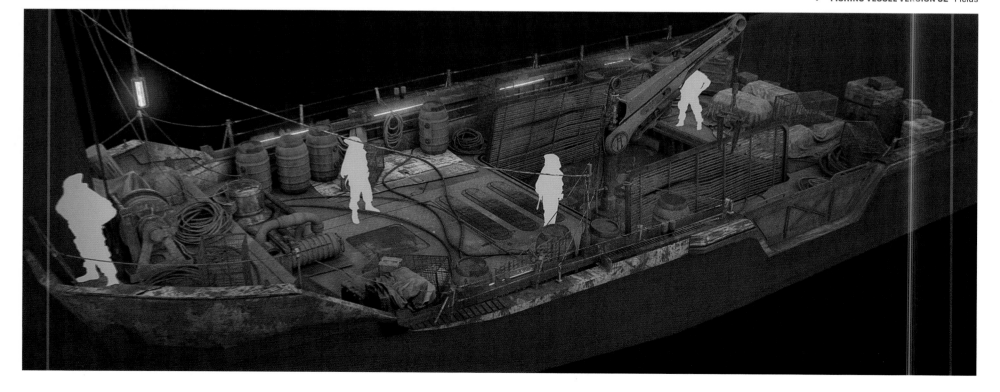

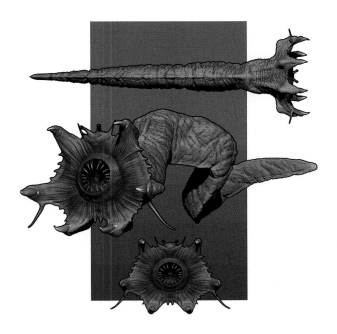

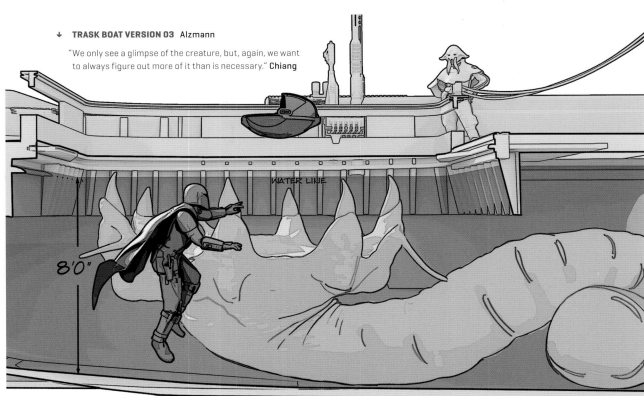

TRASK BOAT VERSION 03 Alzmann

"We only see a glimpse of the creature, but, again, we want to always figure out more of it than is necessary." **Chiang**

WATER LINE

8'0"

↑ **TRASK MONSTER VERSION 290** "The focus here is on the mouth closing and how to make that feel *Star Wars*. I knew we weren't going to see much else than that giant maw, like a sea sarlacc." **Alzmann**

↓ **BABY OVERBOARD VERSION 02** Alzmann

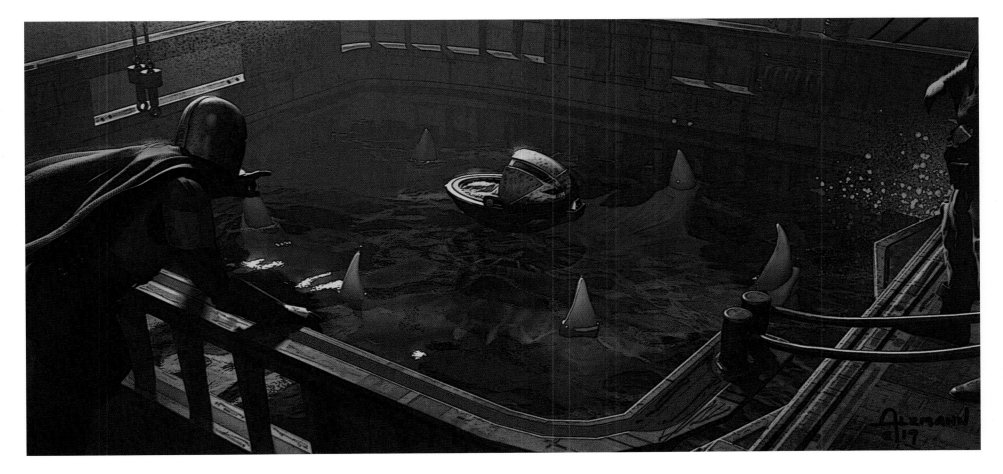

↑ **FLIGHT VERSION 259** Matyas

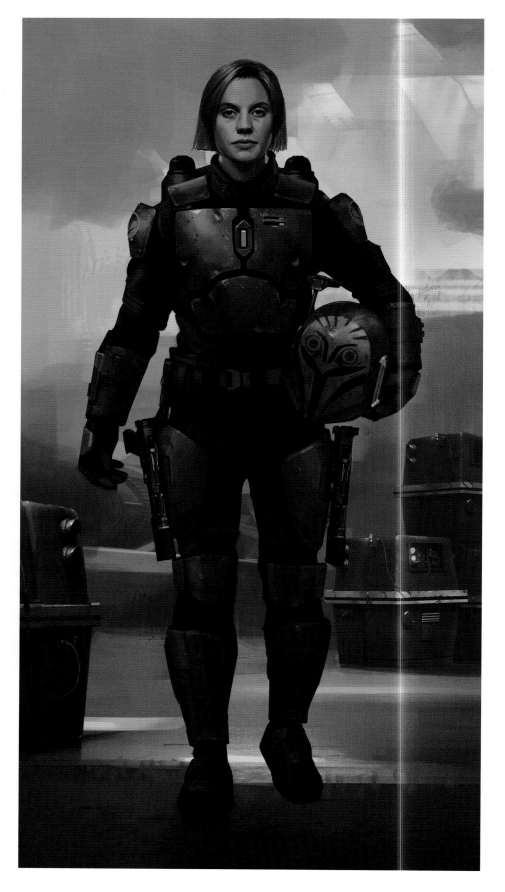

↑ **BO-KATAN HELMET VERSION 01** "Early on, I was exploring how close to the iconic, original aesthetic of the Mandalorian armor the Death Watch should be. Should we differ a little bit? I wasn't sure." Matyas

↗ **BO-KATAN HELMET VERSION 03** "I wanted to give Bo-Katan a sleeker vibe. I'm toning down the shoulder pads, not having them lie flat on top of the shoulders, but more on the side of her arms. With the leg pieces, I was thinking maybe there's some sort of inherent magnetization with beskar, so she wouldn't need a holster. Playing with black

and silver, the muted bluish-gray look with the blue, some subtle variations. But I wanted to stay faithful to her *Clone Wars* look. For the most part, this is pretty conservative, in terms of how far to go from the original animation." Matyas

→ **BO-KATAN HELMET OFF VERSION 03** Matyas

"Shawna Trpcic, our costume designer, watches [*The Clone Wars* and *Rebels*]. She knew Ahsoka and she knew Bo-Katan, so, it was fun to work with her. And every detail on Bo's armor is just, to me, fantastic. I love it. All the layers of detail in it. The stitching and the armor. Katee couldn't believe it." Dave Filoni

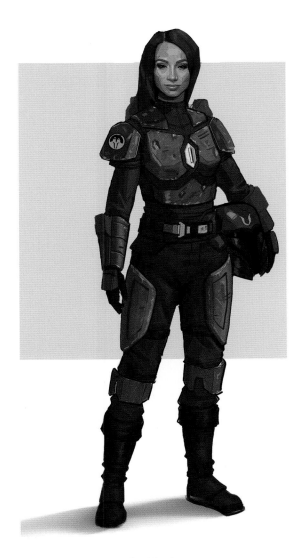

↑ **DECALS VERSION 01** Legacy Effects and Matyas

↑ **KOSKA REEVES** Uwandi and Trpcic

→ **DEATH WATCH VERSION 02** "Those were fun, just to spruce them up and give them some wear, make them look more lived in than the clean Death Watch look in the Season 1, Chapter 8 flashback. And also personalize them a bit more. I always like when armor looks dinged up, where you can see the layers of paint, like with Boba Fett. Every ding has a little yellow where it looks like it was painted yellow first." **Matyas**

↓ **BO-KATAN WEAPON VERSION 2C** Ozzimo

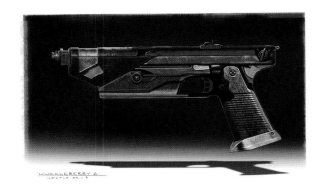

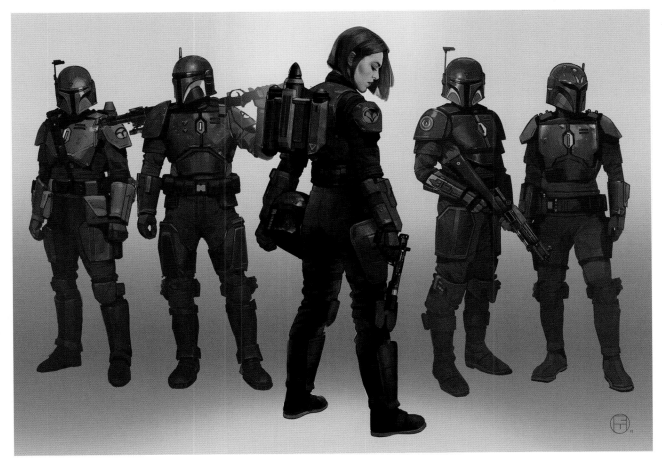

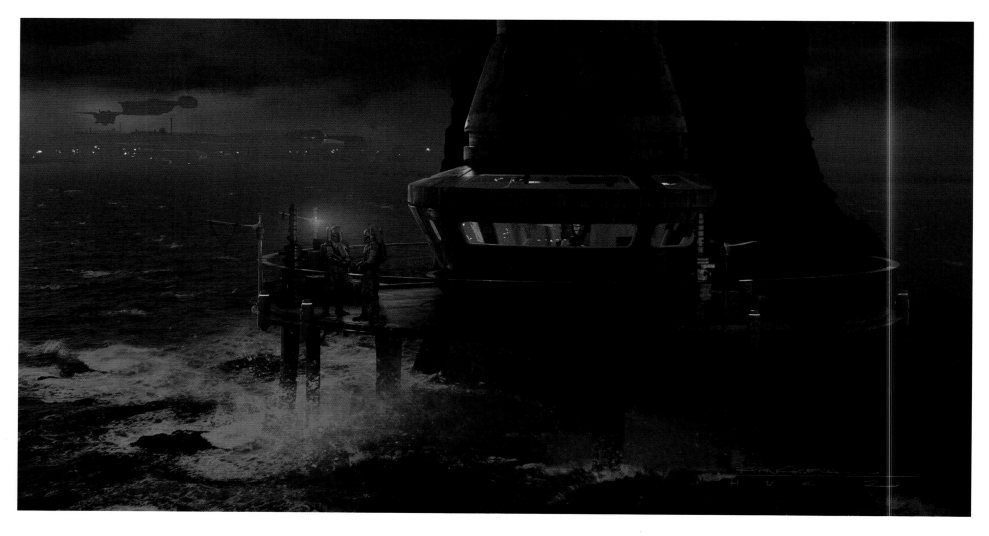

↑ **TRASK ISLAND VERSION 130** Church

"There was an idea for a lighthouse lookout tower. We had designed all
this to be volume-friendly. Story-wise, it changed. But this was going
to be where Mando meets up with the other Mandalorians." **Chiang**

→ **ISLAND TOWER VERSION 163** Church

↓ **LIGHTHOUSE SKETCH** Filoni

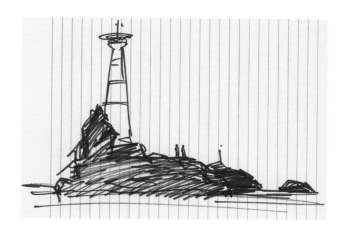

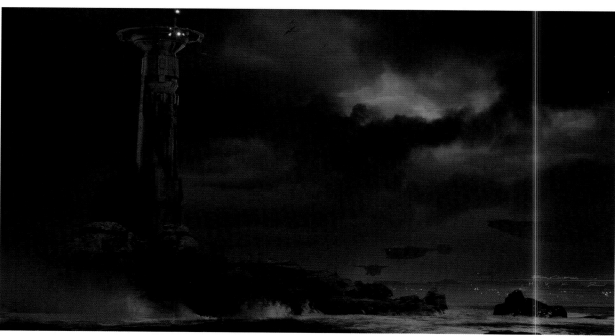

↑ **GOZANTI LANDING VERSION 01** Church

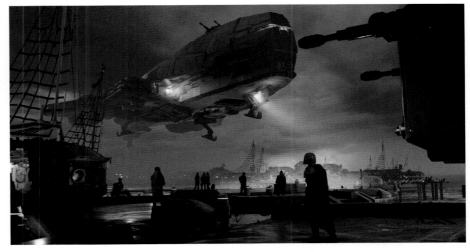

↑ **GOZANTI LANDING VERSION 115** Church

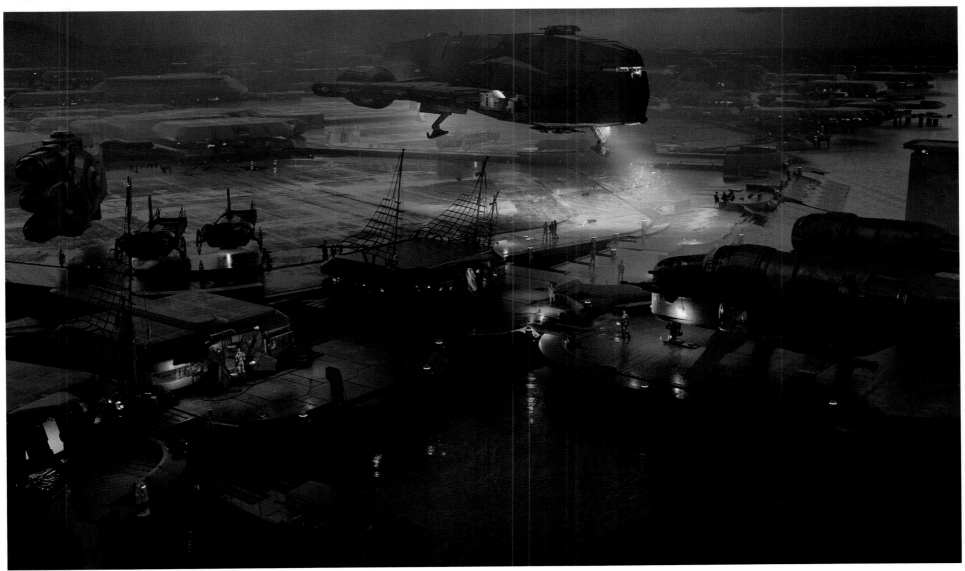

↑ **GOZANTI LANDING WIDE VERSION 116** "That was my take on a live-action version of the [Imperial] Gozanti cruiser, which Rene ran with." **Church**

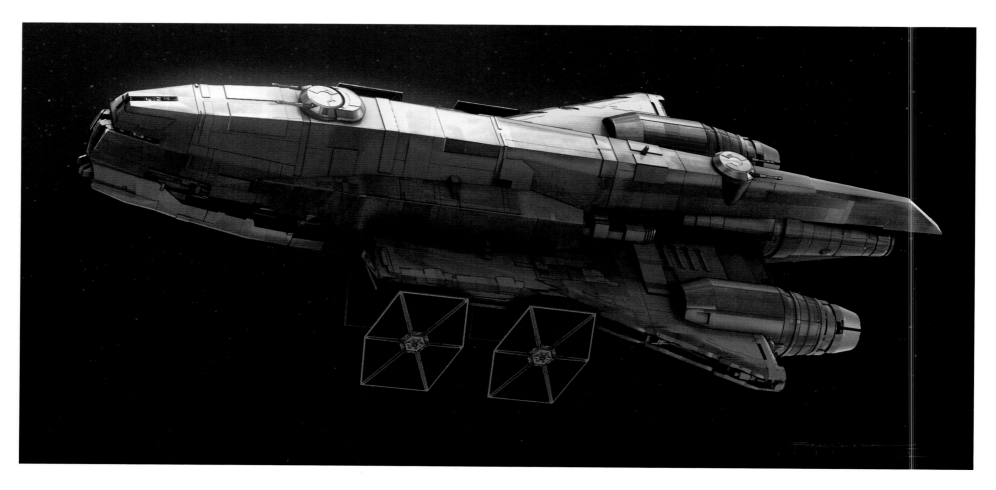

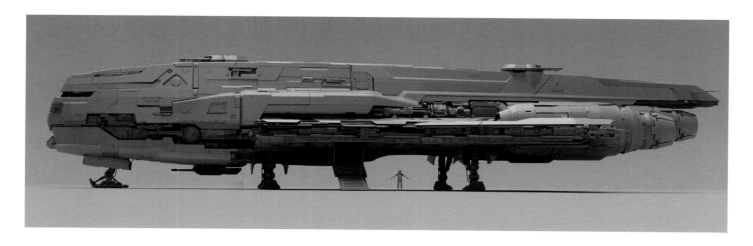

↑ **GOZANTI CRUISER FRONT VERSION 01** Church

← **GOZANTI FREIGHTER VERSION 8B** Garcia

"The Gozanti was another ship from the prequels (seen in the background of Episode I, as our heroes enter Mos Espa) that Dave used [in animation]. Actually, it was initially a design I did for the Republic cruiser that George rejected. But I always thought it was a good design. I'm glad Dave saved it. And then he merged it with some other designs and put TIE fighters on there." Chiang

"How does the Gozanti fit into the Imperial design language? I haven't been able to reverse-engineer that in my mind, because it's a fairly civilian-y looking ship without the TIE fighters. So I will look at it as if it's an older ship. It's from when they went from the Jedi cruiser to the Star Destroyer. The Jedi came up with that arrowhead shape. We shouldn't forget that." Church

← **GOZANTI FREIGHTER VERSION 2B** Garcia

"Rene really went to town and tricked it out completely. And we didn't know how much coverage this model was going to get. We thought it through completely, in terms of the ramps, landing gear, to make sure it all functionally worked." Chiang

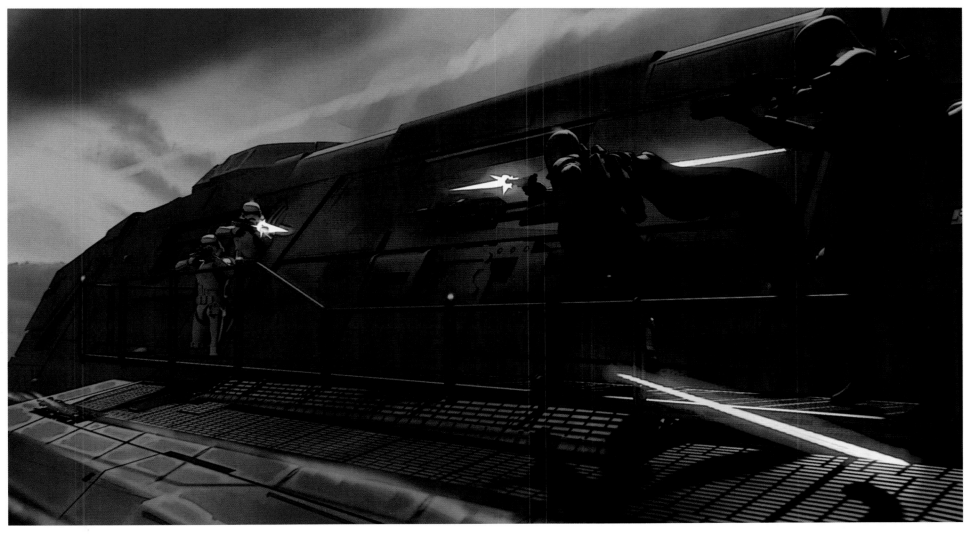

↑ **BOARDING VERSION 295** Alzmann

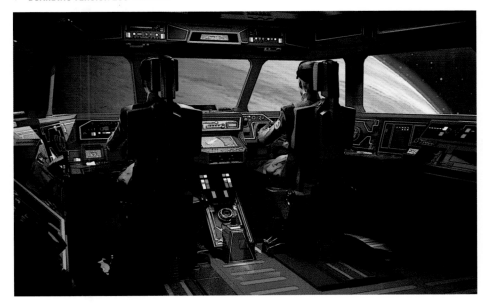

↑ **FREIGHTER COCKPIT VERSION 01** Alzmann

↑ **FREIGHTER HOLD VERSION 01** Church

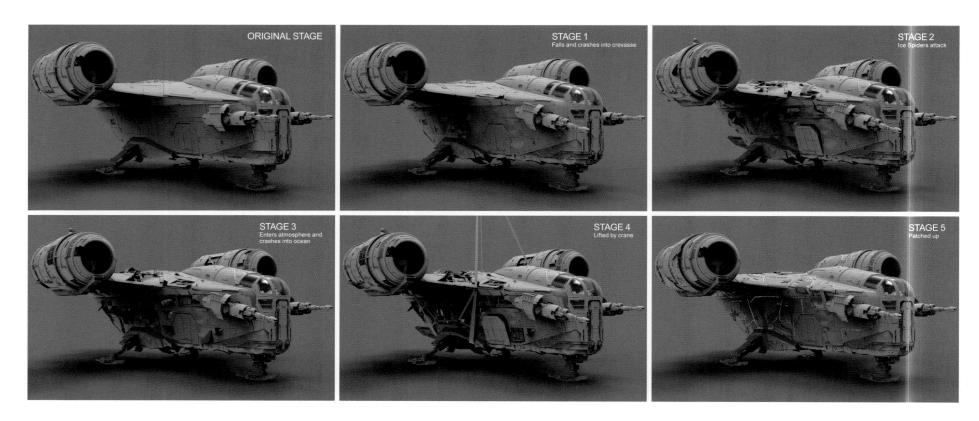

ORIGINAL STAGE

STAGE 1
Falls and crashes into crevasse

STAGE 2
Ice Spiders attack

STAGE 3
Enters atmosphere and crashes into ocean

STAGE 4
Lifted by crane

STAGE 5
Patched up

↑ **RAZOR CREST DAMAGE STAGES** Garcia

"During all this, the *Razor Crest* has been damaged by the mother spider and the ice planet, as well as its crash into the water on Trask. Mando hires the Mon Calamari to fix it, and he does a really janky job. So the design brief was, 'How do we piece this together from scrap so that it looks really bad?' The pieces are welded together, strapped together. It's almost like it's held together by Band-Aids and glue." **Chiang**

↓ **RAZOR CREST REPAIR VERSION 348** "This is the demise of the *Razor Crest*, in a way, showing all the plates welded to it. And there's netting helping to tie things on. I don't think they'll make this toy [laughs]." **Alzmann**

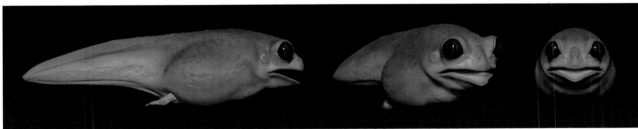

↑ BABY FROG VERSION 384 Alzmann

← BABY FROG VERSION 385 "These tadpoles are just cuteness factor, that last one being like a children's bathtub toy." Alzmann

↓ COCKPIT INVADER VERSION 471 "The squid had to be a little version of the thing that swallowed him up in the boat. And I figured it would be like the way baby crabs are. Crabs have these tiny little things that you barely recognize as crabs. It definitely has a Facehugger kind of vibe when it's that size." Alzmann

↓ COCKPIT INVADER VERSION 470 Alzmann

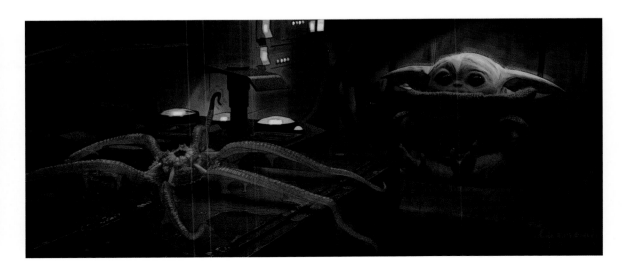

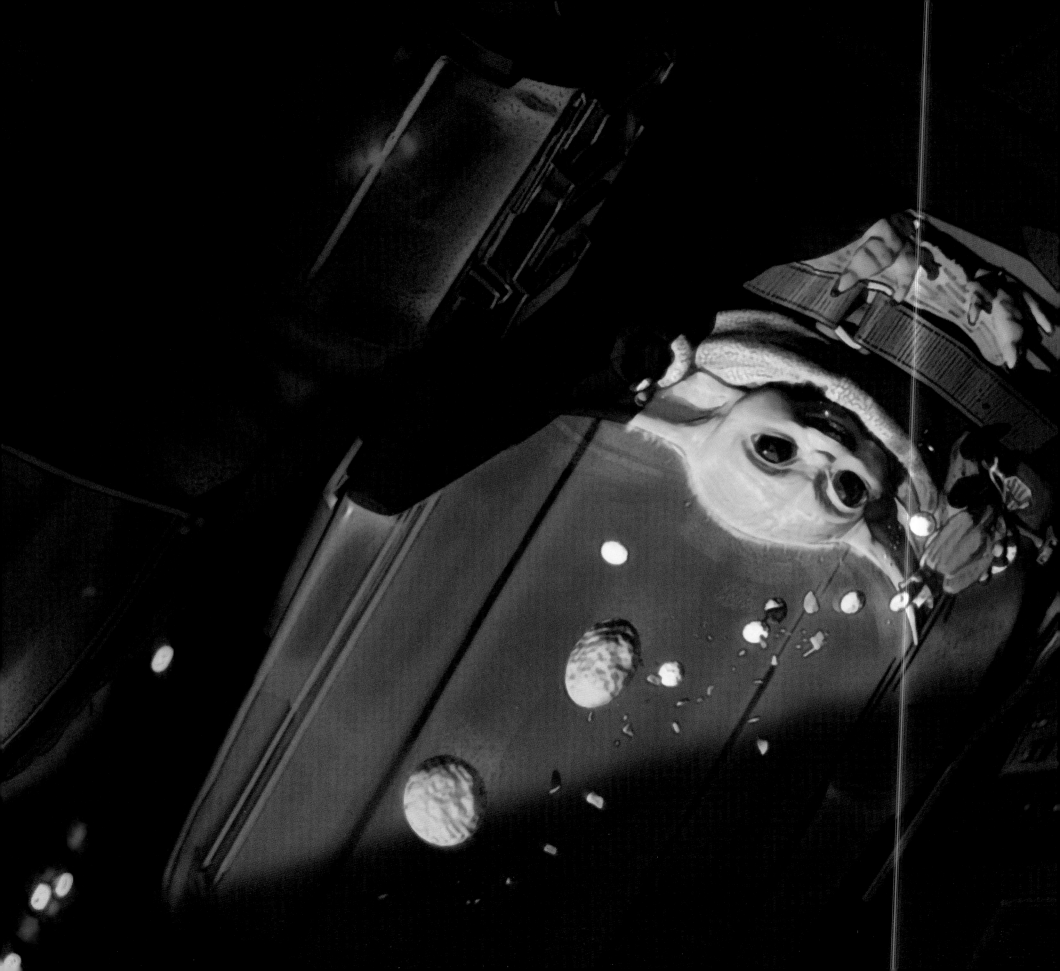

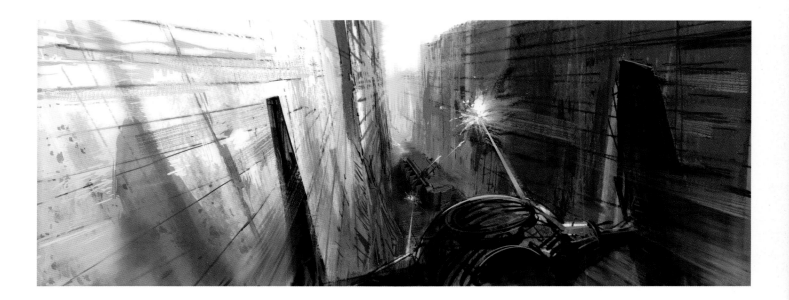

THE SIEGE

In an early meeting between Jon Favreau, Dave Filoni, Doug Chiang, and Andrew L. Jones, a return to Nevarro was briefly discussed. The formerly seedy volcanic world would be cleaned up, almost fully retaken from the Imperial remnant by newly minted marshal Cara Dune and reinstated magistrate Greef Karga. Nevarro would now be "like the bustling town at the beginning of [John Ford's] *Stagecoach*," with Cara Dune the world's Wyatt Earp and families on the city's streets. But Favreau was unsure which episode in the Season 2 lineup would feature this homecoming.

"Training new people [on a show like this] so they can go out there and do their own thing has probably been the most fulfilling aspect of this, for me," said Favreau. "[*The Mandalorian*] is definitely like a dojo; there's a work ethic and a culture, and also this sense of exploration. It's like a skunkworks, as well. It's nice to be making the show, but it's also nice to be innovating the way shows are made while maintaining the culture of cinema, even though we're dealing with a lot of new technologies."

Favreau recalled, "I knew that Carl Weathers was a director. He didn't really have a background in visual effects, but, by being on set the whole first season, he understood what we were doing. Honestly, even if you have a background of visual effects, the volume is a new way of doing things, so it's sometimes good to have people who haven't done it before, because you can teach them this new workflow."

"Carl's years as an action star have given him a deep understanding of that style of cinematic language. He's an incredible presence on the set,

and there was a lot of leadership [from Carl] with the cast, which was great because there were a lot of less experienced actors around him. I realized that Carl was a leader and I knew that, whatever he did, he would learn. He has a great work ethic and is very curious. I loved giving somebody who had paid their dues, in so many ways, the opportunity to show what they could do. It was really fun working with him, and his episode turned out great. That's how *I* learned about filmmaking, by being on a set as an actor. You're absorbing through exposure. By being there every step of the way on the first season, Carl was extremely well qualified to jump into the director's chair."

"[The new Season 2 directors] brought such energy," Filoni said. "By the time we're on set I'm mainly just answering *Star Wars* questions and we're having a good time. We're lucky. Jon is really great and knows tons of people and finds people who are like himself, who really enjoy this and want to be a part of it. And we want to work with people who aren't just talented but that we like! I have enjoyed both director teams that I've worked with now, on both seasons. It feels like one big *Star Wars* camp that we go to every fall to spring and experience this galaxy far, far away."

Doug Chiang's team started work on "Chapter 12: The Siege," with the primary task of designing Nevarro's Imperial base, both exterior and interior. "The base design was a play on the [Eadu] facility from *Rogue One*," Chiang reflected. "We basically took the same form language, even the cylindrical details, and adapted it, so that all Imperial bases have this connective aesthetic tissue. It was also important to make sure that the design communicated that this was not a fully operational base."

As with Season 1, the parking yard, streets, and building exteriors of Nevarro would be constructed and filmed on the production's backlot, along with the new magistrate's office interior set. The interiors for the school, Imperial base corridors, and laboratory would be full soundstage builds, and the perilous base "heat shaft," Nevarro canyon floor, and Marauder canyon chase would occupy the LED volume.

↑ **NEVARRO BASE VERSION 135** "Style sketches are a great way to warm up or just get into the spirit of something without committing to big 3-D builds right away." Tiemens

← **GROGU COOKIES VERSION 433** Alzmann

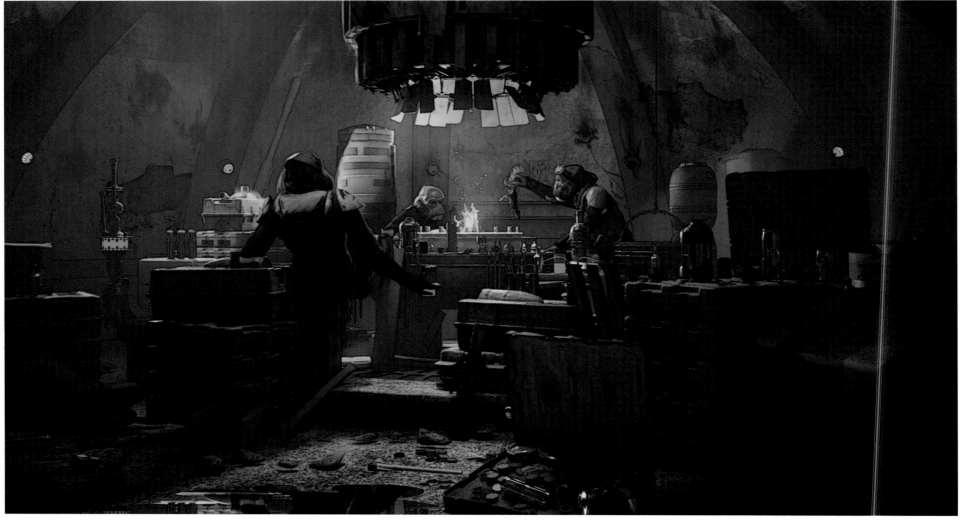

↑ **AQUALISH VERSION 194** Alzmann ↓ **AQUALISH VERSION 193** Alzmann ↓ **FIRE RAT VERSION 121** Alzmann

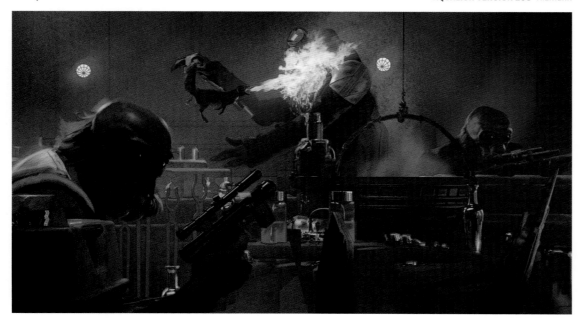

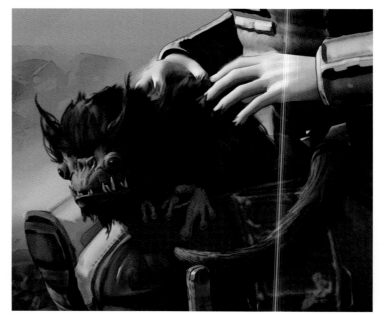

↑ **AQUALISH VERSION 358** Matyas and Chiang

"We took the existing Aqualish, refined the sculpts, and played with different types of facial hair. *Star Wars* aliens are shockingly hard, in some ways. The original trilogy did such a good job of having a bit of that old-school, almost Ray Harryhausen vibe, by getting existing animals in there. And they're all masks. It looks like a Halloween party. But there's iconography there. It's almost on that line of goofy, but it's memorable. That balance between cool and goofy is incredibly hard for me to find sometimes." **Matyas**

↑ **MARSHAL BADGE FINAL RENDER** Ozzimo

→ **CARA DUNE VERSION 198** "The feedback [on my Season 2 Cara design] was, 'Don't really change the armor too much. Let's just play with some sort of identification for her being law enforcement on Nevarro.' The improvements that the costume department made for her were for great." **Matyas**

↓ **CARA SITTING VERSION 358** Matyas

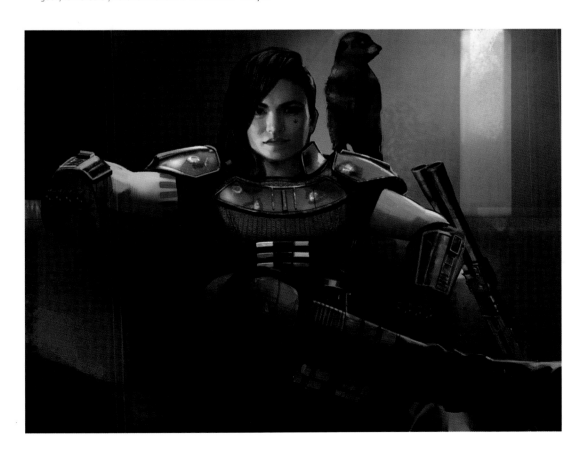

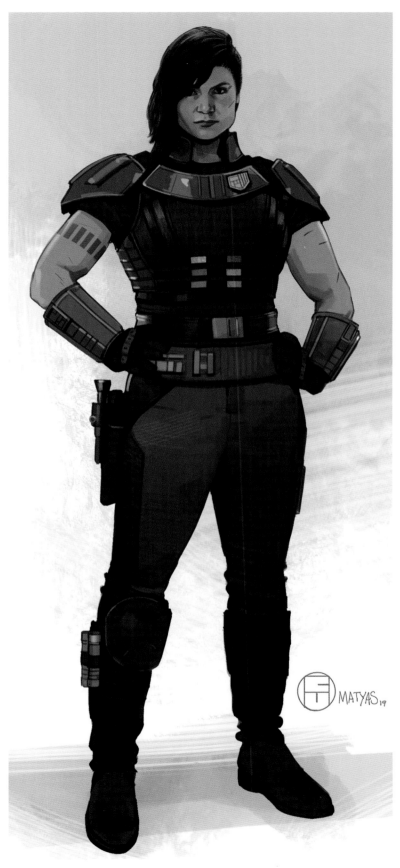

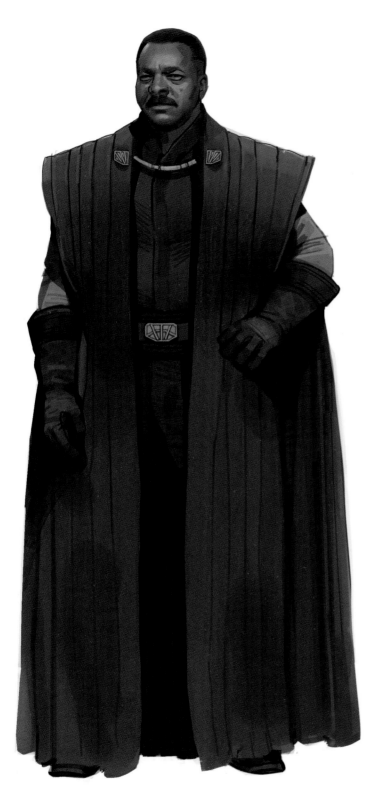
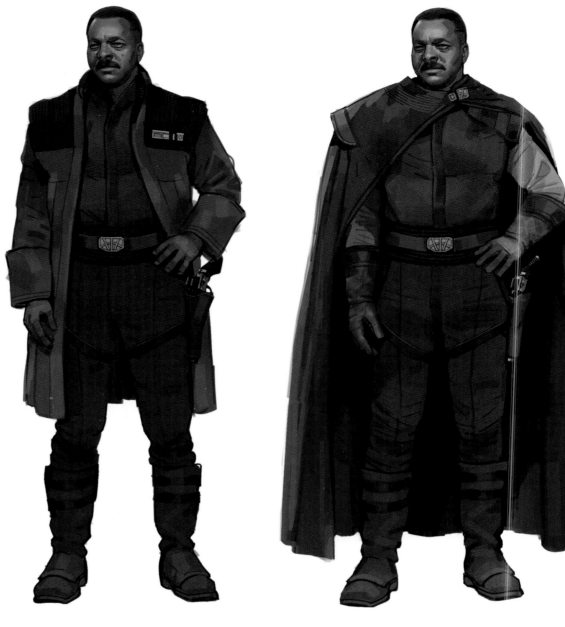

↑ **GREEF KARGA VERSIONS 193, 194, AND 195** "We explored a bunch of looks for Greef Karga. They wanted something that looked a little more regal, like a diplomat vibe. They considered just taking off his Season 1 cape and giving him a pendant or something like that." **Matyas**

→ **NEVARRO REFURBISHED VERSION 01** Church

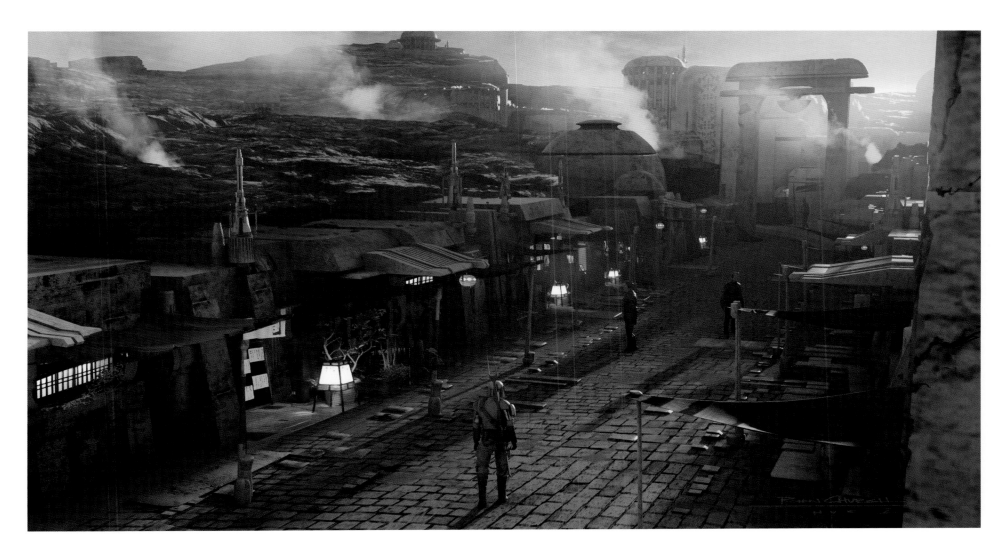

NEVARRO RENEWAL VERSION 01
Church

"We wanted to refresh Nevarro now that the Magistrate and Cara Dune have taken over. So how do we clean it up? They basically swept up the streets and added more color to refresh the facades, brought in a lot of these banners. The palette has changed. Everything is more family-friendly now." **Chiang**

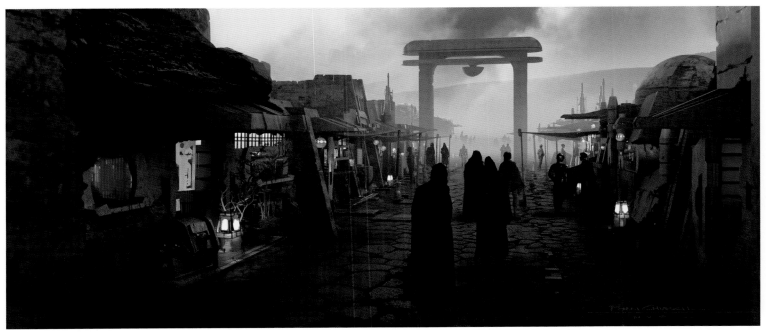

NEVARRO RENEWAL HILL VERSION 01 "I went to Kyoto, Japan, during the Lantern Festival, which is just the most amazing and beautiful thing. So, this is evoking that Kyoto Lantern Festival a little bit." **Church**

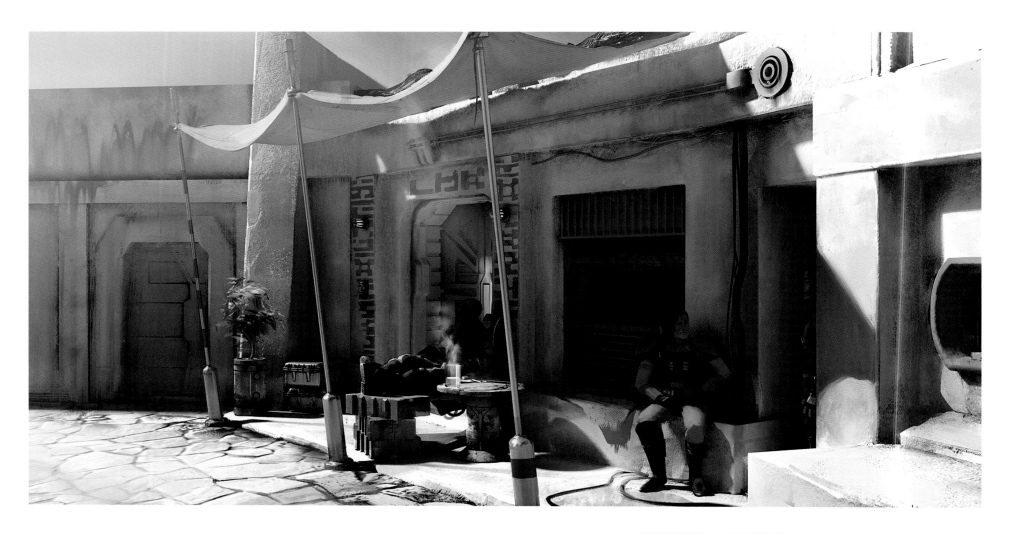

↑ **MAGISTRATE OFFICE VERSION 291** "I did two versions of these with the same outer structure, just changing the interiors, door, and windows. This one was for Greef Karga. More emphasis on the comm station where the Mythrol was running intel." **Grandert**

→ **MAGISTRATE OFFICE VERSION 290** Grandert

↓ **MAGISTRATE OFFICE VERSION 182** Alzmann

↓ **MAGISTRATE OFFICE VERSION 266** Grandert

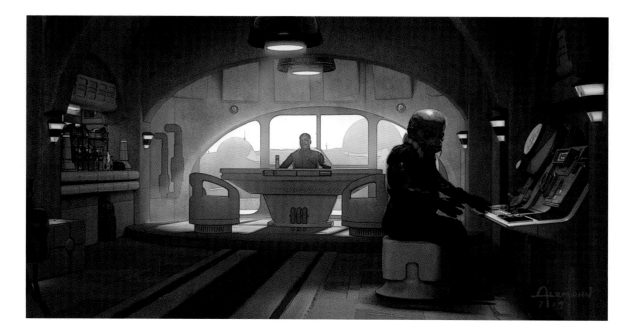

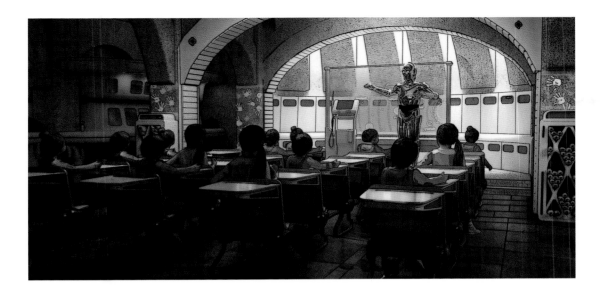

↑ **NEVARRO SCHOOL VERSION 100** Alzmann

↓ **CLASSROOM VERSION 109** Church

"Jon wanted to refurbish the public house, because we saw it completely destroyed in Season 1. Now [the people of Nevarro] have fixed it up and turned it into a schoolroom." **Chiang**

→ **NEVARRO SCHOOL TEACHER VERSIONS 237 AND 238**

"Jon and Dave were interested in variations of well-known characters and droids. The blender of combining things. And so in this case taking an existing model, like the original C-3PO, and playing with variations, and then chipping it away, giving it patina, that kind of thing." **Tiemens**

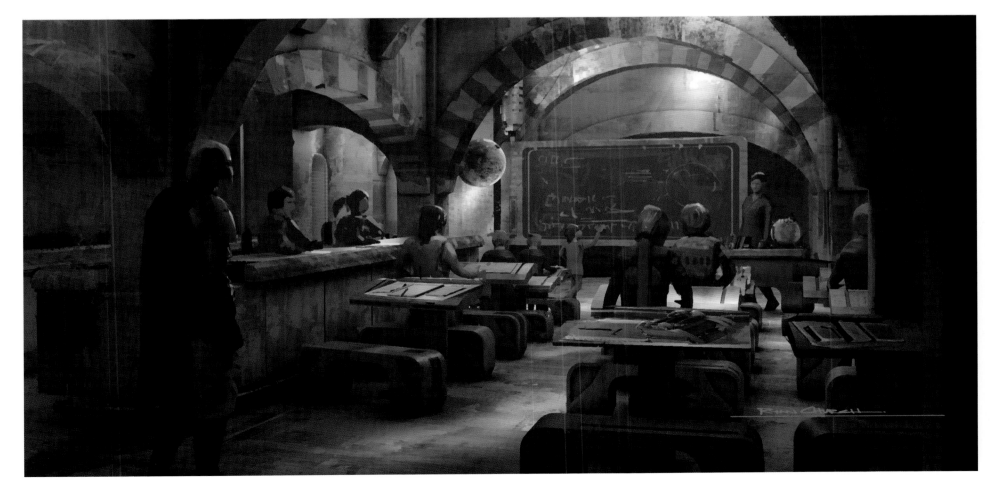

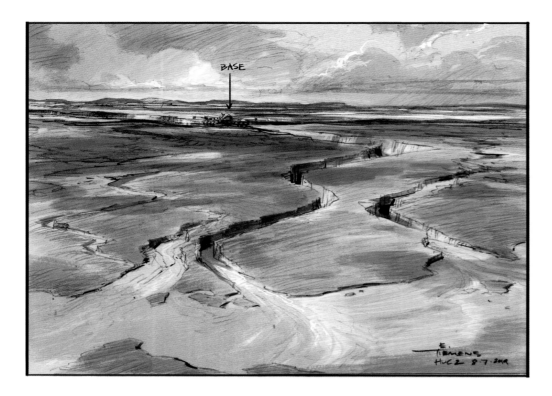

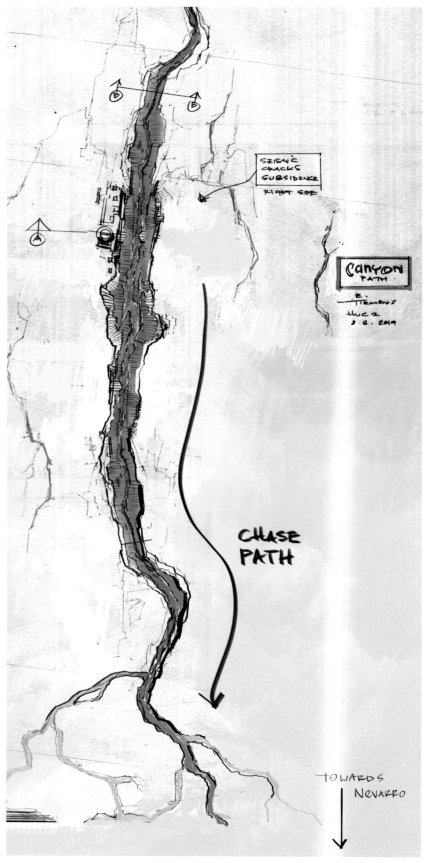

↑ **NEVARRO BASE VERSION 138** "A lot of times, I'll explore by doing maps or schematics. I started to do that on Season 1, when we got some of the first sketches from Dave Filoni on the layout of the lava city on Nevarro and the ice world. Ever since working on the [Galaxy's Edge] parks, I've appreciated plan views more, just laying things out A to B, where we're going to go, even cross-section elevations, that kind of thing. And then, if you're in the ballpark, proceed. This chase was also an homage to the trench run on the Death Star." **Tiemens**

→ **NEVARRO BASE VERSION 134** Tiemens

"This is a schematic of the Imperial base way up in the canyons. And then as it goes down toward Nevarro, you end up in the flat lava plain. So that when they're escaping, they have to go out through the fissures." **Chiang**

↓ **TRENCH SKETCH VERSION 138** Tiemens

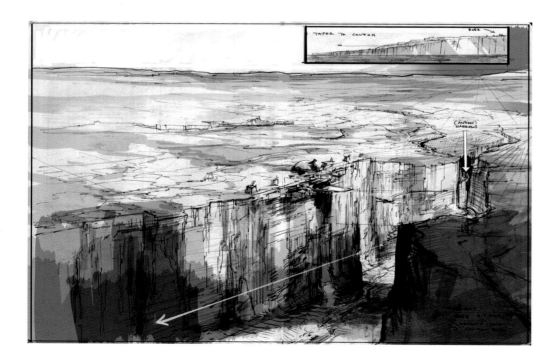

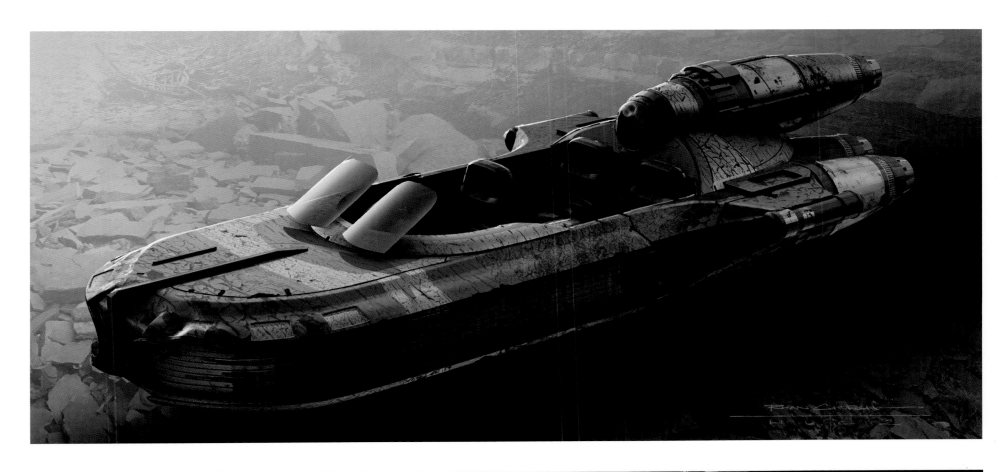

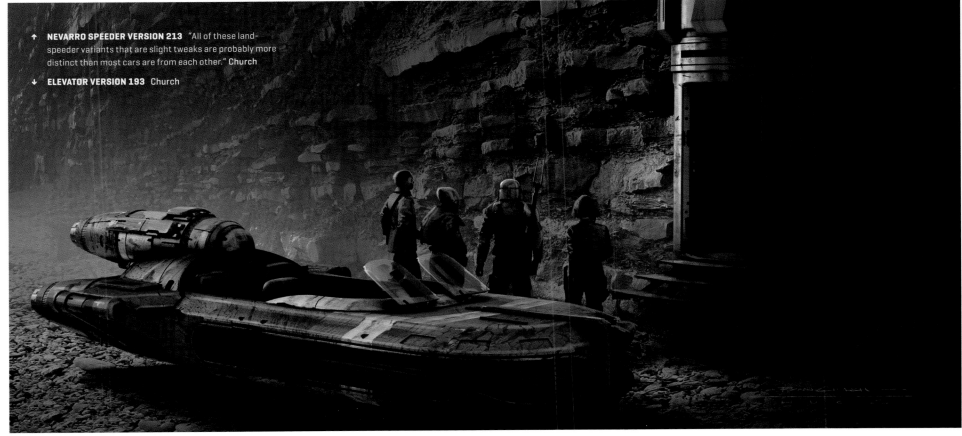

↑ **NEVARRO SPEEDER VERSION 213** "All of these land-speeder variants that are slight tweaks are probably more distinct than most cars are from each other." **Church**

↓ **ELEVATOR VERSION 193** Church

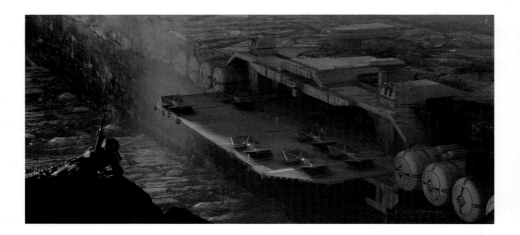

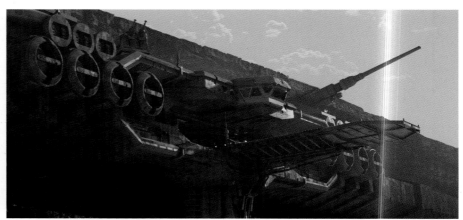

IMPERIAL BASE DOWN VERSION 107 "Doug said, 'Let's do the *Rogue One* thing [in designing this Imperial base],' because that's what the Empire does when they go into a site. Jon wanted the audience to immediately understand how hidden it was. I initially put the *Rogue One* module on the top surface of the cliff. And Doug was like, 'No, it's literally very much like the *Rogue One* thing.' But then, 'How much rock is above it? How big is the overhang?' There was a lot of circling and honing that detail in for Jon. 'Are the guns on the top? Are they smaller?'" **Church**

↗ **IMPERIAL BASE UPSHOT VERSION 272** Church

→ **IMPERIAL BASE VERSION 02** Alzmann

↓ **NEVARRO BASE VERSION 316** "The Nevarro base exterior ended up being a mix of Ryan's, Thom Tenery's [*Rogue One* base], and mine." **Alzmann**

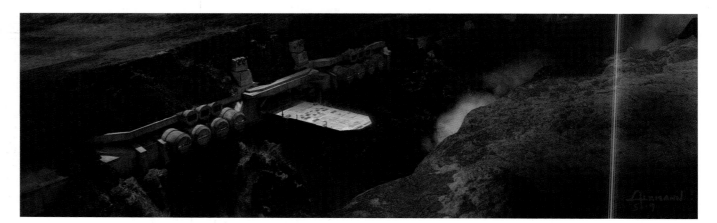

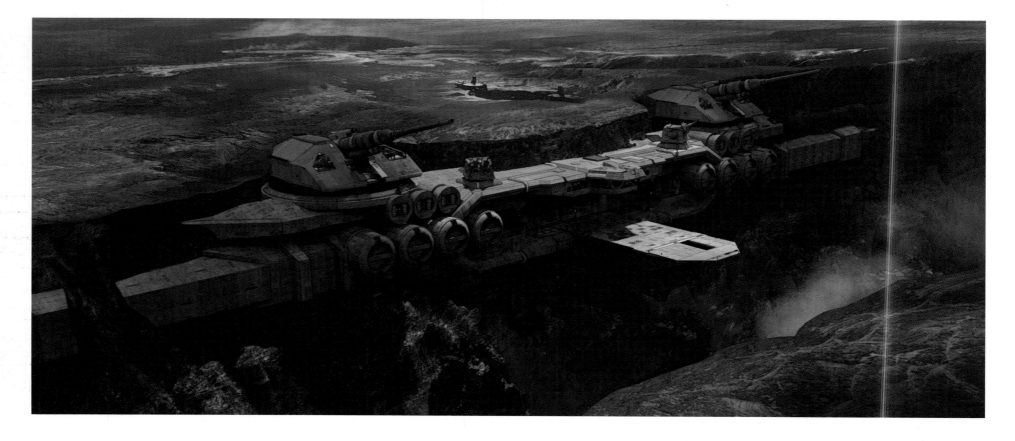

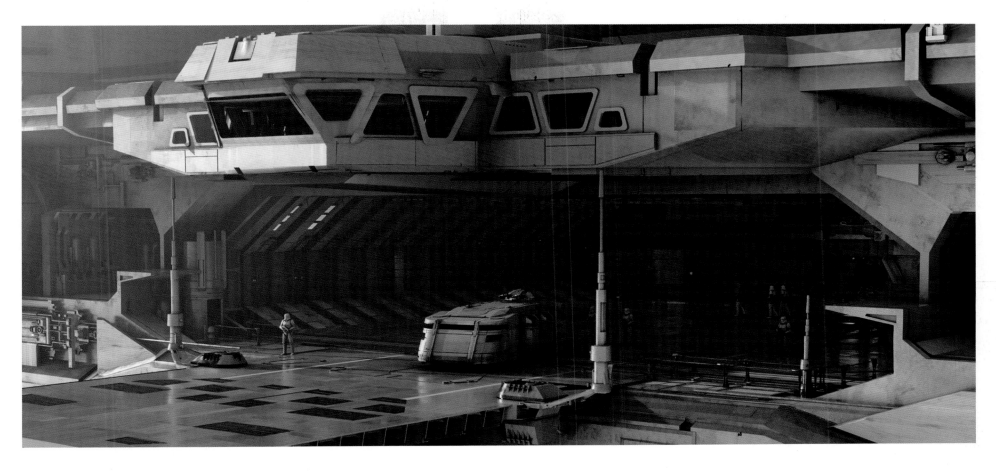

EXTERIOR HANGAR VERSION 220 Church

IMPERIAL BASE VERSION 225 Church

"The idea is that this was a decommissioned base. You can see TIE fighters under tarps, being taken apart or stored." **Chiang**

HANGAR OVERVIEW VERSION 222 "It's a little more disheveled than we're used to seeing Imperial hangars. There's stuff piled in the background. It's disorganized. It's hopefully evoking the lowered status of the Empire, at this point in the timeline." **Church**

IMPERIAL BASE DRESSING VERSION 01 Fields

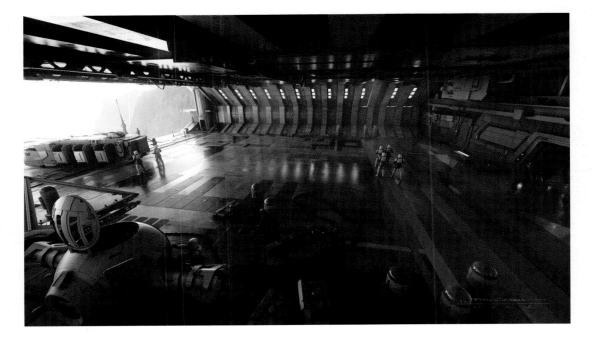

↑ **BASE VERSION 124** "I did a neat little bridge
for John Knoll's original version of *Rogue One*. It
was smaller, more of a militaristic bridge than
a proscenium bridge, which we usually see.
That was the first model I opened up, actually,
the starting point for this one. There's a lower
ceiling and a lot of hanging equipment, which
implies a submarine kind of look." **Church**

"This is our refitted bridge set. Basically, we
changed the material from metal to concrete.
So we kept the front part of the light cruiser
bridge set, stripped out a lot of the set
dressing, and built another bulkhead door and
wall. And it looks very different." **Chiang**

← **BASE HALL VERSION 205** "We wanted to try
this idea from Episode VII: putting rock-carved
hallways in every once in a while, like they're
perfectly laser-cut. We know that's a part of
the Empire's tool kit." **Church**

→ **IMPERIAL BASE CORE VERSION 252** Alzmann

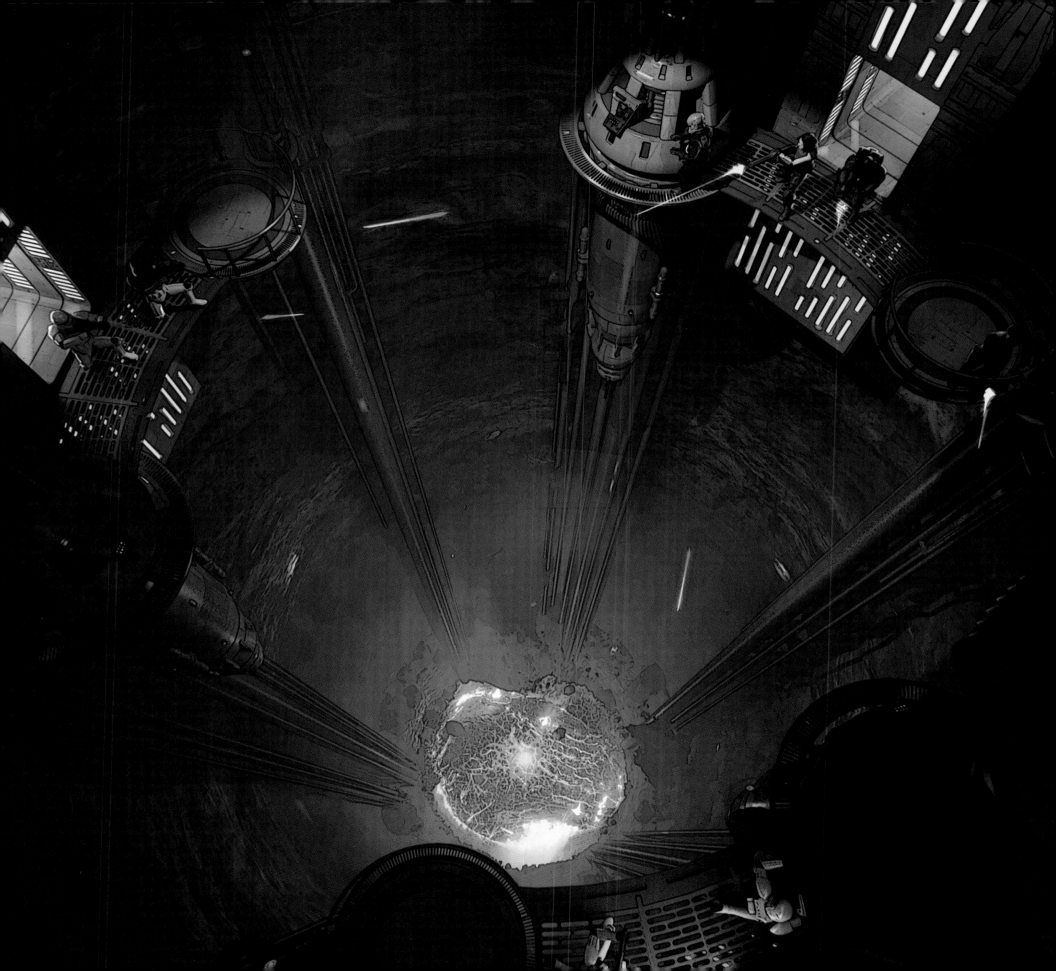

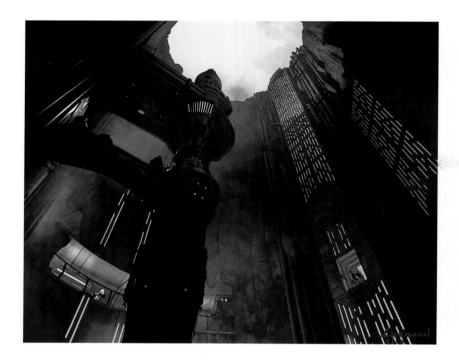

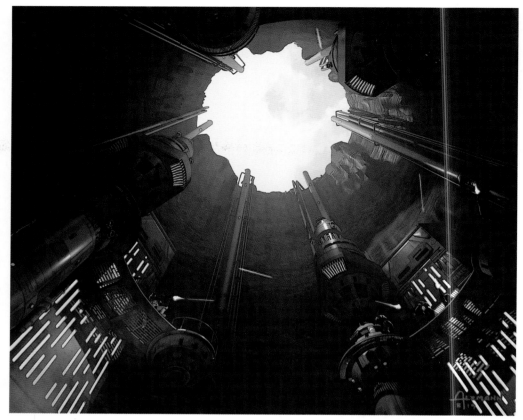

↑ **IMPERIAL BASE CORE VERSION 198** Alzmann

↓ **IMPERIAL BASE CORE VERSION 197** Alzmann

"Originally, we had this design mirror the moment when Obi-Wan is in the power core of the Death Star, turning off the tractor beam. These individual control units are very similar to that. We also kept a very thin walkway to try to make things as precarious as possible. Not make it one-to-one to what we've seen, but evoke that same feeling." **Chiang**

→ **IMPERIAL BASE CORE VERSION 253** Alzmann

↘ **IMPERIAL BASE CORE VERSION 187**

"[The base atrium] was super fun because I'm getting into that territory of designing the [Kenner] Death Star playset. They liked my original version, but it ended up becoming, 'What can we actually build and keep the same vibe?' Anytime you can see a stormtrooper falling after getting shot, it's a win." **Alzmann**

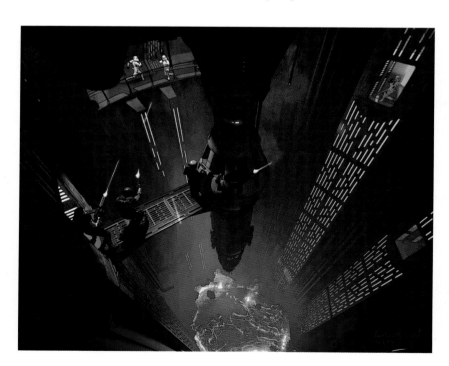

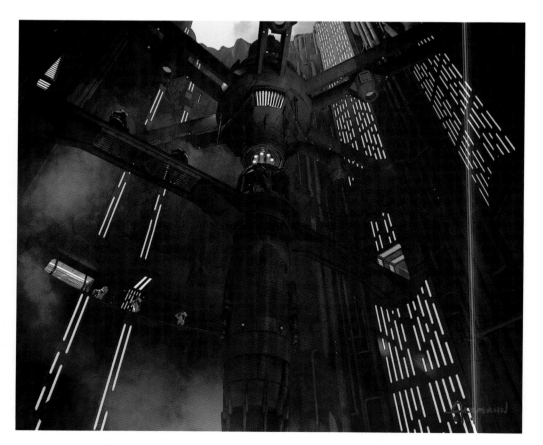

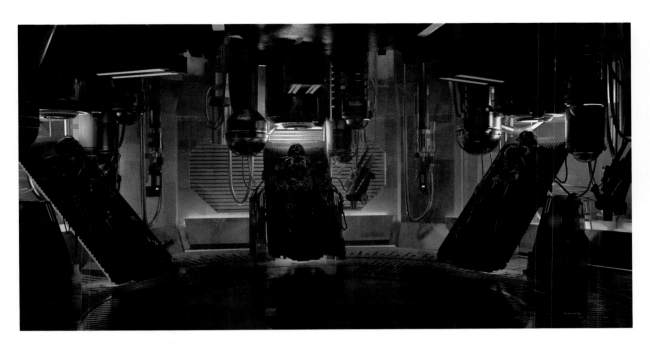

↑ **LAB WALL LOZENGE VERSION 233** Church

← **WORKSHOP VERSION 223** "I was evoking Vader's Episode III rebuilding in this set, because I designed that as well. It's a total *Frankenstein* thing. I wanted to take another pass at it, for this." **Church**

→→ **HEAT SHAFT TOP VERSION 185** Alzmann

↓ **LAB WALL LOZENGE VERSION 232** Church

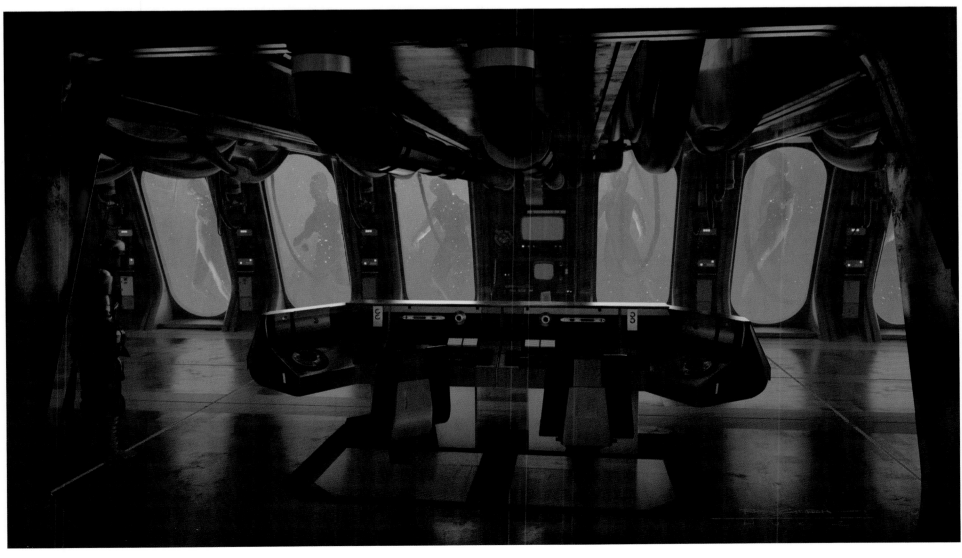

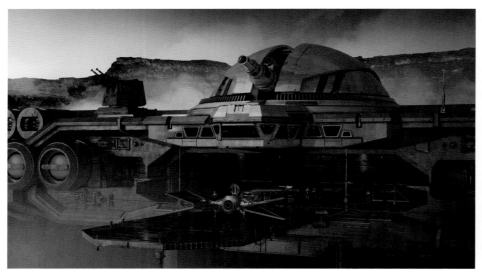

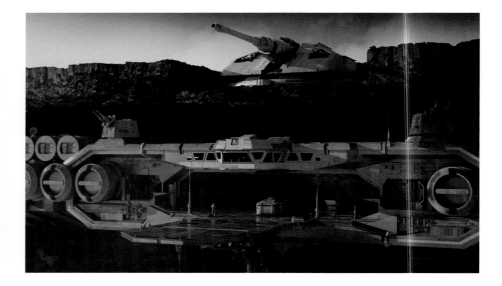

↑ **EXTERIOR GUN VERSION 203** Church

↑ **EXTERIOR GUN VERSION 219**
Church

"Ultimately, this moment is not in
the show. But we designed this giant
gun, like [the ones in the bunkers of]
The Guns of Navarone." **Chiang**

← **TIE DECK VERSION 420** Alzmann

↓ **IMPERIAL BASE GUN VERSION 317**
Alzmann

↑ **TIE LANDING PAD VERSION 128** Church

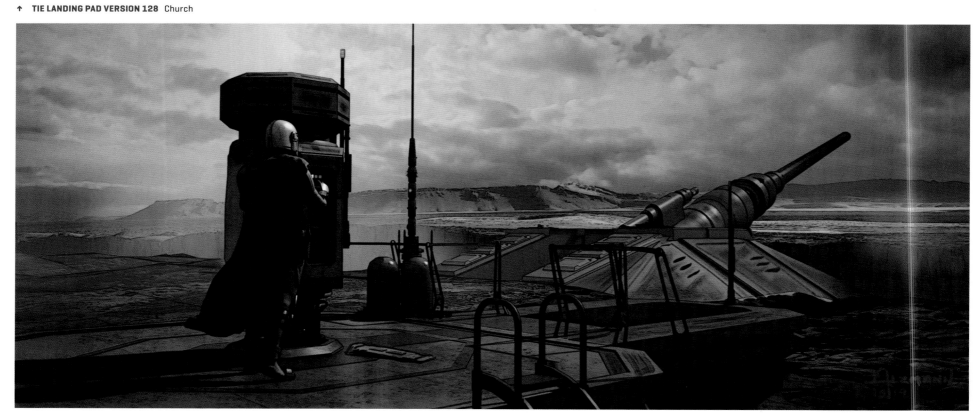

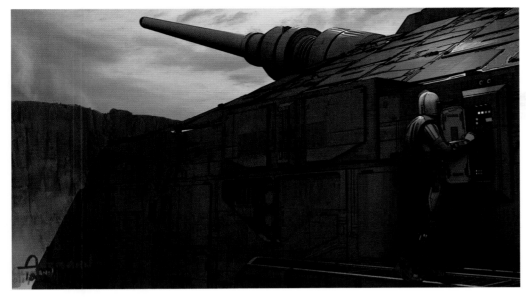

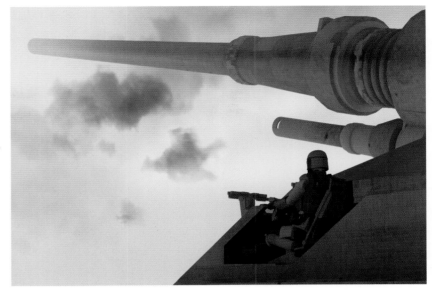

↑ **IMPERIAL BASE GUN VERSION 305** Alzmann ↓ **EXTERIOR BATTLE VERSION 219** Church ↑ **GUN SEAT SHOT VERSION 249** Church

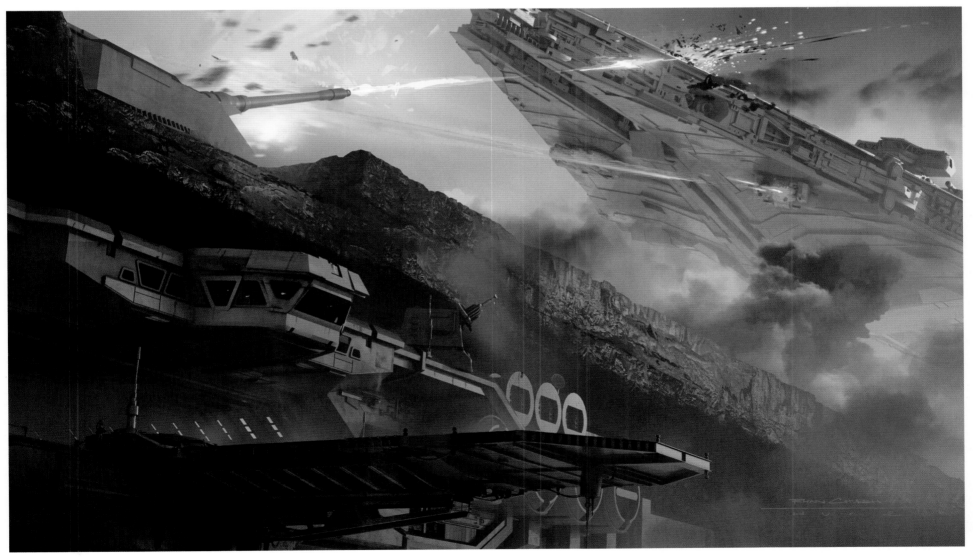

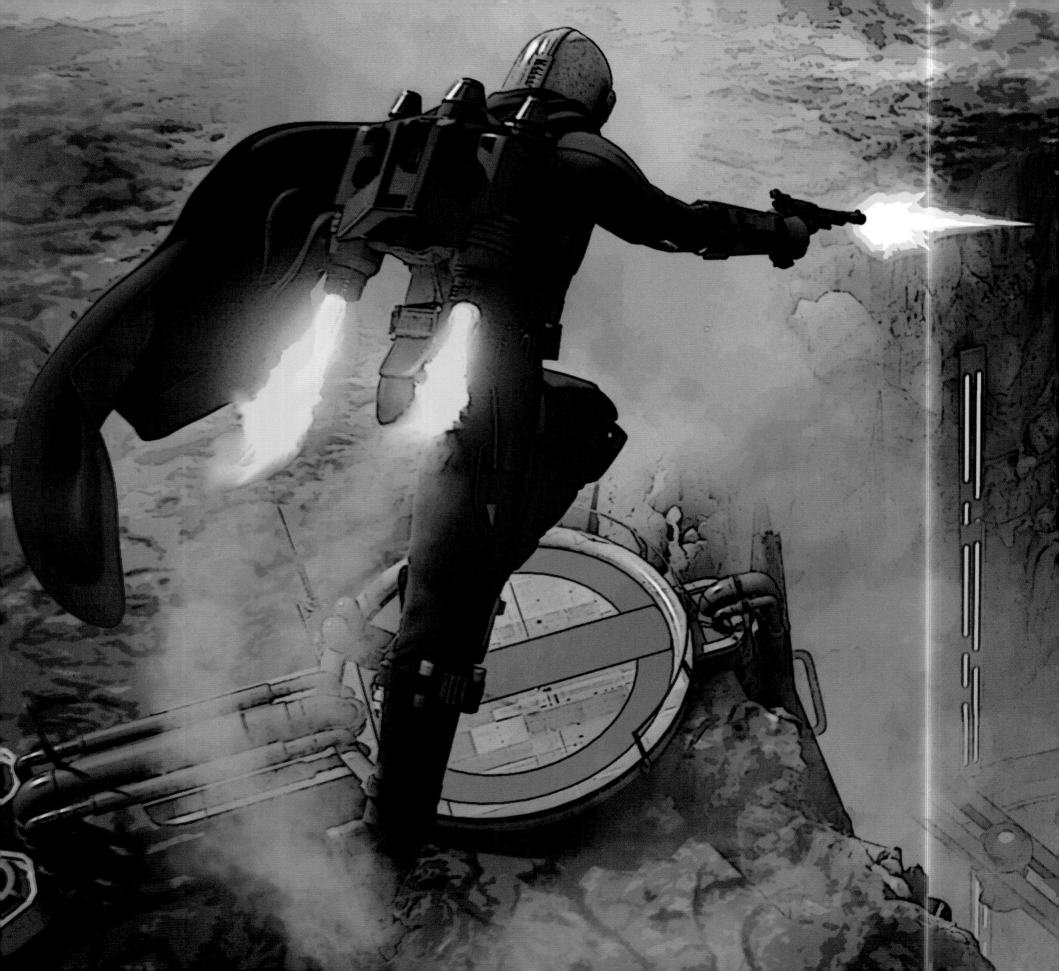

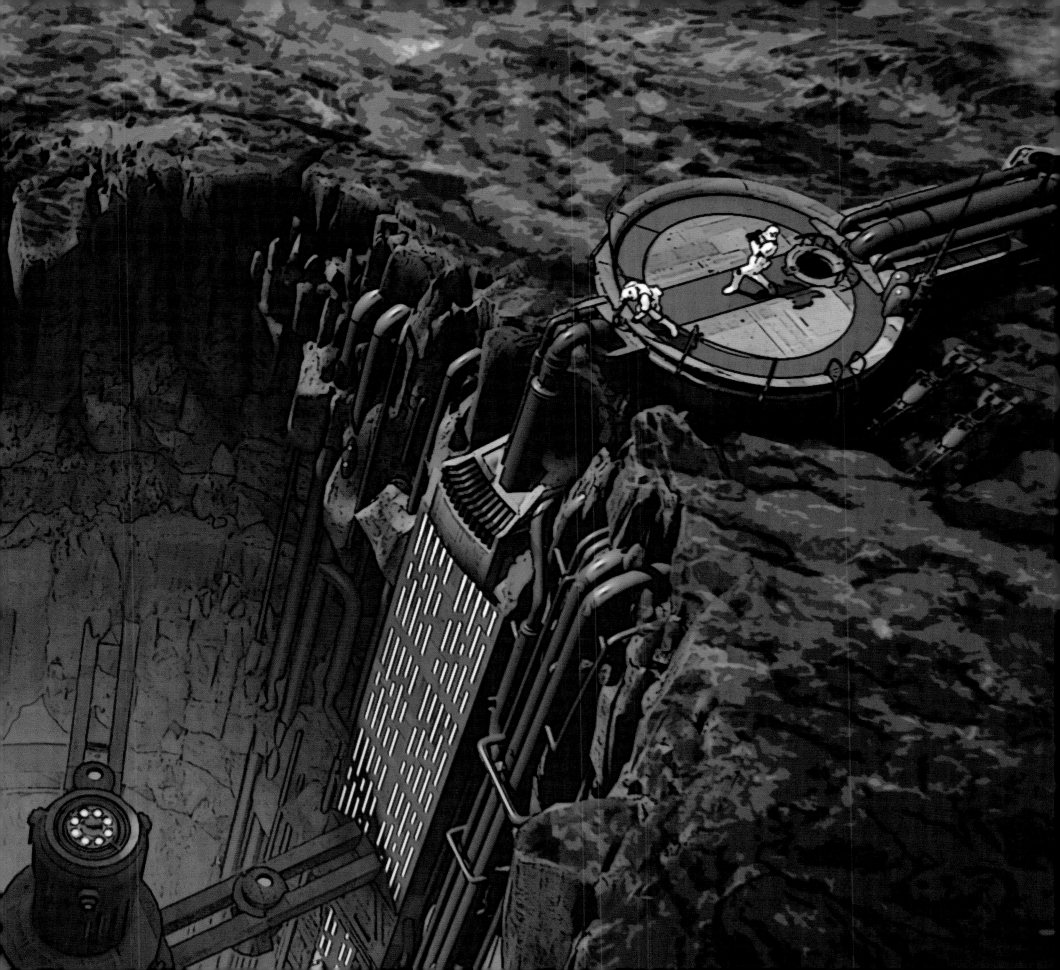

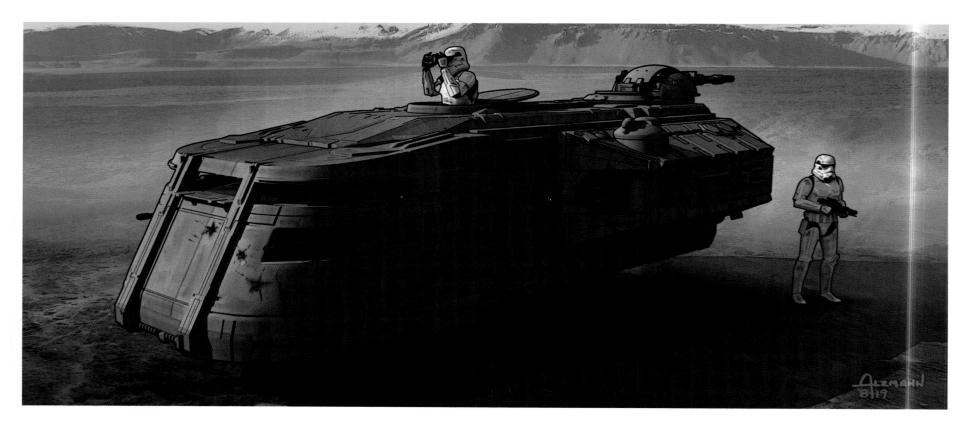

↑ **IMPERIAL TRANSPORT VERSION 248** "You've got to have the guy popping out with binoculars, because that really makes [it like a] toy." **Alzmann**

"We took out all those trooper stations on the side and added more gun armaments to change the profile, to make this a little bit more threatening, more of an offensive vehicle, as opposed to a troop transport. The whole back end of this thing, with the window for the gun turret, is taken right off of a World War II bomber." **Chiang**

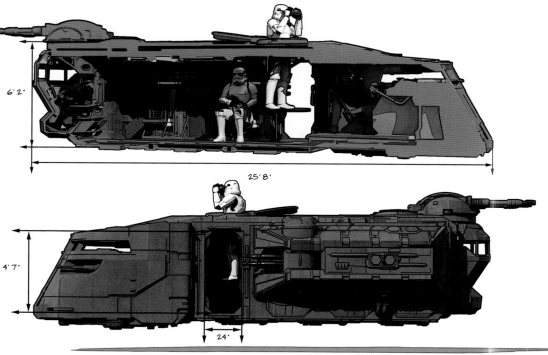

↑ **IMPERIAL TRANSPORT VERSION 204** Alzmann

← **IMPERIAL TRANSPORT VERSION 235**
"Carl Weathers, who was directing this episode, really wanted to see the person inside the turret [from the outside]. And then we added that troop door on the side." **Alzmann**

↑ **IMPERIAL TRANSPORT VERSION 247** Alzmann

Both Chapter 12's Imperial Marauder and the Imperial Troop Transport (ITT) seen in Chapter 7 and several episodes of *Star Wars Rebels* are based on Kenner Products' Imperial Troop Transporter vehicle first released in 1979 as part of the original *Star Wars* toy line.

↑ IMPERIAL TRANSPORT VERSION 178 Alzmann

↑ **IMPERIAL TRANSPORT VERSION 179**
"This was super fun to do, adding the gun chair and putting a TIE fighter targeting system in there, figuring that the Empire would reuse all of the same equipment." **Alzmann**

→ **IMPERIAL TRANSPORT VERSION 190**
"I was looking at gun chairs from our current-day vehicles, and they're not all that different." **Alzmann**

"This suspended seat is our homage to the *Millennium Falcon* gun turret." **Chiang**

↓ **IMPERIAL TRANSPORT VERSION 177** Alzmann

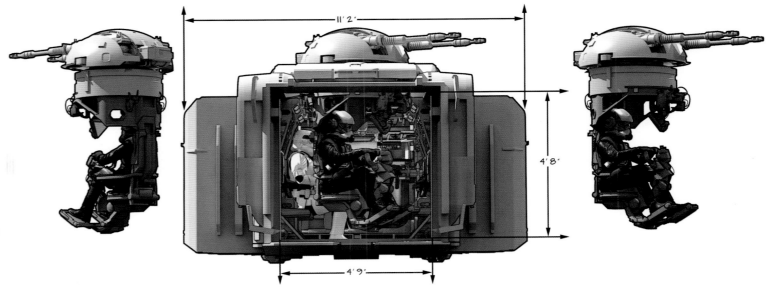

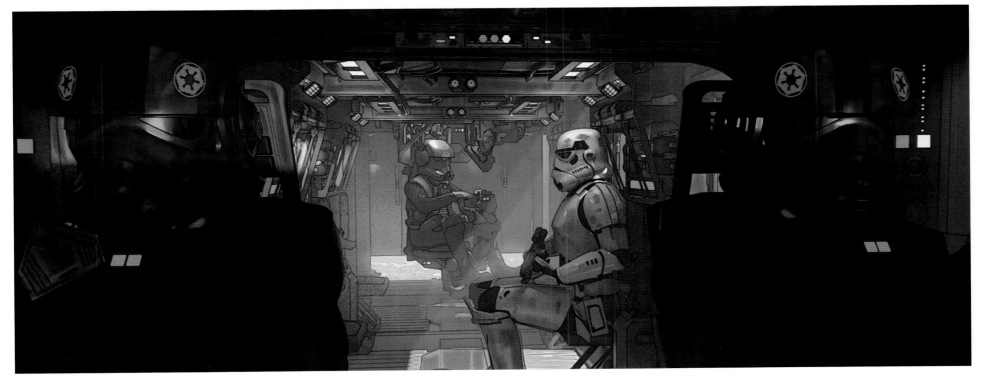

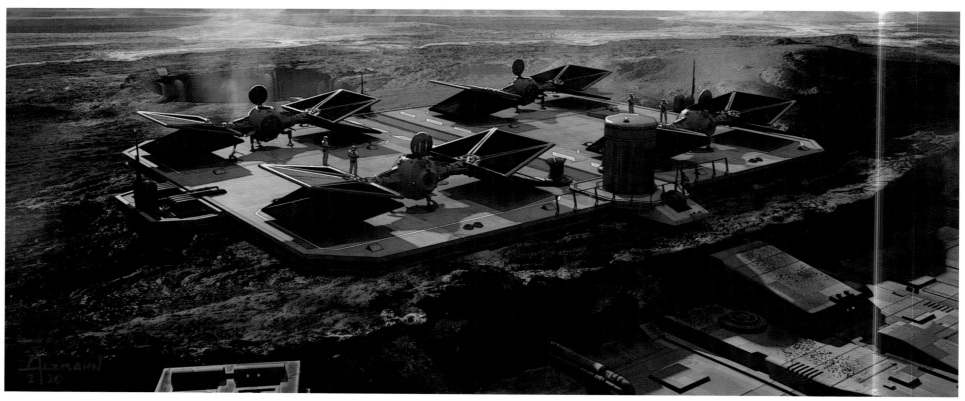

↑ **TIE DECK VERSION 423** Alzmann

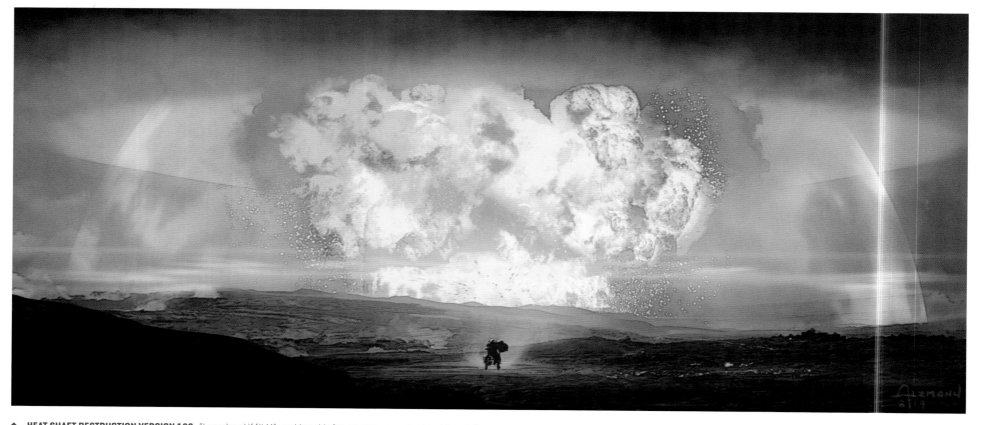

↑ **HEAT SHAFT DESTRUCTION VERSION 186** "I wondered if [ILM] would go this far, a twenty-megaton blast [laughs].
Clearing the clouds away. Tricks I learned from *Indiana Jones and the Kingdom of the Crystal Skull*." **Alzmann**

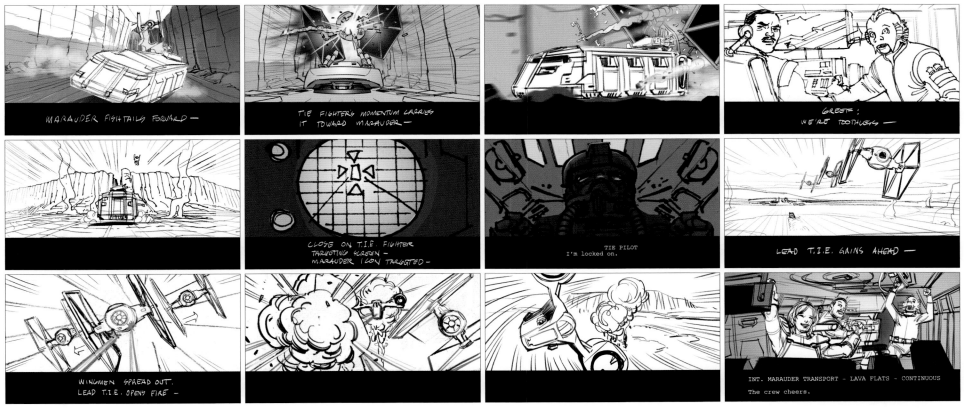

MARAUDER FISHTAILS FORWARD —

TIE FIGHTER'S MOMENTUM CARRIES IT TOWARD MARAUDER —

GREEF: WE'RE TOOTHLESS —

CLOSE ON T.I.E. FIGHTER TARGETING SCREEN — MARAUDER ICON TARGETED —

TIE PILOT
I'm locked on.

LEAD T.I.E. GAINS AHEAD —

WINGMEN SPREAD OUT. LEAD T.I.E. OPENS FIRE —

INT. MARAUDER TRANSPORT - LAVA FLATS - CONTINUOUS
The crew cheers.

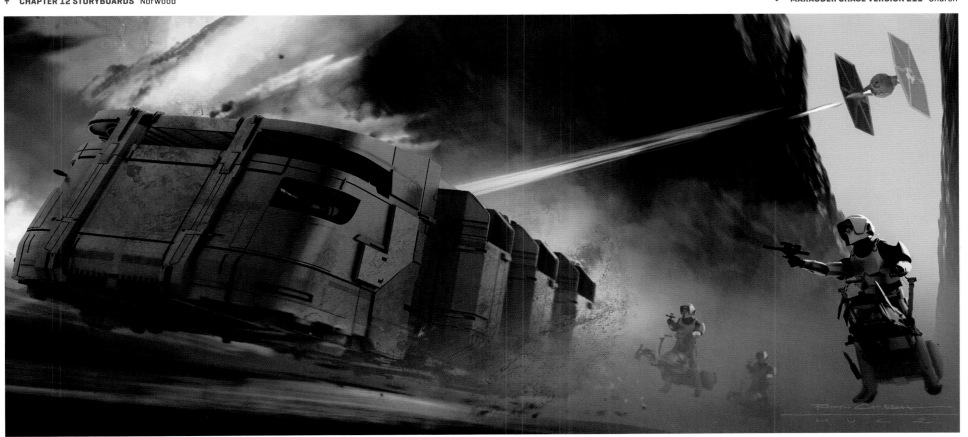

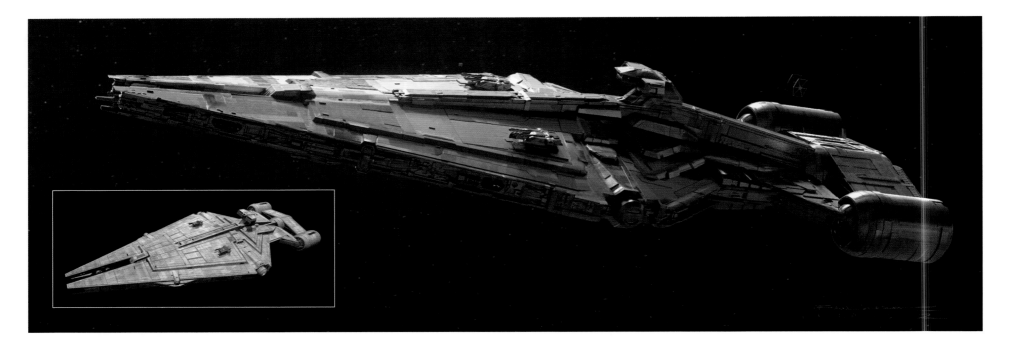

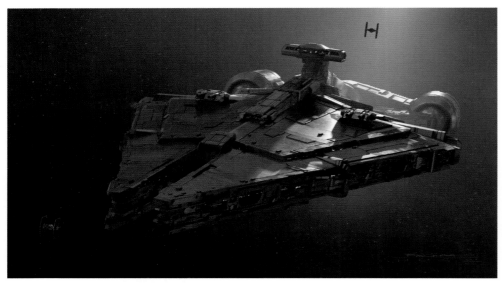

← **IMPERIAL CRUISER STRAIGHT VERSION 01** Church

↓ **CRUISER LAUNCHER INTERIOR VERSION 01** "How the TIE fighters fit in there is very *Battlestar Galactica*–inspired, of course. Also, it's kind of evocative of the Jedi cruiser [seen in *The Clone Wars* and Episode III], the way the hangar in the Jedi cruiser splits open." **Church**

↑ **IMPERIAL CRUISER FRONT VERSION 01** "I spent a lot of time this season making a detailed, live-action version of the light cruiser. Reproportioning the guns. . . . Actually, where this is most different from the animated one is in the cockpit [see light cruiser design from *Rebels* by Amy Beth Christenson [inset]]. I actually took the bridge set that we had, scaled it properly, and put it on this. And that's what drove the design of the exterior." **Church**

↓ **CRUISER LAUNCHER TOP VERSION 01** Church

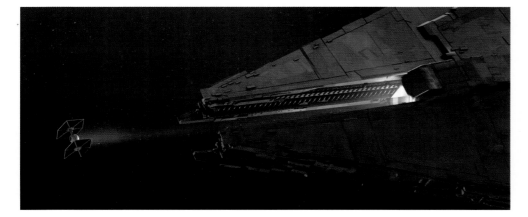

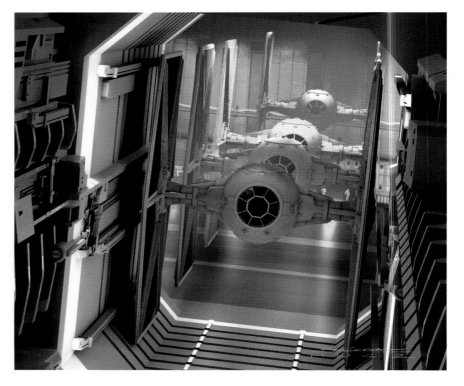

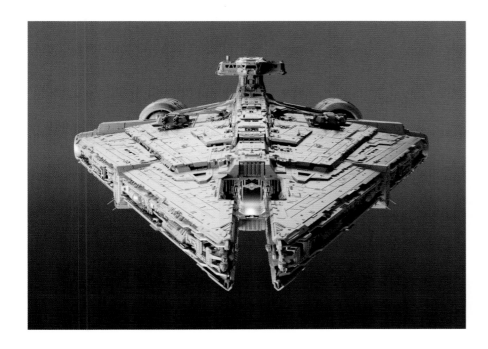

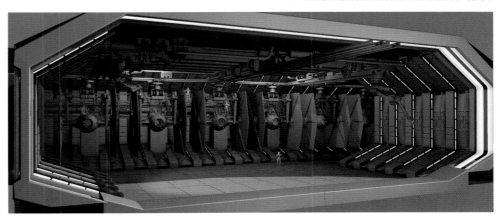

"Dave Filoni and George had the light cruiser designed for *Clone Wars*. Basically, they took the back end of a Republic cruiser and a Star Destroyer and merged them together to create a new mid-class frigate. We updated the design, cleaned it up a little bit, but kept the spirit of what they did, basically just brought it into our live-action world." **Chiang**

"This will be the hangar inside that launch tube. And this was designed way back [in March 2019]. I like to leap ahead and start to figure out how different pieces work, without really knowing if it's going to be needed. Thankfully, it was." **Chiang**

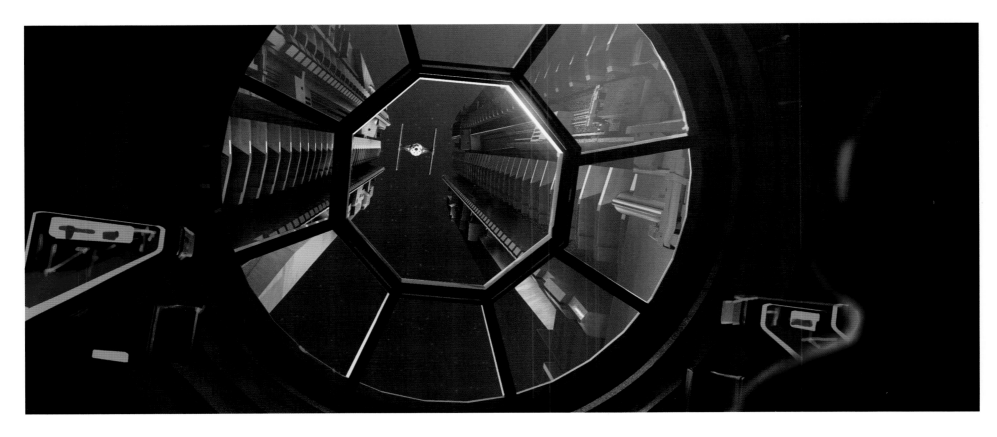

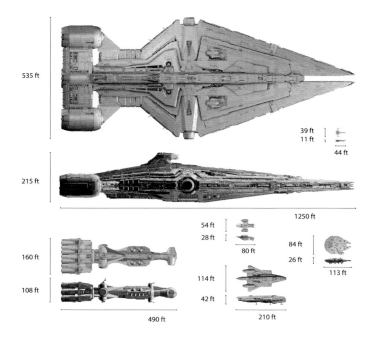

535 ft

215 ft

39 ft
11 ft
44 ft

1250 ft

54 ft
28 ft
80 ft

160 ft

84 ft
26 ft

113 ft

108 ft

114 ft
42 ft

210 ft

490 ft

↑ **SHIP SCALE CHART VERSION 02** Garcia

→ **IMPERIAL LIGHT CRUISER VERSION 46** Garcia

"This is the new light cruiser hangar that we added, which does not
appear on the original animated version. But, story-wise, we wanted
to have a hangar in there." **Chiang**

↓ **TRACTOR BEAM VERSION 325** Alzmann

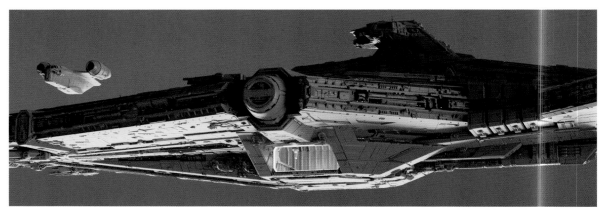

↑ **IMPERIAL LIGHT CRUISER VERSION 47** Garcia

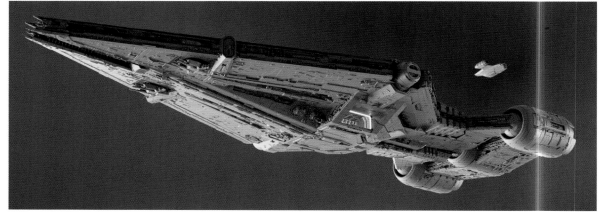

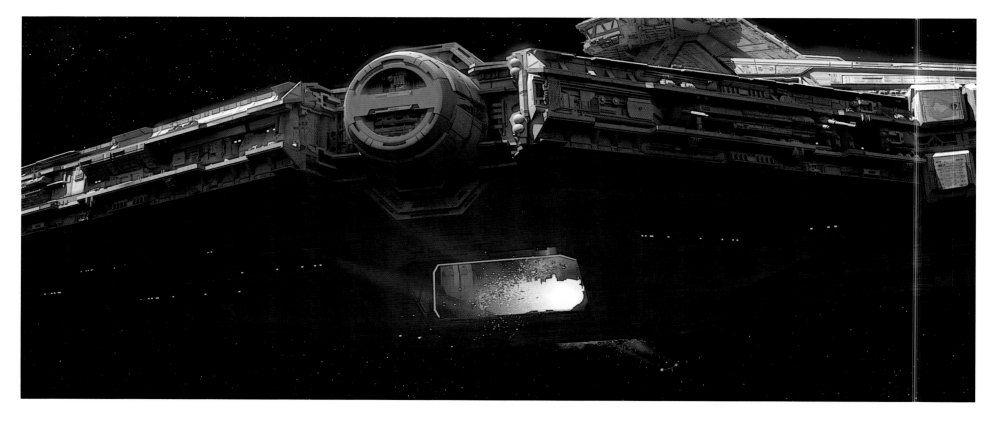

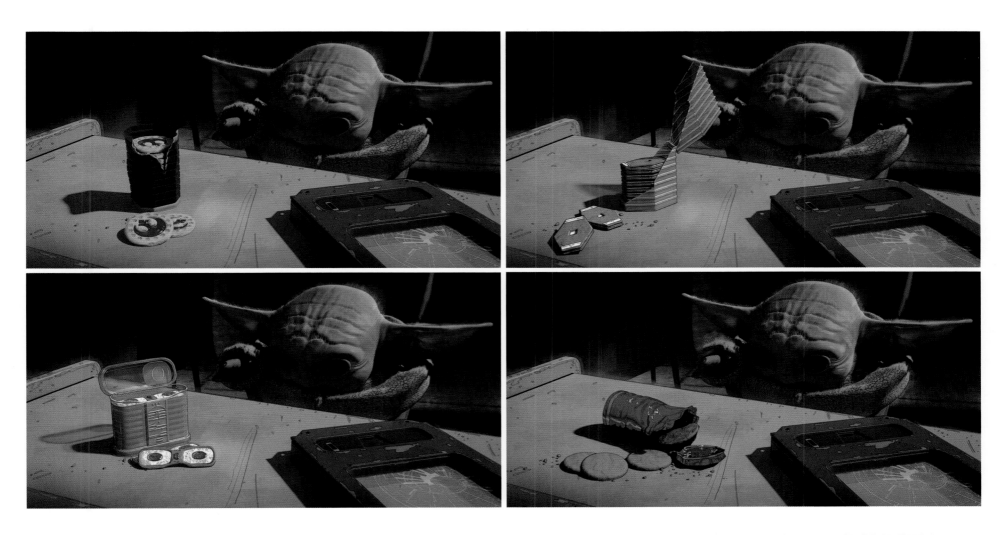

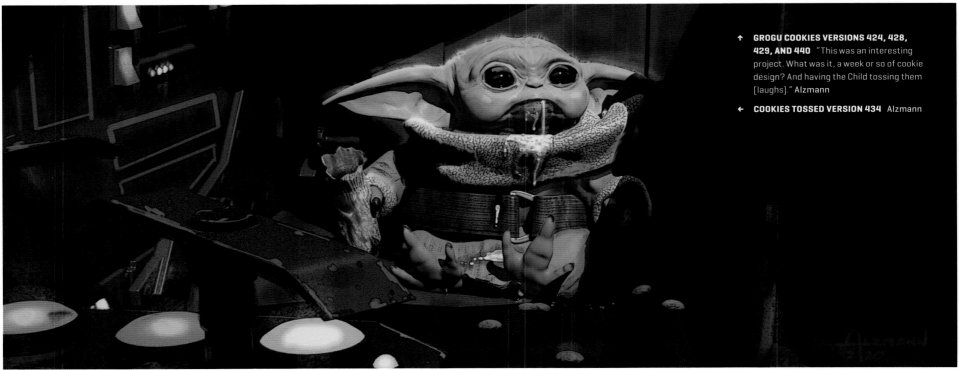

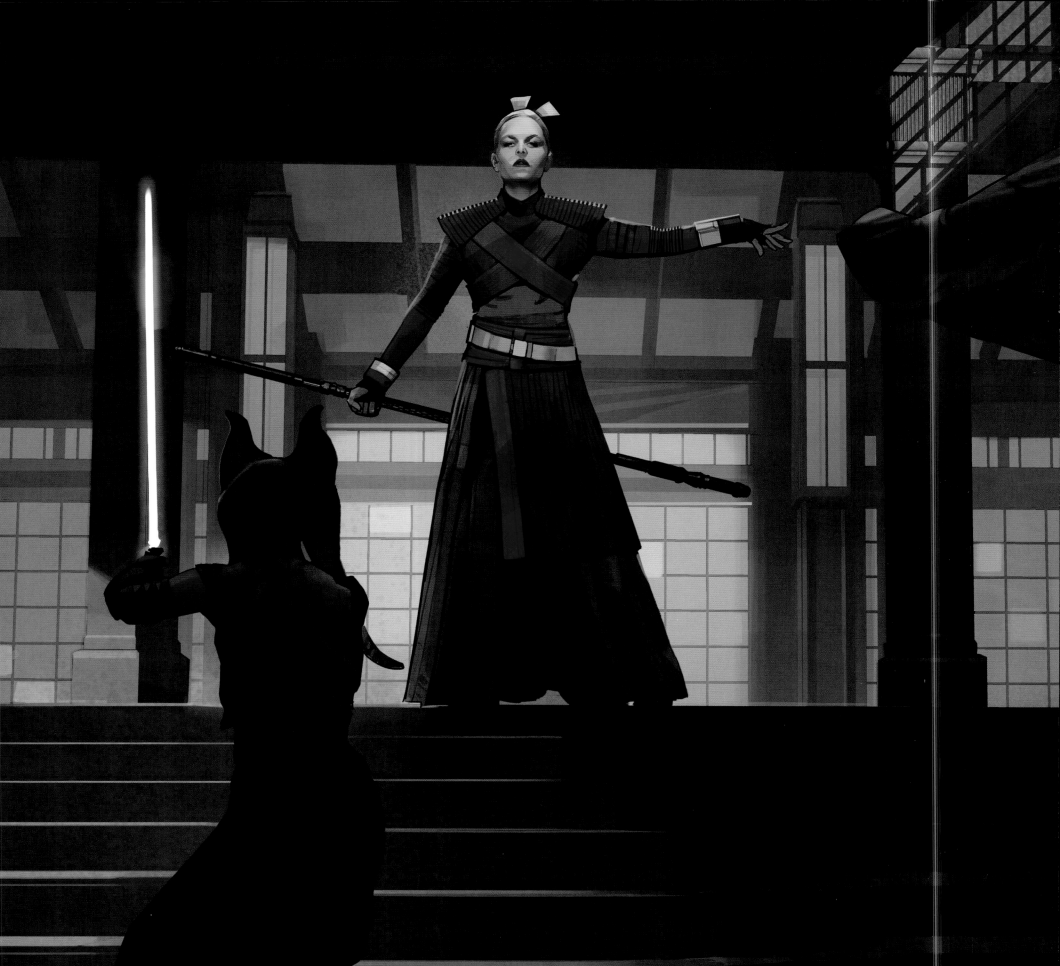

THE JEDI

Following Jon Favreau and Dave Filoni's 2018 discussions about bringing beloved Jedi Ahsoka Tano into *The Mandalorian*, Filoni grew more and more interested in "setting up Ahsoka as a character and seeing how she works in live-action, if that's something that could play. Taking a page from how we did *Mando* Season 1, I decided to put Ahsoka firmly into the samurai genre instead of a Western. To be honest, I always wanted to make a Jedi samurai film, and Ahsoka seemed like the perfect character to do it with."

As in the completed episode, the landscape of Corvus was rolling hills (inspired by the ones seen in Hideo Gosha's 1963 *chanbara* [Japanese for "sword-fighting"] film *Three Outlaw Samurai*) covered by forests from the outset, a setting inspired by Filoni's own experiences with the massive and deadly Northern California wildfires of 2017, 2018, and 2020.

Upon a hilltop lies a "fortress town" modeled after the Japanese castles often seen in samurai films, with flat, angled walls and an imposing gate, the surrounding walls defining the town. "That comes from growing up watching [Akira] Kurosawa films," Filoni reflected. "And knowing the connection that George [Lucas] had to Kurosawa. And then being in Japan and seeing these massive stone walls, the monolithic nature of them. You find things. 'Wow, I can't believe nobody's done a Japanese castle in *Star Wars* yet.' It's provided a different aesthetic altogether, but it felt very *Star Wars* nonetheless. Doug Chiang and I talk about it all the time: You don't have to do *Star Wars* things to make it feel like *Star Wars*. *Star Wars* really can be anything if you catch it the right way and add the right things to it."

"The magistrate is a former Imperial, but she's an industrialist. My idea was that she had a knowledge of metallurgy and obviously knew what beskar was. And she was pillaging this planet and stealing all of its resources—people who were willing to take everything from a world and give it to the Empire were valuable to the Empire. And even after the fall of the Empire, the people who built the war machine were still out there and really dangerous. They need to be tracked down because otherwise, they're going to keep doing what they're doing and find new ways to exploit people.

Nailing the iconic look of Ahsoka Tano was one of the greatest challenges facing Filoni in his second-season episode. "The rule I had for Shawna [Trpcic] in Costumes was that if we do Ahsoka's costume right, she could basically walk into a shot in [Kurosawa's] *Seven Samurai* and not stand out that much, apart from being orange with a stripey head," he said. "But if you took that out, the costume should feel like one of those, just with some more technological gack on it from *Star Wars*; communicators and things like that. So that was a big inspiration: the *Seven Samurai* looks."

"I had a talk with George, at one point, about the Child, and his main concern was that the kid has to have a proper amount of training.

"I [also] started talking to Jon about the possibility that Ahsoka could actually learn the Child's name because she's the only person who could actually talk to him. And that's where I was having ideas of them listening to each other's minds. I was really interested in that moment and that scene.

"It was pretty astonishing, I've got to say. Jon let me go in there and write this episode about the Child, which includes his backstory. He told me the kid's name, because he named him. Jon knows that I'm very protective of Ahsoka and her history and what she's about. We went through a couple rounds where I'd write a bunch and then he'd look at it and give me his take—that perspective becomes really valuable for me to then communicate this character that maybe the larger audience doesn't know but the fans do. And get at the root of what makes her special."

"Chapter 13: The Jedi," directed by Filoni, was the sixth episode of the season put before the camera. Most of Calodan's sets would be traditional soundstage builds, including the city's main street, outer wall and gate, and the burned forest just beyond. The remainder of the episode was filmed on the volume, including the tranquil inner courtyard, site of the closing duel between Tano and the magistrate. "The biggest, most difficult thing we had was the lightsaber fight," Filoni recalled. "I don't know what time we started that day, but it went until about 2–2:30 in the morning. It was the first lightsaber fight we'd ever shot on this show, so it was a big deal."

"[The fans love Ahsoka because] they grew up with that character," says Favreau. "They watched her start as a very flawed child and go on the whole hero's journey. There's something that's really relatable about characters who you see mature before your eyes, especially when the stories are being told with such care."

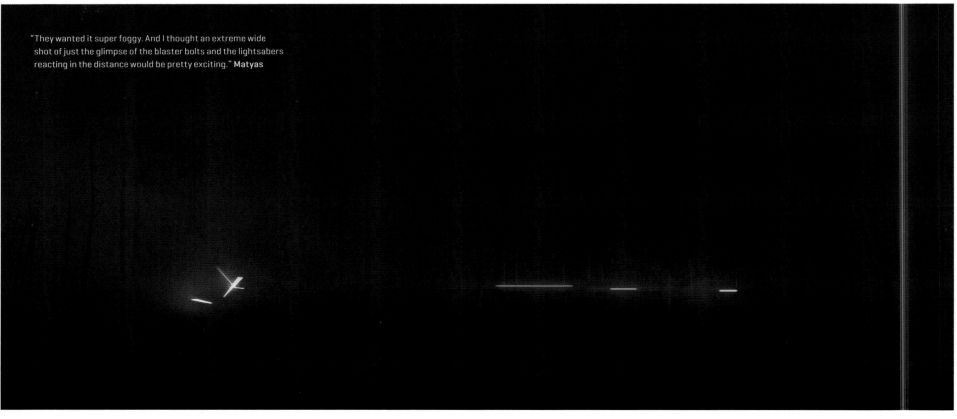

"They wanted it super foggy. And I thought an extreme wide shot of just the glimpse of the blaster bolts and the lightsabers reacting in the distance would be pretty exciting." **Matyas**

↑ **FOG DUEL VERSION 284** Matyas

↓ **FOG DUEL VERSION 285** Matyas

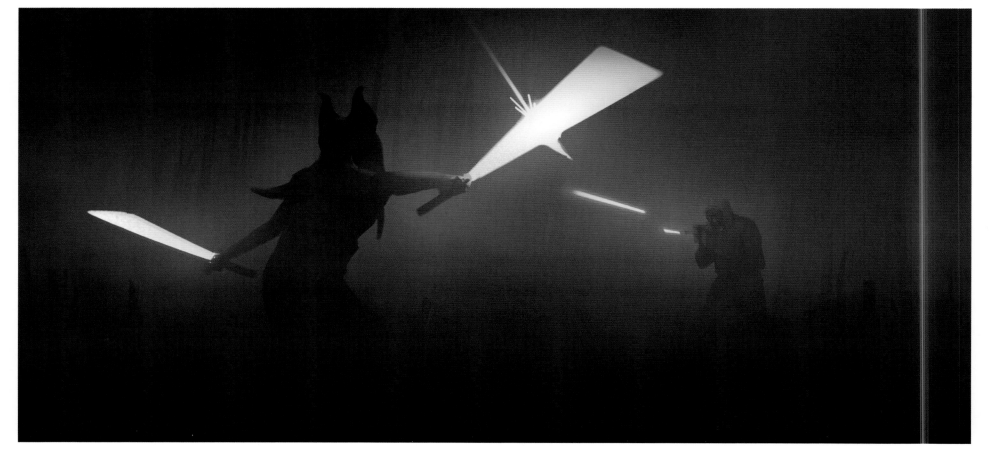

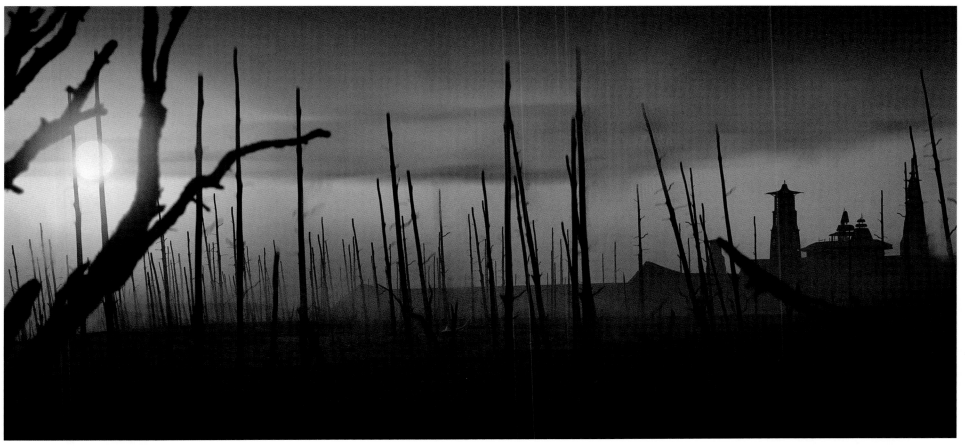

↑ **FORT 11 VERSION 01** Grandert

↓ ***RAZOR CREST* LANDING VERSION 02** Church

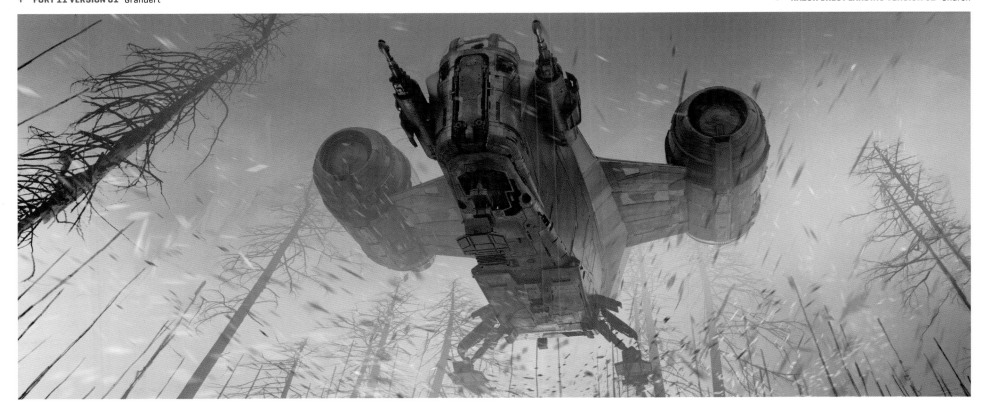

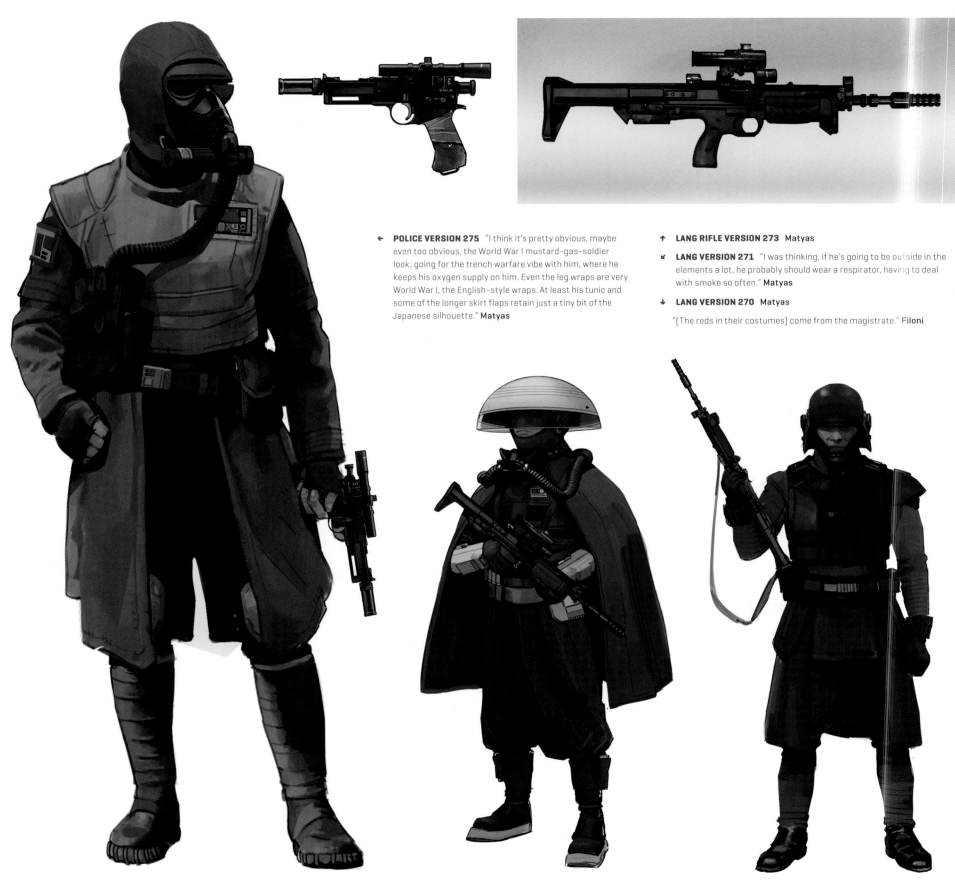

← **POLICE VERSION 275** "I think it's pretty obvious, maybe even too obvious, the World War I mustard-gas-soldier look; going for the trench warfare vibe with him, where he keeps his oxygen supply on him. Even the leg wraps are very World War I, the English-style wraps. At least his tunic and some of the longer skirt flaps retain just a tiny bit of the Japanese silhouette." **Matyas**

↑ **LANG RIFLE VERSION 273** Matyas

↙ **LANG VERSION 271** "I was thinking, if he's going to be outside in the elements a lot, he probably should wear a respirator, having to deal with smoke so often." **Matyas**

↓ **LANG VERSION 270** Matyas

"[The reds in their costumes] come from the magistrate." **Filoni**

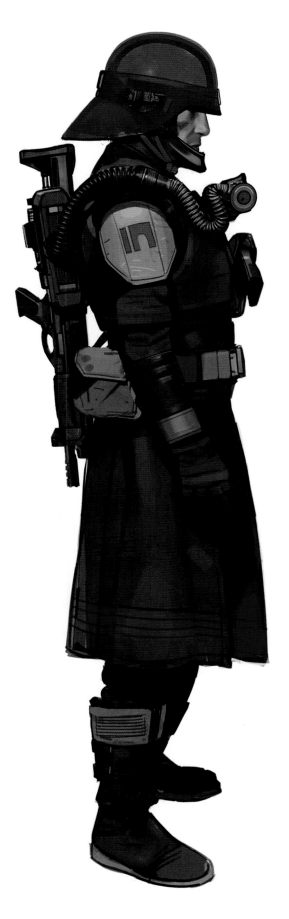

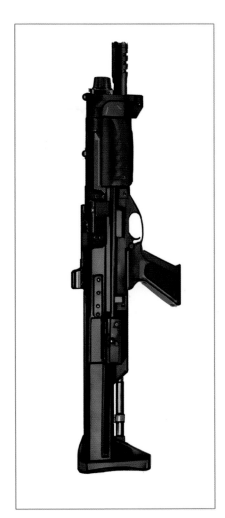

← **LANG VERSION 280** "They wanted some sort of shotgun, like a large spread blaster rifle, for him." **Matyas**

"[Lang actor] Michael Biehn made a huge impact on the episode because, while I had developed Ahsoka and her role and the magistrate, Lang's character, to some degree, had become just a hired gun. So Michael had all kinds of questions. And his experience of playing these types of characters, going back to Johnny Ringo (from the film *Tombstone*), was invaluable. Michael had a whole philosophy for how his character would try to take out somebody like Mando, who he logically thought would be younger and better than him. So he brought a reality and a nuance to the character that really brought him to life in a way that I did not have on the page." **Filoni**

→ **LANG VERSION 281** "For this entire planet, down to the costuming, we were riffing on feudal Japan/samurai. Even with this character's neck guard and his helmet being tied with a thick rope—the way samurai helmets are—and not giving him the face mask of the alien bounty hunter that I did. That's a very samurai mask. But more of a chin guard, playing with that." **Matyas**

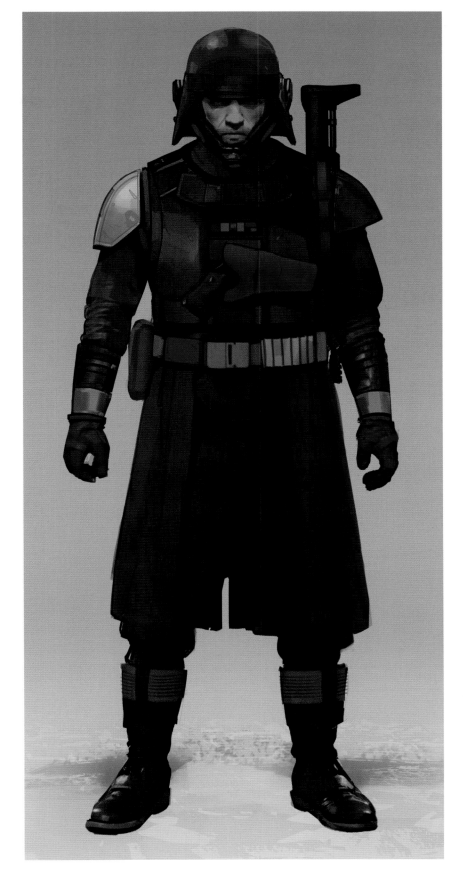

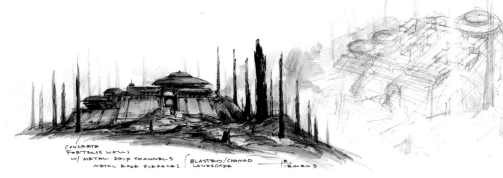

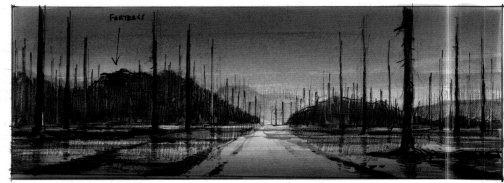

↑ **BURNT WOODS SKETCHES VERSION 01** Tiemens

← **CALODAN LAYOUT ROUGH VERSION 01** Tiemens

↓ **CALODAN VILLAGE SKETCH VERSION 01** "I was really inspired by the idea that Dave had of these massive curved Japanese walls. And what can we do to make it *Star Wars*–like on top? And contrasting that with the burnt landscape. A lot of it is based on those Chinese apartment villages." **Tiemens**

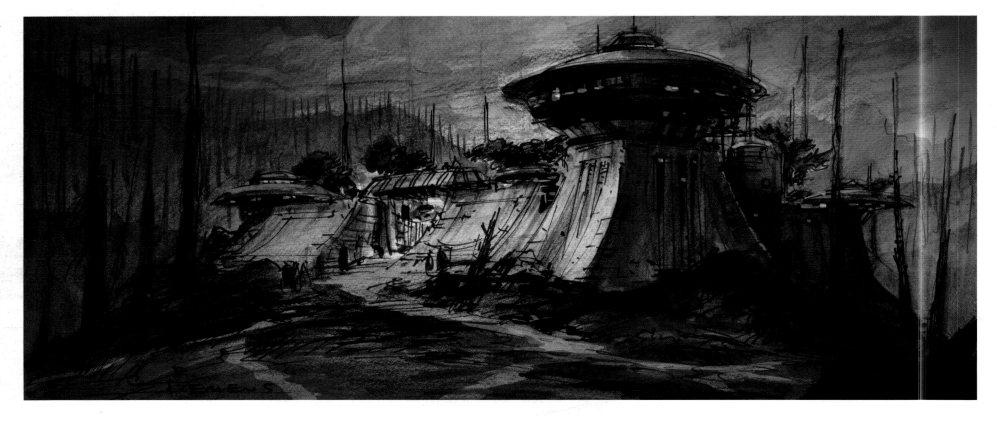

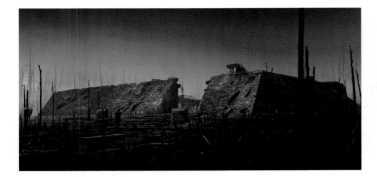

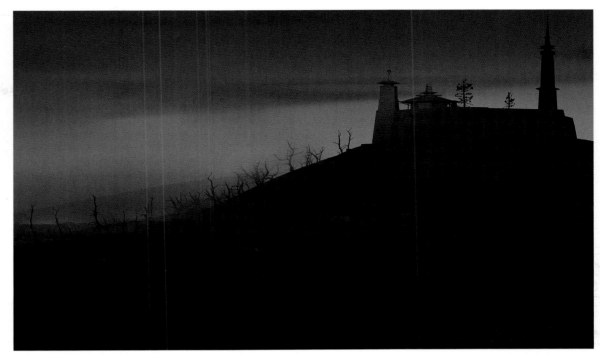

↑ **VILLAGE WALL VERSION 02** Church

↓ **JABBA'S PALACE EXTERIOR CONCEPT SKETCHES** McQuarrie

"While doing research I looked through my Ralph McQuarrie books and found these [1980–1981 early Jabba's Palace] sketches that inspired my direction for the first drafts of the city." **Grandert**

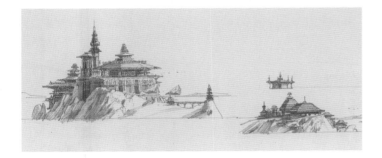

↑ **FORT 07 VERSION 01** "Not only did I have to think about the design of the walled city, but also how the landscape would look and feel. I always start with doing research, looking for interesting references. Forts, Kurosawa's movie *Ran*, old Ralph McQuarrie pencil sketches, Chinese and other Asian-vernacular architecture, Icelandic landscapes, and forest fires." **Grandert**

↓ **CALODAN WIDE SHOT VERSION 252** Grandert

"We first see the fortress from Mando's point of view when he arrives. It's in this overcast, gloomy, desolate landscape, and we made sure it had the simplicity of Japanese forts." **Chiang**

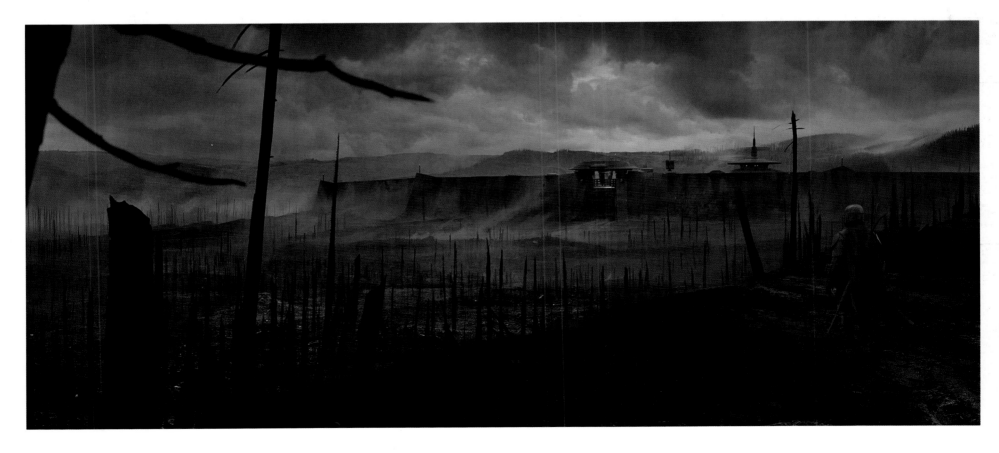

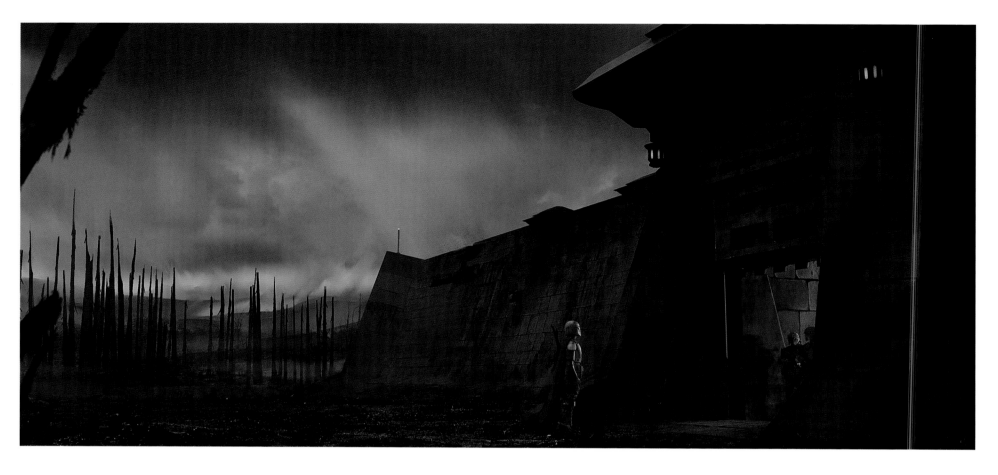

MAIN GATE VERSION 358 "I remember that it was really tricky to make the stairs work without changing the layout of the gate passage, since the stairs had to be at an angle so people walking up could be seen clearly from the main street inside the walls." **Grandert**

"Even on the inside, we designed it so it was very symmetrical, so it had all of those same Japanese castle characteristics, where the stonework is also very form-fitting [without mortar to bind it]." **Chiang**

CALODAN GATE SHOT VERSION 252 "For the actual gate, I wanted something really massive, something that would withstand fires, earthquakes, and wars over millennia. After some research I found something I liked in floodgates, and based the design off that." **Grandert**

MAIN GATE VERSION 361
"I wanted the gate to open in an interesting way, and tried all kinds of ways before I came up with this interlocking system, which felt very Japanese. Like how Japanese woodwork/carpentry is made, everything matches up perfectly. I also added a little eye in the middle, which was a reference to Jabba's palace's main gate." **Grandert**

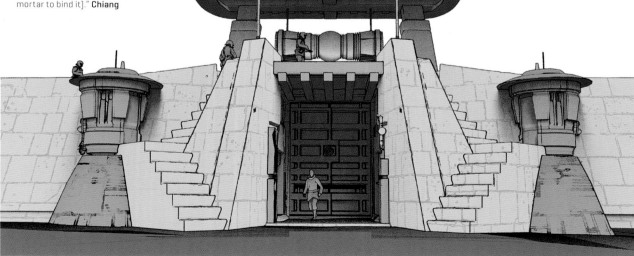

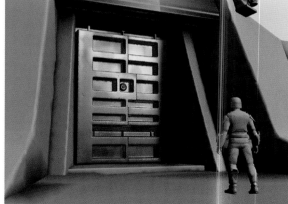

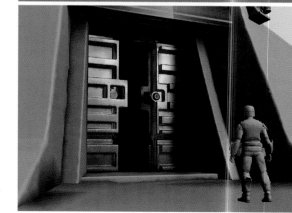

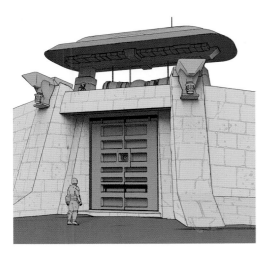

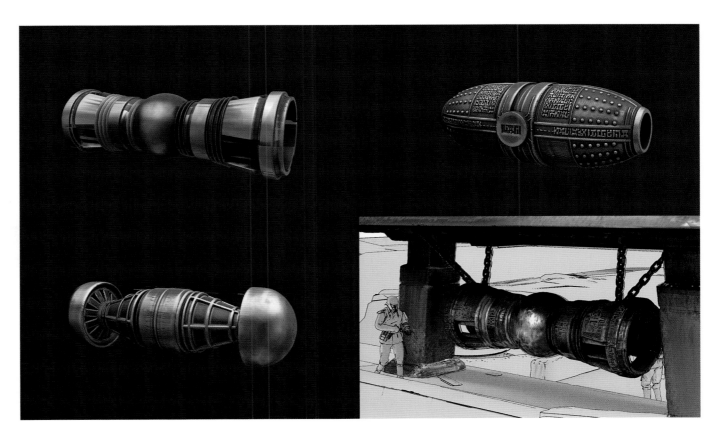

↑ **MAIN GATE VERSION 355** Grandert

→ **BELL VERSION 367** "The bell was lots of fun. I wanted it to look like it would have an interesting, ominous, and mysterious sound when hit with a mallet. I introduced some *Star Wars* inscriptions, something you would find in an Asian temple. And in one version I made it to look like it had the shape of a rocket engine, mirrored for symmetry, with some tech bits on it." **Grandert**

↓ **FOYER VERSION 02** "There was going to be a place where you leave your arms, like a coat check." **Alzmann**

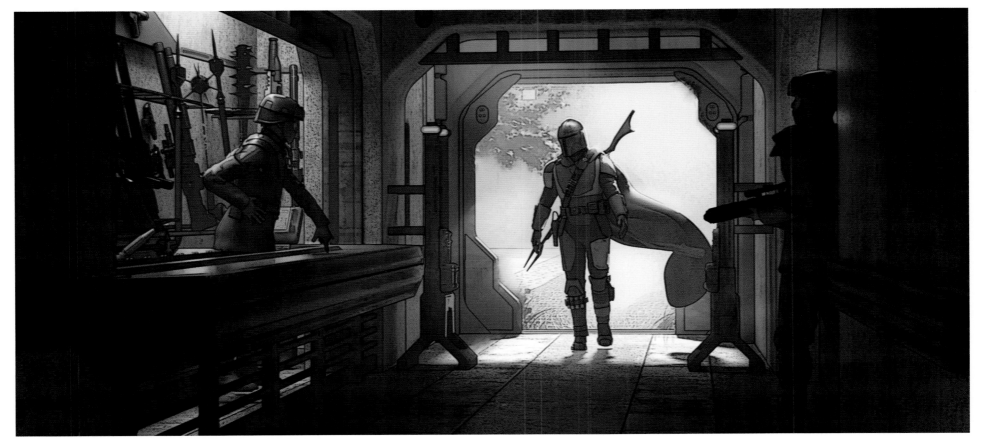

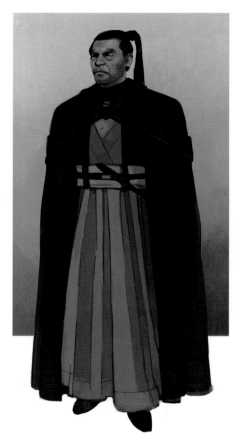

↑ **MAGISTRATE WITH COAT VERSION 01** Matyas

↑ **MAGISTRATE VERSION 04** Matyas

↑ **MAGISTRATE VERSION 06** Matyas

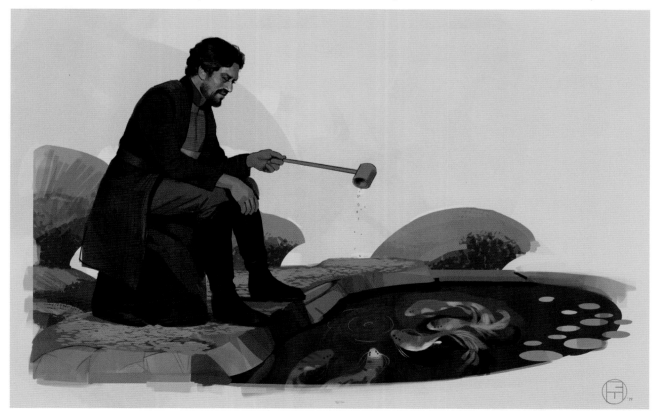

↑ **MAGISTRATE CLOAK VERSION 05** "This design incorporates a lot more formal Japanese elements, especially in the pleating of the skirts. The hard construction on some of the chest elements, and even the sleeves, are kind of like origami: really flat, graphic, and hard." **Matyas**

← **FISH FEED VERSION 01** "This is when I tried to go further away from the Japanese aesthetic. I looked at Italian Carabinieri; that's an Italian army look, with these really beautiful half-capes." **Matyas**

↑ **MAGISTRATE VERSION 1B** "It was around this time that they wanted to make the magistrate a woman and to maybe wear more red, the wine palette." **Matyas**

→ **MAGISTRATE VERSION 119** "I really like graphic elements, something that has a really strong silhouette, especially for *Star Wars*; it's so important. [My concept art mentor] Dermot Power does such a good job with side profiles of characters. I think some of that, in my brain, it came out in this side view. [I was also exploring] the airbrush *Blade Runner* look for combat makeup and different hairstyles; if you can get the hair to work with the origami look for the clothing, heat-pressed hair that can be like very chiseled in structure." **Matyas**

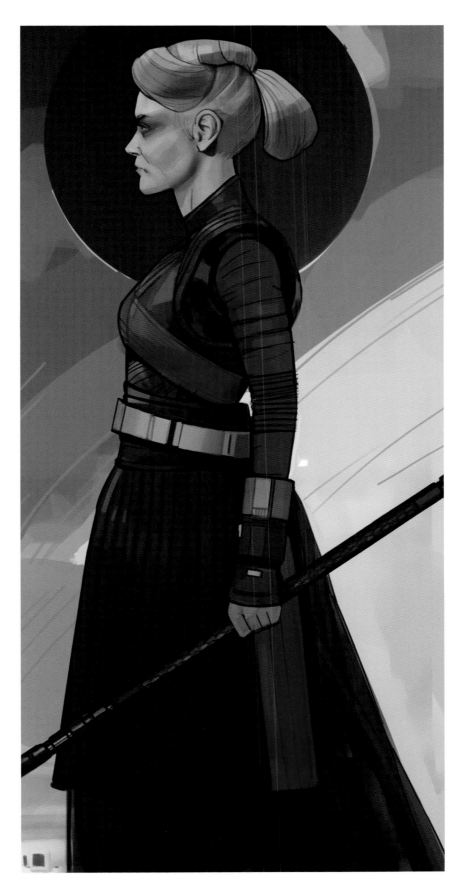

↑ **MAGISTRATE VERSION 02** Matyas

↑ **MAGISTRATE VERSION 4B** Matyas

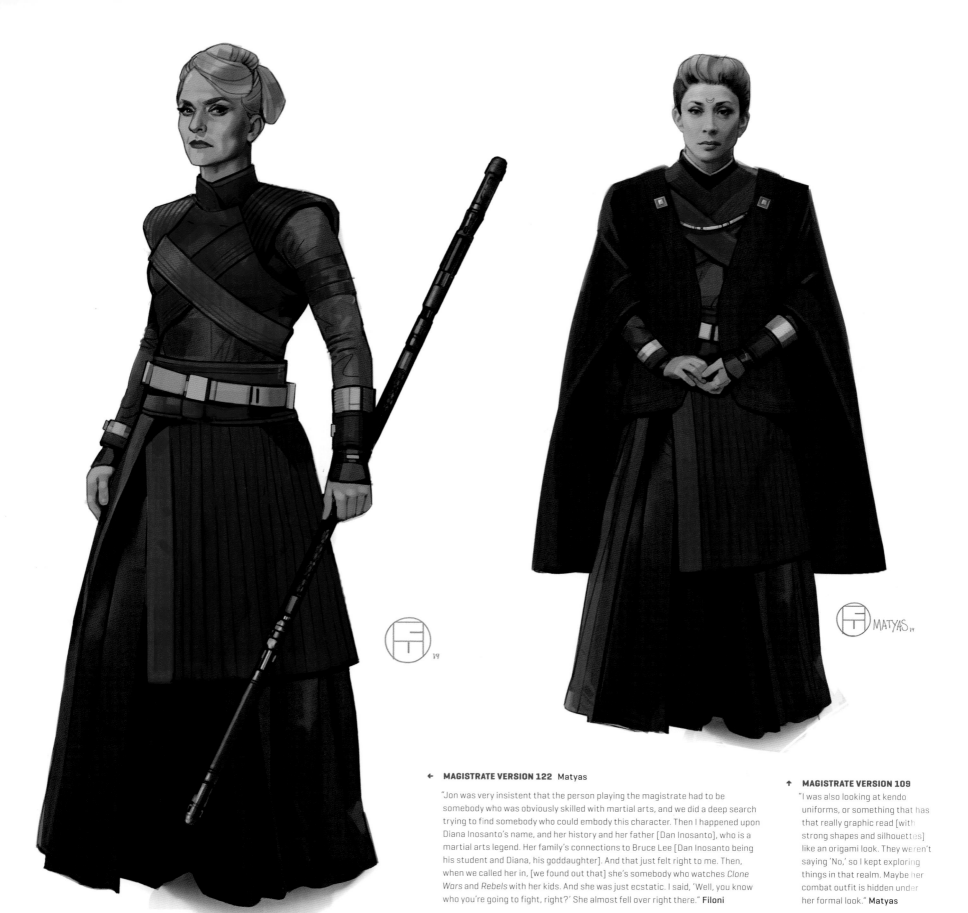

MAGISTRATE VERSION 122 Matyas

"Jon was very insistent that the person playing the magistrate had to be somebody who was obviously skilled with martial arts, and we did a deep search trying to find somebody who could embody this character. Then I happened upon Diana Inosanto's name, and her history and her father [Dan Inosanto], who is a martial arts legend. Her family's connections to Bruce Lee [Dan Inosanto being his student and Diana, his goddaughter]. And that just felt right to me. Then, when we called her in, [we found out that] she's somebody who watches *Clone Wars* and *Rebels* with her kids. And she was just ecstatic. I said, 'Well, you know who you're going to fight, right?' She almost fell over right there." **Filoni**

MAGISTRATE VERSION 109

"I was also looking at kendo uniforms, or something that has that really graphic read [with strong shapes and silhouettes] like an origami look. They weren't saying 'No,' so I kept exploring things in that realm. Maybe her combat outfit is hidden under her formal look." **Matyas**

↑ **CALODAN DROID VERSION 102** Alzmann

↓ **CALODAN DROID VERSION 103** Alzmann

↑ **BOUNTY HUNTER CONCEPT SKETCH** McQuarrie

→ **BOUNTY HUNTER DROID VERSION 278** Matyas

"I based them on the HK-style droid that appeared in *Knights of the Old Republic* [BioWare's 2003 RPG video game] and Doug and the team, we did our own version of it. I just thought it would be neat to have a more capable droid. They're obviously old, at this point. They keep things feeling a little more *Star Wars* and a little less straight-up period Japan." **Filoni**

↓ **HK DROID VERSION 100** Garcia

"I wanted to sort of create a new kind of droid that was like the KX droids [from *Rogue One*], keeping those long-leg proportions. And the head itself was taken right off of an old Ralph McQuarrie drawing of a [droid bounty hunter] head. Brian basically grafted Ralph's head onto K-2. And then in the spirit of making it *Star Wars*, we gave it a little bit of wardrobe, like General Grievous's [IG-100] MagnaGuards [from Episode III]." **Chiang**

↑ **CALODAN GIBBET VERSION 379** Alzmann

↗ **CALODAN STREET VIEW VERSION 57** "Japanese, Korean, and Chinese architecture is woven into the rooftops and stone, just that little ten to fifteen percent was really appealing. The compression of space and overhangs in our set pieces seem familiar and Old World, a nod to Kurosawa films, but we're still in dialog with the Westerns, too, coming into town." **Tiemens**

→ **CALODAN HOUSES VERSION 108** "I thought that if I worked smart, I only needed to create a few 3-D buildings that could be combined in numerous ways to give the impression of a complex city. Initially, I think I only created five different types." **Grandert**

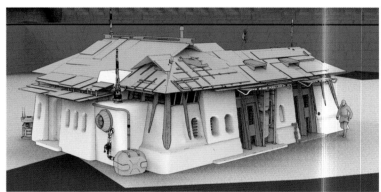

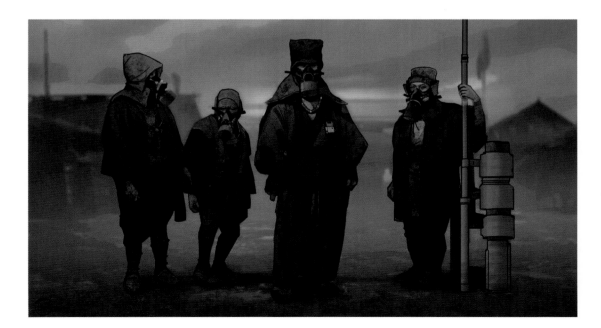

← **PEASANTS VERSION 244** Matyas ↓ **CALODAN VERSION 251** Grandert

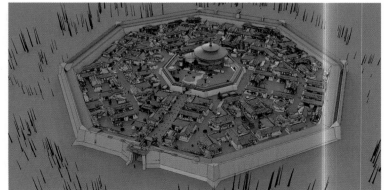

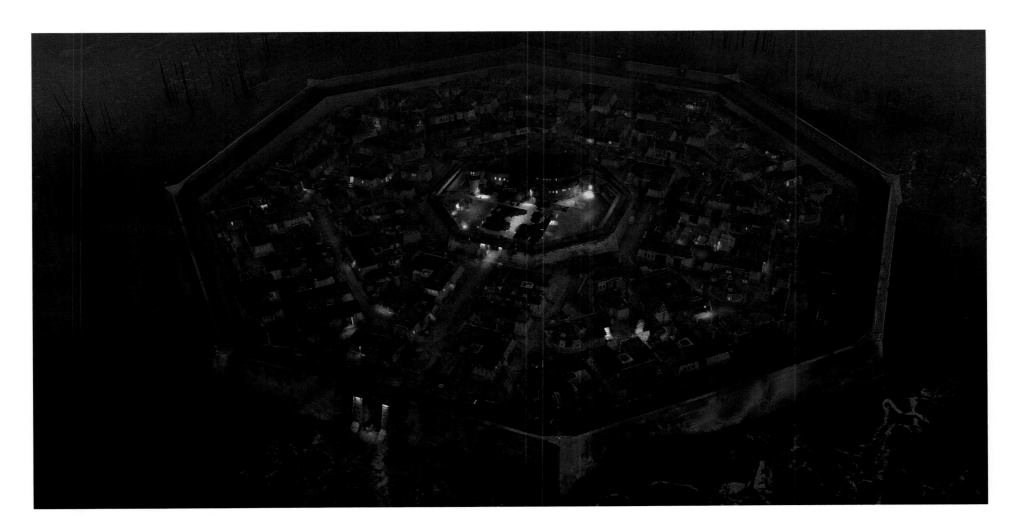

CALODAN HOUSES VERSION 193 "It was fun to see the city come to life once I had all the building blocks. It became pretty complex, especially when the size of the city had to be changed, which meant I had to move all the houses individually to make the streets make sense. I tried not to repeat myself, creating areas with a bit of a different flavor. For example, there's a market square on the right [from the map's top view] and poor quarters with shacks around the wall." **Grandert**

"In terms of the scale, a lot of this was driven by the Japanese village in *Yojimbo*. That was the layout motif." **Chiang**

CALODAN HOUSES VERSION 191 "I was trying to find a style for these buildings, and looked a lot at Japanese/Asian traditional houses. It took lots of research. So I had to find a look that gave clear associations to that style, without making anything too obvious or copying designs straight off." **Grandert**

"We wanted to make the roofs very ramshackle. But then the walls are angled to give it that special quality that looks *Star Wars*. Even the window slits are very unique." **Chiang**

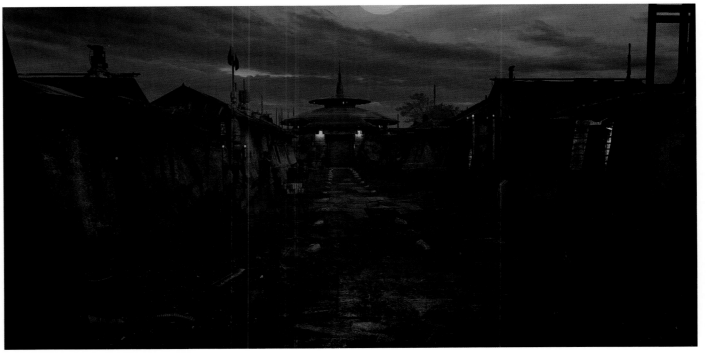

↑ **RONIN TRANSPORT VERSION 01**
"I had maybe two hours to do this sketch. They were entertaining the idea that [the bounty hunters] had to ride some animals. I pretty much took a camel, a rabbit, and a kangaroo and I mixed them all together [laughs] for that thing." **Matyas**

↓ **CORVUS ISOPOD VERSION 03** "I just wanted to do a very [Hayao] Miyazaki–inspired design. I'm always trying to get invertebrates into *Star Wars*. We do the reptile and mammal thing all the time." **Church**

→ **MANDO RIDING VERSION 03** Alzmann
"We were trying to create something that could live in the forest. 'OK, a tall reptilian beast, like a giraffe, so it can be foraging above the burned ground.' That [mount for the Mandalorian] idea ultimately got scrapped. Then it became just a beast wandering the landscape." **Chiang**

↘ **MANDO SPEEDER VERSION 02**
"This was, of course, riffing on Doug's design of Darth Maul's speeder from Episode I." **Alzmann**

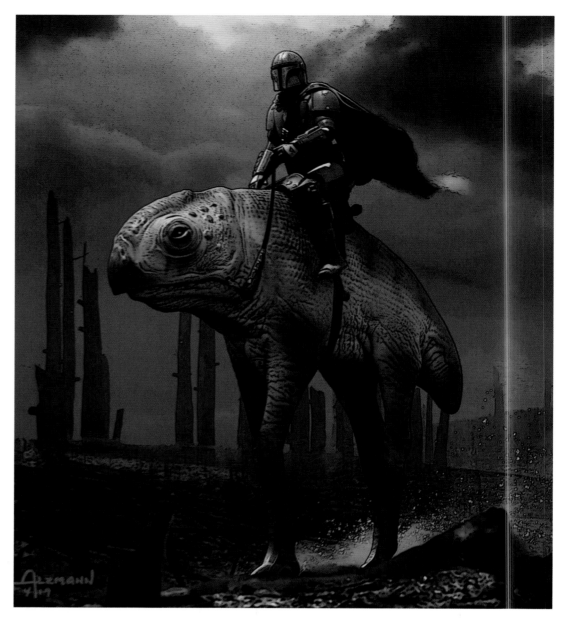

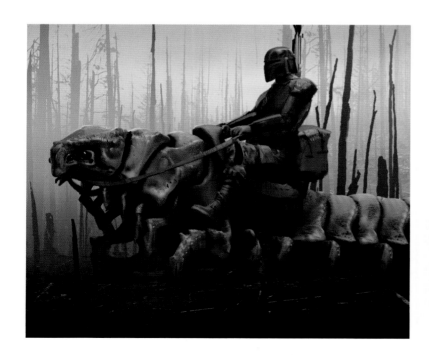

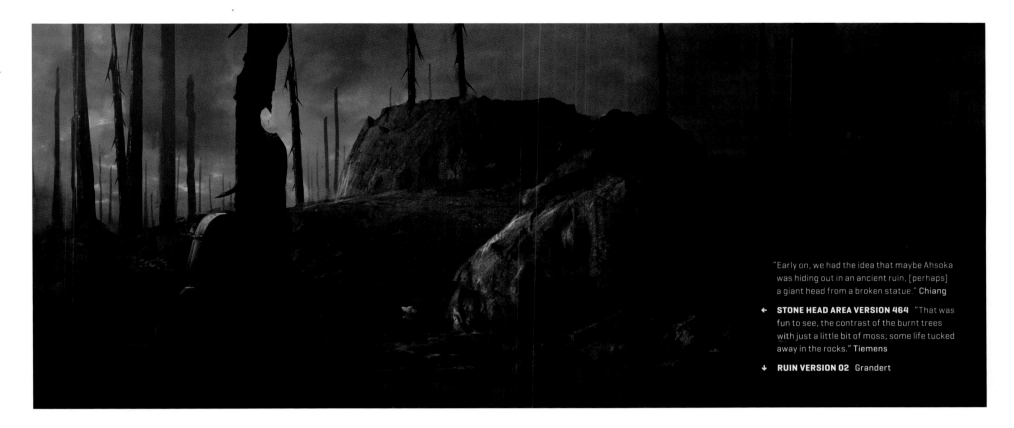

"Early on, we had the idea that maybe Ahsoka was hiding out in an ancient ruin, [perhaps] a giant head from a broken statue." Chiang

← **STONE HEAD AREA VERSION 464** "That was fun to see, the contrast of the burnt trees with just a little bit of moss; some life tucked away in the rocks." Tiemens

↓ **RUIN VERSION 02** Grandert

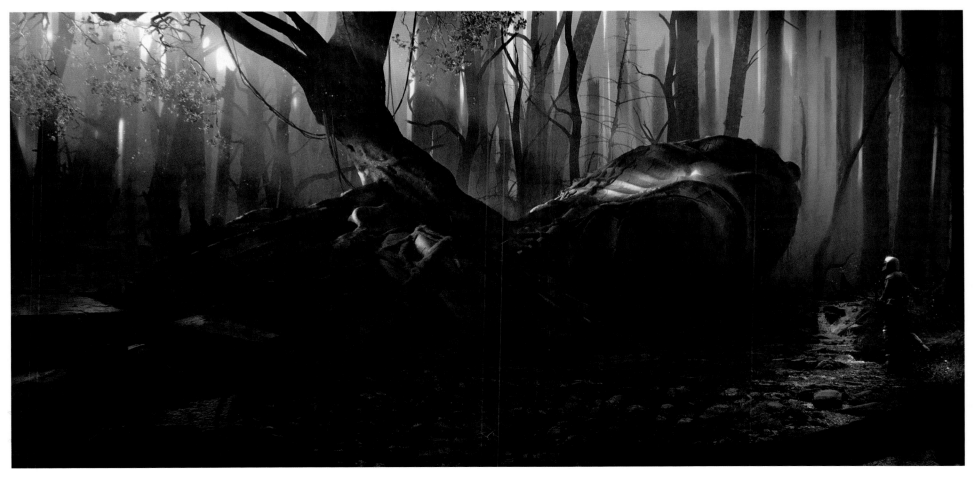

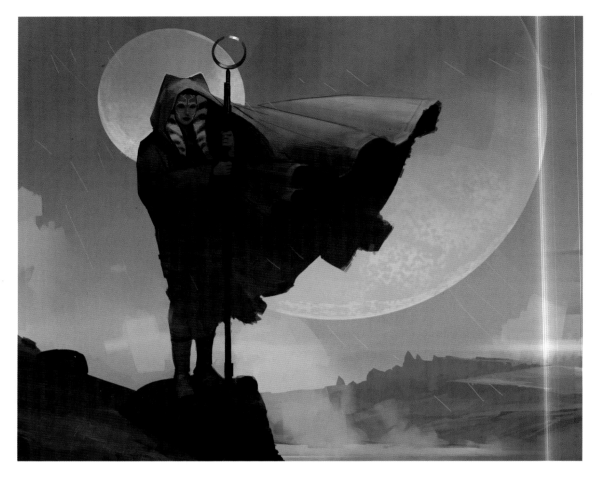

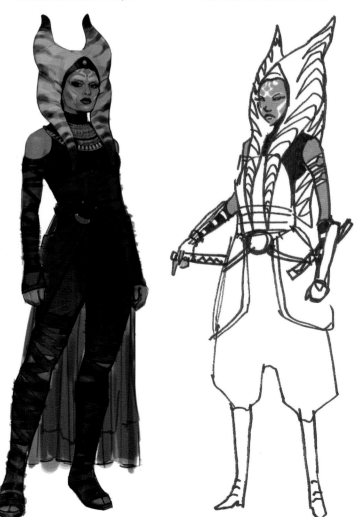

↓ **AHSOKA VERSION 02** Matyas ↑ **AHSOKA COSTUME SKETCH 01** Filoni

↑ **AHSOKA VERSION 01** Matyas

← **AHSOKA COSTUME SKETCH 02** "I had done one drawing of Ahsoka a while ago that actually became the inspiration for her outfit in *Rebels*. It had these more puffed-out samurai pants that were taken in at the lower legs and calves. And they just created a great silhouette. It's not a look that works really well in animation. So, when we came to this, I started exploring that again as a possible look." **Filoni**

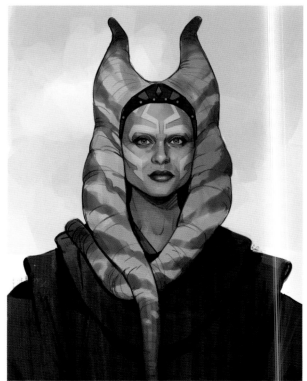

→ **AHSOKA VERSION 03** Matyas

"What if the Ahsoka that we have in animation was actually based on this [live-action] version of Ahsoka? One of the things you would do in animation is an exaggeration, making the montrals bigger. Once they're in real life, suddenly it becomes a little less believable to the eye, at least for me. And if you ever see footage of Shaak Ti (another Togruta Jedi character seen in the *Star Wars* prequels) in action, there's a lot of rubbery movement in the montrals. That works great for that character in the background, as she was, but if you're talking a featured character, right up front, delivering drama, you have to make it all seem as natural as possible. And I don't want you staring at the montrals and the lekku." **Filoni**

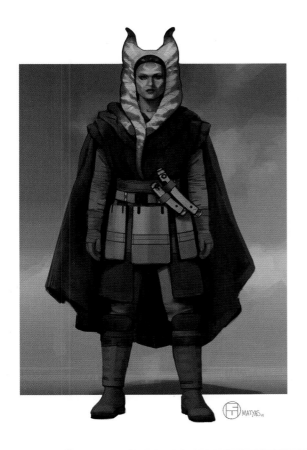

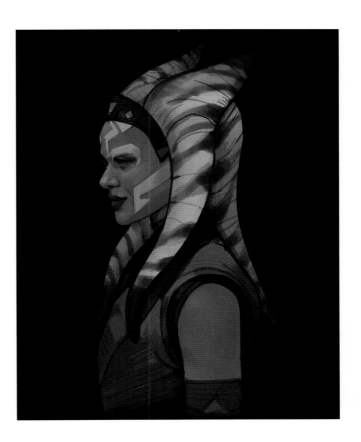

↑ **AHSOKA POSES SKETCH 01** Filoni

← **AHSOKA FOREST VERSION 01** "Early on, I played with some samurai plates, because her lightsabers have a very *katana* and *tantō* hilt vibe. And a lot of her vibe is very Japanese, Kurosawa-inspired. Dave really wanted a light-gray vibe with her costuming." **Matyas**

→ **AHSOKA PORTRAIT VERSION 138** Matyas

↓ **AHSOKA VERSION 144** "I knew there was a pond or some sort of water source, so we have the glint of the lightsaber playing off of that. And maybe the magistrate's in the extreme foreground." **Matyas**

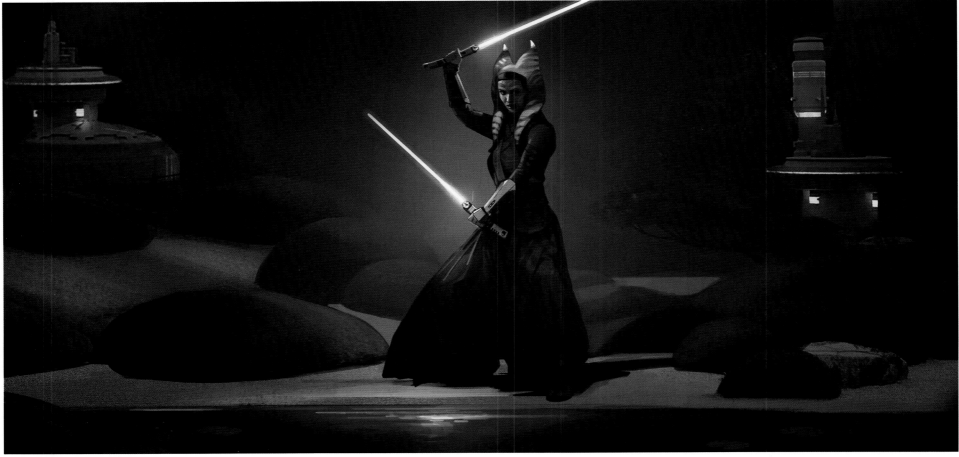

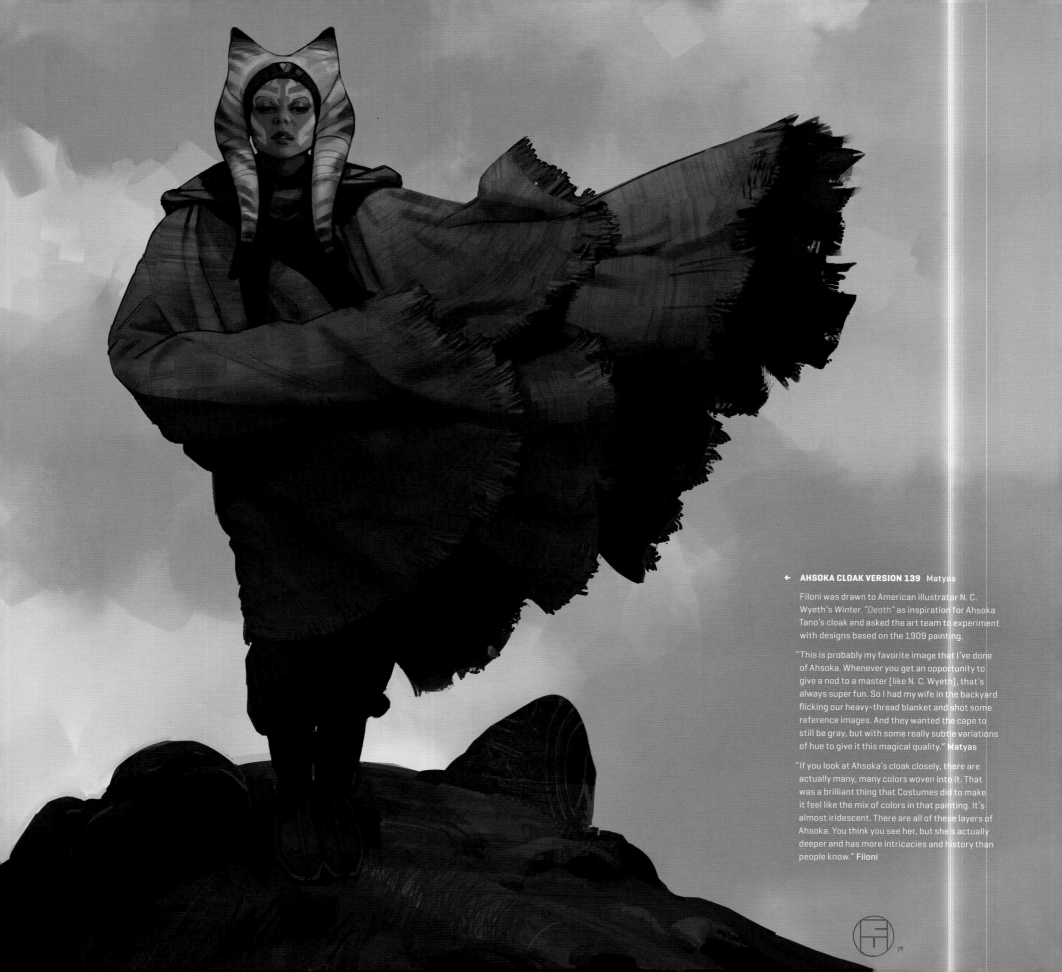

← **AHSOKA CLOAK VERSION 139** Matyas

Filoni was drawn to American illustrator N. C. Wyeth's *Winter. "Death"* as inspiration for Ahsoka Tano's cloak and asked the art team to experiment with designs based on the 1909 painting.

"This is probably my favorite image that I've done of Ahsoka. Whenever you get an opportunity to give a nod to a master [like N. C. Wyeth], that's always super fun. So I had my wife in the backyard flicking our heavy-thread blanket and shot some reference images. And they wanted the cape to still be gray, but with some really subtle variations of hue to give it this magical quality." **Matyas**

"If you look at Ahsoka's cloak closely, there are actually many, many colors woven into it. That was a brilliant thing that Costumes did to make it feel like the mix of colors in that painting. It's almost iridescent. There are all of these layers of Ahsoka. You think you see her, but she's actually deeper and has more intricacies and history than people know." **Filoni**

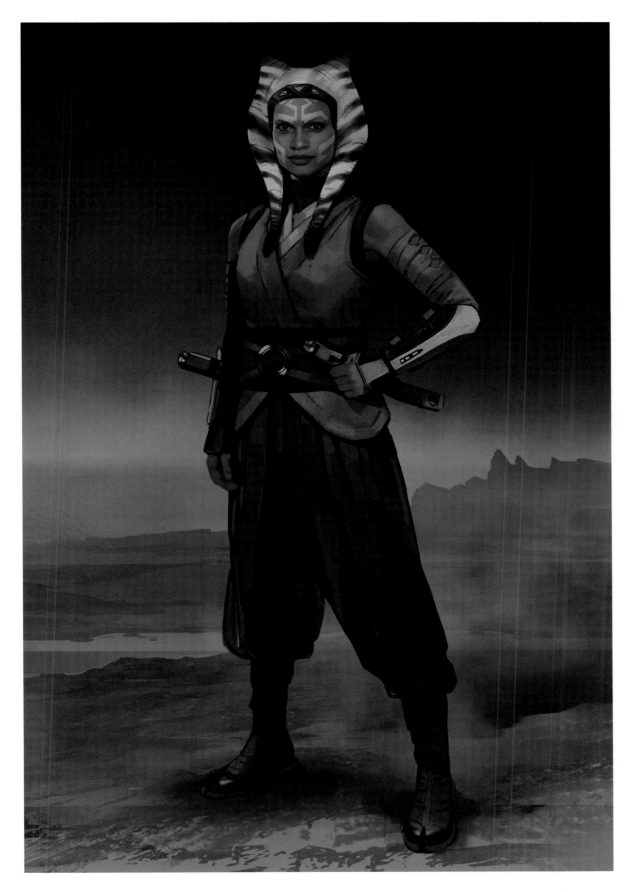

↑ **AHSOKA ROSARIO** Matyas

← **AHSOKA FULL BODY VERSION 184** "I looked at a lot Japanese garments. Hakama, the Aikido or Kendo-style pants that have an elaborate waist-tying system, that was the inspiration." **Matyas**

"The animated Ahsoka is rather bright, which works in the style of that world, but we had to find a balance of skin tone, since the volume screen dramatically affects the color and brings out way more red. We had to do a lot of tests and then look at the facial markings and try to discover what highlighted the brow, what really lit up the eyes, just little details, thickness on the cheeks. It took a lot of fine-tuning, but it's totally worth it. I really couldn't be happier with how it turned out." **Filoni**

↑ **AHSOKA SCULPT VERSION 1A** McVey

→→ **CALODAN RUINS VERSION 02** Alzmann

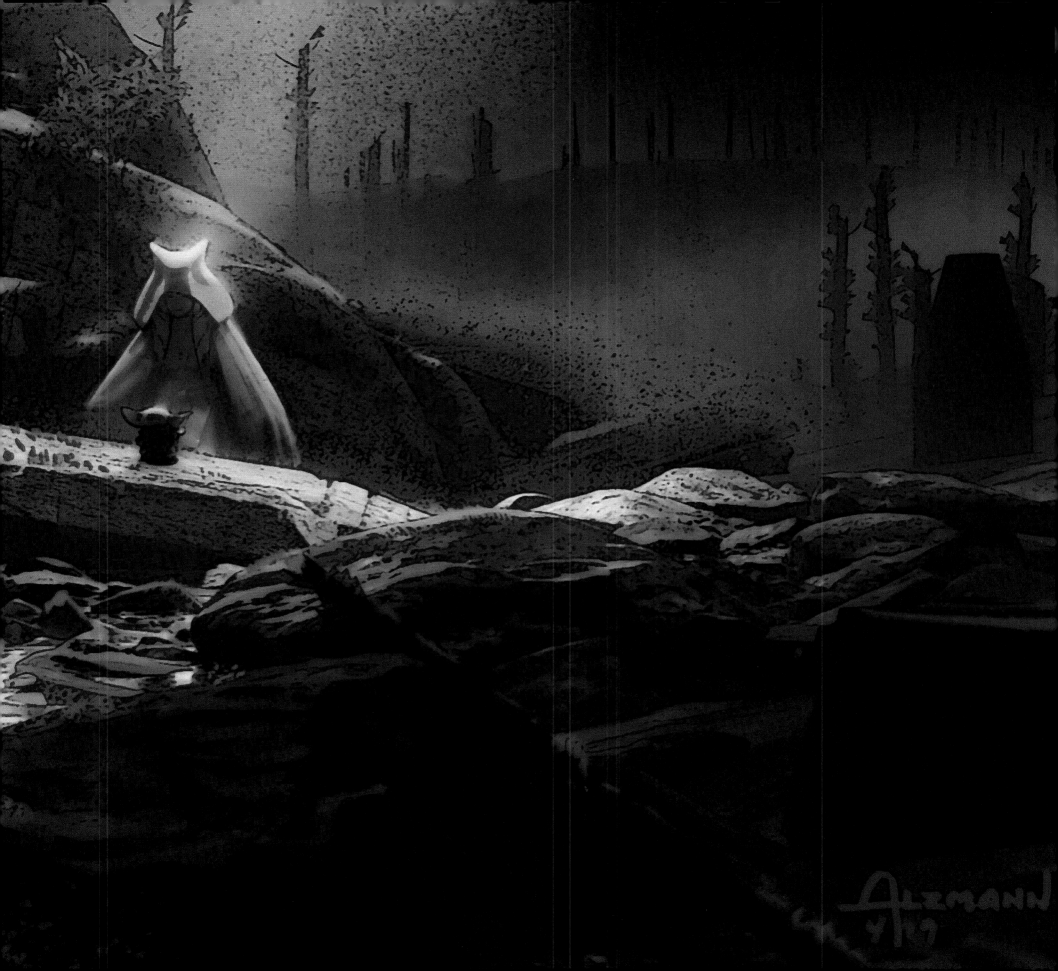

↑ **AHSOKA BABY SKETCH** Filoni

↑ **AHSOKA BABY SKETCH** Filoni

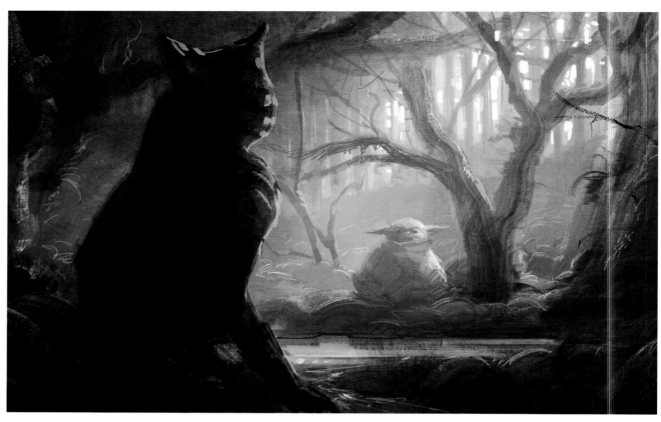

↑ **AHSOKA AND CHILD VERSION 01** Tiemens

↑ **MEETING BABY SKETCH** Filoni

"Ahsoka meeting the Child was important, because I could harken back to the things that George taught me about the Force. And being that Ahsoka was a student of Anakin, who was a student of Obi-Wan, she quotes, pretty directly, Alec Guinness's line 'The Force is what gives the Jedi their power. It's an energy field created by all living things.' I like the idea that that is taught as a baseline Padawan learning.

→ **MEETING BABY VERSION 205** Matyas

"In animation, I can control the entire performance, the expressions and attitude. But on set, in that moment right in front of you, *that is* the moment. And that's the wonderful, frightening, amazing thing about live-action. It's going to happen right there in front of you, and you just have to capture it." **Filoni**

↓ **ROCKS BABY SKETCH** Filoni

"The baby exercising his Force abilities, lifting rocks. The moment is not quite this big anymore." **Chiang**

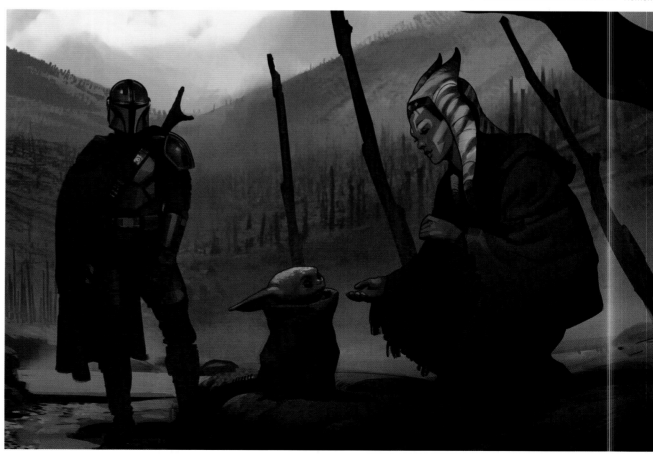

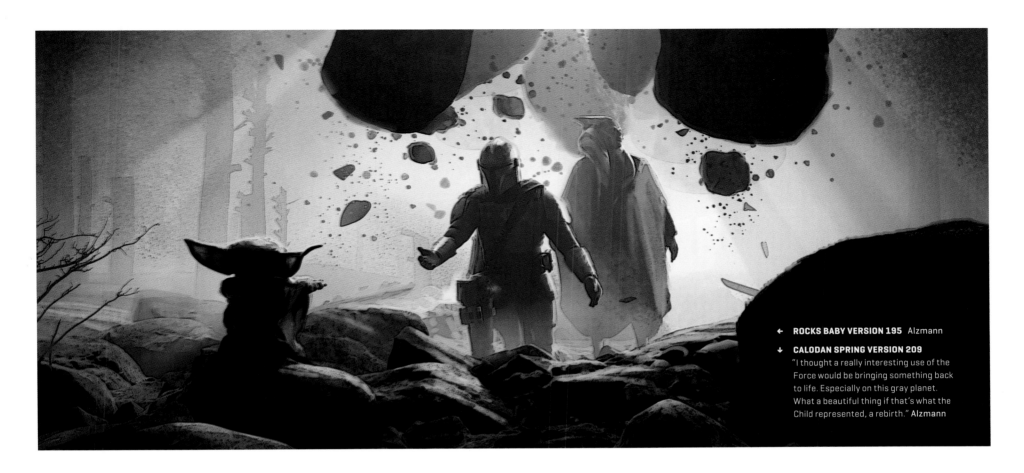

← **ROCKS BABY VERSION 195** Alzmann

↓ **CALODAN SPRING VERSION 209**
"I thought a really interesting use of the Force would be bringing something back to life. Especially on this gray planet. What a beautiful thing if that's what the Child represented, a rebirth." **Alzmann**

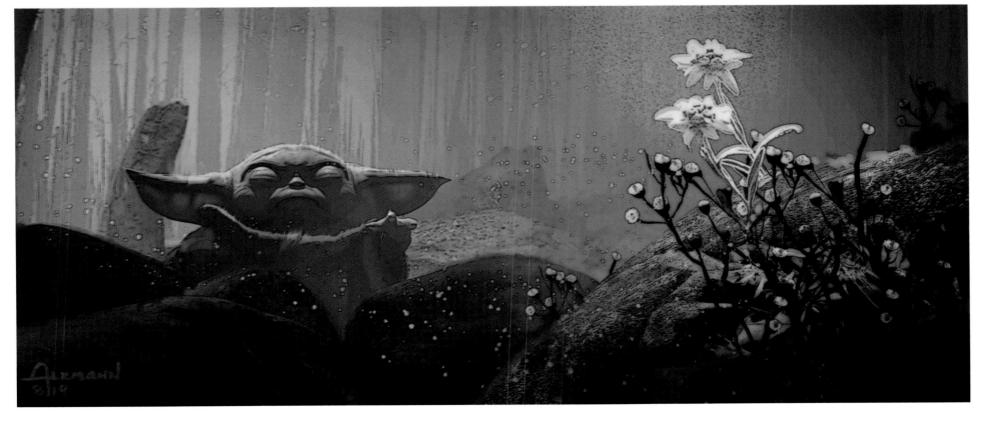

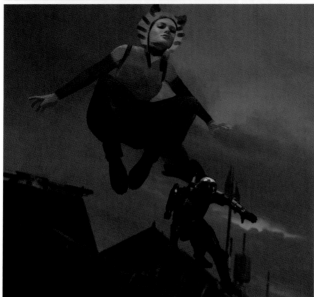

↑ **MANDO ROOFTOPS VERSION 167** Matyas

↑ **ROOFTOP SKETCH** Filoni

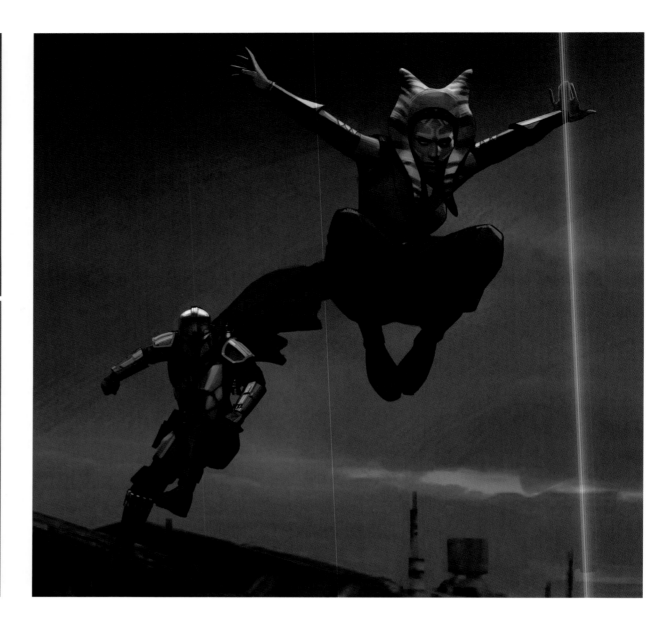

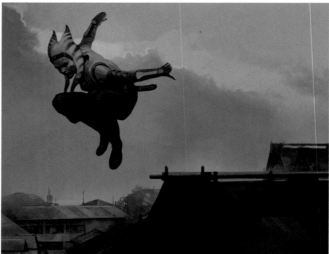

↑ **AHSOKA MANDO ROOFTOPS VERSION 172** "We explored a sequence of her jumping rooftop to rooftop, doing some light parkour, and then Mando joins her." **Matyas**

"There are lots of little ways I played with good and evil, power and lack of power. The wind and smoke and the way the leaves blow are part of telling you how turbulent things are, or how lonely. When Ahsoka walks down the street, it's a straight homage to *Yojimbo*. It's pretty much the same shots, because they're so powerful. Kurosawa uses the environment to put you on edge, evoking emotions and making you feel what he wants you to feel, and we wanted to honor Kurosawa and the influence/inspiration that his film provided us. People have found most of the homages that we did, but there is one I can think of that no one has caught yet; a nod to Toshiro Mifune's portrayal of Kuwabatake Sanjuro that is quite subtle, so watch for it closely. [Hayao Miyazaki's] *Princess Mononoke* was an influence, as well. I really love that film." **Filoni**

← **AHSOKA VERSION 166** Matyas

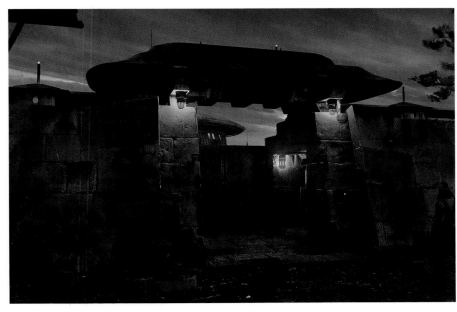

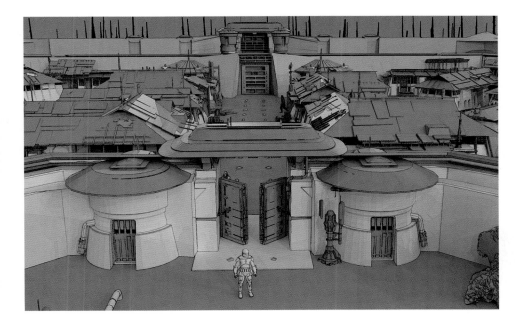

↑ **CALODAN INNER GATE VERSION 192** Grandert

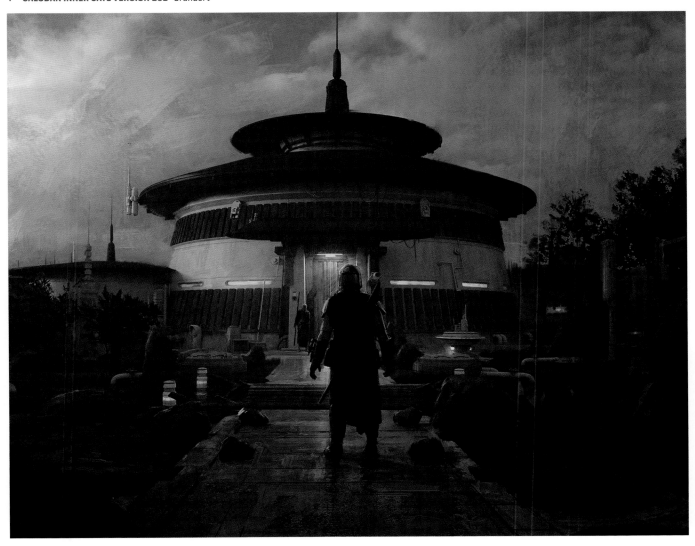

↑ **CALODAN VERSION 250** Grandert

← **MAGISTRATE POND VERSION 104** Tiemens

"The magistrate's inner courtyard has this tranquil, Zen-like area. There are places in L.A. you can go, in Little Tokyo, where outside there is hustle and bustle but then you go into these little courtyards and it's incredibly calm. It's a very deceptive thing, though, because it's life under complete control. She's curated this environment." **Filoni**

→→ **BATTLE VERSION 1A** Matyas

"This early idea shows what Ahsoka's pose could be with her costume. We didn't know if there was going to be a moment when she was inside the magistrate's office." **Chiang**

"Originally this duel was to take place inside the magistrate's temple. I was inspired by the Kyoto Butokuden (Japan's oldest competition hall for martial arts, built in 1899 at Heian-Jingu Shrine), which I have had the privilege of visiting." **Matyas**

↓ **STAFF VERSION 10** Ozzimo

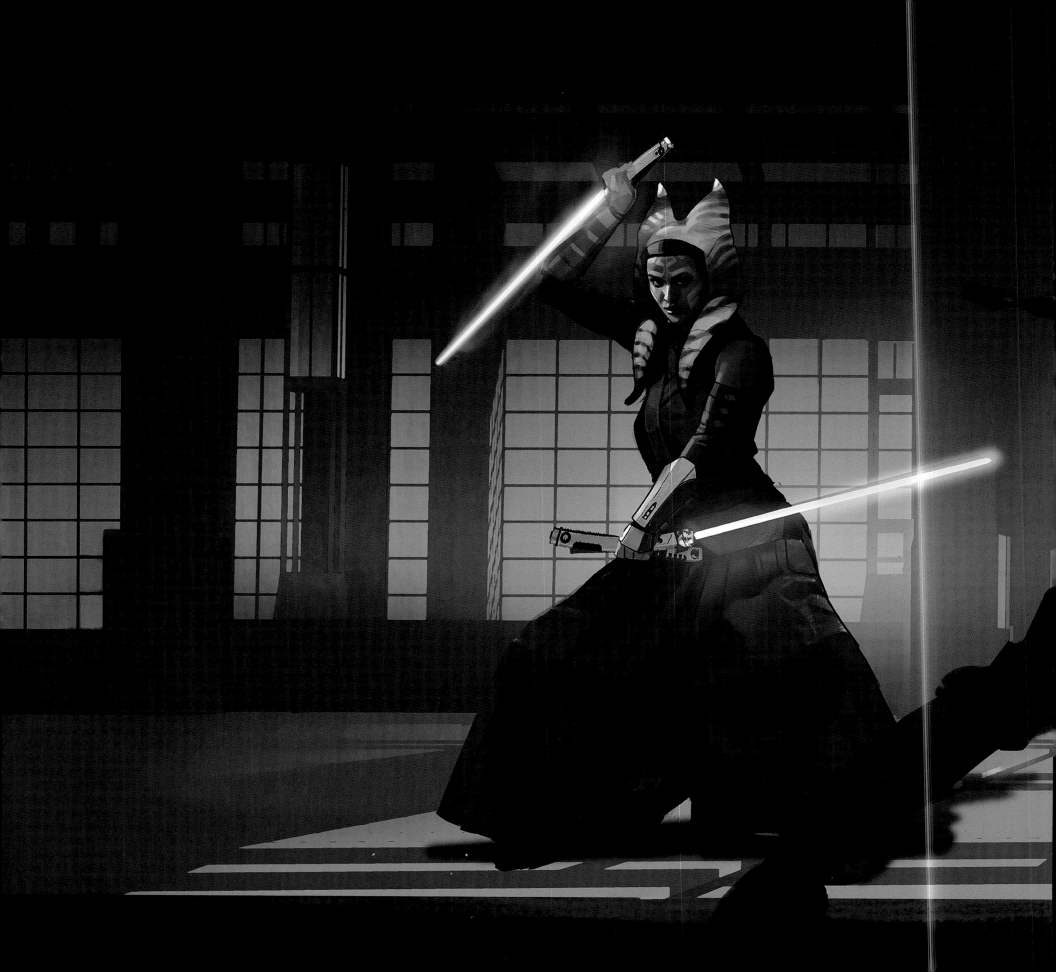

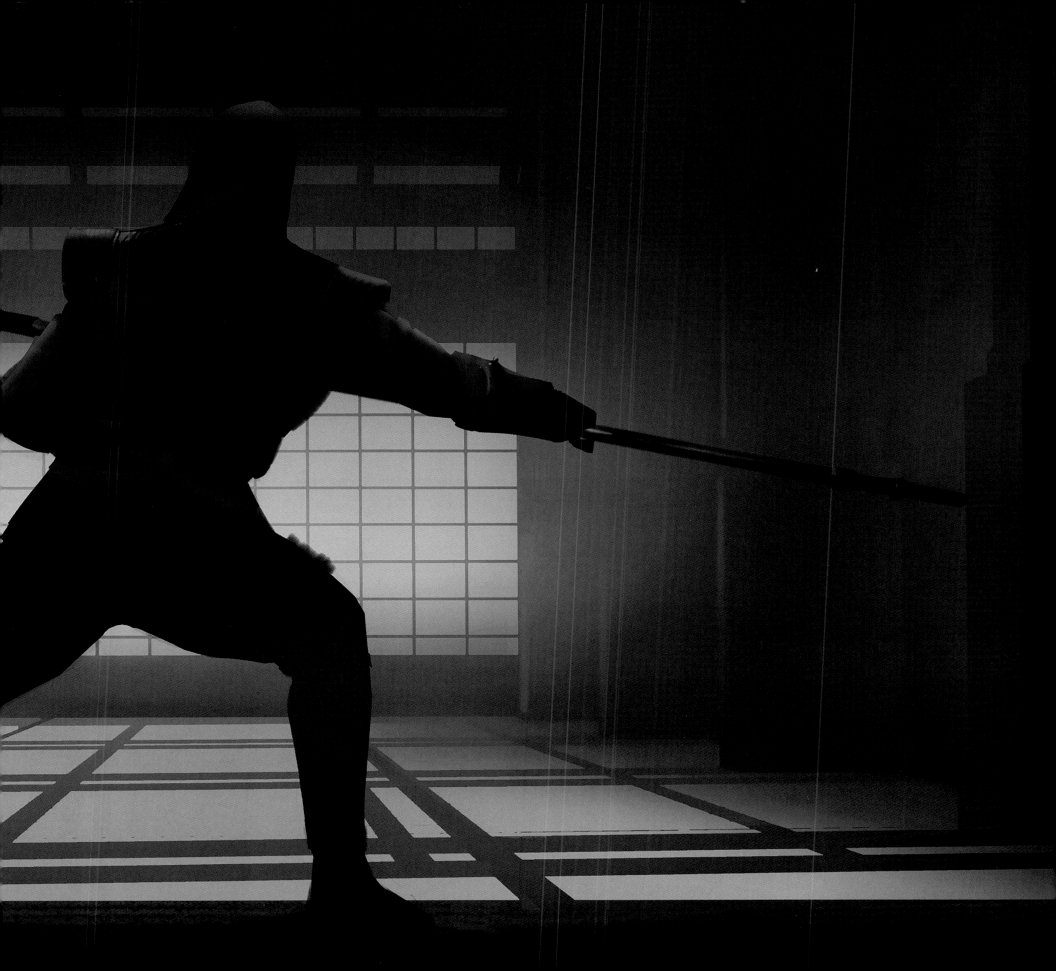

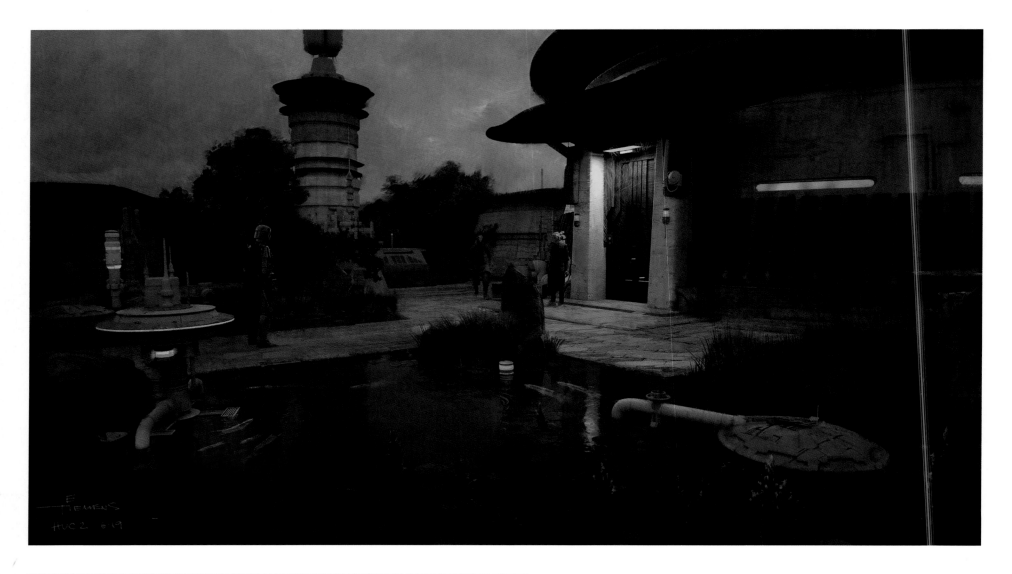

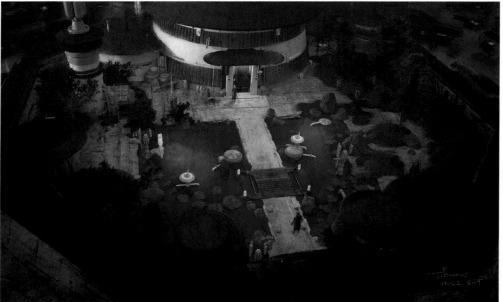

← MAGISTRATE POND VERSION 105
"Here, we took a Japanese Zen garden and put our *Star Wars* touches on it. It contrasts with the devastation outside, the burnt woods and all the trials and tribulations that are literally just outside this courtyard's walls." **Tiemens**

↓ KOI EEL VERSION 317 "We gave the koi a moray-eel look, with a little bit of creepiness to them. On first glance you notice the koi fish patterning, but when you get a good look at it, you realize you don't want to stick your finger in there [laughs].'" **Matyas**

↑ MAGISTRATE POND VERSION 111 Tiemens

"Epic battles always seem to be up on a bridge or a walkway or something with limited space. I also felt like the lightsaber fight would look good with a reflective area of water in the volume. I wanted this nice wide two-shot of Ahsoka and the magistrate approaching each other, so Baz [Idoine, director of photography] and I ran a virtual volume in the volume [using the LED screens to block out the scene's shots utilizing a rough model of the set] and we realized that we're never going to be on the back side of the bridge. Why give all of that space up? So we pushed everything away from the camera." **Filoni**

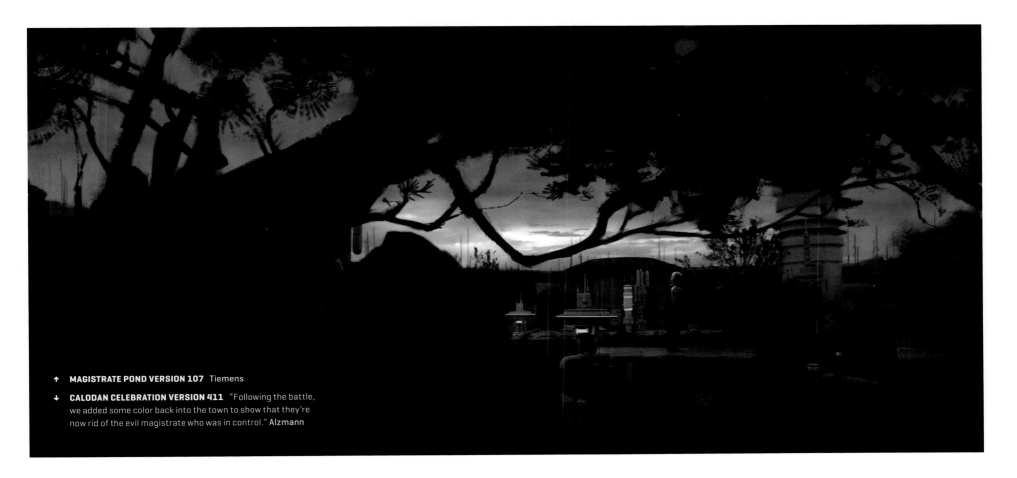

↑ **MAGISTRATE POND VERSION 107** Tiemens

↓ **CALODAN CELEBRATION VERSION 411** "Following the battle, we added some color back into the town to show that they're now rid of the evil magistrate who was in control." **Alzmann**

THE TRAGEDY

Mandalorian culture and lore, greatly expanded upon in Dave Filoni's animated series *The Clone Wars* and *Star Wars Rebels*, can all be traced back to a single figure: Boba Fett.

When Jon Favreau started developing his own *Star Wars* stories, Boba Fett was foremost in his mind. "The idea of Boba Fett emerging from the sarlacc pit, or suggesting that he had survived the sarlacc, was something that I wanted to see.

"There's something really compelling about a person, like Iron Man or the Mandalorian [or Boba Fett], inside a shell of technology. And with weapons developed, in [*Star Wars*] lore, to fight the spiritual and magical qualities of a Jedi, it's an interesting angle: humanity vs. technology. And we're further exploring those things. How do you harness technology? How do you have technology serve humanity? How do you make the world better through it without letting it take you over?

"I don't know that I could have gone in there with a fresh pitch and said, 'I want to make a Boba Fett TV show.' I figured starting off with something very simple and small and of the scale of the original *Star Wars*, the scale of the old Westerns, would leave us someplace to go, because we wouldn't have the responsibility of trying to compete with other big movies. Here, we were just going to tell a small *Star Wars* story and introduce new characters. It gave us a lot more freedom. Now we can bring in established characters and weave them together.

"We knew that Boba Fett was someone who was going to have to be dealt with at some point, especially considering that the first season was about a Mandalorian who is explicitly not Boba Fett," Favreau said. "And it may have been the way that the character was first introduced when I was a kid, but it always felt like there was more to him. There was a lot of fan fiction, a lot of Expanded Universe stuff, as well, so apparently everybody felt the same way."

"Chapter 14: The Tragedy" was the next-to-last script Favreau penned for *The Mandalorian*'s second season, and the episode was among the simplest of the season for the Lucasfilm art department, with only Tython's "Force-henge" and the Empire's stormtrooper transport presenting major design challenges. "Really, the brief was Stonehenge mixed with Vasquez Rocks [Natural Area Park] (a frequent *Star Trek* shooting location) in Southern California," Doug Chiang recalled. "And how do we make that our own?" During this time, the Lucasfilm art department also enlisted concept artist Benjamin Last, who contributed to Chapters 14 and 15.

Favreau approached independent filmmaking legend Robert Rodriguez to direct Chapter 14. "Remember, Rodriguez and Quentin Tarantino were the two new young directors who were doing the exciting stuff [in the nineties]," Favreau said. "And they're also people who are intrigued by genre. They aren't snobs. They're into sci-fi and pulp and Westerns, Leone and Peckinpah. So we're all coming from the same frame of reference. When I was coming up, he was *the* guy. Even while we were making *Swingers* [Favreau's 1996 breakthrough film as writer-actor], we were reading his book [*Rebel Without a Crew*] about how he made *El Mariachi* [Rodriguez's 1992 directorial breakthrough]. Over time, you become part of the same community of filmmakers and you get to know one another, but we'd never worked together before. When I pitched the idea of possibly doing this, he was like, 'Hell, yeah.' And Boba Fett was a character that he really connected with.

"Robert got more and more involved to the point that we're working together beyond just an episode," Favreau said. The end-credits scene for *The Mandalorian*'s second season finale, which first aired December 18, 2020, teased *The Book of Boba Fett*, coming December 2021, with Rodriguez joining Favreau and Filoni as an executive producer.

← **FORCE-HENGE BABY GRAB VERSION 292**
Alzmann

→ **SHRINE STEPS VERSION 127** "When you sketch out a design, there's less invested. But you get your idea across quickly. I might color them or tint them digitally. But if they look like they're done really quickly, on sort of crumbly tracing paper, that's just a straight-up hand drawing [on paper]." **Tiemens**

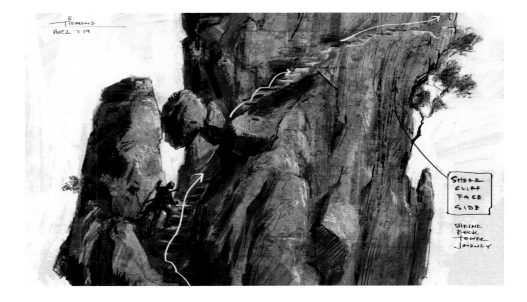

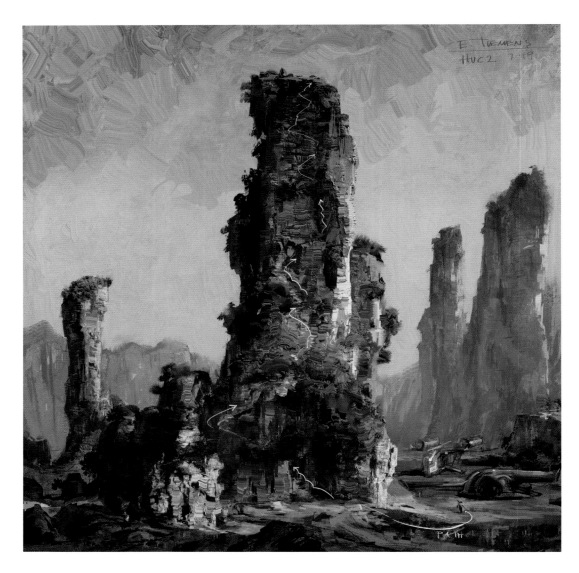

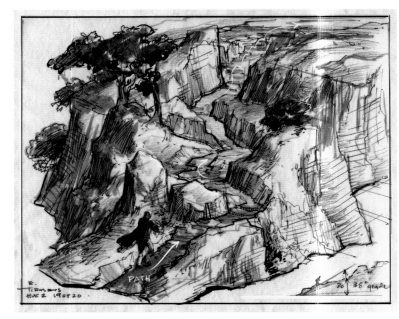

↑ **FORCE-HENGE VERSION 151** Tiemens

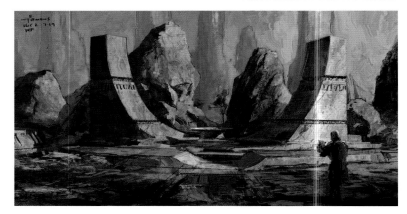

↑ **SHRINE VERSION 128** Tiemens

↑ **SHRINE VERSION 129** "[My work on] the parks [*Star Wars* Galaxy's Edge] might have been brushing off on me here. I love the idea of a place that is mystical, in that realm of the Jedi. They have to climb up, get to a spot that's special, like a hermitage in Greece, where it's not in an obvious place." **Tiemens**

→ **FORCE-HENGE VERSION 237** "I took some inspiration from Scotland's famous Loudoun Hill, where Robert the Bruce fought and won a battle in 1307." **Alzmann**

"We wanted to communicate that these rocks are helping to channel the Force energy, so we angled them in to look like a funnel that can direct and focus that energy, not unlike Vader's castle or the Jedha temple's [from *Rogue One*] 'tuning forks.' It all has that same form language." **Chiang**

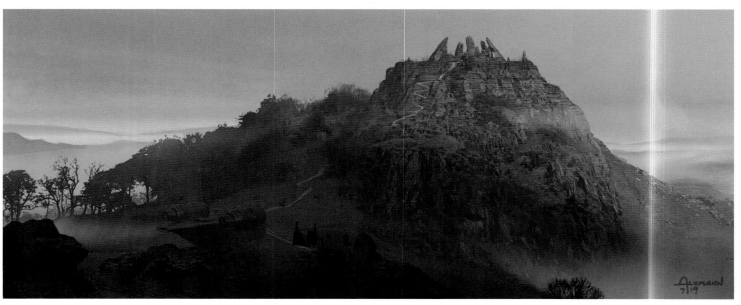

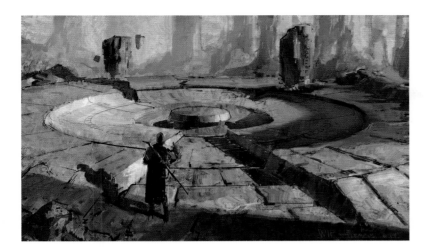

↑ **ROCK TOWER SHRINE VERSION 125**
"I was thinking, 'Well, maybe it's this dish, like what we saw in [Ahch-To's Jedi temple in] Episode VIII, but expanding on that idea.' It's almost like the Indian mathematical astronomy engravings that convey the movement of the sun, all of those scientific but artistic-looking things carved into stone." **Tiemens**

→ **FORCE-HENGE VERSION 137** Tiemens

"This blocking model from Erik informed the whole set. We took out the steps, made it more natural, but that was really the only thing that changed. What we see beyond that is all LED content. But hopefully it's all seamless on-screen." **Chiang**

↓ **FORCE-HENGE VERSION 148** Tiemens

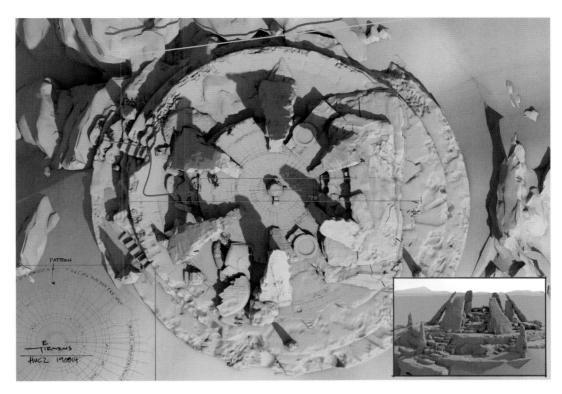

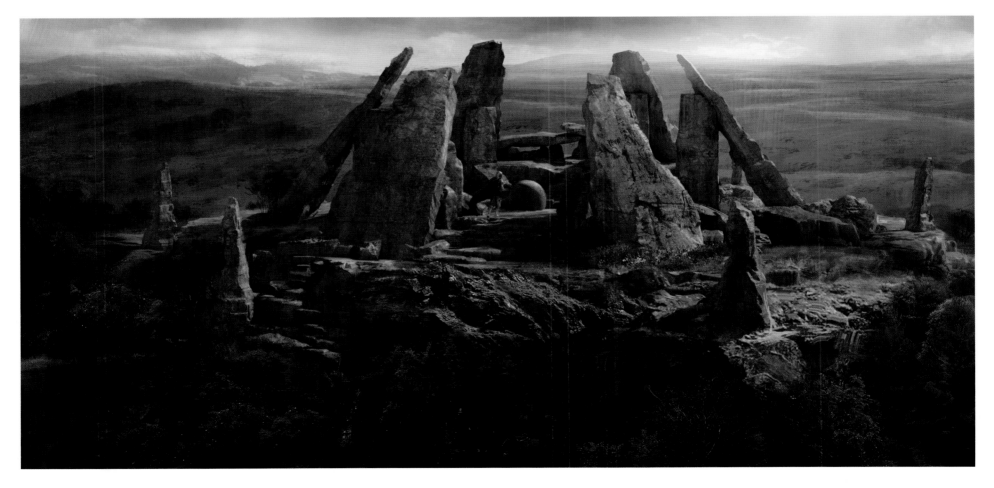

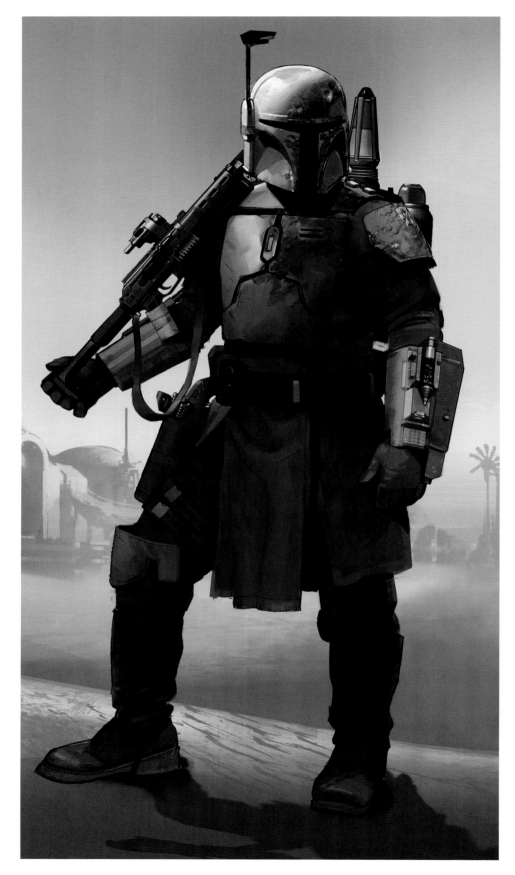

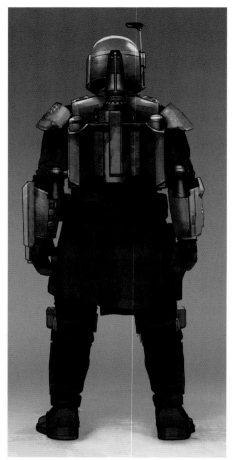

↑ **BOBA BACK VERSION 01** Matyas

↑ **BOBA 02** Uwandi and Trpcic

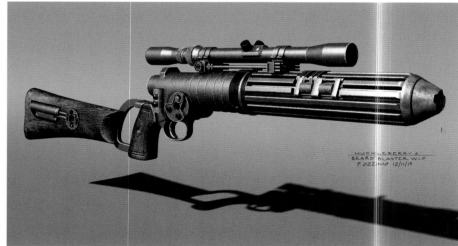

↑ **BOBA BLASTER RIFLE VERSION 01** Ozzimo

← **BOBA VERSION 19** "If the sarlacc digests its meals over a thousand years, I would imagine that the acidification takes a while, right? So how much of Boba Fett's paint is now going to be worn off? Is it going to start bubbling? Is it going to be just wiped clean? Was he lying in the bile on his side and now half of the paint is missing? I referenced the Hot Toys eighteen-inch Boba Fett figure for this, and posing him and then painting and getting all those details in was really fun to explore." **Matyas**

↑ **FENNEC WOUND VERSION 323** "I remember when Luke gets his hand shot in *Return of the Jedi*, you see some charred skin. It's all black, so it doesn't look like actual meat, but it still looks painful. I was trying to explore something similar with Fennec's abdomen wound, the cybernetics and the repair job in there." **Matyas**

→ **FENNEC INTERIOR VERSION 02** Uwandi, Trpcic, and Matyas

↓ **FENNEC WOUND VERSION 331** Matyas

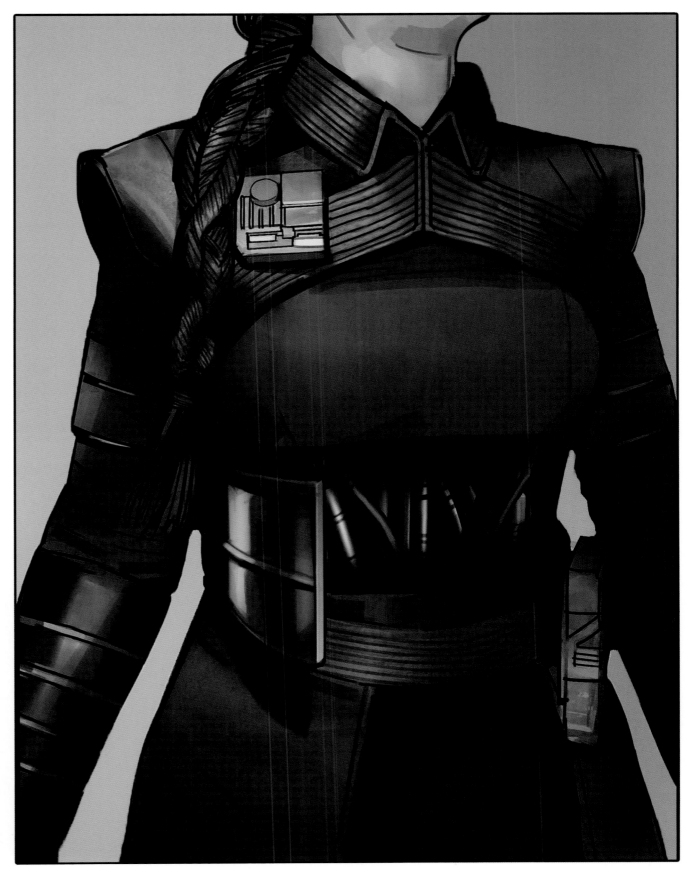

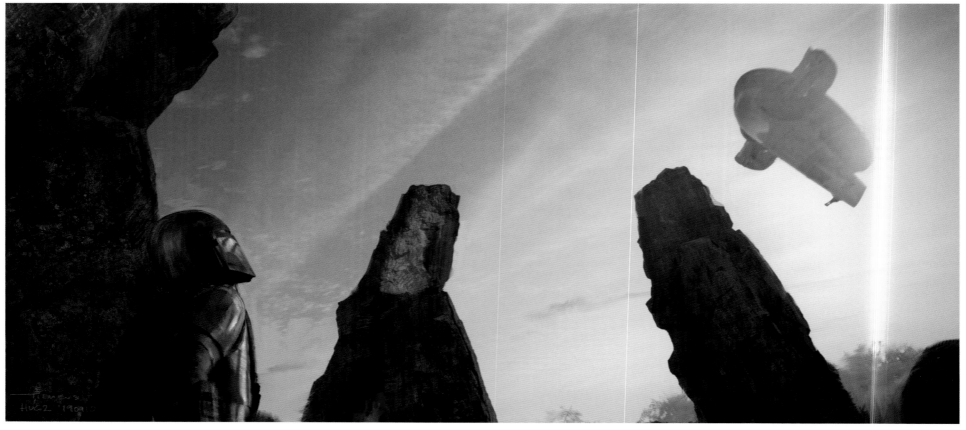

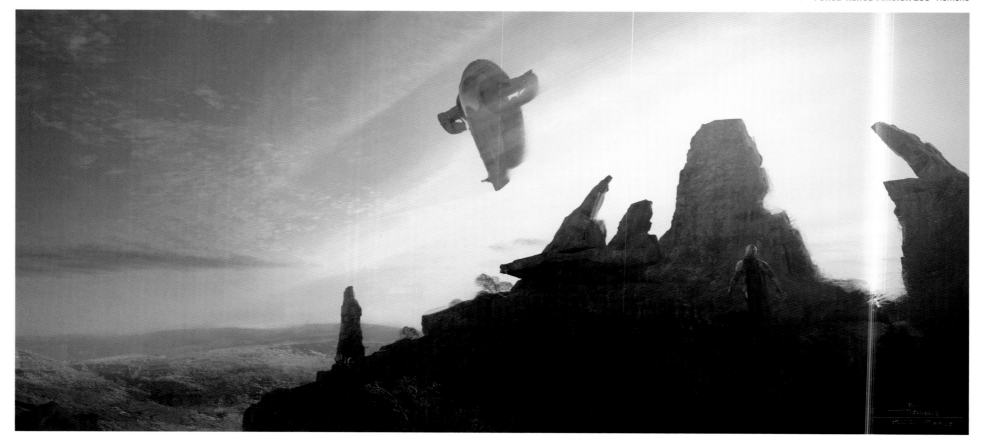

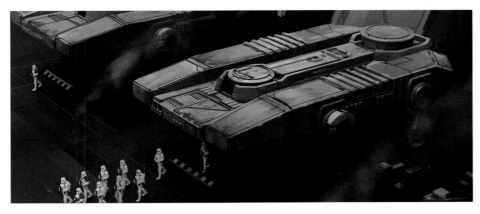

↑ **DEPLOYMENT VERSION 19** Benjamin Last

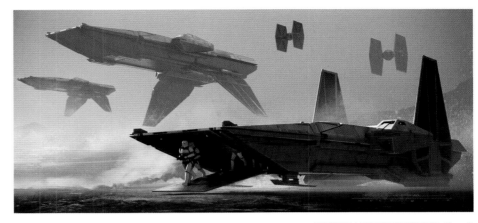

↑ **IMPERIAL LANDER VERSION 01** Church

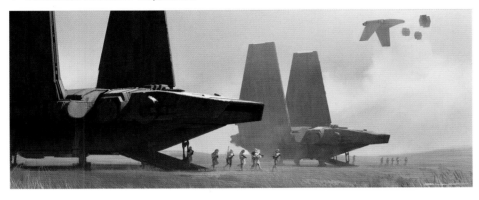

"We have a new Imperial transport for our troopers. This was supposed to be the precursor to the First Order troop transport [first seen in *The Force Awakens*], our version of a Higgins landing craft [extensively used in World War II, most famously on D-Day's Normandy beach landings]." **Chiang**

↑ **LANDED VERSION 26** Last

→ **ORTHO VERSION 50** Last

↓ **LANDED VERSION 49** Last

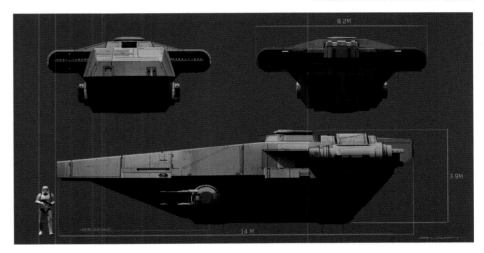

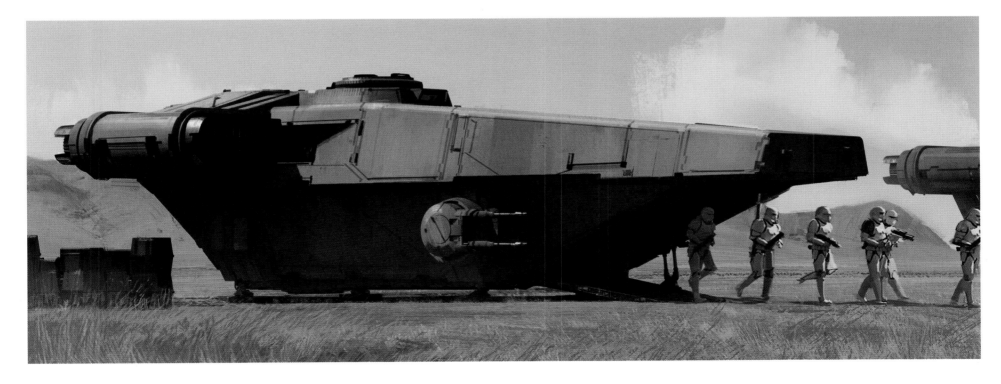

Imperial dark troopers first appeared in 1995's *Star Wars: Dark Forces* computer game. *The Mandalorian*'s second season marked the first live-action appearance of dark troopers in *Star Wars*.

→ **DARK TROOPER VERSION 152** "I wanted the dark troopers to feel like guys in armor, more than full-on robots. It's fun whenever you get to do stormtroopers of any kind, which I haven't really gotten to do too much." **Matyas**

"Dark troopers have very unusual robotic proportions. And the challenge was, how do we capture that, translate that into a live-action world?" **Chiang**

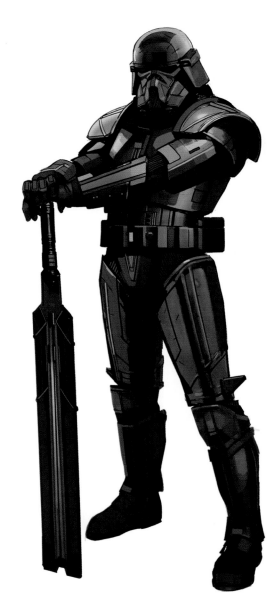

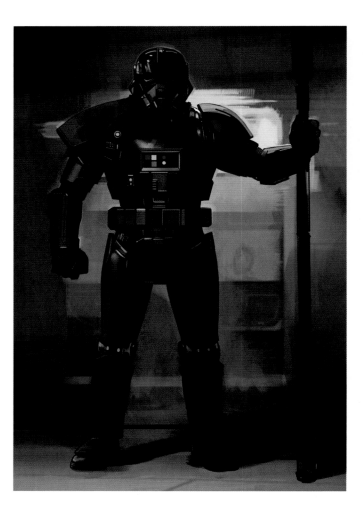

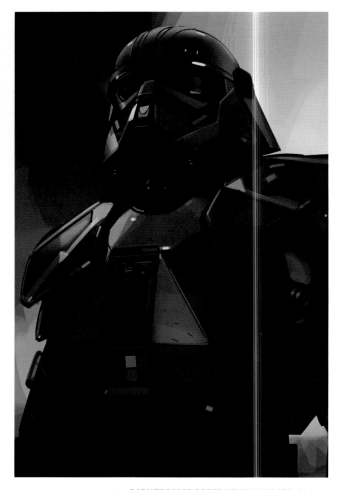

↑ **DARK TROOPER PORTRAIT VERSION 158** Matyas

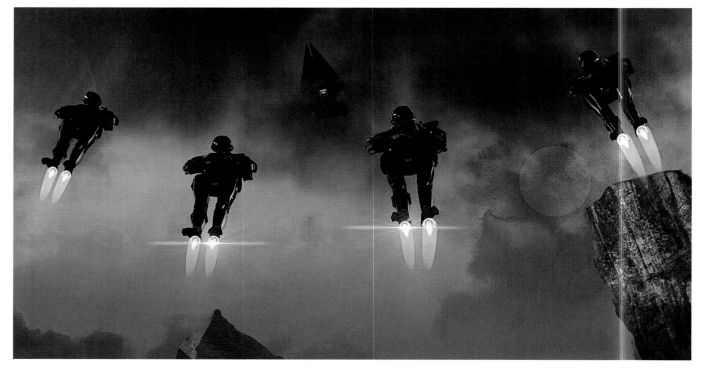

↑ **DARK TROOPER VERSION 154** Matyas

→ **TROOPER DROP VERSION 283** Alzmann

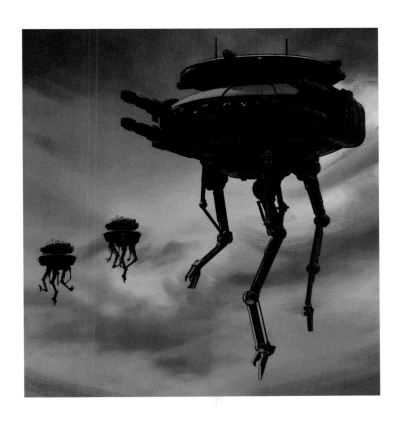

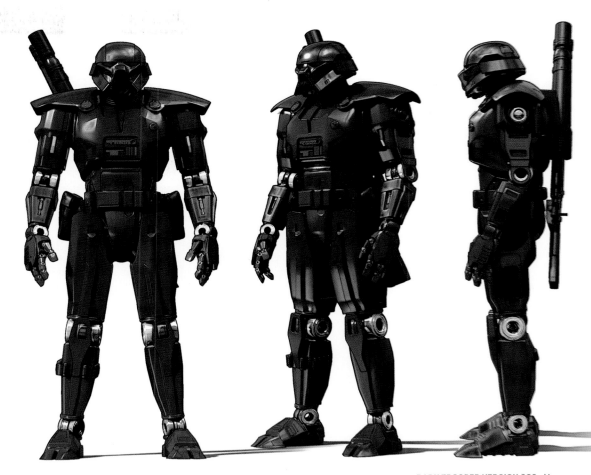

↑ **MEGA PROBE DROID VERSION 256** Alzmann

↓ **ATTACK VERSION 244** "Doug asked for a 'mega probe droid' to drop down as support for the dark troopers." **Alzmann**

↑ **DARK TROOPER VERSION 208** Alzmann

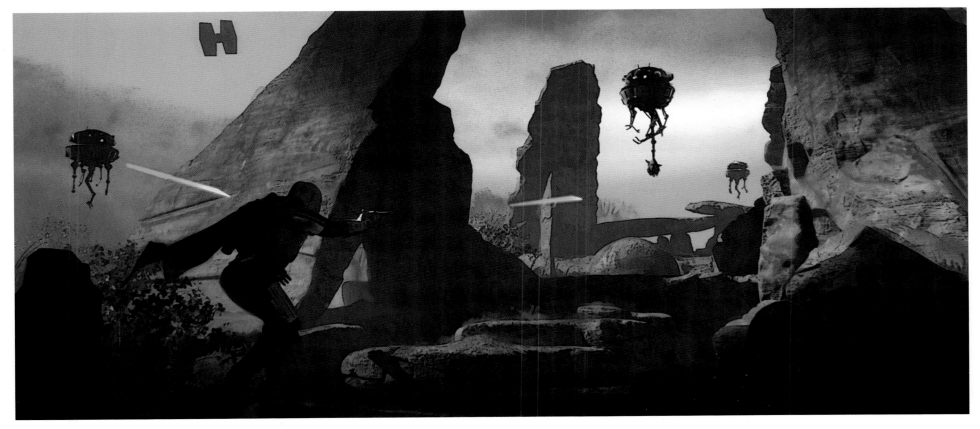

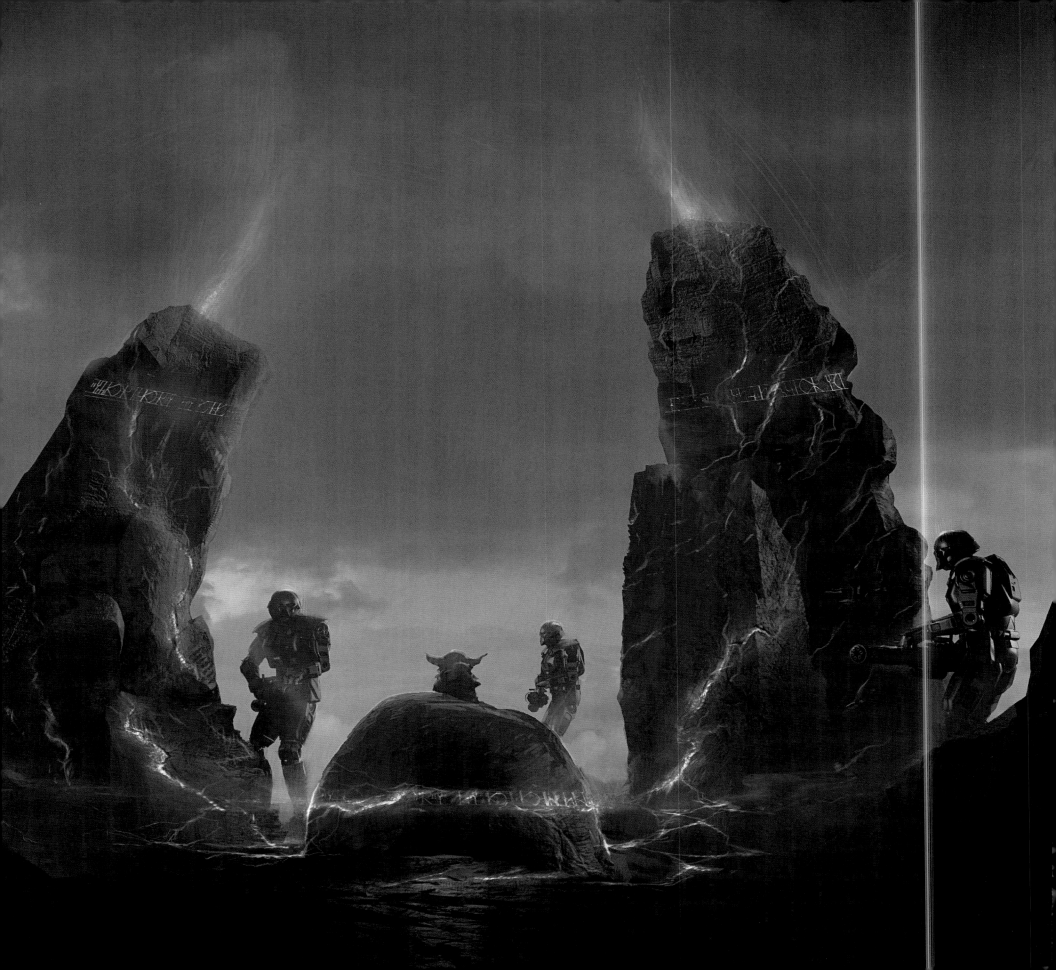

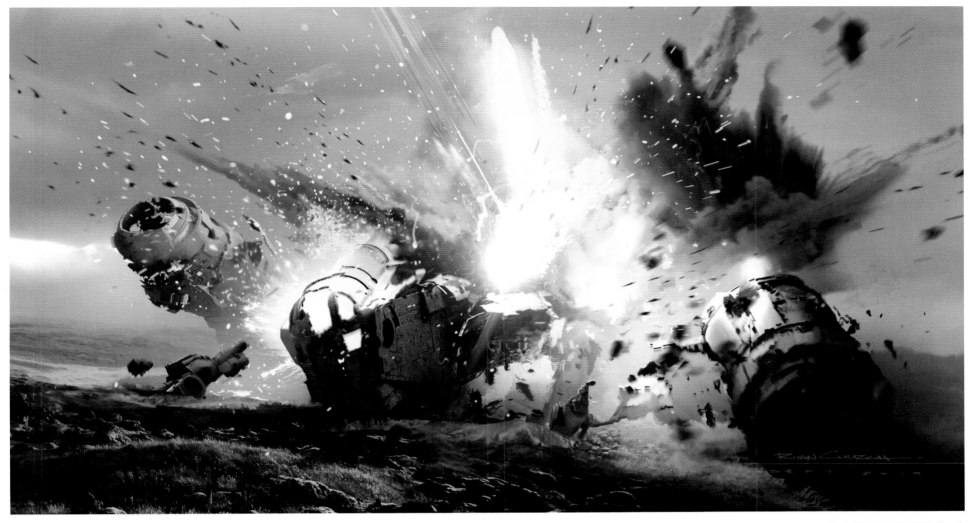

↓ **RUINS VERSION 268** Church

↑ ***RAZOR CREST* DESTRUCTION VERSION 198** "Doug came to me [as designer of the *Razor Crest*] and said, 'I think Jon's talking about the *Razor Crest* getting destroyed.' And I said, 'Oh, you mean, 'And then it comes back, right?' Doug's like, 'No, it really gets blown up.'" **Church**

← **HIEROGLYPHS VERSION 369** Alzmann and Tiemens

↓ **RUINS VERSION 245** Church

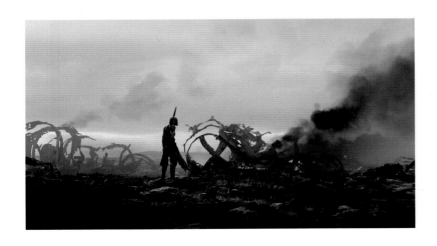

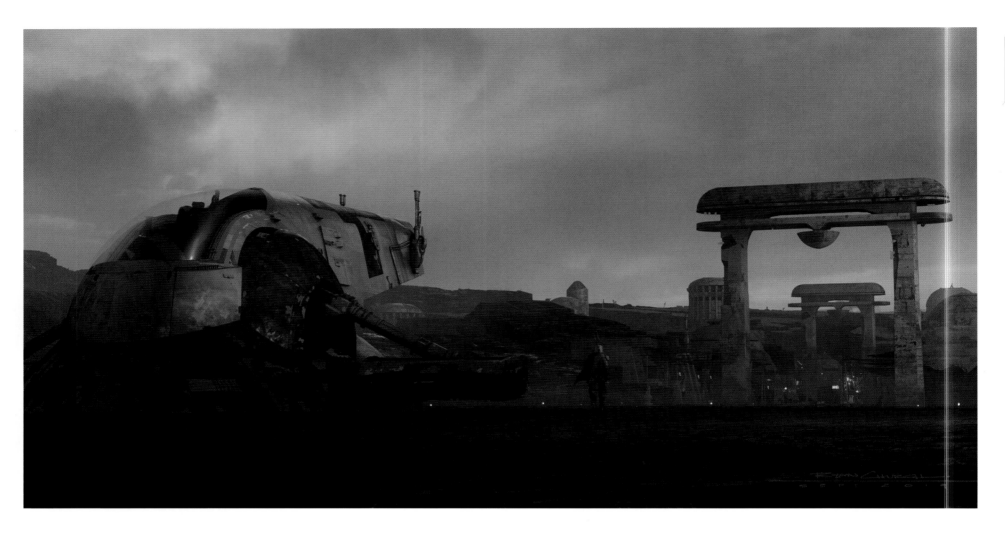

↑ **FIRESPRAY ARRIVAL VERSION 256** Church

← **SHERIFF OFFICE VERSION 377** Grandert

↓ **SHERIFF OFFICE VERSION 387** "I put a little workbench in [Cara's office], where I picture her modding weapons and armor." Grandert

"Cara Dune's office is a redress of Greef Karga's—same set but different set dressing. We always try to get the most mileage out of our sets, so we brought in the jail cell door from Mos Pelgo. The thinking was, 'Okay. Since we have it, we'll use it.' As the sheriff of the town, she would have a jail cell." Chiang

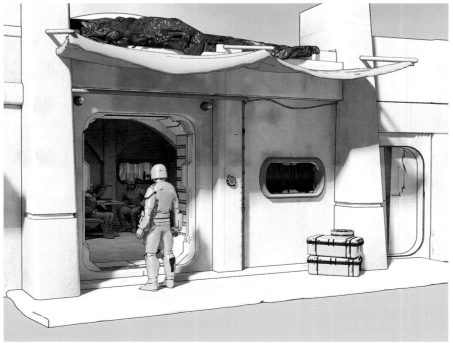

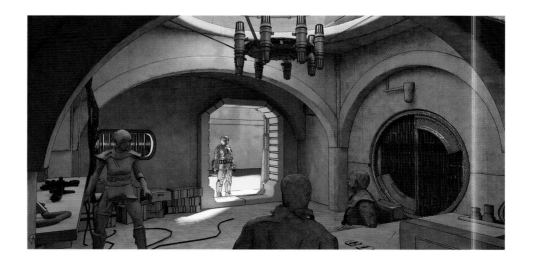

STARSHIP INTERIOR VERSION 146 "This is my version of the interior. I went in a pretty different direction from what Ryan ended up doing." **Alzmann**

"The only interior that had really been designed before was the cockpit, and we knew that when Boba was in the landing position, he was on his back, and then in flight, he was vertical. We thought, 'Well, how should that affect the inside? Should it transform?' Once we decided that it should, the challenge became, 'What should move and what should not?' Ryan Church cracked it." **Chiang**

COCKPIT AFT VERSION 166 "In a lot of—especially Russian—fighter planes, they have a white vertical line painted in the cockpit, so that when you're completely disoriented and you have two percent brain capacity because you're pulling Gs and you're shot, you can still see this white line and put the stick there. And it works. It's saved many pilots. In this design, having a yellow stripe down the middle evokes that. When the ladder is going in two directions, that's when you know we're in a zero-G or rotating environment. That says 'space.'" **Church**

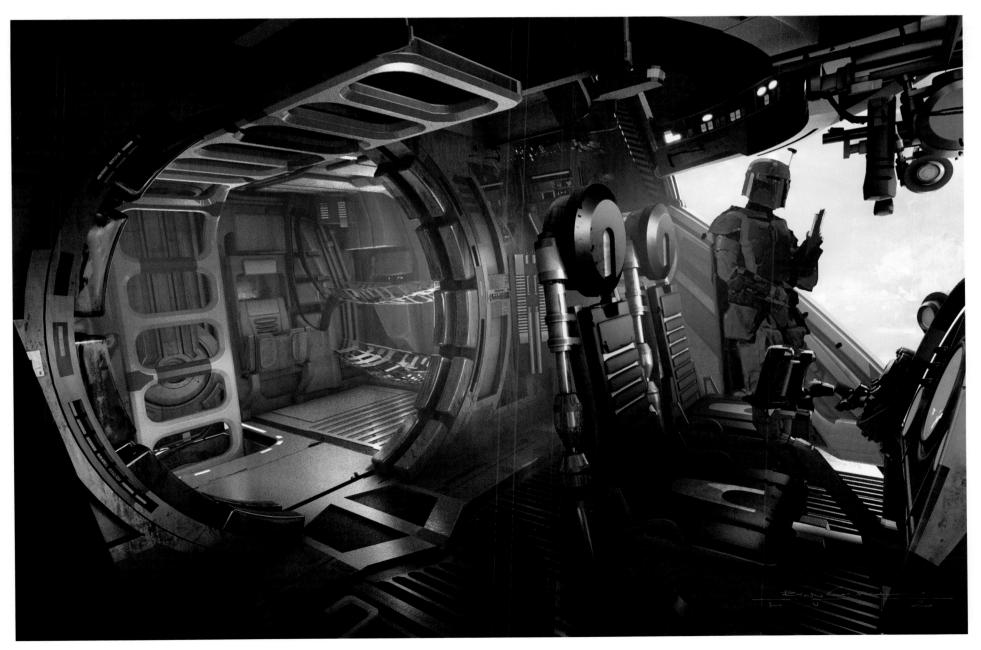

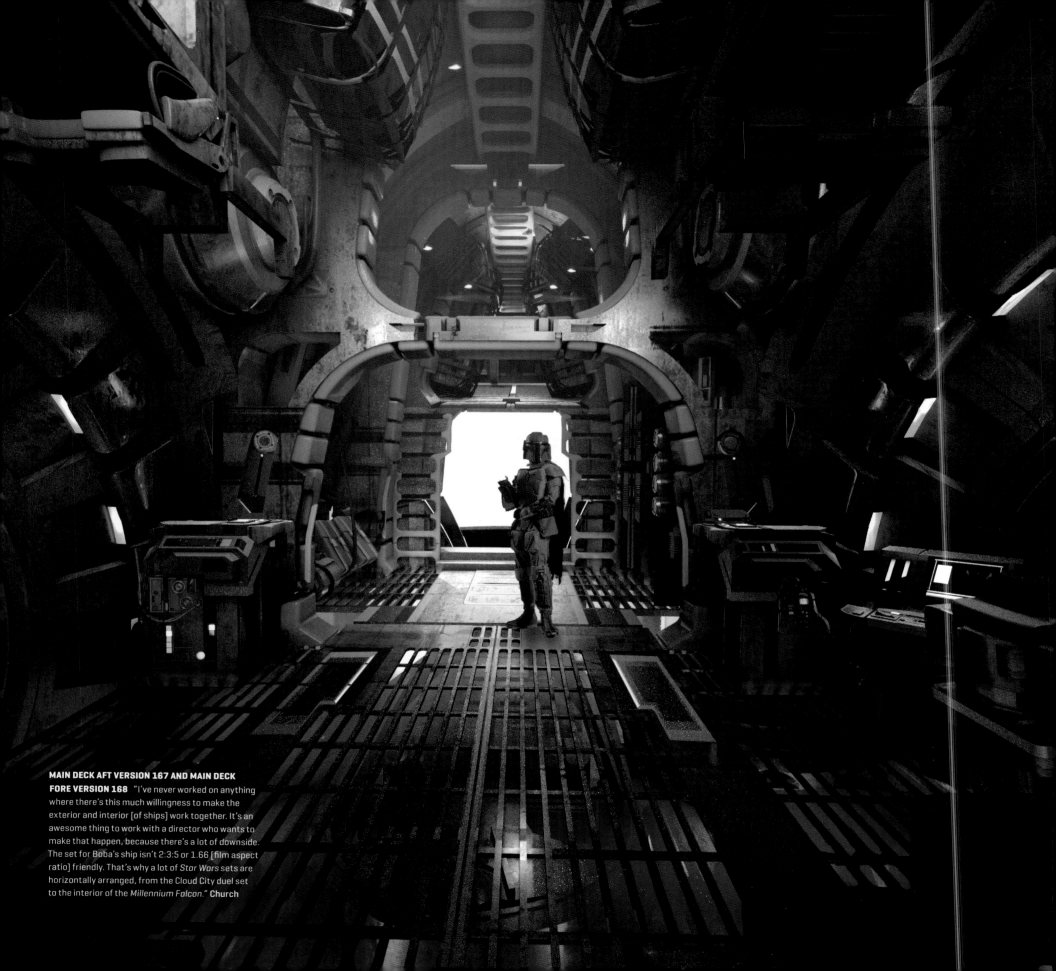

**MAIN DECK AFT VERSION 167 AND MAIN DECK
FORE VERSION 168** "I've never worked on anything
where there's this much willingness to make the
exterior and interior [of ships] work together. It's an
awesome thing to work with a director who wants to
make that happen, because there's a lot of downside.
The set for Boba's ship isn't 2:3:5 or 1.66 [film aspect
ratio] friendly. That's why a lot of *Star Wars* sets are
horizontally arranged, from the Cloud City duel set
to the interior of the *Millennium Falcon*." **Church**

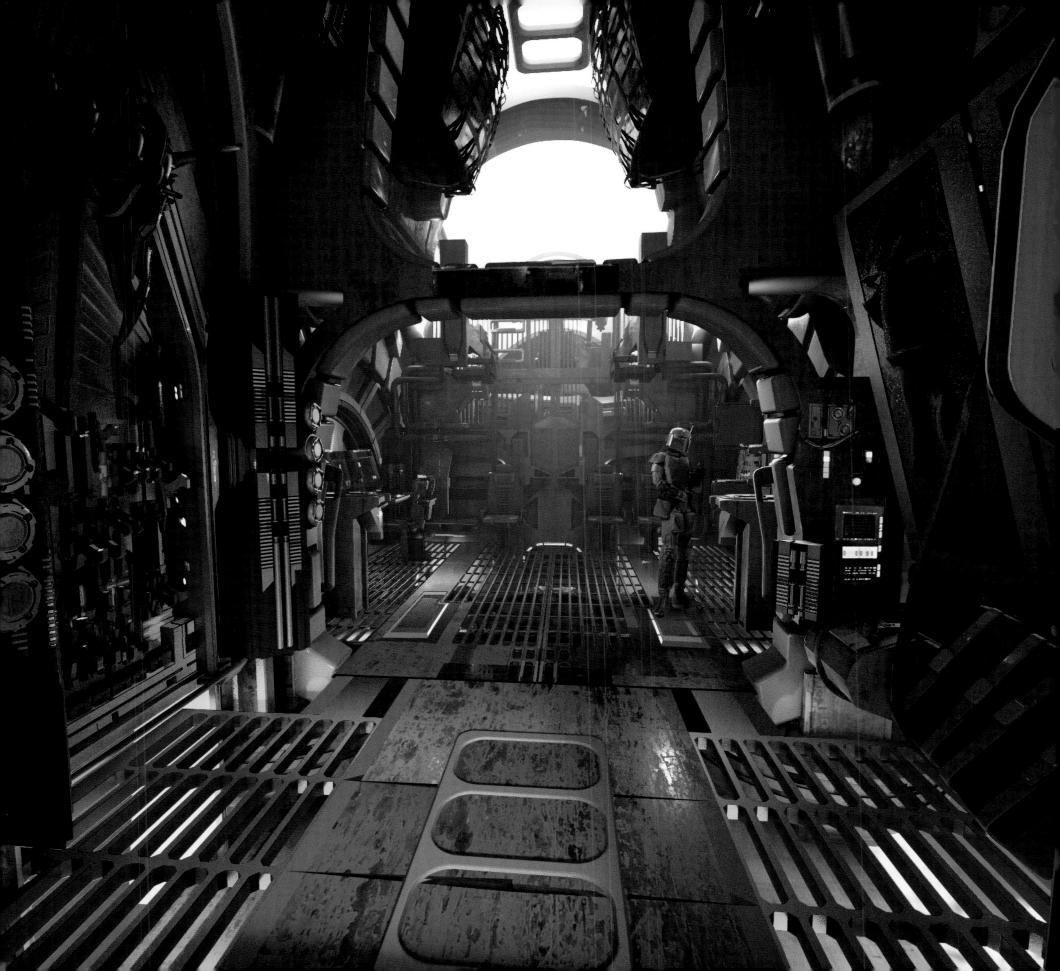

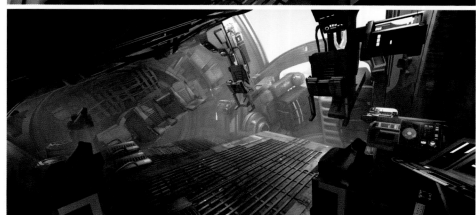

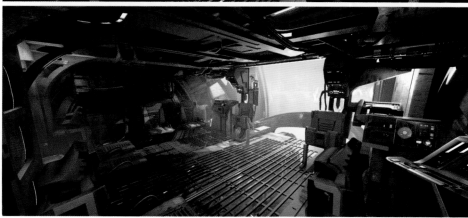

← **MAIN DECK QUARTERS 1 (VERSION 169), 3 (VERSION 171), 4 (VERSION 171), 5 (VERSION 172)** "We're doing the interior forty years after the exterior, and it's awesome to see the top light become a front light." Church

↑ **INTERIOR COCKPIT LANDED VERSIONS 149 AND 150** "You can do any design on paper, but to make a design feel like it could move? That's the *Star Wars* mantra: Make it feel like it could do it, even though it can't. My original idea was to

go in and make quite an alien-looking spaceship, with a different form language than we'd seen, but the heavy lifting was done by having it rotate. And then, having the exterior wing axle be the hub through which everything else rotates on the ship, basically. So, when you're sitting inside the ship, you immediately know where you are in relation to the exterior [due to the rotating platform being flanked by the two wing hubs]. You're immediately seeing it work." Church

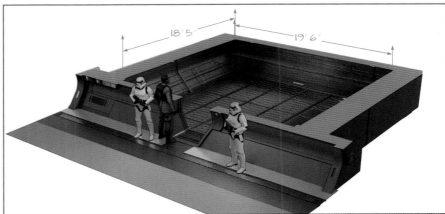

↑ **HOLDING CELL VERSION 271** Alzmann

"The design inspiration for this is Leia's prison cell on the Death Star. We just enlarged the cell to accommodate the action." **Chiang**

→ **FORCE SHACKLES VERSION 01** Ozzimo

↓ **HOLDING CELL VERSION 266** "This is the baby in his cell, just taking out stormtroopers." **Alzmann**

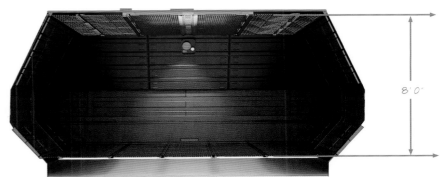

↑ **HOLDING CELL VERSION 273** Alzmann

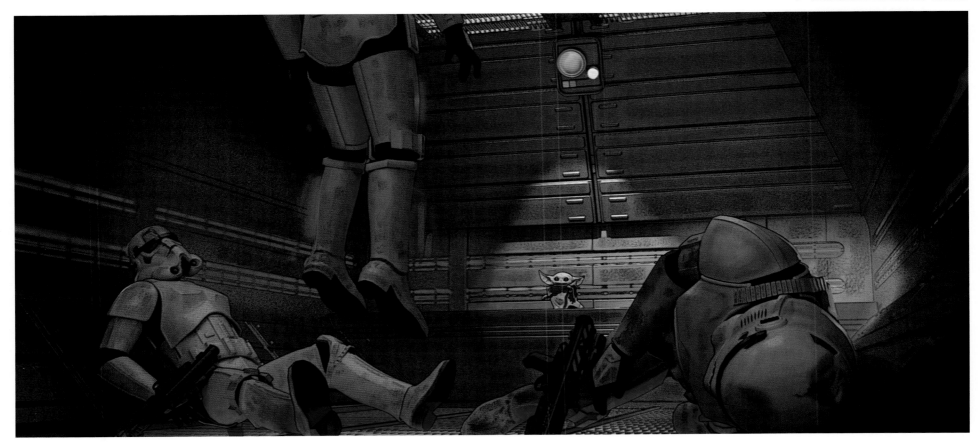

THE BELIEVER

The Mandalorian Season 1 director Rick Famuyiwa returned for Season 2's "Chapter 15: The Believer," which he also wrote.

"Texturally, most of the planets for Season 2 are very rich, very distinct," Doug Chiang explained. "For Chapter 15, we wanted to create a new planet, our lush planet. We leaned into Hawaii, thinking that would be a really good look for this," and areas of both Oahu and Kauai, Hawaii, were scouted as potential locations for ILM photogrammetry (three-dimensional environments pieced together from thousands of location photographs).

Ultimately, it was the Valle de la Muerte, or Valley of Death, outside of San Pedro de Atacama in Northern Chile that virtual production visualization supervisor Landis Fields, environments visual effects supervisor Enrico Damm, and visual effects artist Giles Hancock journeyed to for Season 2, capturing photogrammetry for the desert landscape surrounding Chapter 9's Mos Pelgo. For Chapter 15, pre-existing photogrammetry of the Maldives islands, originally shot for *Rogue One: A Star Wars Story*, was instead utilized by ILM to represent Morak's dense jungle, layered into scenes shot on *The Mandalorian*'s Los Angeles backlot, as well as computer-generated post-production establishing shots. As with previous episodes in the series, scenes taking place in direct sunlight, which, for Chapter 15, included the Mandalorian and Migs Mayfeld's passage through the jungle, the action sequence atop the Juggernaut transport, the ridge where snipers Cara Dune and Fennec Shand were camped out, and the rooftop of the Imperial refinery, were filmed on the backlot, as that quality of light remains difficult for the StageCraft volume's LED screens to replicate.

The StageCraft LED volume did receive some substantial upgrades for *The Mandalorian*'s second season, most obvious being its relocation to a larger soundstage to accommodate its new oblong shape (as opposed to the round volume utilized on Season 1), increasing its overall capacity by a third. "The physical volume was bigger and the resolution of the displayed content was increased considerably due to additional machine hardware and render engine improvements over Season 1," visual effects supervisor Richard Bluff said.

Chapter 15 sequences shot in the upgraded StageCraft soundstage include the Karthon Chop Fields where Mayfeld is imprisoned, the interior of the rhydonium mine the Juggernaut transport passes through, and the massive Imperial refinery interior and its adjoining officers' mess hall, a combination volume and traditional set build, respectively. It was that Imperial refinery set, including the full-size Juggernaut cab build abutting the LED screens, that the Lucasfilm art department walked onto during their Season 2 set visit. "[My experience designing the Juggernaut] culminated in going to see it on the set," Ryan Church recalled.

↗ **JUNGLE PIRATE ALIEN VERSION 302** Matyas

← **MANDO SAVES MAYFELD VERSION 345** Matyas

"Originally, Mando and Mayfeld were going to be on the Juggernaut transport as they're escaping and they're saved by Boba Fett, but this moment is now up on top of the facility." **Chiang**

"And you're like, 'Well, there it is.' You're looking up at it. And then you climb up in it (the Juggernaut cockpit was seven feet and three inches off of the stage floor). Everything looks ten times better than you thought it would." The entire art department, myself included, piled into the Juggernaut cab during their brief time in the volume, momentarily disrupting the mess hall scene being shot with actors Pedro Pascal and Bill Burr.

Along with Season 2's StageCraft enhancements, *The Mandalorian*'s physical miniatures team also upped their game, particularly in Chapter 15. "We shot more of our Season 1 *Razor Crest* miniature, as well as a new five-foot Imperial light cruiser that John Goodson and Dan Patrascu built and [ILM visual effects supervisor] John Knoll shot using a garage-built motion control camera rig he developed for Season 1, nicknamed the 'K-flex' [a riff on the 'Dykstraflex' motion control camera system pioneered by special effects supervisor John Dykstra for *A New Hope*]," Bluff said. "And Jason Mahakian teamed up with Landis on a [Karthon Chop Fields] junkyard tabletop miniature that VFX scanned and transferred into a computer-generated set to be displayed on the LED volume wall."

Not to be outdone, *Star Wars* original trilogy animator, designer, and *Return of the Jedi* ILM creature shop supervisor Phil Tippett's Tippett Studio, which recently contributed holographic creature chess animation to *Star Wars* films from *The Force Awakens* to *The Rise of Skywalker*, designed and stop-motion-animated walkers that were composited into the deep background of the Karthon Chop Fields. Tippett was an animator for the original *Star Wars* walkers, the Imperial AT-ATs, for 1980's *The Empire Strikes Back*.

Rick Famuyiwa's "Chapter 15: The Believer" premiered on the Disney+ streaming service December 11, 2020.

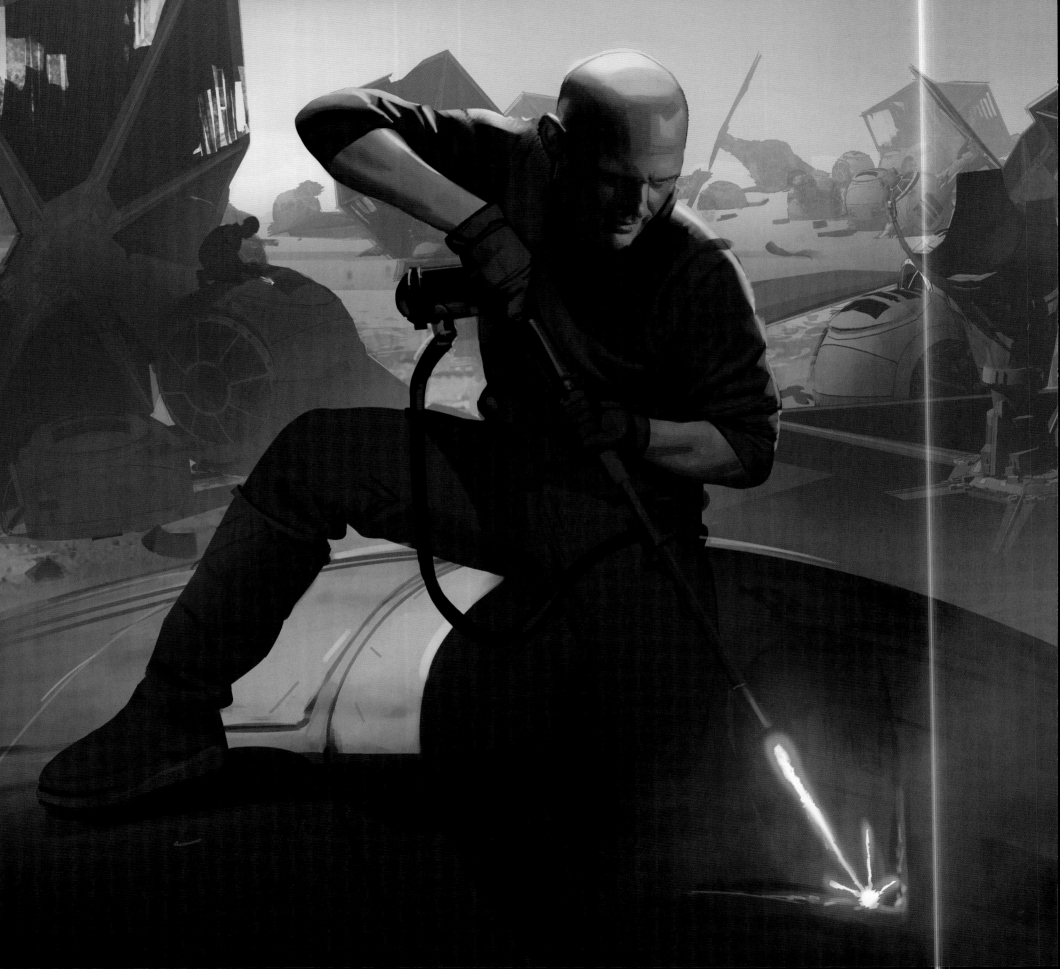

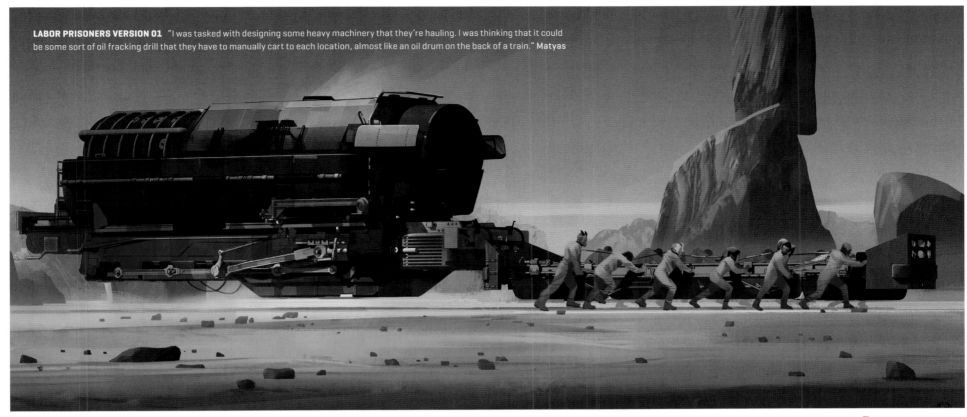

LABOR PRISONERS VERSION 01 "I was tasked with designing some heavy machinery that they're hauling. I was thinking that it could be some sort of oil fracking drill that they have to manually cart to each location, almost like an oil drum on the back of a train." **Matyas**

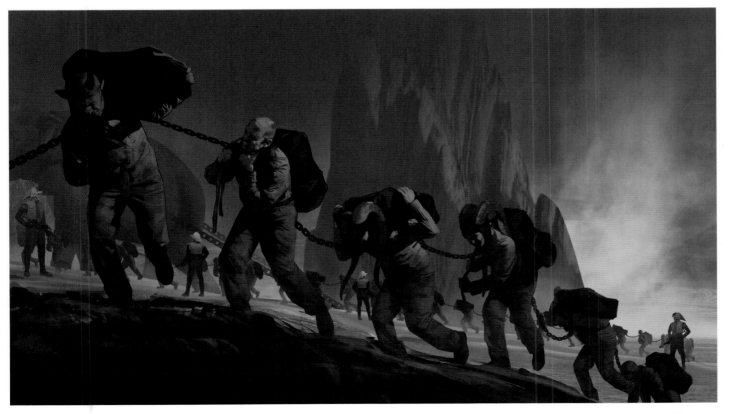

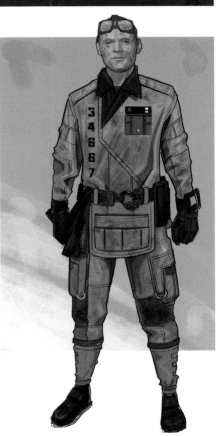

← **MAYFELD LABOR VERSION 248** Matyas ↑ **LABOR PRISONERS VERSION 07** Matyas ↑ **PRISONER MAYFELD** Uwandi and Trpcic

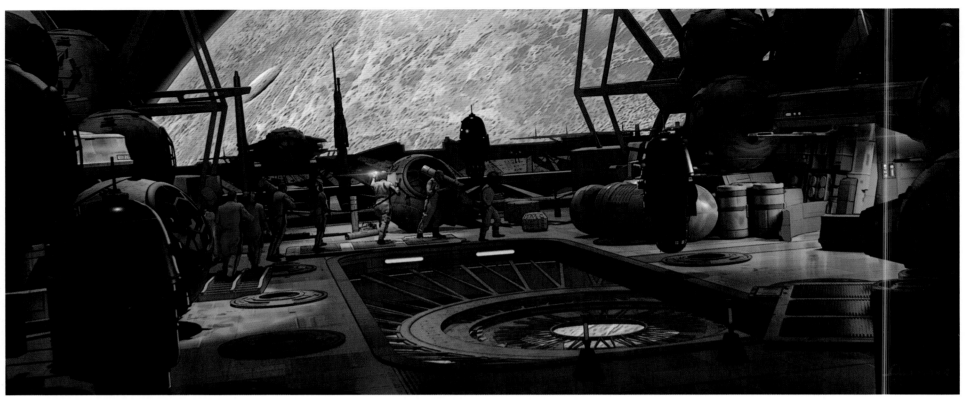

↑ **ORBITAL PRISON DROP VERSION 284** Alzmann

↑ **ORBITAL PRISON DROP VERSION 286** "This was the orbital platform. And then Mayfeld [gets thrown off by a reprogrammed prison droid], does a chute slide like Luke [in *The Empire Strikes Back*], and gets rescued." Alzmann

→ **PRISON GUARD VERSION 607** "I essentially took the New Republic security droids that Christian designed [for Chapter 6: "The Prisoner"], designed some batons for them, and painted them slightly differently." Matyas

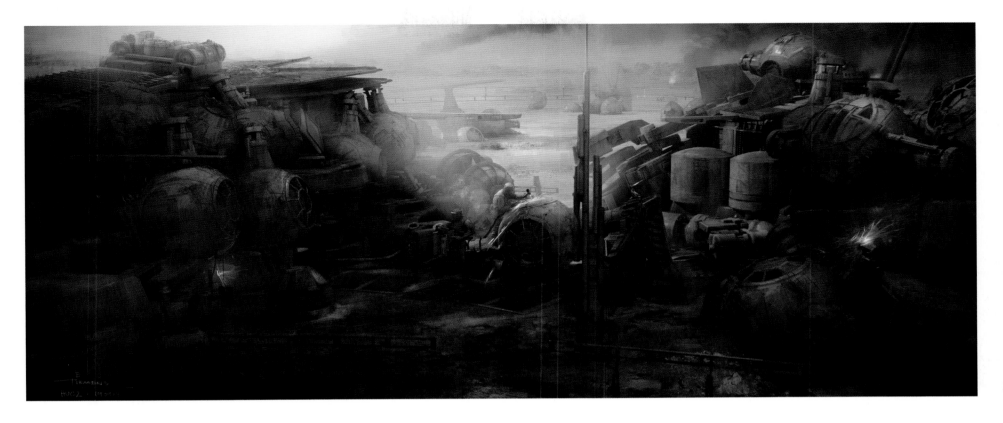

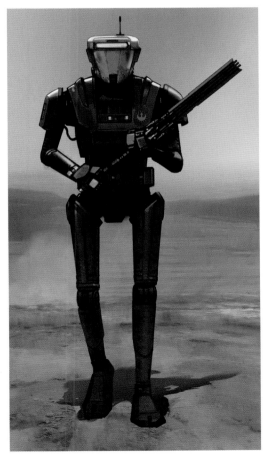

↑ SHOCK BATON VERSION 606 Matyas

↓ GARBAGE DRAIN VERSION 365 Tiemens

"We built a miniature set that was scanned and used as the LED content on the seventy-foot volume, which was *extremely* successful. In an early version of the story, Mayfeld goes down a tube and comes up through this sewer tunnel in the center of the set; that's where he escapes." **Chiang**

↑ CHOP SHOP VERSION 187 "There were some early passes I did on Episode VII of an almost Venetian water-logged junked-out area, where they're recycling Imperial ships [as seen in *The Art of Star Wars: The Force Awakens*], so it wasn't too far off to then make this jump. Wouldn't it be visually appealing in this junkyard if all of these remnants are scattered out like a boneyard? Aircraft paraphernalia and ships and fuselages." **Tiemens**

"The design brief was an Imperial chop shop where prisoners are doing hard labor, like the ship-cutting yards in India, but specifically with TIE fighter balls and other Imperial things in the background. We wanted to make it look like a car junkyard." **Chiang**

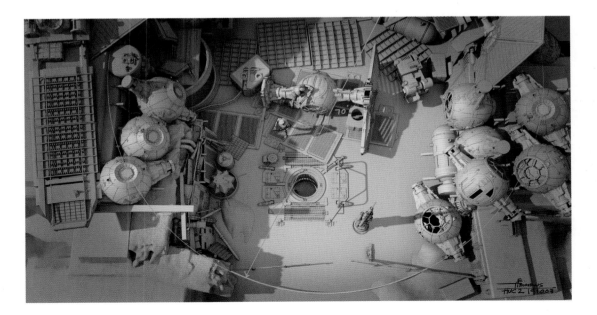

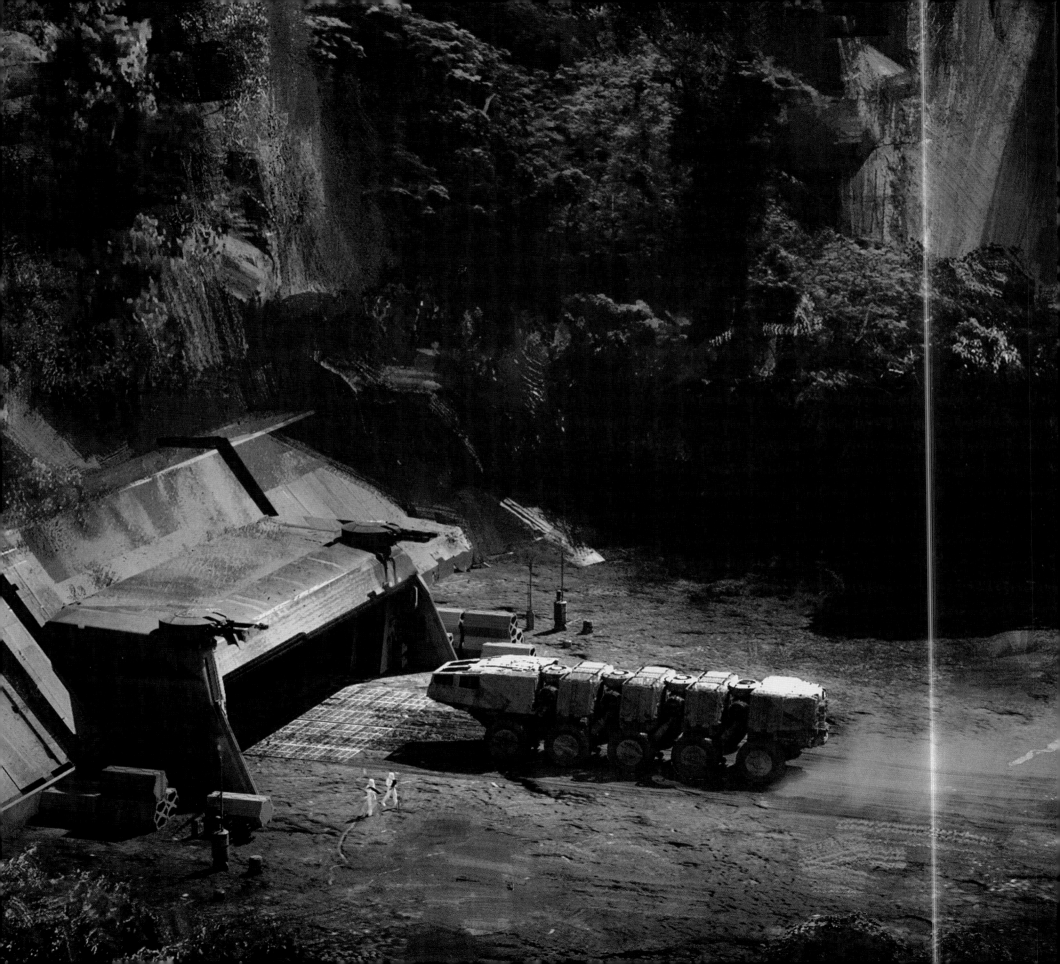

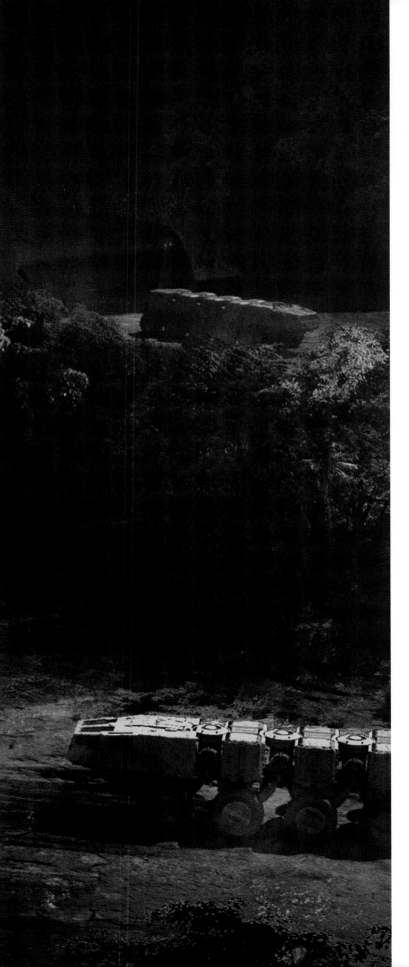

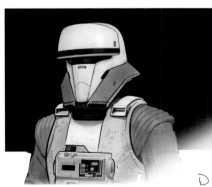

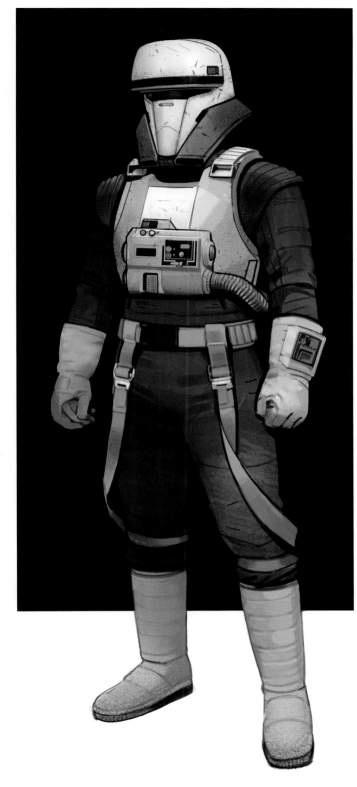

A

B

C

D

↑ **HELMETS VERSION 114** Matyas

← **MINE OP VERSION 57** Last

"Rick wanted two Imperial bases [on our jungle planet]: a refurbished dam that the Empire have taken over and a mining facility, built underground." **Chiang**

↑ **TRUCK PILOT VERSION 113** Matyas

"An early idea was that the Imperial drivers were wearing the same armor as the AT-AT commanders [from *The Empire Strikes Back*]. Ultimately, we decided to go with the tank troopers from *Rogue One* [a design chosen by George Lucas on a *Rogue One* pre-production set visit]." **Chiang**

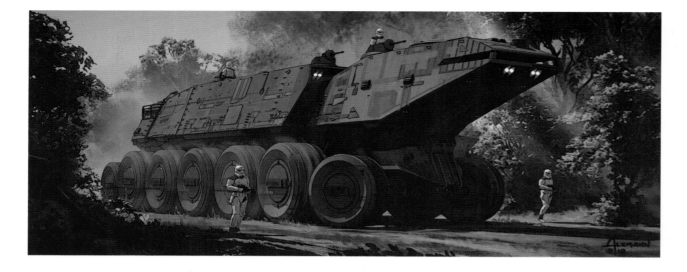

"Initially, the Empire was going to be mining coaxium [the explosive hyperdrive fuel featured in *Solo: A Star Wars Story*], but when that changed to rhydonium, we needed to start thinking about trucks. I thought, 'Okay, well, the only wheeled vehicle we've really seen [in *Star Wars*] is [original *Star Wars* trilogy art director] Joe Johnston's Juggernaut [an Imperial tank designed for *The Empire Strikes Back* and seen in *Revenge of the Sith* and *Rogue One*], so why don't we just adapt that and turn it into a workhorse Imperial truck?'" **Chiang**

↑ **JUGGERNAUT VERSION 235** "I tried to pull the cab out so that it had a sleeker quality to it." **Alzmann**

↓ **JUGGERNAUT DRIVING VERSION 239** "The slim windshield kind of got watered down in the real version, because, well, 'We actually have to see out of that.' Seeing out of it is so overrated! It should look cool! But vehicle design has to result in a set that actually works. And there's a lot of stuff that has to take place here." **Church**

↗ **JUGGERNAUT COCKPIT VERSION 240** **Church**

→ **TRUCK VERSION 234** "I love a segmented, centipede kind of thing, where a lot of articulation is implied. This was my last iteration, and I thought, 'Well, Jon's never going to choose this one.' The Juggernaut is so Joe Johnston; it's almost got a face on the front of it, which most good vehicle designs should have, but [my version] was just totally sleek, automotive, Syd-Mead-at-the-height-of-his-sleekness. I really was thrilled that Jon picked that one." **Church**

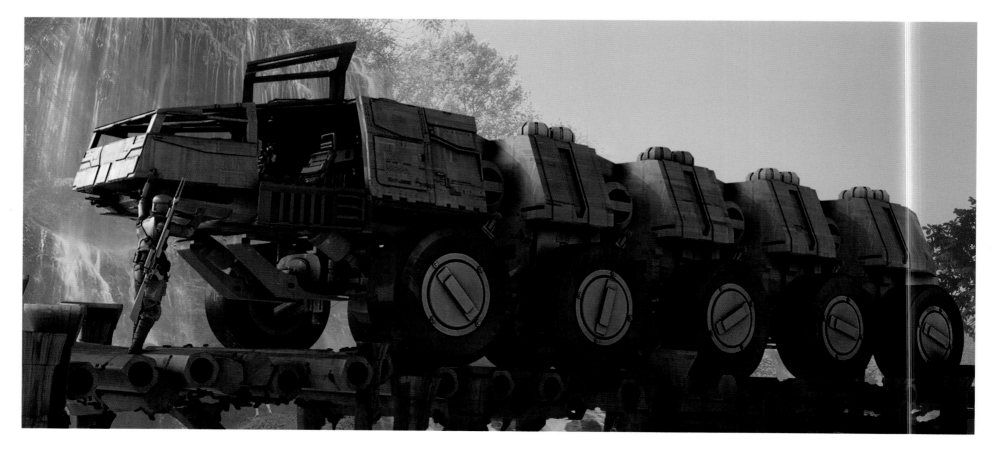

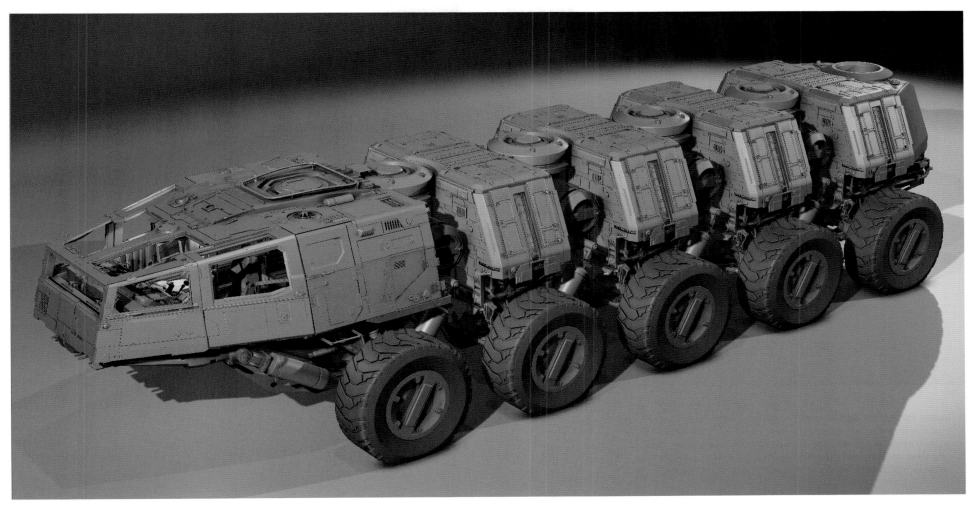

↑ **REFINERY TRUCK VERSION 13** Garcia

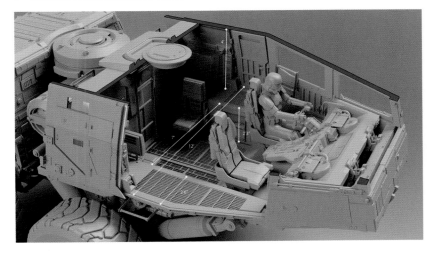

↑ **REFINERY TRUCK VERSION 23** Garcia

"I'm really glad we went with this controller. It's not a steering wheel, it's not a stick or something, which is completely abstract, it's a differential controller, which is very *Battlezone*, the [1980 arcade] video game." **Church**

→ **REFINERY TRUCK VERSION 05** Garcia

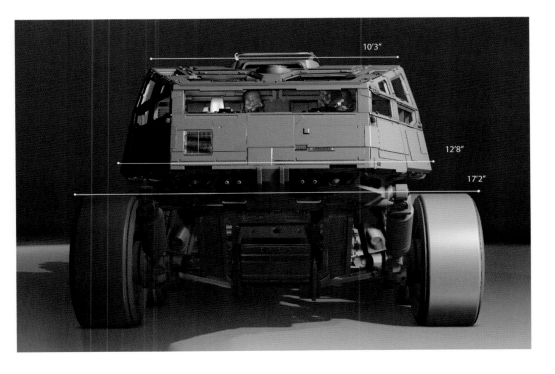

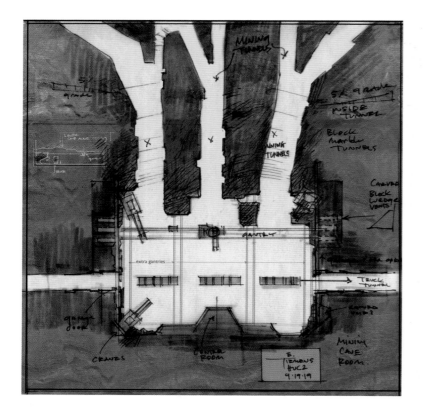

↑ **MINING CAVE LAYOUT VERSION 232** "I loved the research for this, looking at marble mines or even salt mines that have this chunky nature. The research is always a little bit of a homework assignment, but Phil Szostak finds wonderful references. We digest that, and those things help us answer the questions: How industrial, how complex, how loaded do we want to make this?" **Tiemens**

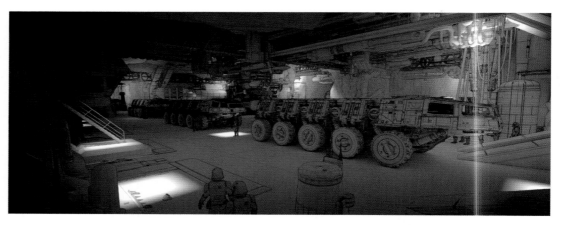

↑ **LAYOUT WALLS VERSION 332** Tiemens

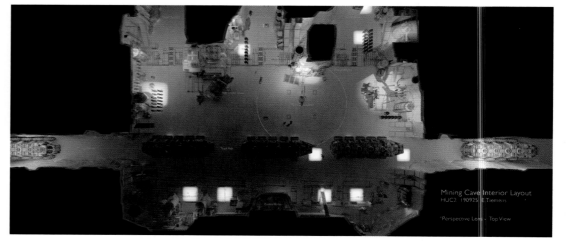

Mining Cave Interior Layout
HUC2 190925 E.Tiemens

*Perspective Lens - Top View

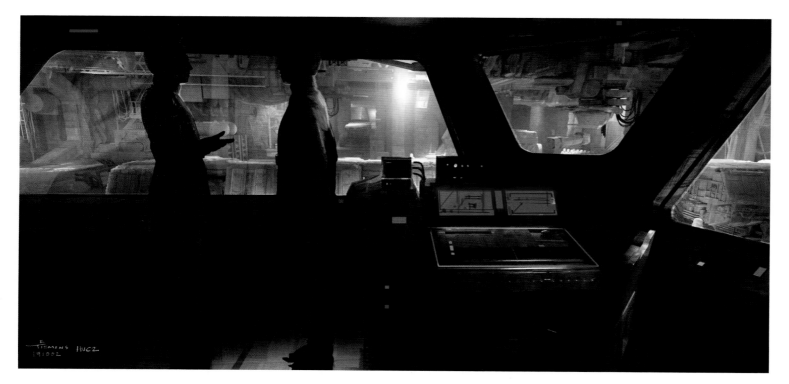

↑ **LAYOUT WALLS VERSION 337**
"What was really helpful, in this rather complex space, was looking at a schematic. 'OK. I think it's three tunnels that go deeper into the mineral deposits and then a loading room with a one-way vehicle pass.'" **Tiemens**

← **CONTROL ROOM VERSION 367**
Tiemens

"This is our very familiar bridge (redressed and reused elsewhere in Season 2 as the bridge of Gideon's light cruiser and the Nevarro Imperial base control room), used here as a mine control room." **Chiang**

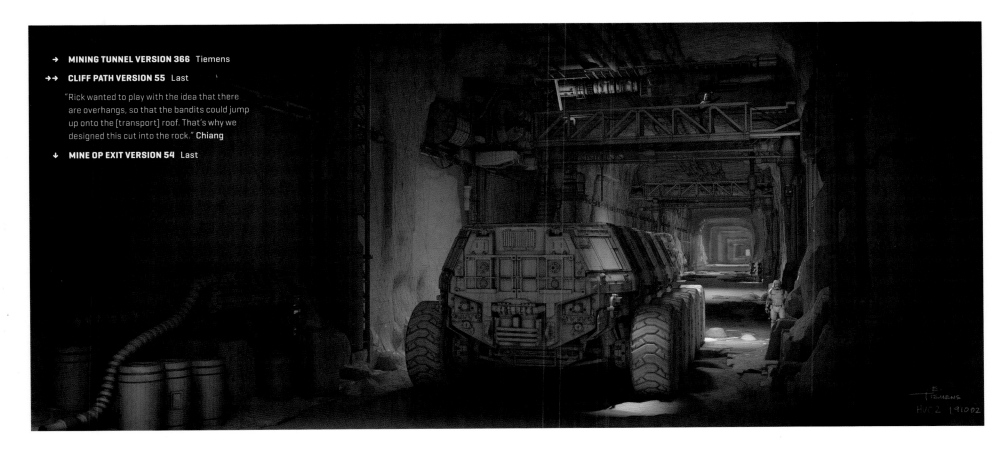

→ **MINING TUNNEL VERSION 366** Tiemens

→→ **CLIFF PATH VERSION 55** Last

"Rick wanted to play with the idea that there are overhangs, so that the bandits could jump up onto the [transport] roof. That's why we designed this cut into the rock." **Chiang**

↓ **MINE OP EXIT VERSION 54** Last

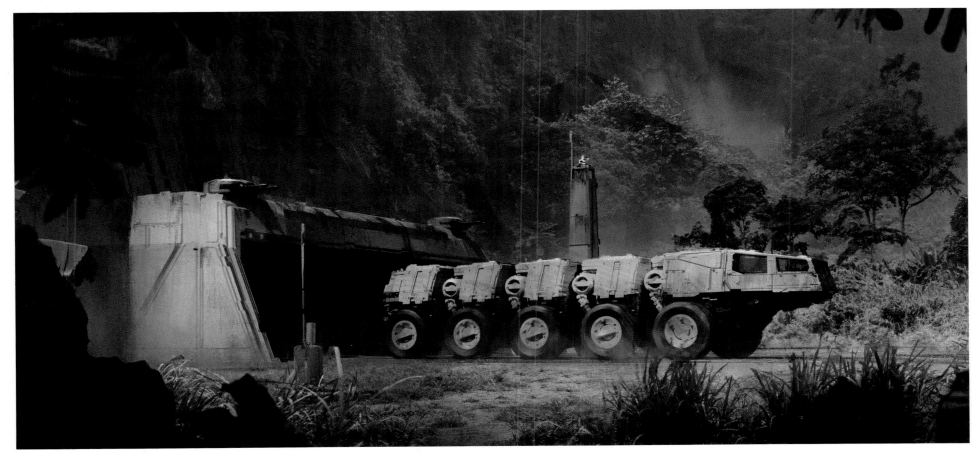

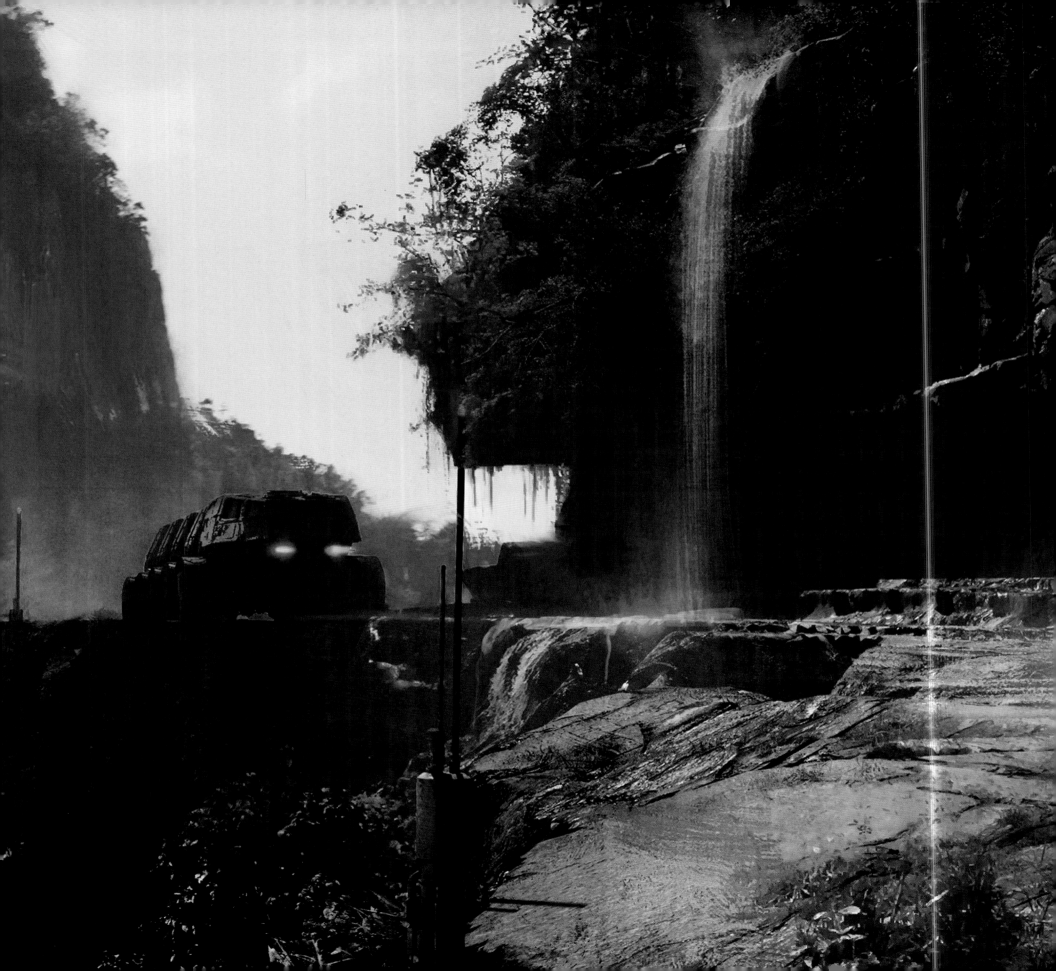

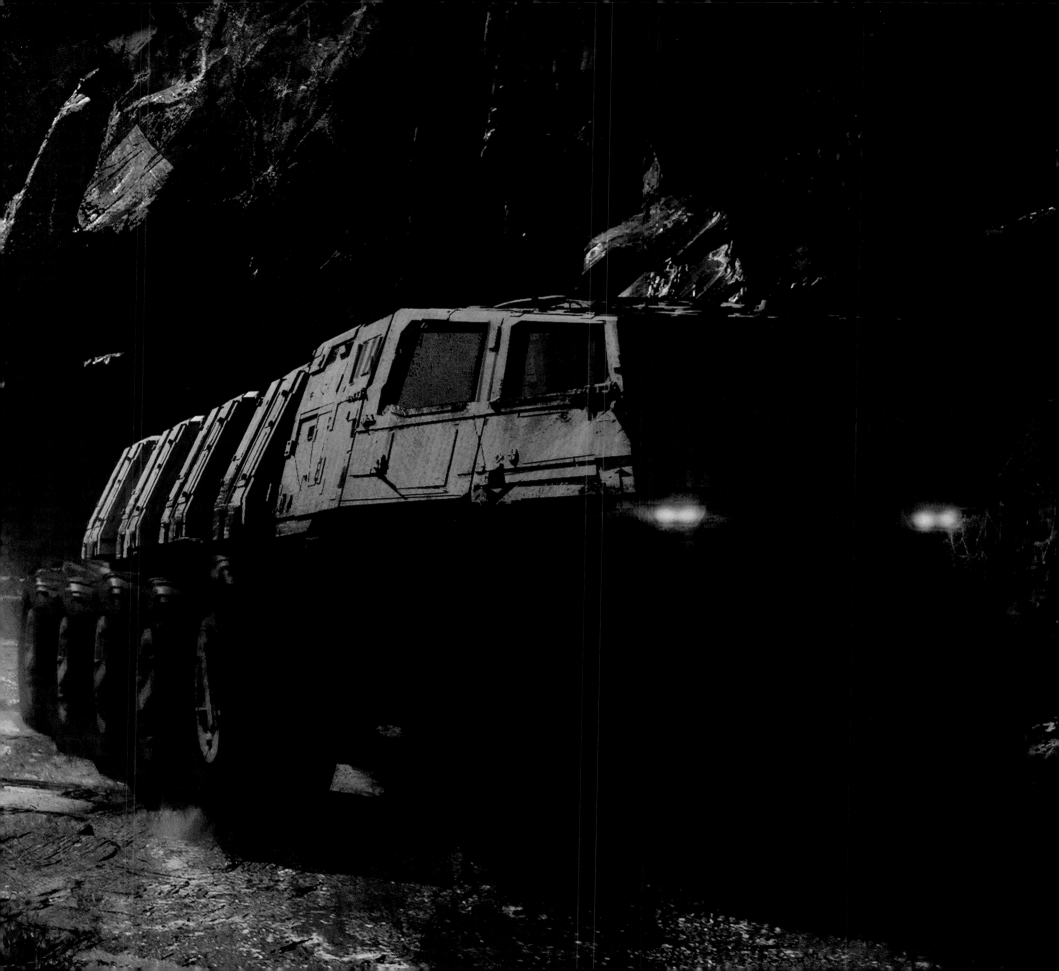

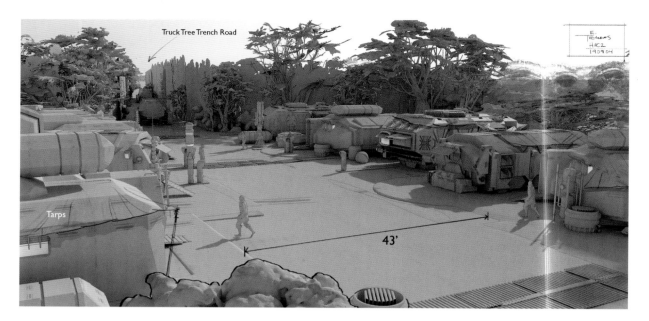

↑ **JUNGLE VILLAGE VERSION 193** "Playing with shots, weighing out how the miners might have cleared part of the fields, creating farmland." **Tiemens**

→ **JUNGLE VILLAGE VERSION 188** Tiemens

"These are the same salvaged shipping containers from the Trask village. We didn't end up using them, but the thinking was that, if we were going to build them for the Trask set, we could repaint and reuse them here." **Chiang**

↓ **JUNGLE MINING TOWN VERSION 149** Tiemens

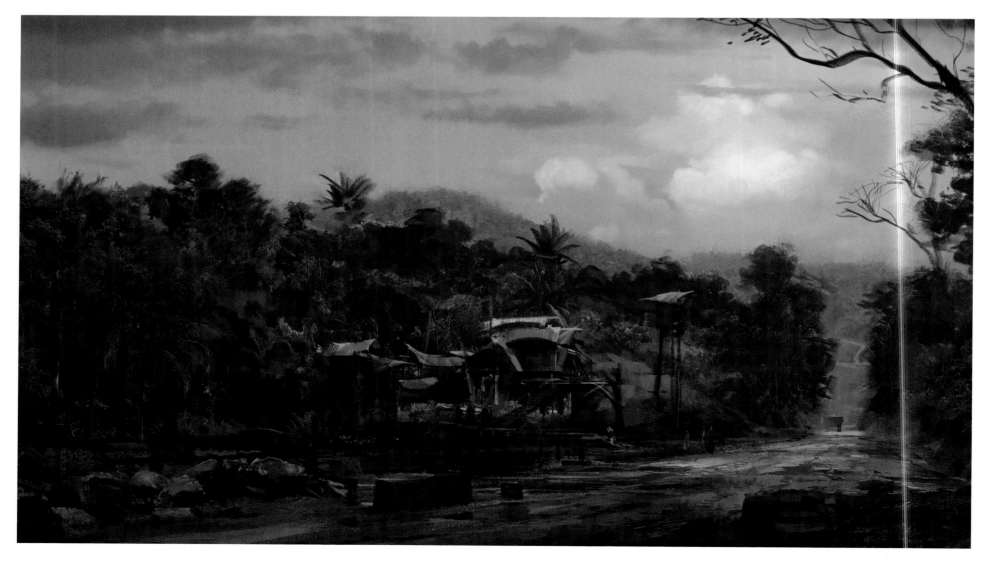

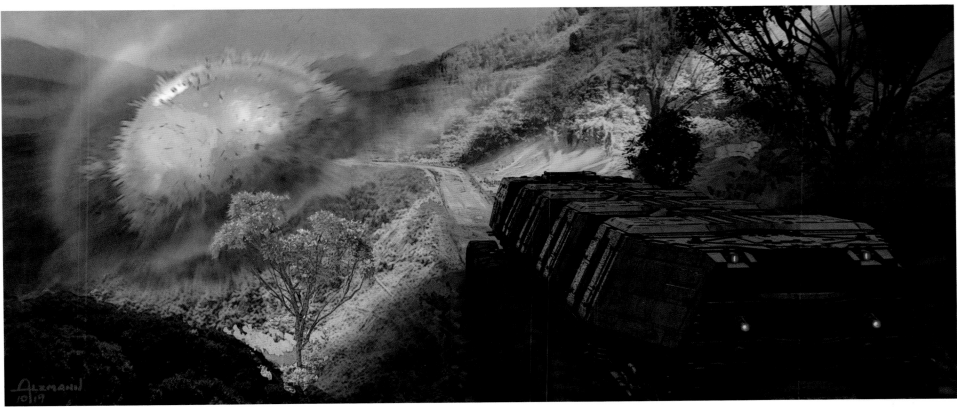

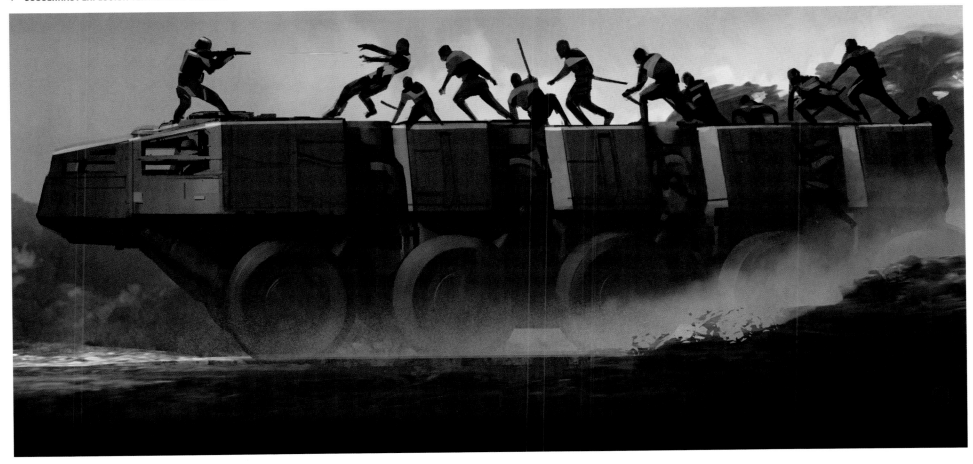

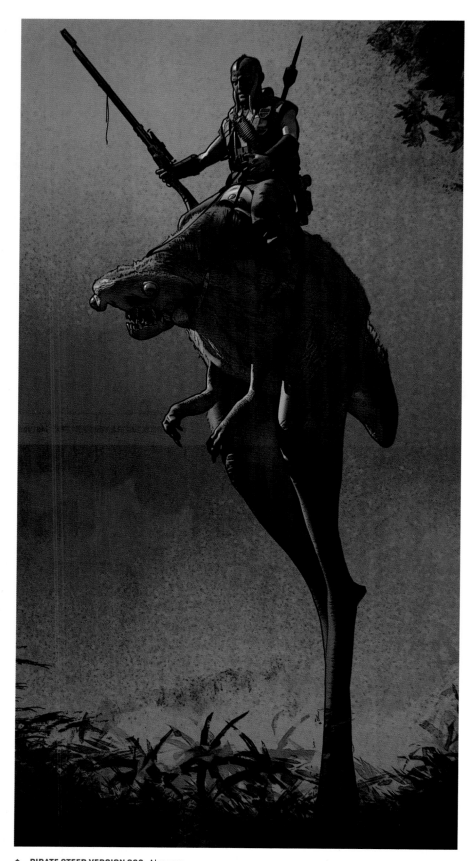

↑ **PIRATE STEED VERSION 288** Alzmann

↑ **JUNGLE PIRATE ALIEN VERSION 300** Matyas

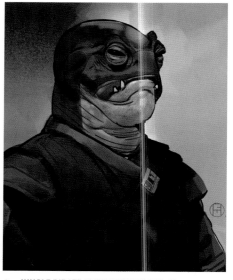

↑ **JUNGLE PIRATE ALIEN VERSION 303** Matyas

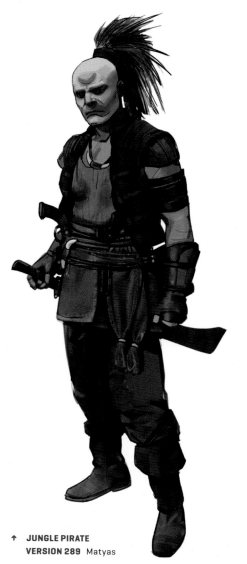

↑ **JUNGLE PIRATE VERSION 289** Matyas

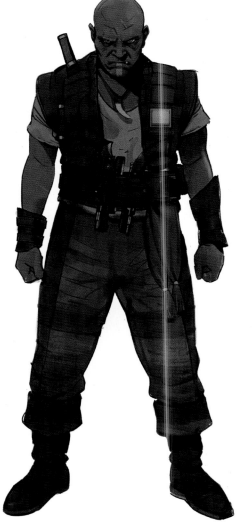

↑ **JUNGLE PIRATE VERSION 292** Matyas

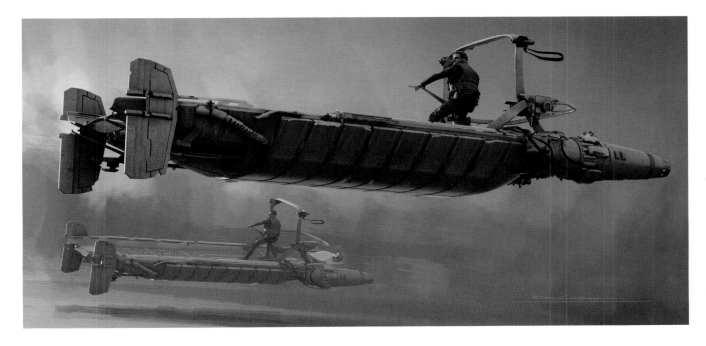

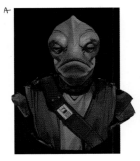
A

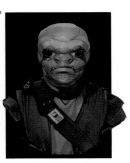
B

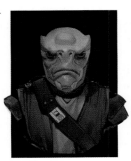
C

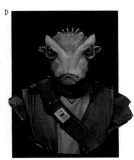
D

↑ **PIRATE SKIFF VERSION 338** "Doug had a pretty clear direction on this, in that he wanted the bottom to feel like a boat hull." **Church**

"Originally, the bandits were going to be riding on creatures, but that proved to be too cost-prohibitive. So we decided to give them flying skiffs." **Chiang**

→ **JUNGLE PIRATE VERSION 286** "For the costumes, I was heavily riffing off of the classic swashbuckling Errol Flynn–era pirates. I looked at *Black Sails*, as well as some of the Osprey Publishing reference books for the more colonial-era and even Victorian-era admiral naval costumes. Differing degrees and variations of a disheveled pirate—a lot of cloth belts, a lot of layers, musket-inspired blasters, thin-material scarves to wipe the sweat off their faces." **Matyas**

↓ **ATTACK VERSION 254** Alzmann

↑ **JUNGLE PIRATE ALIENS VERSION 298** "The design of the aliens was pretty open. It could be prosthetics, it could be a full mask, so I was playing in the realm of full-head mask." **Matyas**

↓ **JUNGLE PIRATE ALIEN VERSION 301** "They went with more of the prosthetic look [for the aliens]. But it totally makes sense why they would pick something that's a little subtler. It's not like they're just going to be sitting down at a bar, drinking." **Matyas**

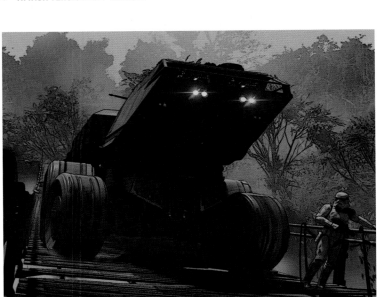

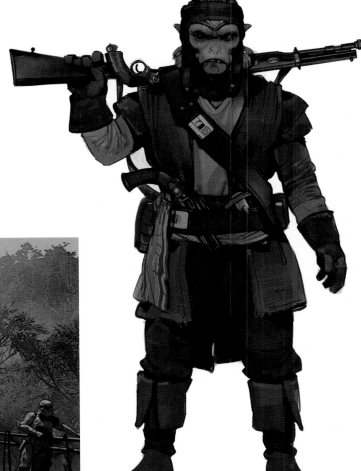

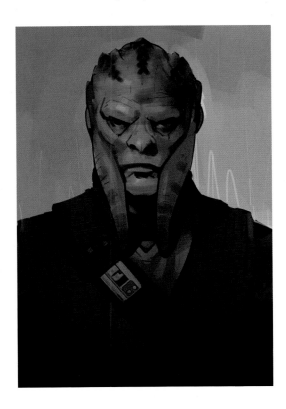

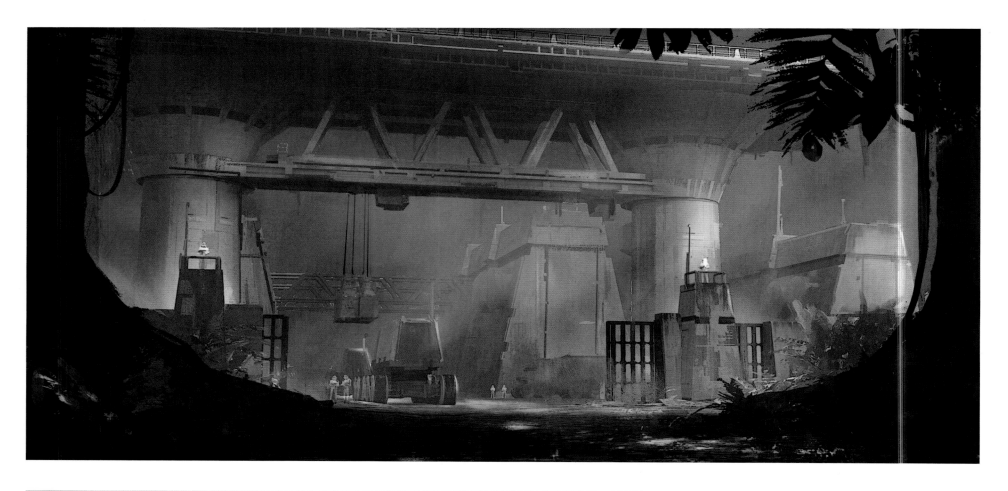

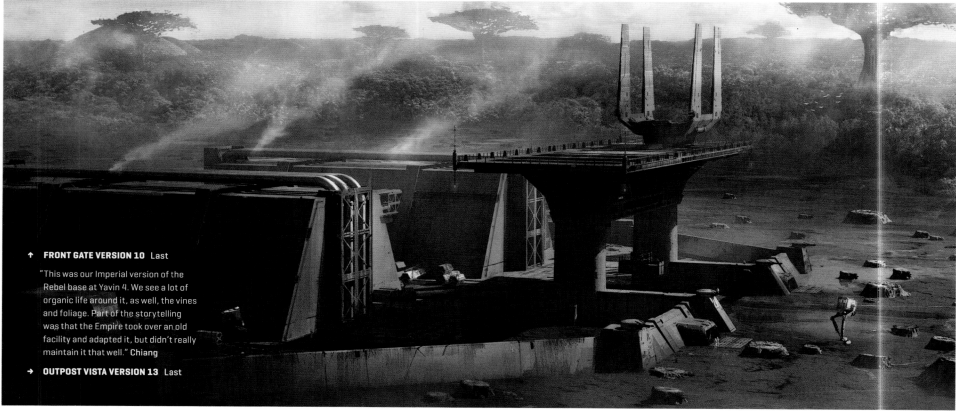

↑ **FRONT GATE VERSION 10** Last

"This was our Imperial version of the Rebel base at Yavin 4. We see a lot of organic life around it, as well, the vines and foliage. Part of the storytelling was that the Empire took over an old facility and adapted it, but didn't really maintain it that well." **Chiang**

→ **OUTPOST VISTA VERSION 13** Last

↑ **IMPERIAL REFINERY VERSION 278** "My first sketch has this idea of a polluted river turned red, the result of the processing done in the facility. I thought it would be striking if the refinery could be found just by tracing the red river upstream." **Grandert**

→ **REFINERY LAYOUT VERSION 503** Grandert

↓ **REFINERY LAYOUT VERSION 504** "I started off with something more industrial, inspired by refineries in Detroit and Pittsburgh, as well as Imperial architecture from previous movies. I also looked at some photos I took from a Chernobyl trip, and used them as a guide for the main buildings." **Grandert**

"Our final facility is based on an old dam in Costa Rica. It's all rusted and you can see exposed girders, but then the Empire have added their gun turrets, done just enough to make it their own. We even have an old mining shuttle up the landing platform." **Chiang**

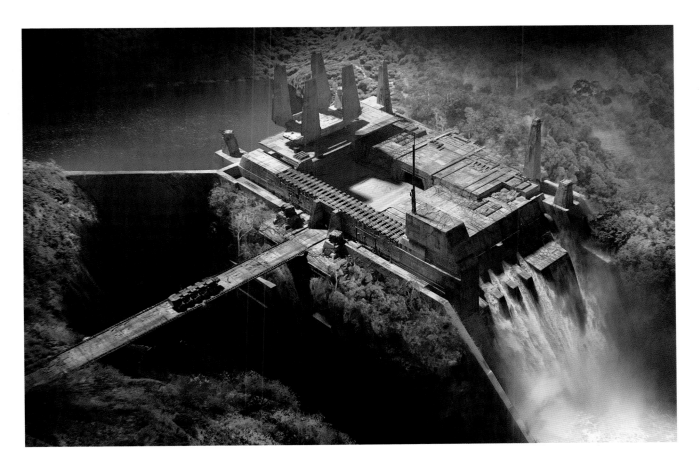

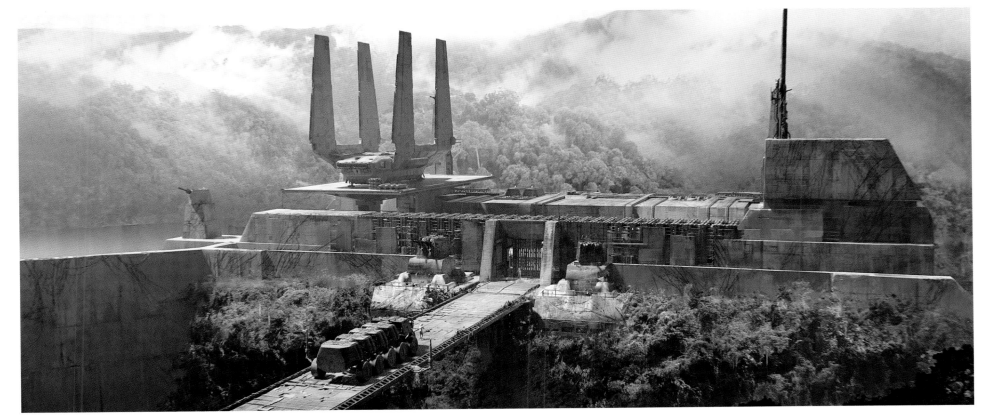

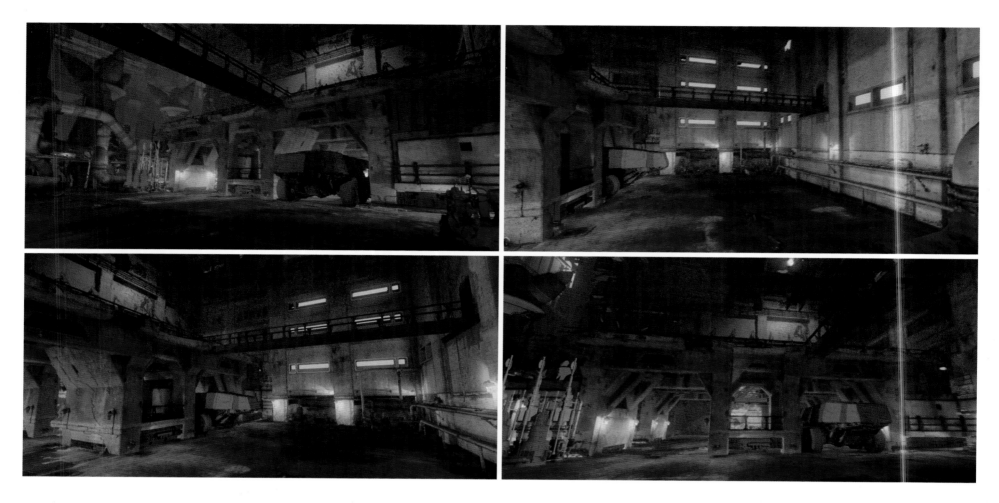

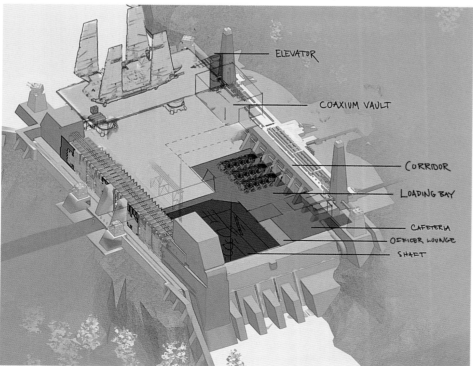

← **REFINERY LAYOUT VERSION 429** "This was quite a challenge, I have to admit. I had never built anything this big before. Maybe because of my years in the game industry, I wanted everything to make sense logically, so that the interior and exterior would match. Now, I know that, in film, it doesn't really have to match. But in making a level for a game, it's much harder to cheat, since it's a 3-D interactive environment." Grandert

↓ **REFINERY HANGAR VERSION 524** Grandert

↑ **REFINERY COURTYARD A** Fields

"Ultimately, Andrew and team found this great location [the NRG Power Plant in Long Beach, California] with similarly sloped concrete pillars that we scanned for the texture of the material. But the original thinking was that the trucks would pull up in here and we'd have these elevated walkways and overhead cranes that would remove the material." Chiang

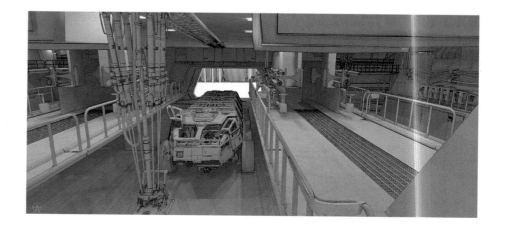

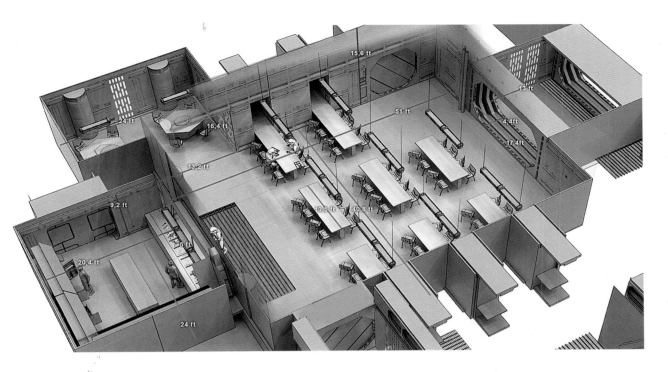

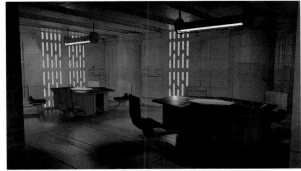

↑ **REFINERY CAFETERIA VERSION 475** Grandert

← **REFINERY CAFETERIA VERSION 476** "The cafeteria was pretty straightforward to create. In my first draft, I had the tables and lights above sliding out from the walls, like big vertical drawers, with the classic Death Star panels for fronts." Grandert

→→ **FENNEC CARA SHOOTOUT VERSION 339** "They wanted an *Aliens* vibe for this one. A lot of thick atmosphere and a very retro-'80s palette with the blaster bolts saturating the air." Matyas

↓ **REFINERY CAFETERIA VERSION 471** Grandert

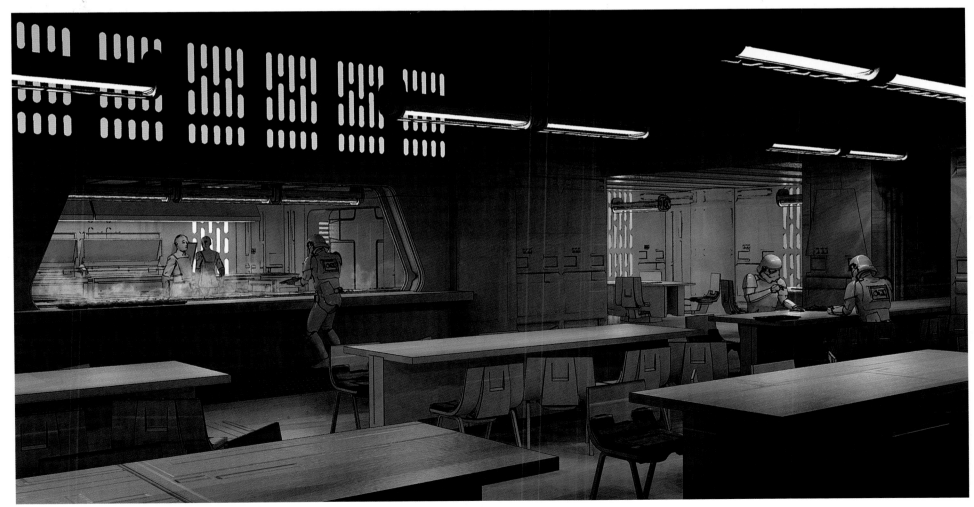

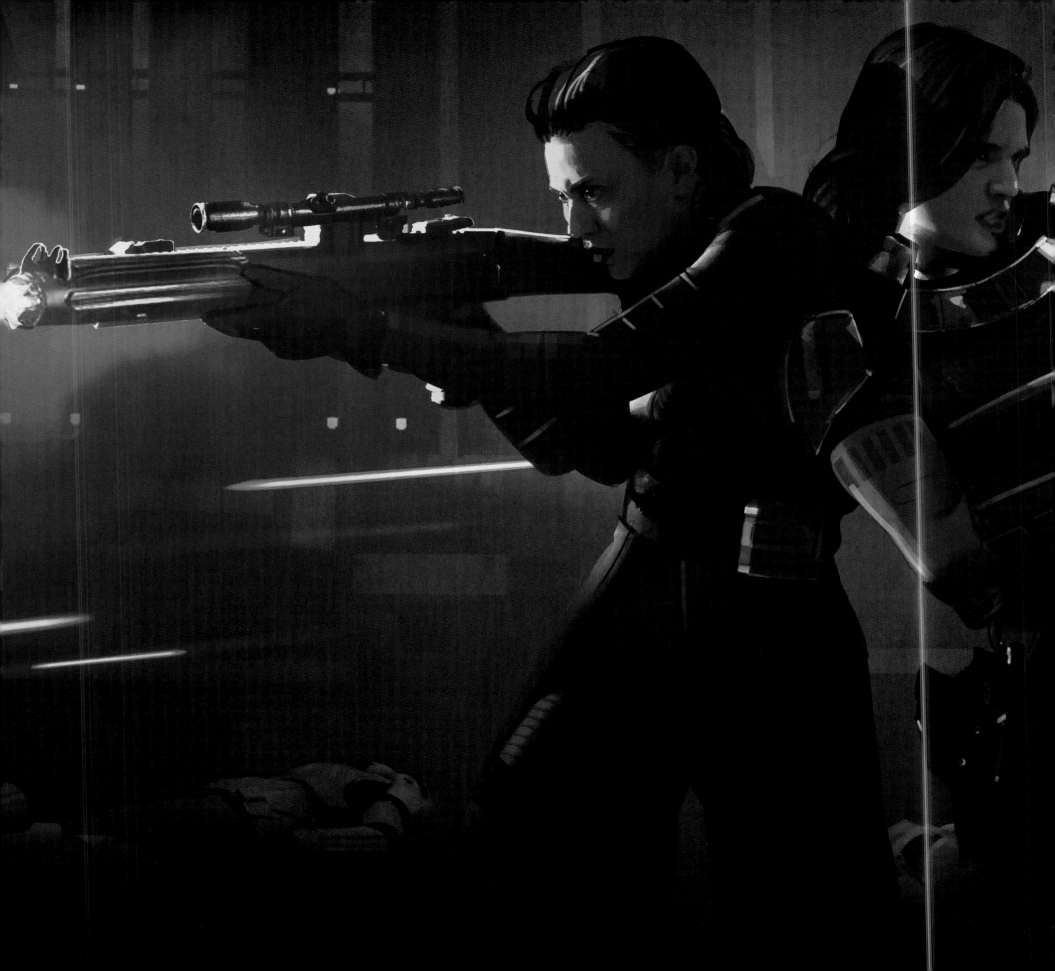

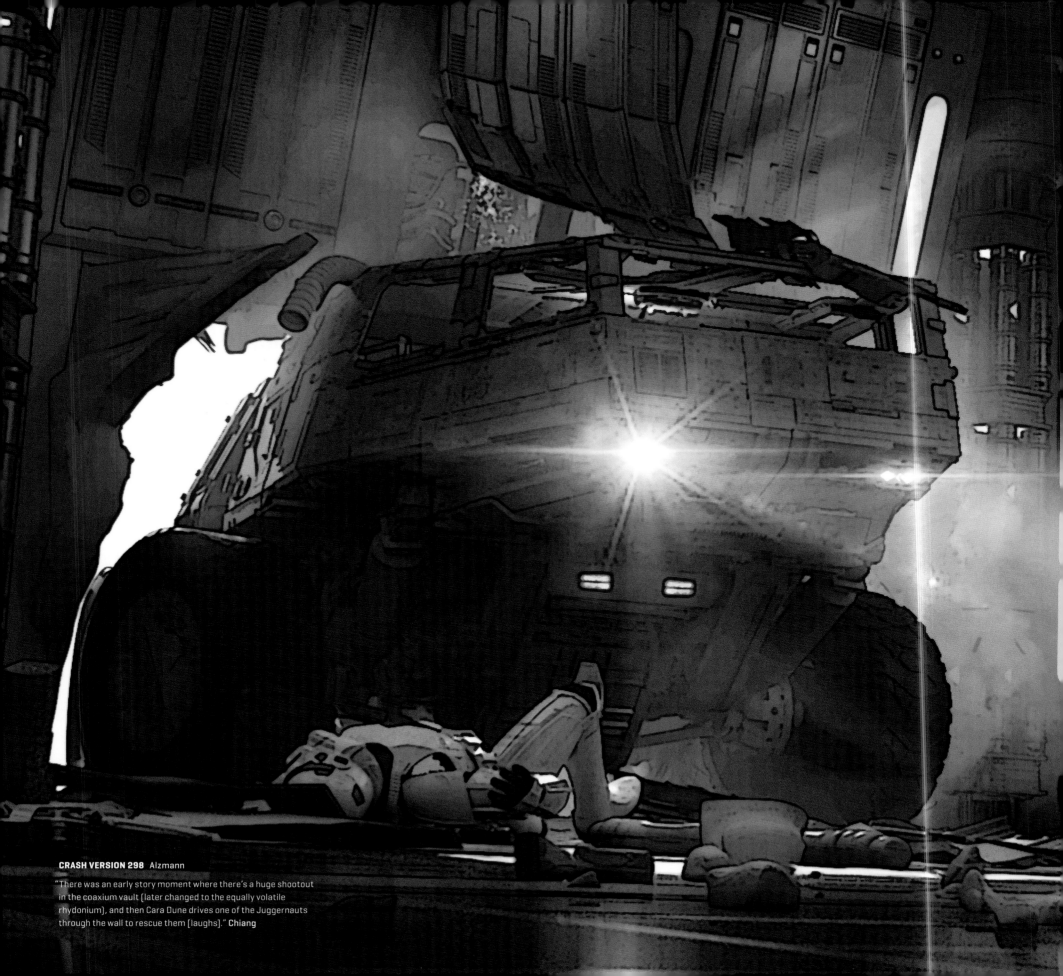

CRASH VERSION 298 Alzmann

"There was an early story moment where there's a huge shootout in the coaxium vault (later changed to the equally volatile rhydonium), and then Cara Dune drives one of the Juggernauts through the wall to rescue them [laughs]." **Chiang**

↑ **MAYFELD SAVES MANDO VERSION 344** Matyas

↓ **GIDEON TRANSMISSION VERSION 342** Matyas

THE RESCUE

Director Peyton Reed returned for his second episode of the season with "Chapter 16: The Rescue," an episode that would include the dramatic introduction of Luke Skywalker into the world of *The Mandalorian*. A plan so secret that no concept art clearly identifying the iconic Jedi knight was created. "There were a lot of debates about [Ahsoka Tano pointing the way to Luke Skywalker]," Dave Filoni recalled. "And Jon and I went back and forth, because if [Ahsoka can't take care of Grogu,] then who will? Taking care of the Child is not her destiny. That's not what I've been planning for her to do [laughs], so I can't change it up. But it is interesting if Ahsoka's there along the way, not as somebody who takes this burden away from Mando but as somebody to say, 'You might be forgetting that this kid has a choice too. It's not just about you and your oath to your covert.'"

The Lucasfilm art department worked hand in hand with Favreau as he crafted his screenplay for Chapter 16, just as they had for the entirety of Season 2. Concept artist Amy Beth Christenson, known for her work on Lucasfilm Animation projects like *The Clone Wars*, *Rebels*, and *Star Wars Resistance*, briefly joined the effort in mid-October. The bulk of that work consisted of the maze-like interior of Moff Gideon's light cruiser, and the two briefly seen backdrops bookending the episode, the "truck stop" at the Port of Lafete and Jabba the Hutt's former palace.

"Scope-wise, Season 2 is about twice the size of Season 1," Doug Chiang said. "There was a vast quantity of new designs that Jon was asking for. And yet, we somehow managed to design it in less time. I think we've gotten so much better at designing for this. Jon and Dave really push the aesthetics, which I find exciting. And I like the idea, especially in Season 2, that we're merging some prequel-era design with the original trilogy. It's bringing the whole universe cohesively together." Design supervisor Christian Alzmann agreed, "By the second season, we definitely had [Jon's aesthetic] down."

"It's all in the script," design supervisor Ryan Church said. "It's all there. Everything. And it just got better in Season 2. It got nailed."

For Filoni, "It's just become a fun thing. I love the team we work with. We did things in Season 2 that we wouldn't have tried in Season 1, because we had so much more experience, awareness of how the volume worked, and what we could accomplish in a day. That makes a big difference when you're going into writing it. Jon and I know each other better now, so we really evolved the story in a meaningful way for both of us."

"Joseph Campbell's Monomyth has always been about self-sacrifice for the greater good of the whole community," Favreau reflected. "And that's what *Star Wars* is clearly about. It's about living in service to a greater good. The Force is an emanation of that, but even if you strip the Force away, *Star Wars* is still about spiritual growth. And as you tell the story over many seasons, you have to make sure that it's not one story that gets resolved at the end. You're constantly creating opportunities to find different contours within that same growth path. Each character has their flaws and they overcome their flaws and become better people. Or you're telling tragic stories where people are deteriorating. But I think in the spirit of what George did, these are hopeful stories. Life can be interpreted in many different ways, but if you can find the path that leads to hope, that's when you're going to flourish. That's where humanity flourishes."

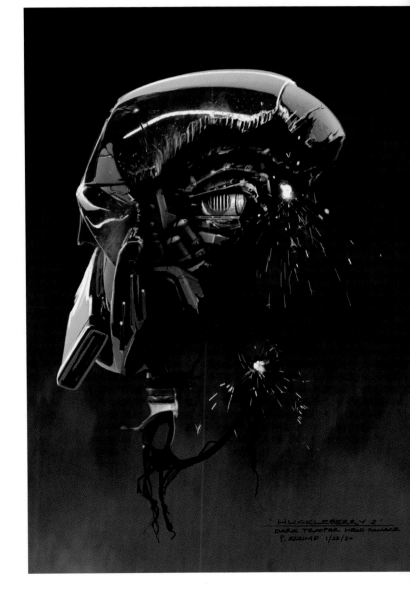

← **MEETING MANDO VERSION 366** Matyas and Church

→ **DARK TROOPER DAMAGE VERSION 2D** Ozzimo

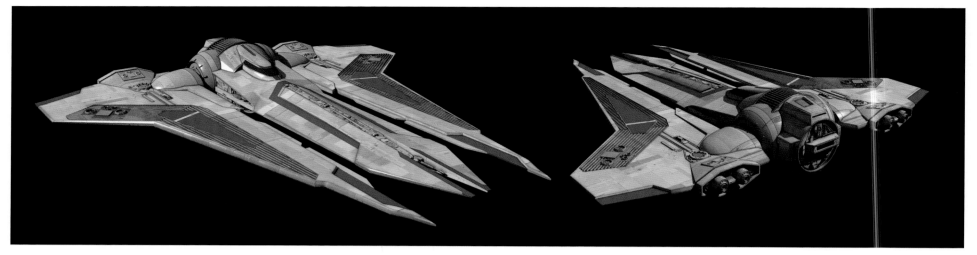

↑ **MANDALORIAN GAUNTLET VERSION 150** Alzmann

↓ **MANDALORIAN GAUNTLET VERSION 16** Garcia

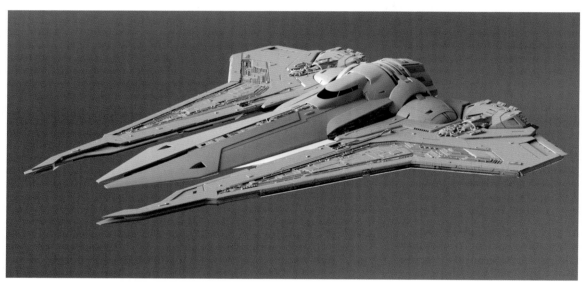

↑ **MANDALORIAN GAUNTLET VERSION 08** Garcia

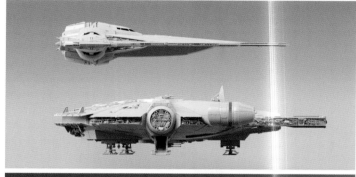

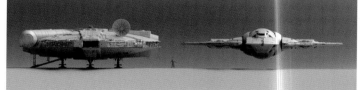

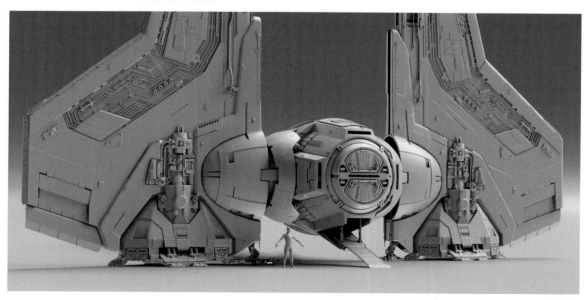

↑ **MANDALORIAN GAUNTLET VERSION 14** Garcia

"We realized that, in real life, Bo-Katan's ship was just way too big. It was almost twice the size of the *Falcon*, which didn't make much sense. So we kept scaling it down, scaling it down, while keeping it true to its animated origins." **Chiang**

← **MANDALORIAN GAUNTLET VERSION 12** Garcia

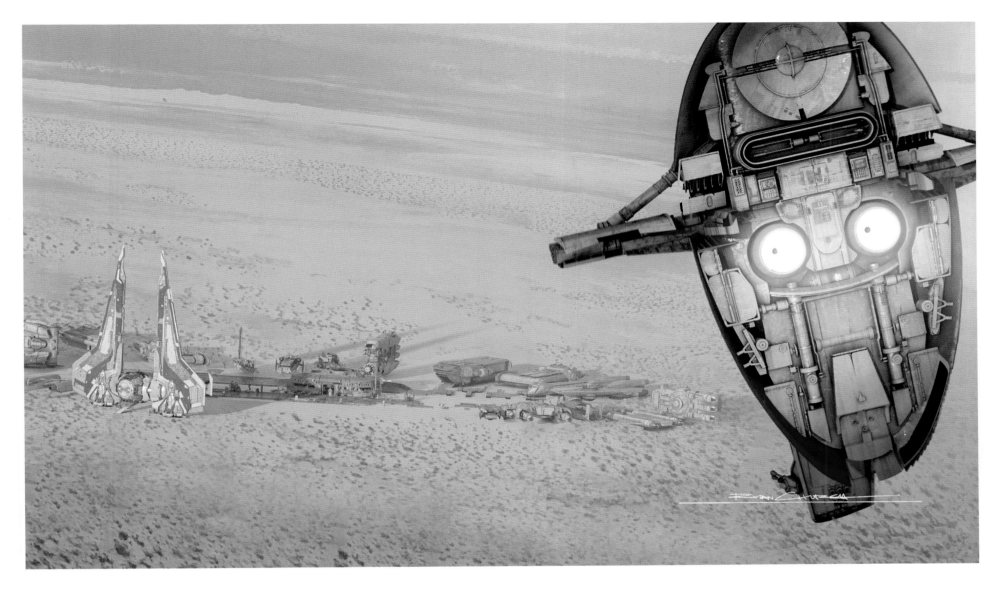

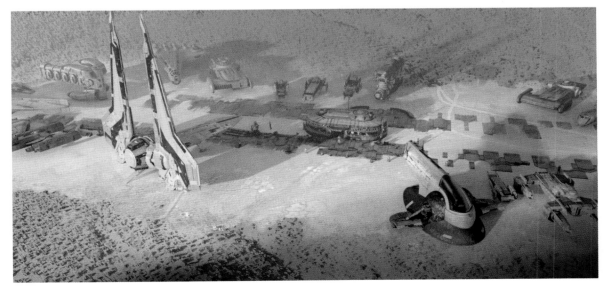

↑ **TRUCK STOP VERSION 314** Church

← **TRUCK STOP VERSION 315** "I put the creosote bushes from the Mojave Desert in there, just like you'd see between Barstow and Las Vegas. It just seemed like the exact right thing to do." **Church**

↓ **TRUCK STOP VERSION 313** Church

↑ **DINER VERSION 534** Grandert

→ **DINER VERSION 546** "I made this into a diner reusing the Mos Pelgo saloon set. *Star Wars* meets the 1950s, but more rough and rusty." **Grandert**

↓ **DINER VERSION 551** Grandert

"This is the exact same shape as the Mos Pelgo saloon. We changed all of the windows and the door, dropped the ceiling down, and then moved the bar over to the end, but we kept the same pillars. Once we have a set, we can repurpose it very quickly and change the motif, change the lighting condition. We really wanted to make sure that this felt like a dusty old truck stop with the harsh sunlight coming in." **Chiang**

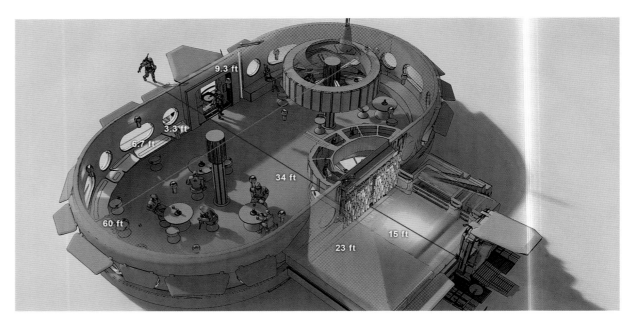

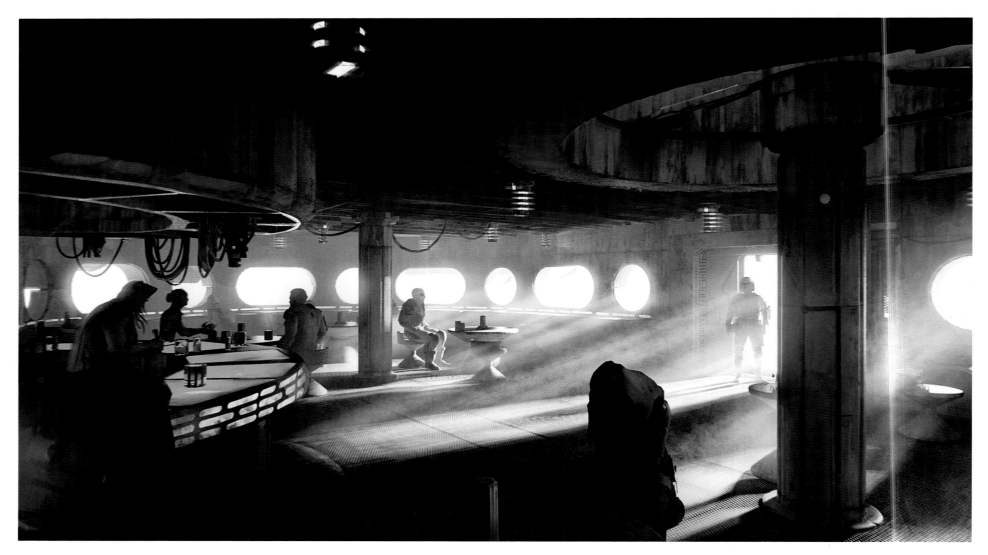

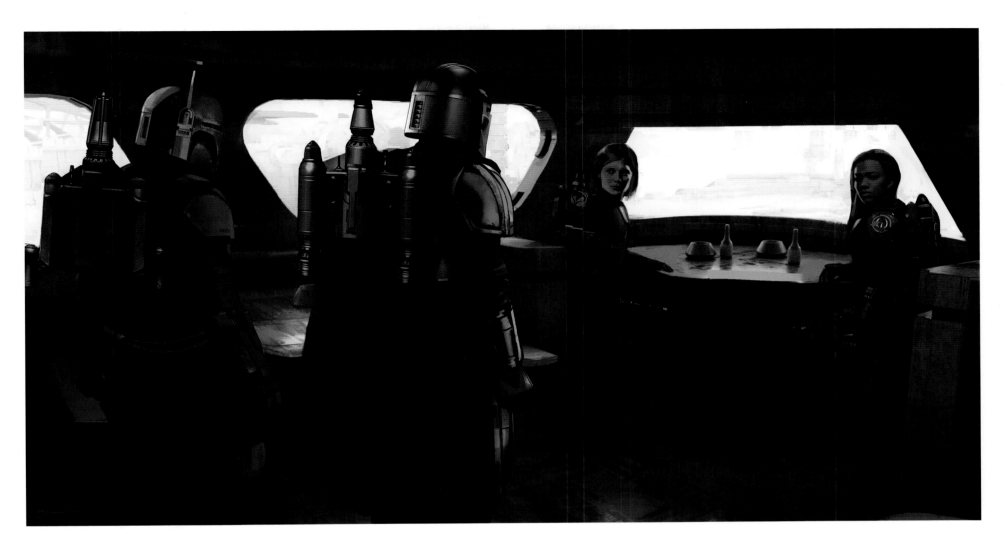

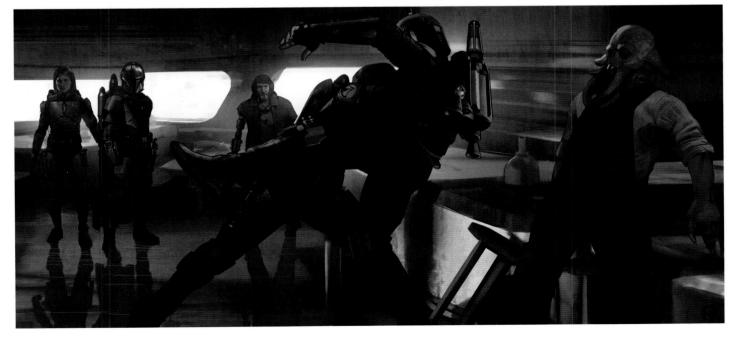

↑ **CONFRONT VERSION 376** Matyas and Church

"When you think of fifty miles outside of Barstow, you think of *Duel* [Steven Spielberg's 1971 feature debut], of course. The scene when Dennis Weaver walks into that bar [laughs], and the guys are playing pool, that is definitely where this interior lighting scheme and vibe come from. It's the kind of place where you walk in the door and everybody looks over at you, and you're just like, 'Oh, boy.'" **Church**

← **TRUCK STOP FIGHT VERSION 377** Matyas

→→ **FLAMETHROWERS VERSION 378** "Fire cancels out fire, right? Ten-year-old me always wanted to see Boba Fett do something like this." **Matyas**

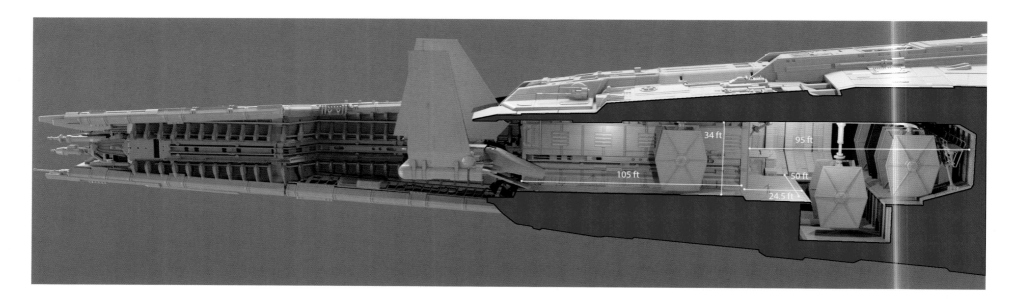

LIGHT CRUISER VERSION 76 Garcia

"We opened up [the space] a little bit so that the Lambda-class shuttle could fit into the hangar. In the final version, we ended up cheating it so that the shuttle flies down the whole thing, but we figured it all out, including the inside—how the shuttle will fit, where the hangar is, how the TIE fighters are loaded. Again, it's always nice to do the math to figure out exactly how it fits properly." **Chiang**

→ **TOWARDS HANGAR VERSION 246** Church

↓ **SHUTTLE LANDING VERSION 245** Church

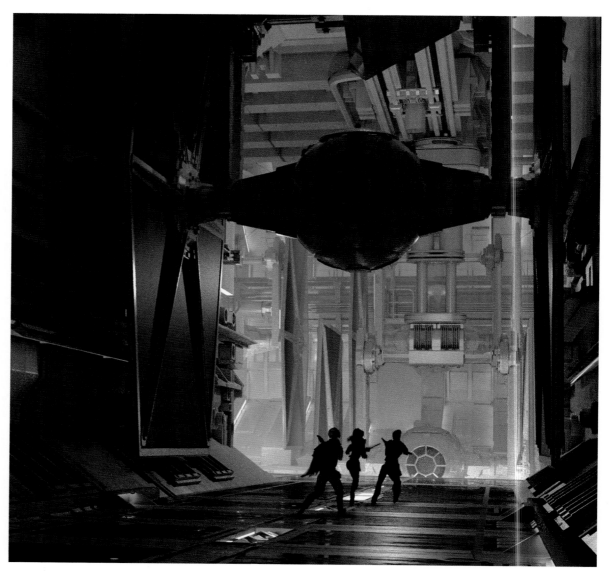

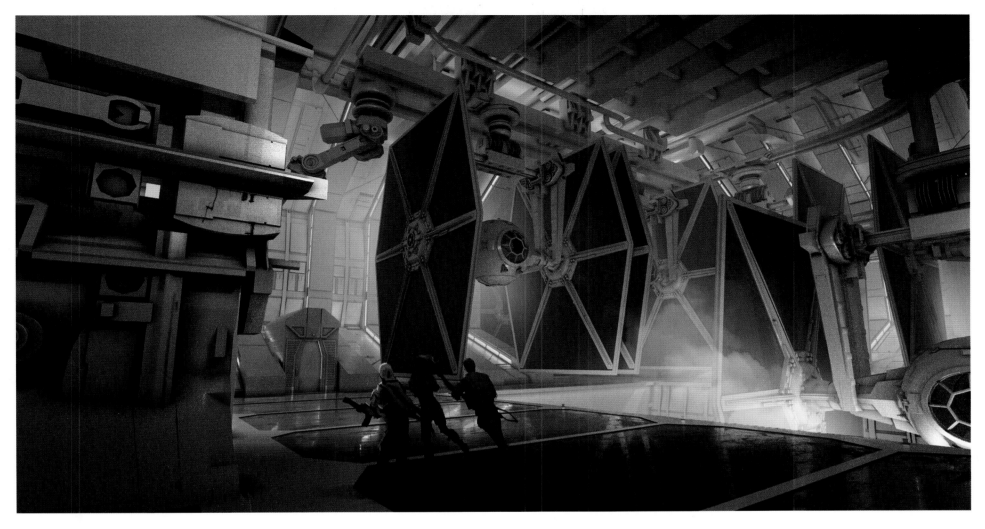

↓ **HALLWAY CONCEPTS**
VERSION 378 Tiemens

"Here we used that same corridor [from the Nevarro Imperial base] but reconfigured it to serve our needs inside the cruiser." **Chiang**

↑ **IMPERIAL CRUISER VERSION 247** Church

"This hangar is a volume set where [the build] is really just the floor. Everything around the actors is LED content" **Chiang**

→ **LIGHT CRUISER ORTHO VERSION 02**
Chiang and various

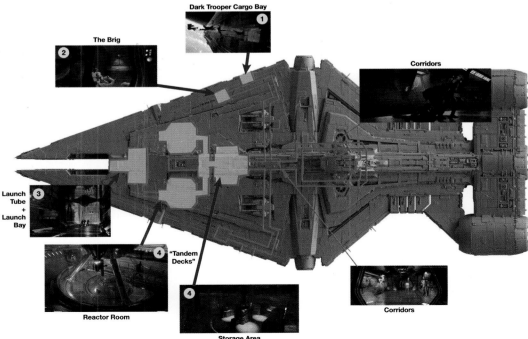

Dark Trooper Cargo Bay

The Brig

Corridors

Launch Tube + Launch Bay

"Tandem Decks"

Reactor Room

Storage Area

Corridors

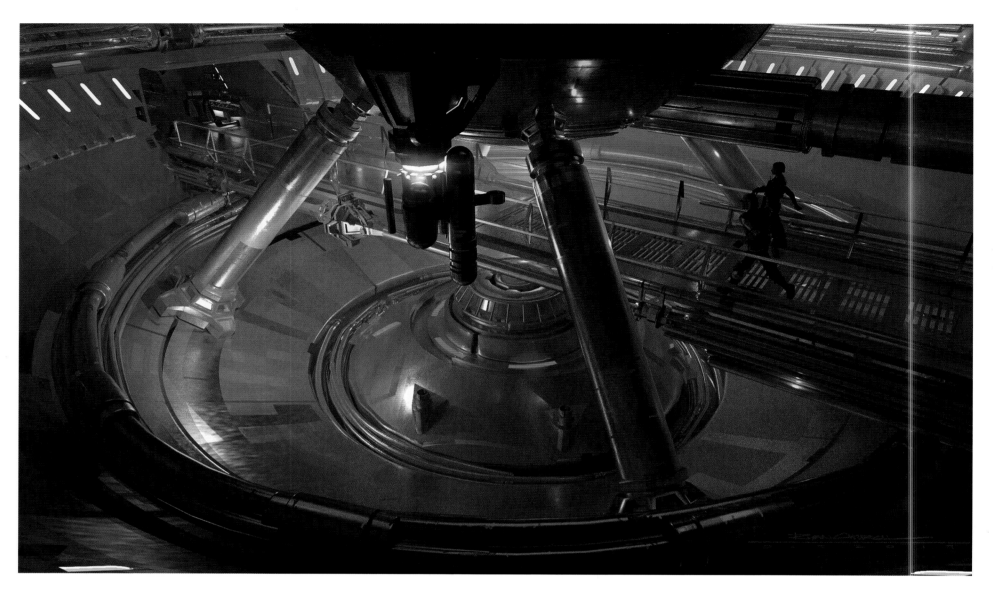

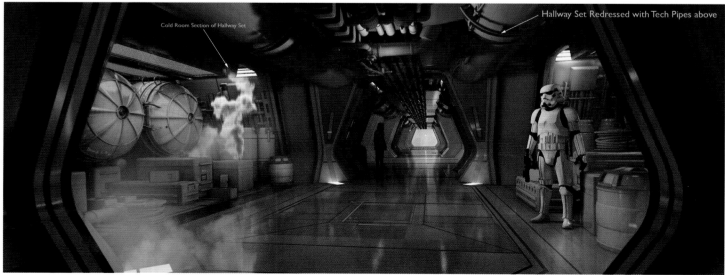

Cold Room Section of Hallway Set

Hallway Set Redressed with Tech Pipes above

↑ **REACTOR ROOM VERSION 247** "Doug said, 'Add something that we could run past that would look cool in the volume,' so I thought about the big bubble thing underneath every Star Destroyer, which to me implies there is a spherical power source inside. I wanted to evoke that in this illustration." **Church**

← **HALLWAY CONCEPTS VERSION 380** "I was kit-bashing parts of existing hallways that Ryan had designed into these one-off flexible set pieces. Here we have a cold room section with tech pipes above." **Tiemens**

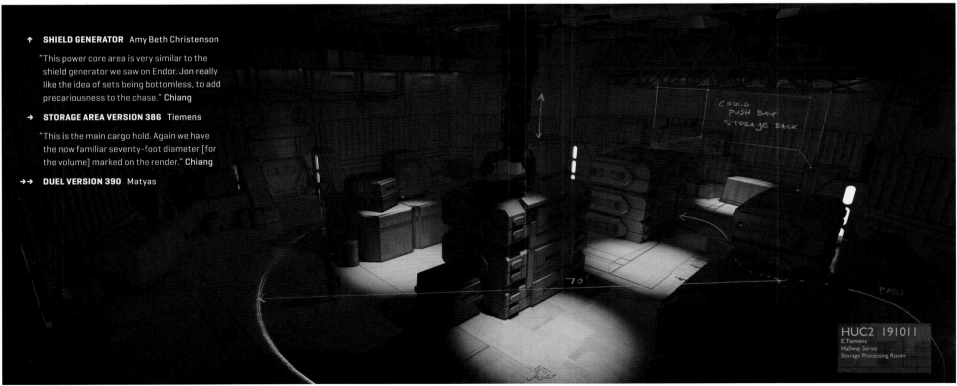

↑ **SHIELD GENERATOR** Amy Beth Christenson

"This power core area is very similar to the shield generator we saw on Endor. Jon really like the idea of sets being bottomless, to add precariousness to the chase." **Chiang**

→ **STORAGE AREA VERSION 386** Tiemens

"This is the main cargo hold. Again we have the now familiar seventy-foot diameter [for the volume] marked on the render." **Chiang**

→→ **DUEL VERSION 390** Matyas

COULD
PUSH BAY
STORAGE BACK

70'

PATH

HUC2 191011
E.Tiemens
Hallway Series
Storage Processing Room

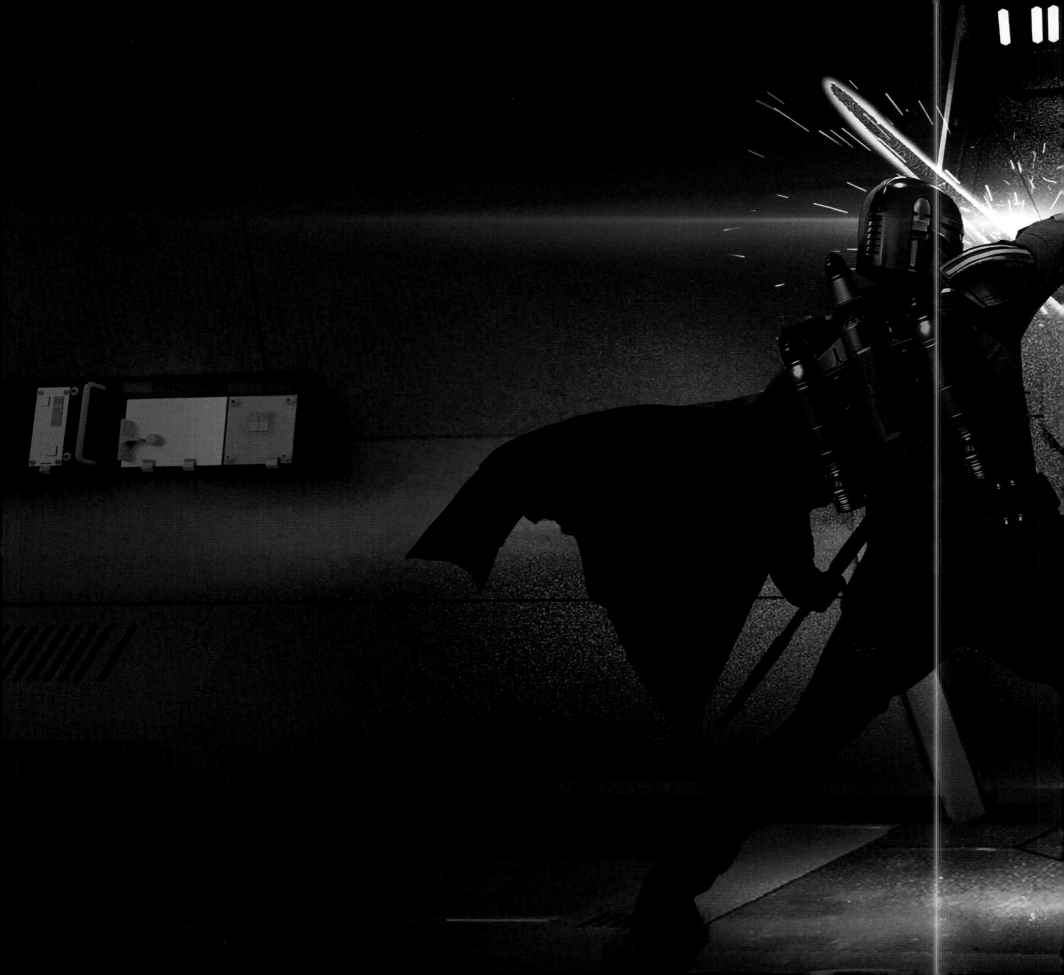

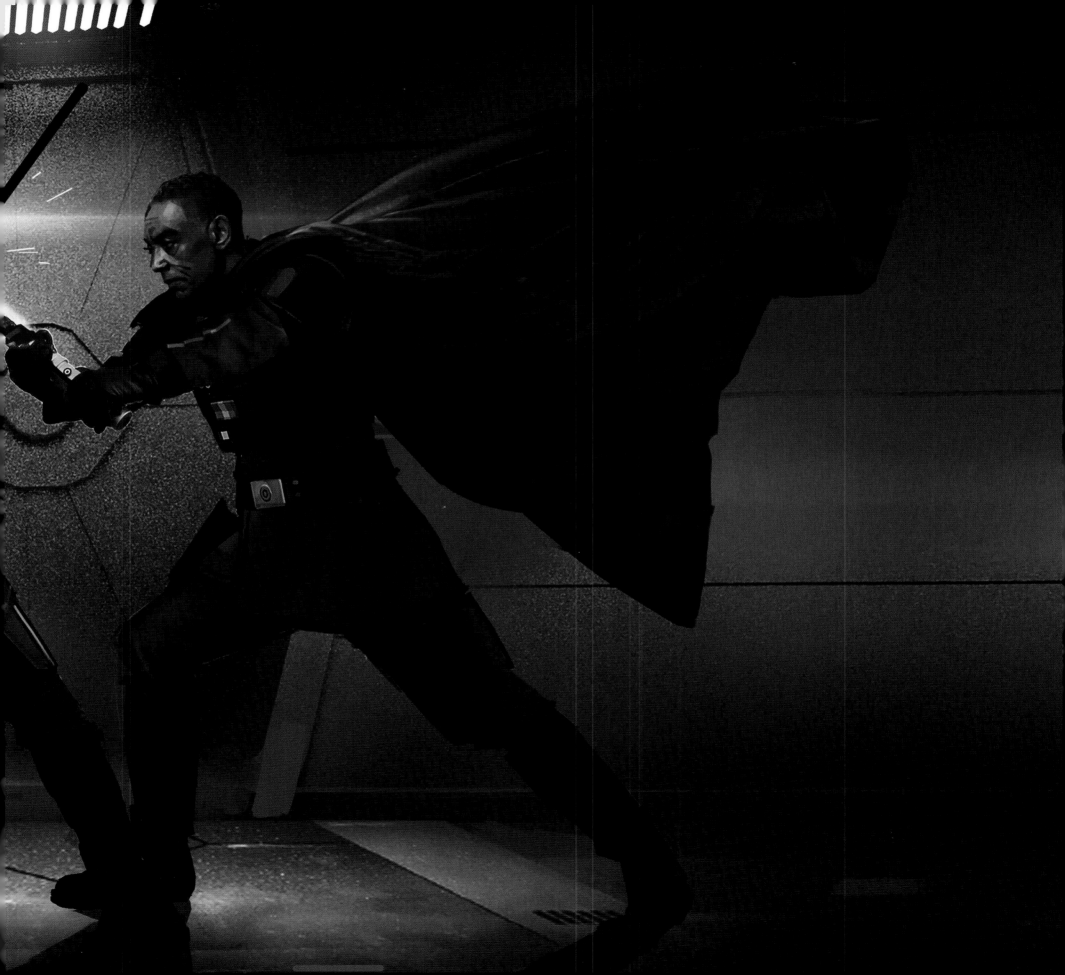

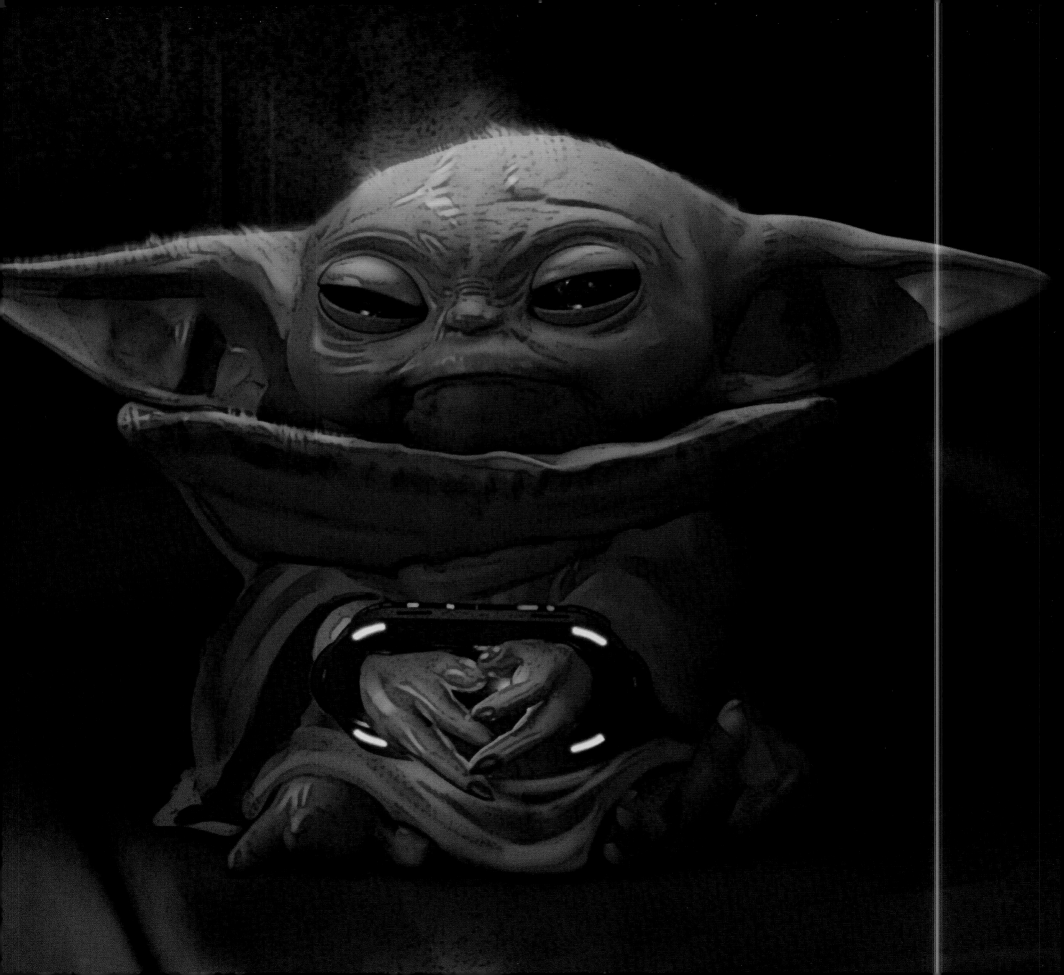

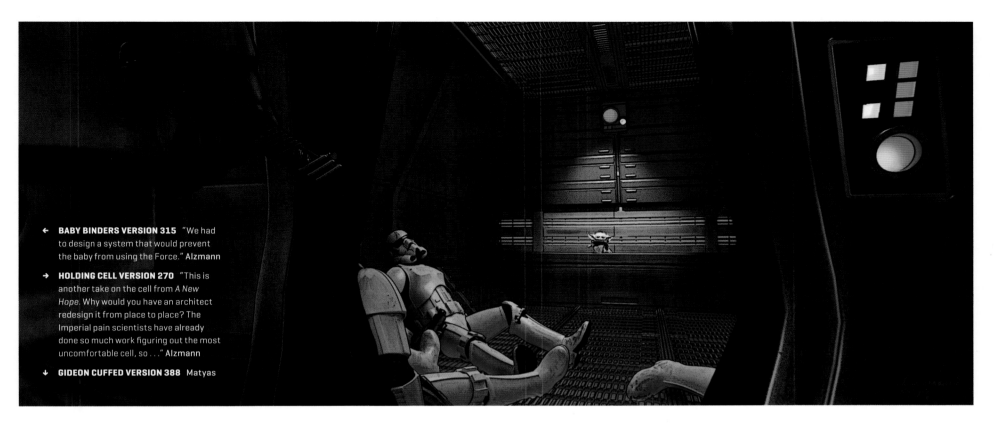

← **BABY BINDERS VERSION 315** "We had to design a system that would prevent the baby from using the Force." Alzmann

→ **HOLDING CELL VERSION 270** "This is another take on the cell from *A New Hope*. Why would you have an architect redesign it from place to place? The Imperial pain scientists have already done so much work figuring out the most uncomfortable cell, so . . ." Alzmann

↓ **GIDEON CUFFED VERSION 388** Matyas

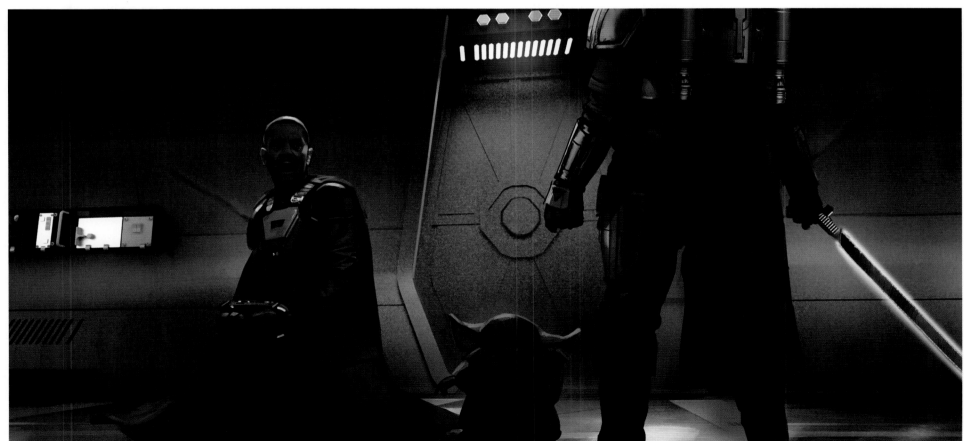

CRUISER BRIDGE SIDE VERSION 01 Church

"We came up with the idea that in the back, there would be was this holotable and other workstations. It made the bridge slightly T-shaped, and it matched the exterior design pretty well. We knew that this was going to be a huge build, so it was designed to be turned into multiple sets." **Chiang**

← **COMMS OFFICER VERSION 04** "I was playing with red for the communications officer's look. I don't know if that's ever been done for Imperial officers." **Matyas**

→ **COMMS OFFICER VERSION 3C** "A lot of these designs are just little subtle tweaks on what we already know. Here we gave her a new hat, with a couple of little points, placing it somewhere between the First Order hats and the Imperial hats of the original trilogy, while injecting a bit of Soviet-era Russian design in there, as well." **Matyas**

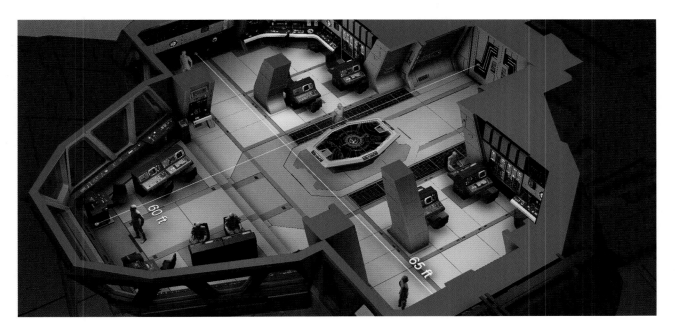

← **IMPERIAL BRIDGE CUTOUT** Garcia

"This was a really good exercise in design because, within our budget, we wanted to create as much spectacle as possible. We knew that we wanted a fully contained bridge that was going to be in the volume, so all of the content outside, whether it was planets or stars, would be on the LED screen. We redesigned a regular Star Destroyer bridge to fit within the volume; it was smaller but kept the form language, while also making it distinct." **Chiang**

↓ **RESCUE CRASH VERSION 124** "I said, 'Well, we've got the *Razor Crest* cockpit as a real build and we have the bridge as a real build, let's just mash them together.' You'd see the horizon tilt and stormtroopers getting sucked out into space." **Church**

This bridge rescue idea was pitched by Ryan Church prior to the Lucasfilm art department's learning that the *Razor Crest* would be destroyed in Chapter 14.

→→ **HERO LADIES VERSION 394** "Fun image of all of the heroic ladies after taking over Gideon's bridge. Intended to be from the POV of Din Djarin. I think that's one of the last shots I did." **Matyas**

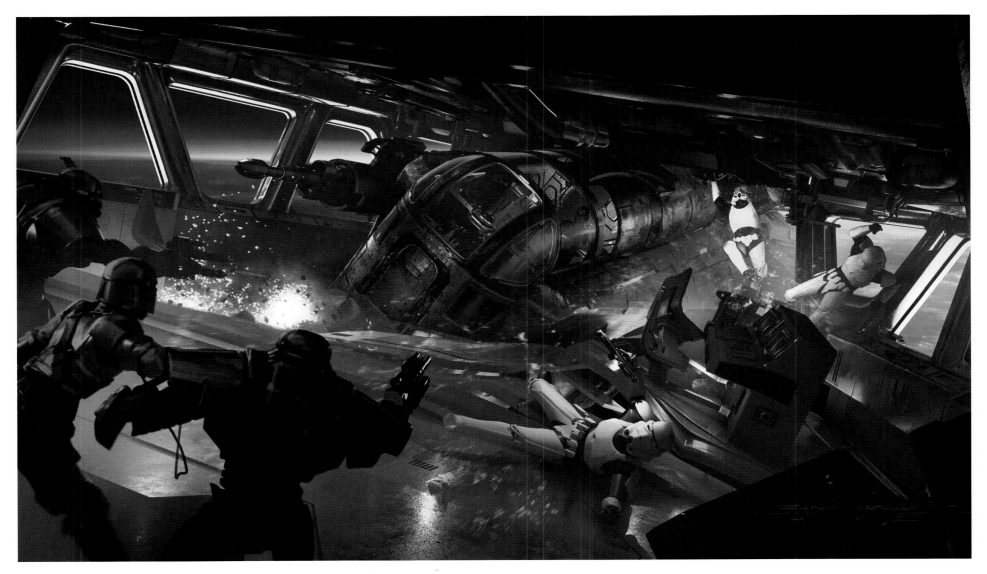

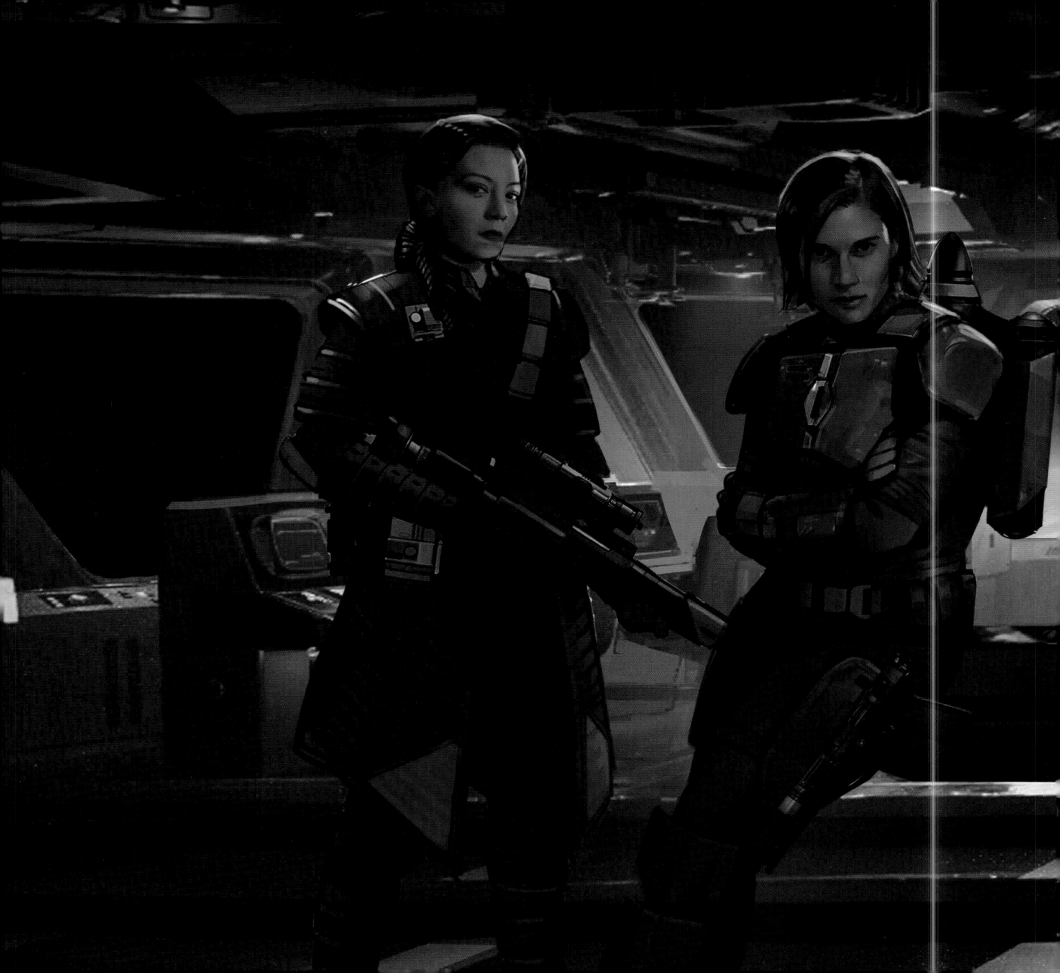

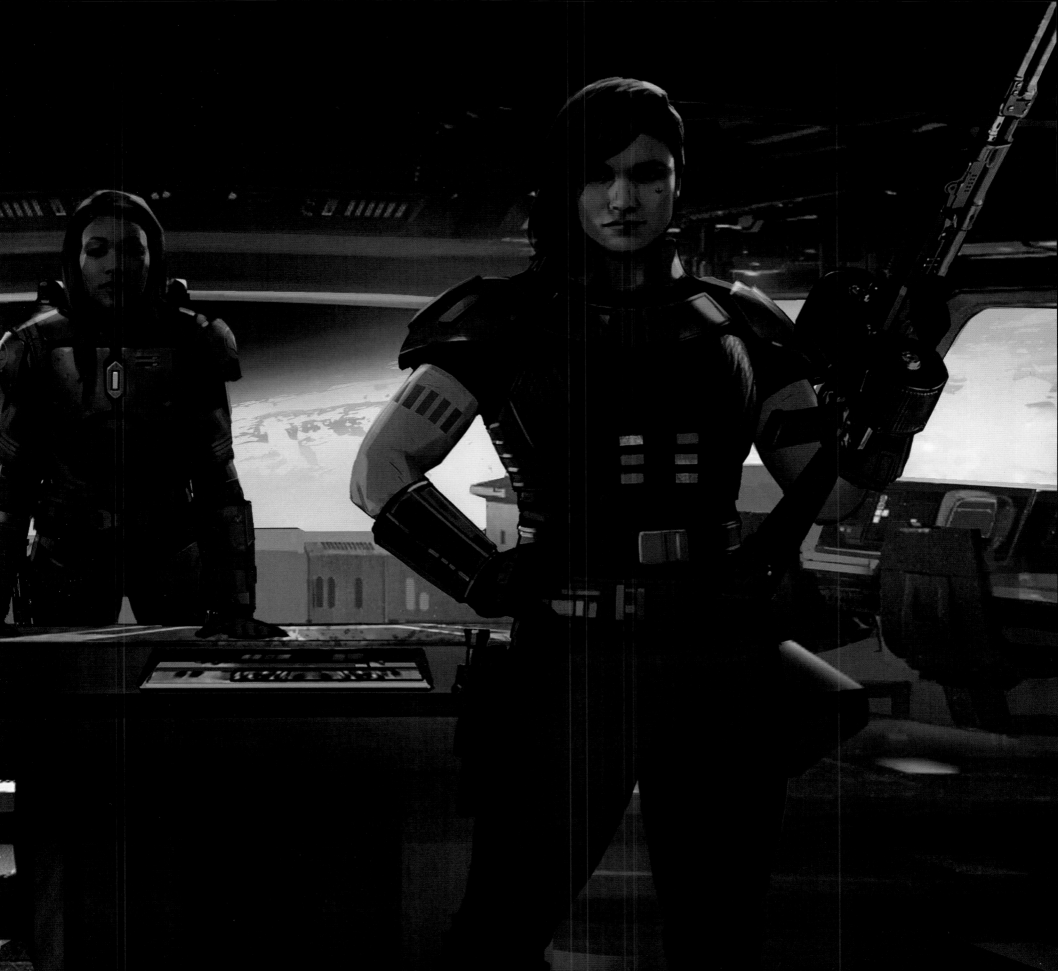

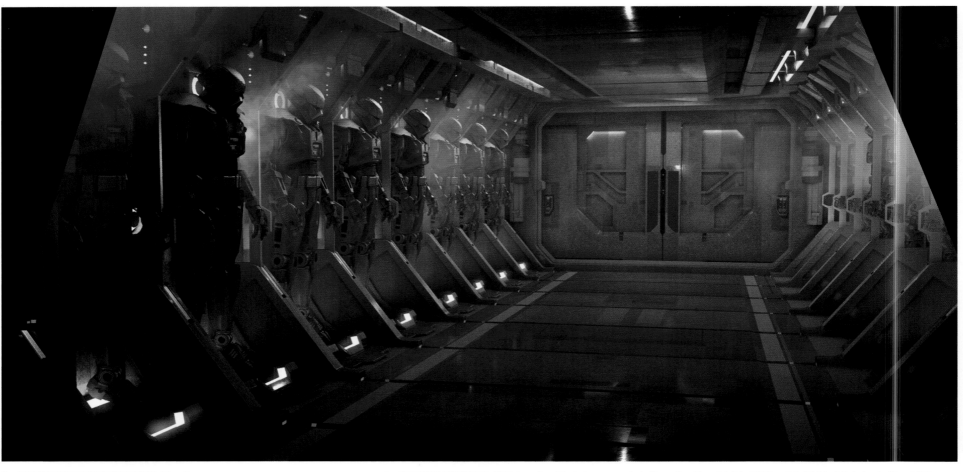

↑ **DARK TROOPER BAY VERSION 330** Church ↓ **ATRIUM VERSION 322** "This is on the ship, before we see Luke Skywalker. They didn't build this set, but I did a full design build-out." **Alzmann**

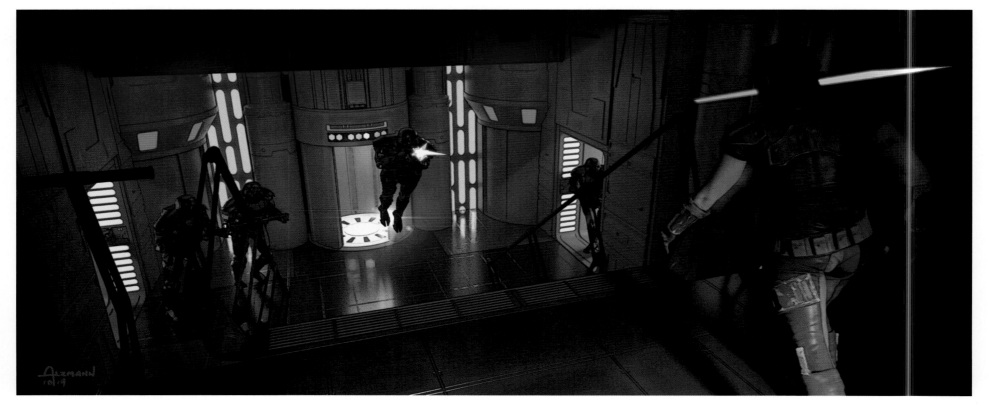

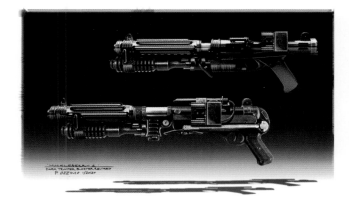

↑ **DARK TROOPER BLASTER VERSION 02** Ozzimo

→ **DARK TROOPER BAY VERSION 318** Church

↓ **DOORS OPEN EJECTION VERSION 299** "A shot of what it looks like when the dark troopers are sucked out of the airlock. Very fun to do action stuff like that." **Church**

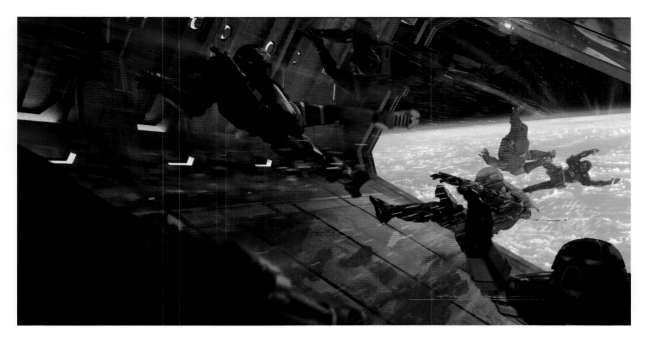

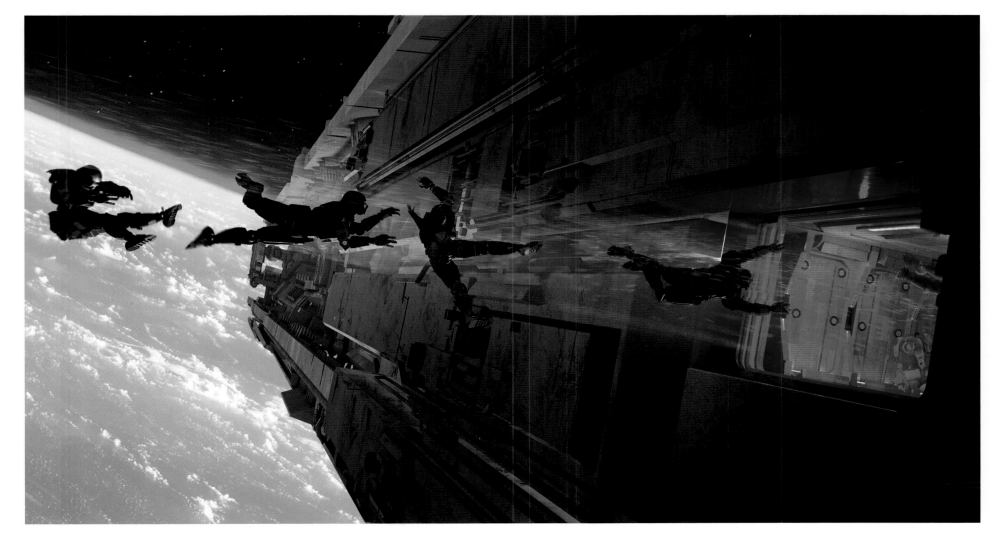

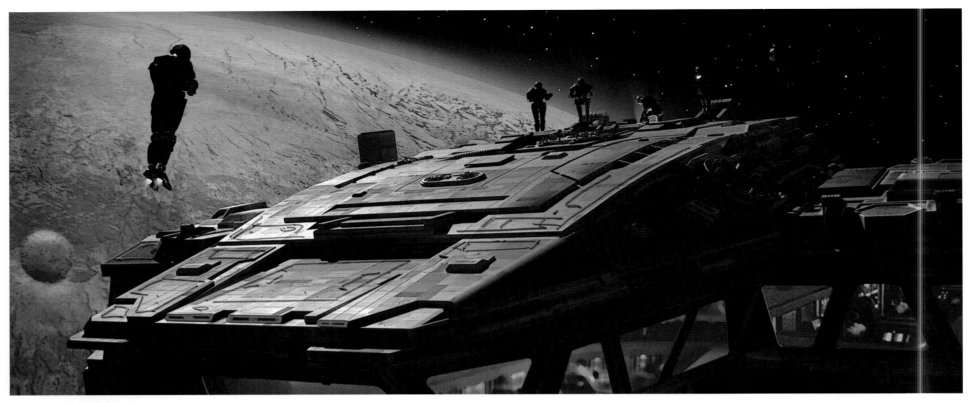

TROOPERS VERSION 318 Alzmann

↓ BAY VACUUM VERSION 276 Church

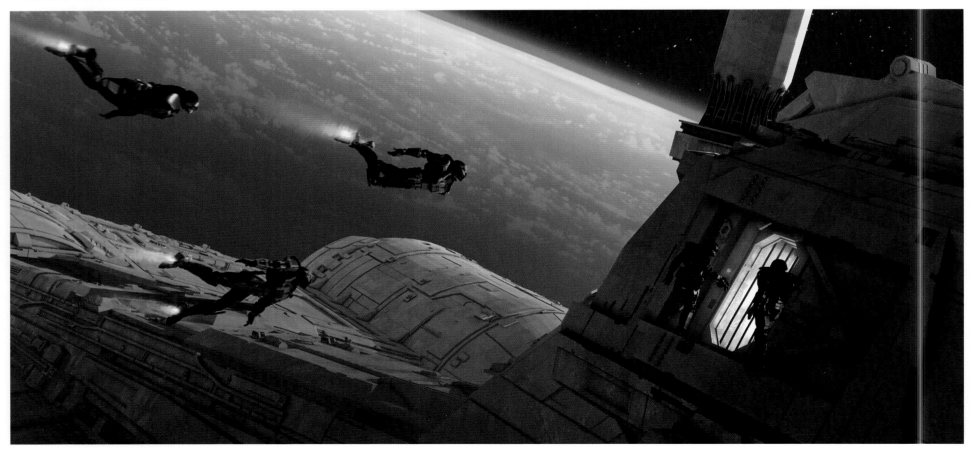

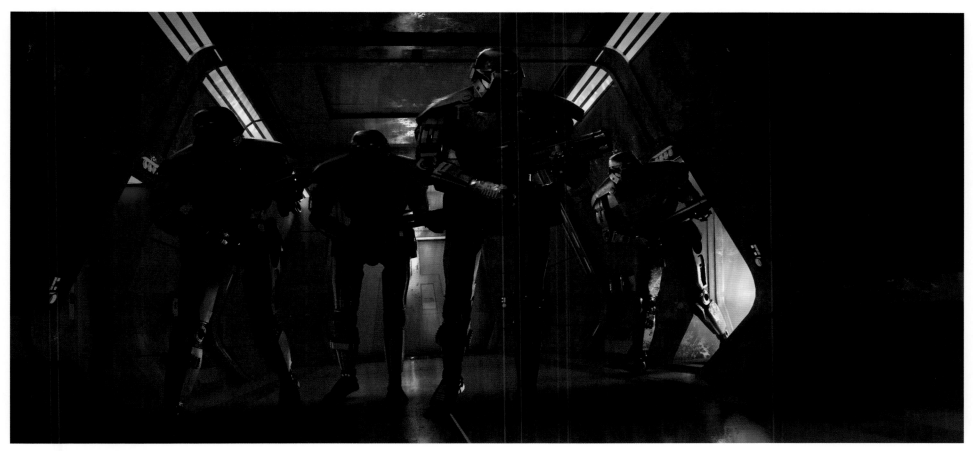

↑ **BRIDGE INVASION VERSION 277** Church

↓ **DARK TROOPER VERSION 115** Alzmann

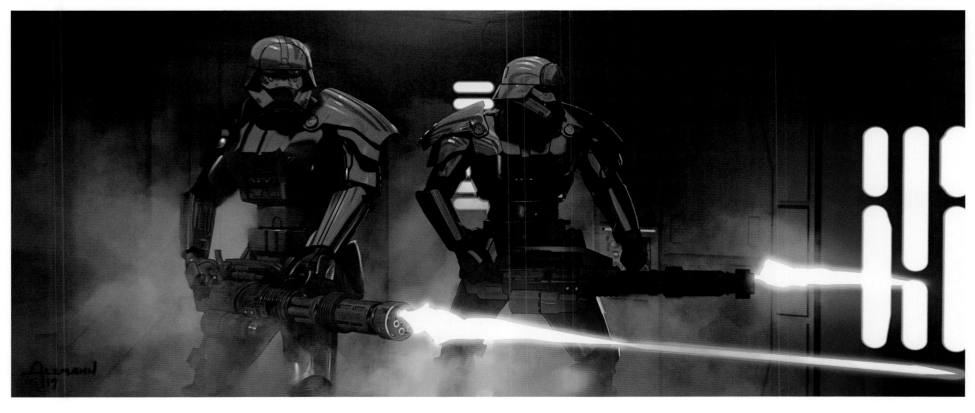

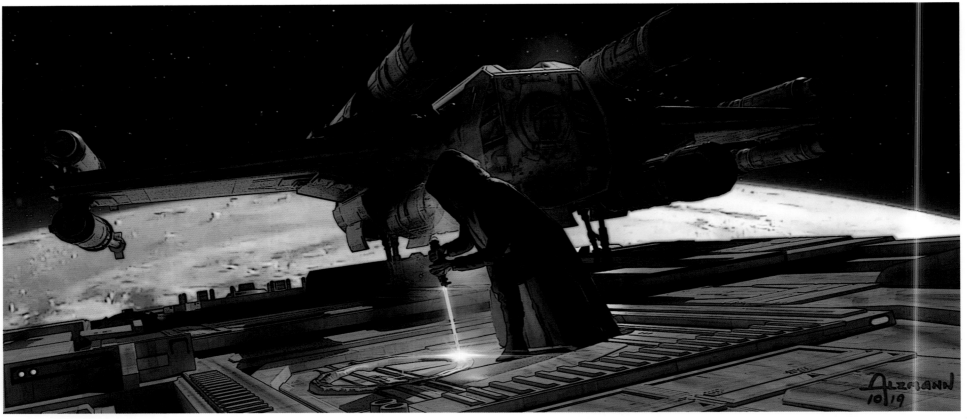

↑ **BREACH VERSION 311** Alzmann

↓ **INSIDE VERSION 312** Alzmann

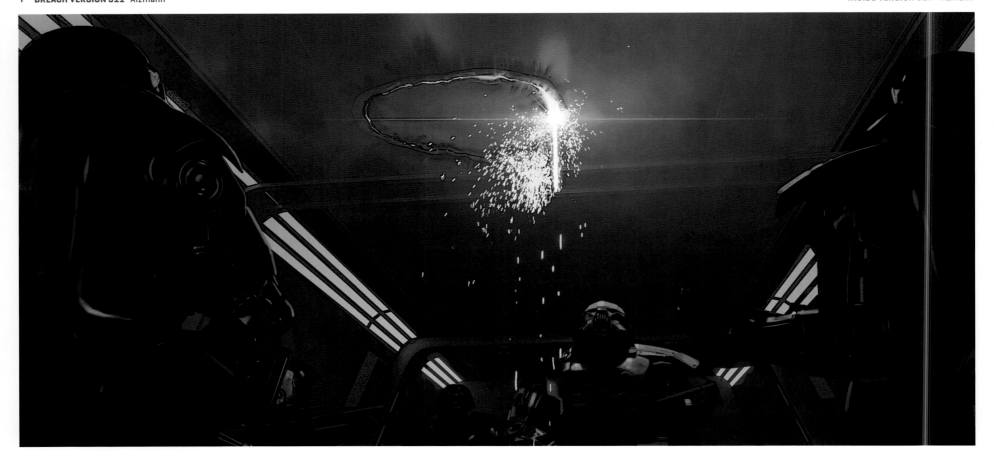

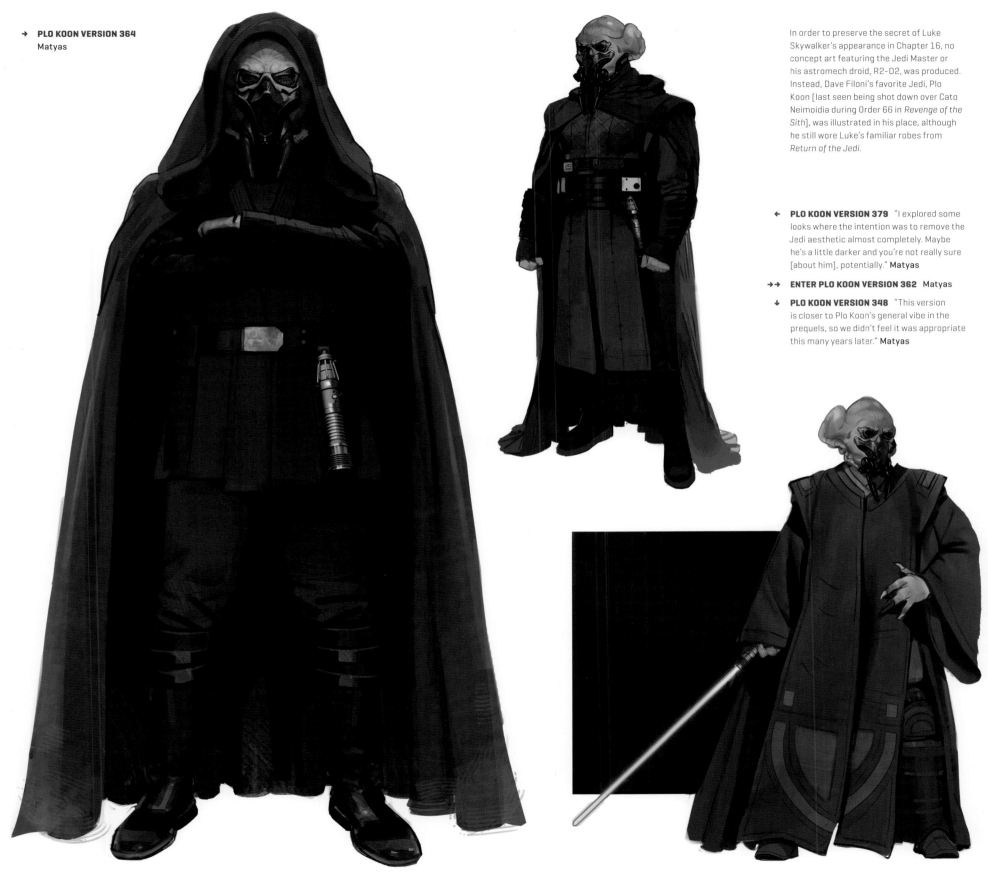

→ **PLO KOON VERSION 364**
Matyas

In order to preserve the secret of Luke Skywalker's appearance in Chapter 16, no concept art featuring the Jedi Master or his astromech droid, R2-D2, was produced. Instead, Dave Filoni's favorite Jedi, Plo Koon [last seen being shot down over Cato Neimoidia during Order 66 in *Revenge of the Sith*], was illustrated in his place, although he still wore Luke's familiar robes from *Return of the Jedi*.

← **PLO KOON VERSION 379** "I explored some looks where the intention was to remove the Jedi aesthetic almost completely. Maybe he's a little darker and you're not really sure [about him], potentially." **Matyas**

→→ **ENTER PLO KOON VERSION 362** **Matyas**

↓ **PLO KOON VERSION 348** "This version is closer to Plo Koon's general vibe in the prequels, so we didn't feel it was appropriate this many years later." **Matyas**

← **ENTER PLO KOON VERSION 3656** Matyas

→ **R2 MEETS GROGU VERSION 308** "I was careful to color this so that it didn't look like a certain famous droid." Alzmann

→→ **R2 MEETS GROGU VERSION 319** Alzmann

↓ **AFTERMATH VERSION 310** "I thought, this was fun; Plo Koon is using the Force to hold up the droid as he cuts him in half [laughs]. I mean, that dude has so much experience killing droids too." Alzmann

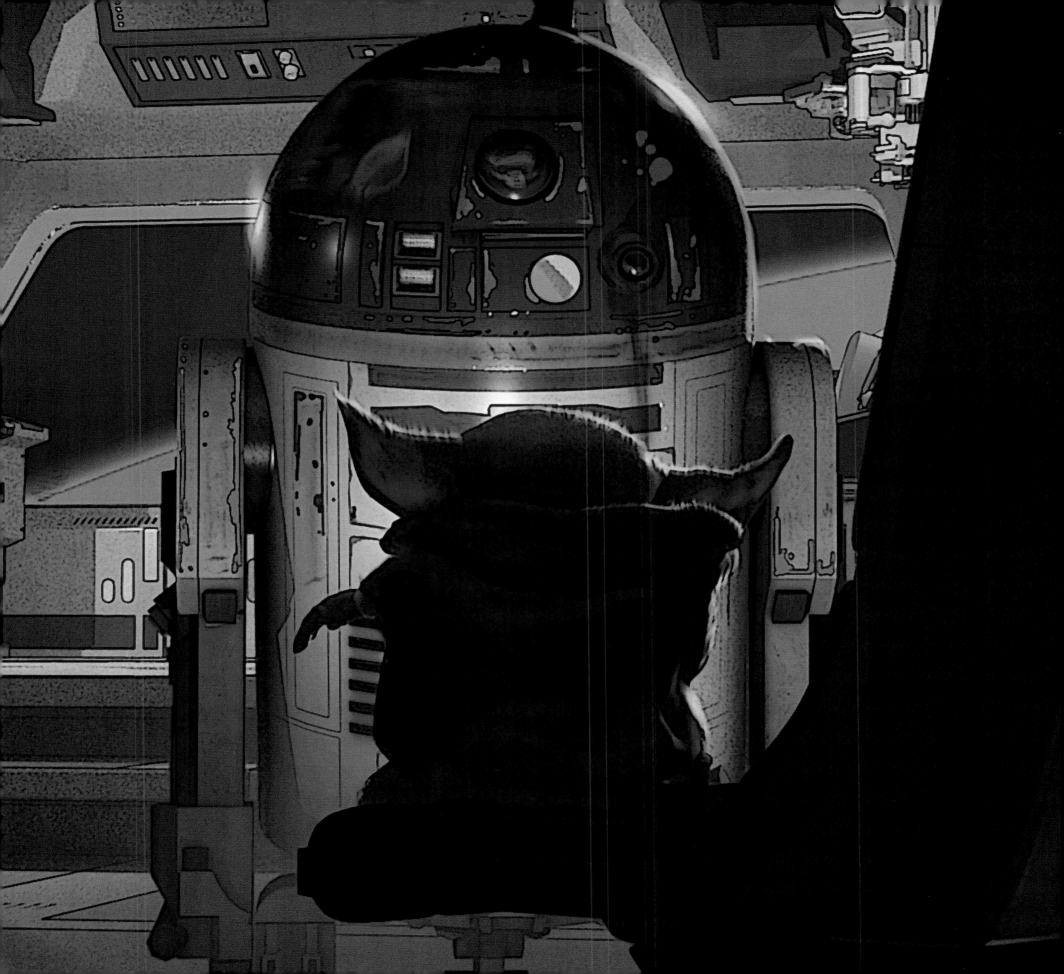

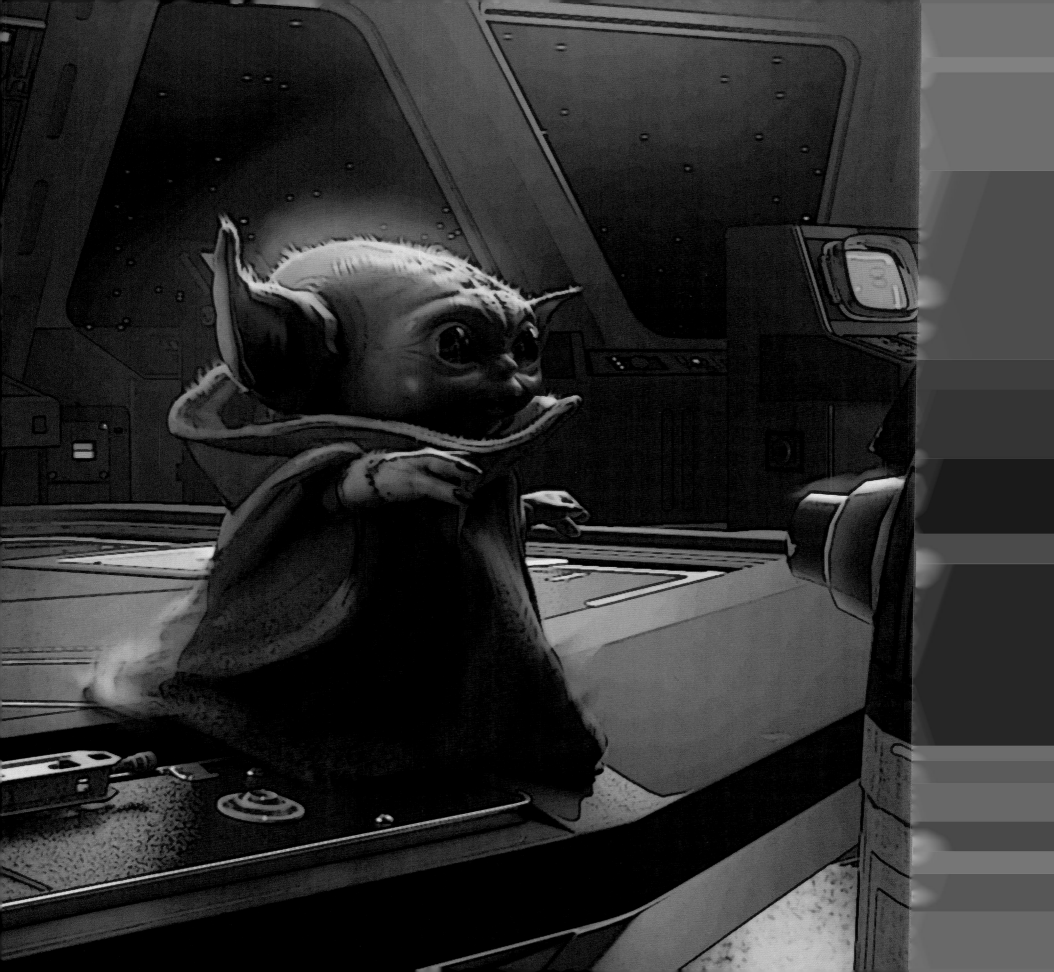

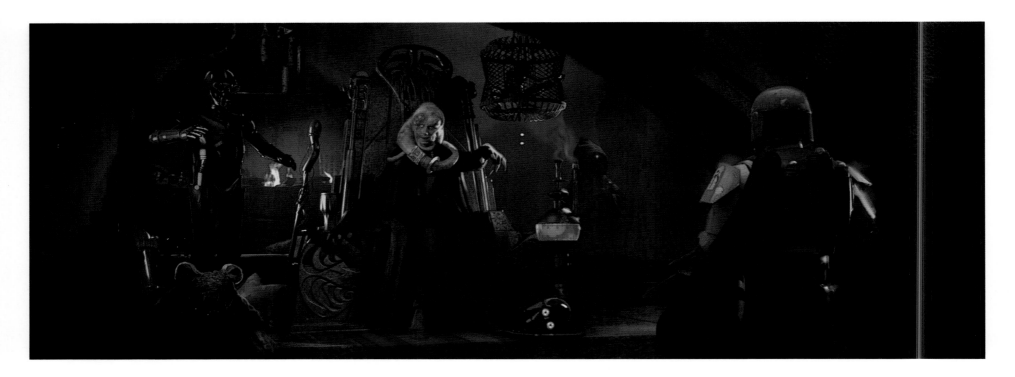

↑ **BIB THRONE VERSION 322** "We were trying to make Bib Fortuna look a little sick and diseased. I was thinking, 'What's the *Star Wars* version of gout, the so-called rich man's disease?' He was already very unhealthy-looking to begin with, how could I make it even worse? And then above his shoulder, he's got Salacious Crumb in a cage, because I figured they were always trying to compete for Jabba's attention." **Alzmann**

↓ **BIB THE HUTT VERSION 300** "When Doug said that Bib Fortuna would look a bit different now, an image just popped into my head of these giant growths on his head circling around." **Church**

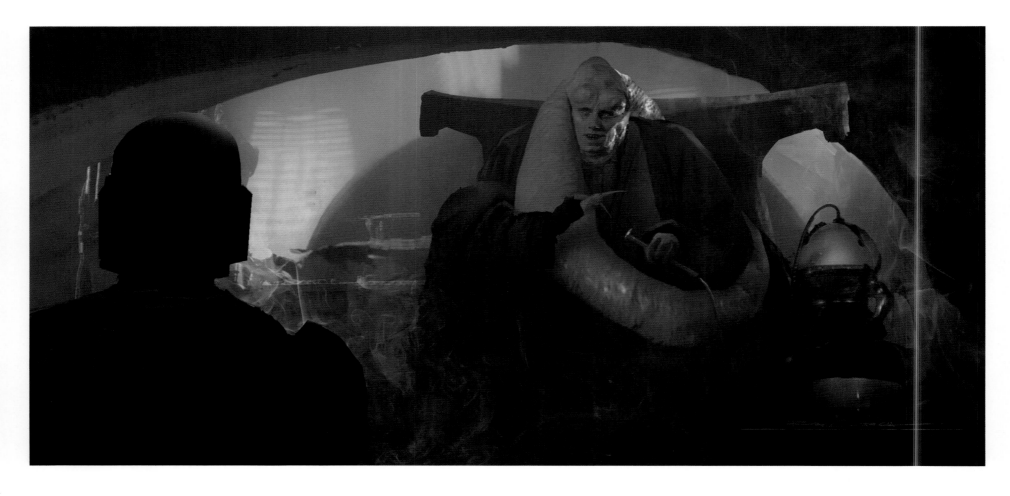

↑ **BOBA THRONE VERSION 339** "I looked at a lot of set photography for the shapes that were in Jabba's palace and tried to get inside Bib Fortuna's mind. What would he have changed? Is he trying to show how different he is from Jabba? Is he trying to show that he's the same as Jabba, or what? And then I did a simple design, then a more complex one, running the gamut. These thrones were so quick to do. I bashed them out, not even thinking about how Boba was going to look sitting on one." **Church**

→ **BIB FORTUNA VERSION 367** "This is not 100 percent faithful to Bib Fortuna's original appearance, which had this chest armor look with holes punched in. But for the most part, the palette vibes off of what you remember from *Return of the Jedi*. He's wearing more jewelry and more cloth now." **Matyas**

↓ **BOBA THRONE VERSION 344** "Different throne designs, which were super fun to build. Just adding things like the little rancor head sculptures on the side." **Alzmann**

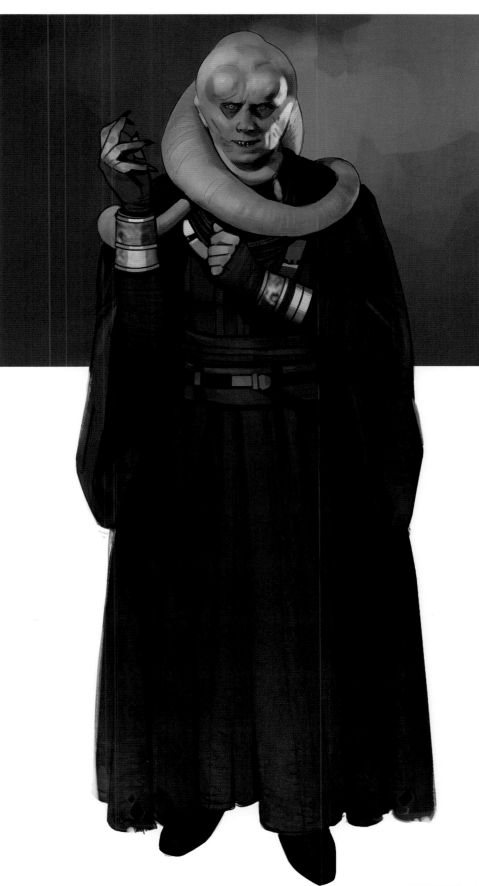

↓ **BOBA THRONE VERSION 339** Alzmann

INDEX

ACKNOWLEDGMENTS

To Jonathan Rinzler, for asking me to be a part of the Art of *Star Wars* book series, for which I will always be grateful.

To George Lucas and Kathleen Kennedy, for allowing me and countless others to tell our *Star Wars* stories and play in the sandbox that you created.

To Jon Favreau, Dave Filoni, Doug Chiang, Christian Alzmann, Ryan Church, Erik Tiemens, Anton Grandert, Brian Matyas, Tony McVey, Richard Bluff, and Landis Fields, for sharing your stories with thoughtfulness and candor, once more.

To Anjali Iyer, Amanda Pastunick, Noah Kloor, Kristen Schreck, Cam Brantley-Rios, and Lissette Cruess, for facilitating my interviews with Jon and Dave.

To Eric Klopfer, Connor Leonard, Liam Flanagan, Mary O'Mara, Lisa Silverman, Katie Gaffney, and Denise LaCongo at Abrams Books and Robert Simpson in Lucasfilm Publishing, for seven years of incredible work on these books.

To Mike Siglain and Troy Alders in Lucasfilm Publishing; Pablo Hidalgo, Leland Chee, Matt Martin, Emily Shkoukani, Kelsey Sharpe, and Kate Izquierdo in the Lucasfilm Story Group; Gabrielle Levenson, Nicole LaCoursiere, Bryce Pinkos, and Erik Sanchez in Lucasfilm's Asset Team; Greg Grusby in ILM Public Relations; Tracy Cannobbio in Lucasfilm Publicity; and Zack Bunker and the entire Atris Team.

To Jennifer Hsyu, Michelle Thieme, Katarina Kushin, and Madeleine Sandrolini in the Lucasfilm Art Department.

To Kristin Baver in Lucasfilm's Online Team, for your ongoing and invaluable support and friendship.

Lastly, to my family, Joseph, Barbara, Martin, David, Grace, and Leo Szostak, and friends, Lila Atchison, Sean and Sarah Dicken, Mike and Lucy Bates, Matt Davis, Shawn Hunter, Chris Wales, and Tina Fossella.

↑ **SALACIOUS SKETCH** McVey

Concept sculptor Tony McVey designed and fabricated Salacious B. Crumb for *Return of the Jedi*, initially as a parrot-like companion for Ephant Mon, another Jabba's palace character that McVey worked on. Ultimately, Crumb would be elevated to a featured character at the Hutt's side. Thirty-five years later, McVey fabricated another Kowakian monkey-lizard for Chapter 1 of *The Mandalorian*.

→ **ENTER BOBA VERSION 368** Matyas

→→ **BOBA CONFRONTS BIB VERSION 374** Matyas

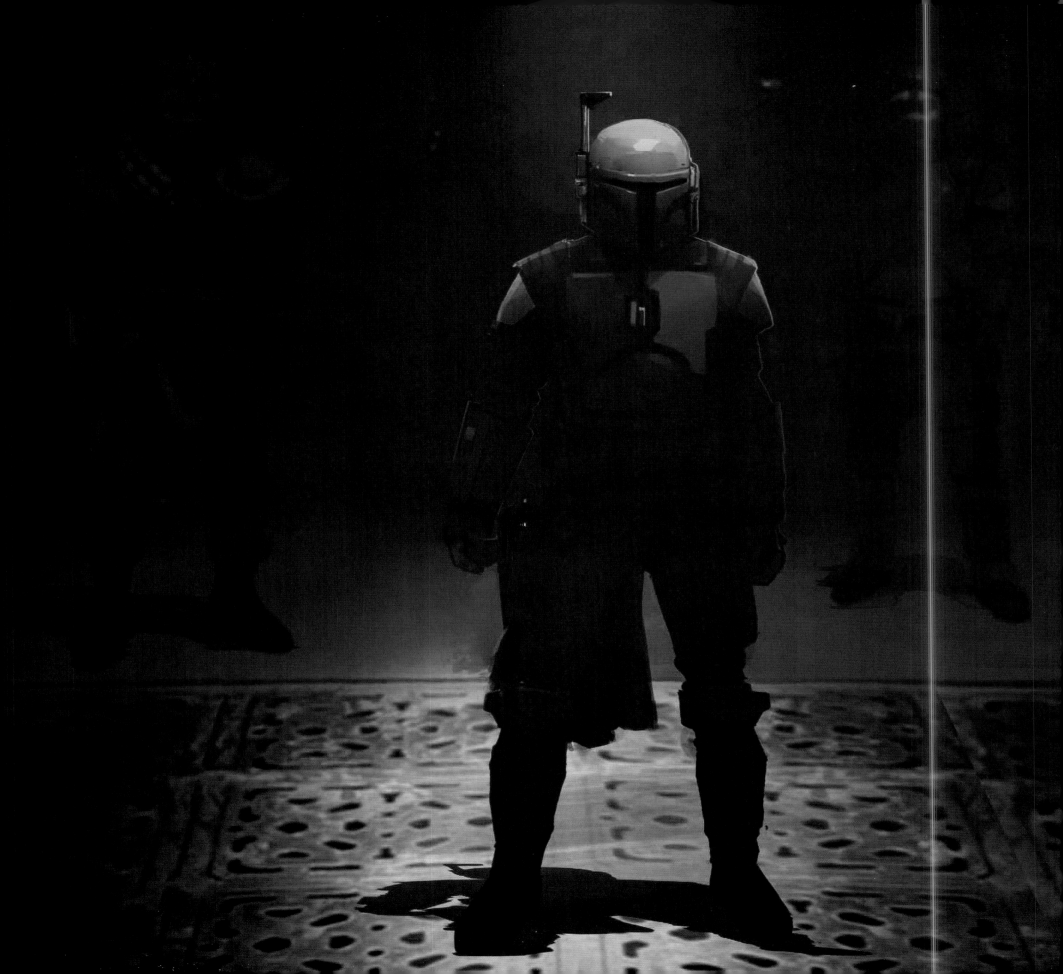

→ **BOBA SHOOTS BIB VERSION 372** Matyas

→→ **BOBA THRONE VERSION 345** "Here we're going for a King Conan [as depicted in 1984's *Conan: The Destroyer*] vibe. Doug had me pull all the company out so that Boba Fett is alone. I thought a protocol droid's head on a plate was interesting symbolism." **Alzmann**

Case CRASH SPIDER VERSION 105 Church

For Lucasfilm Ltd.

Senior Editor Robert Simpson
Creative Director Michael Siglain
Art Director Troy Alders
Asset Group Nicole LaCoursiere, Gabrielle Levenson,
Bryce Pinkos, Erik Sanchez, and Sarah Williams
Story Group Leland Chee, Pablo Hidalgo, and Matt Martin

For Abrams

Editor Connor Leonard
Designer Liam Flanagan
Design Manager Diane Shaw
Managing Editor Lisa Silverman
Production Manager Kathleen Gaffney

Library of Congress Control Number: 2021938119

ISBN: 978-1-4197-5651-1

© 2021 & TM Lucasfilm Ltd.

Printed and bound in China
10 9 8 7 6 5 4 3 2 1

Abrams books are available at special discounts when purchased
in quantity for premiums and promotions as well as fundraising or
educational use. Special editions can also be created to specification.
For details, contact specialsales@abramsbooks.com or the address
below. Abrams® is a registered trademark of Harry N. Abrams, Inc.

ABRAMS The Art of Books
195 Broadway, New York, NY 10007
abramsbooks.com

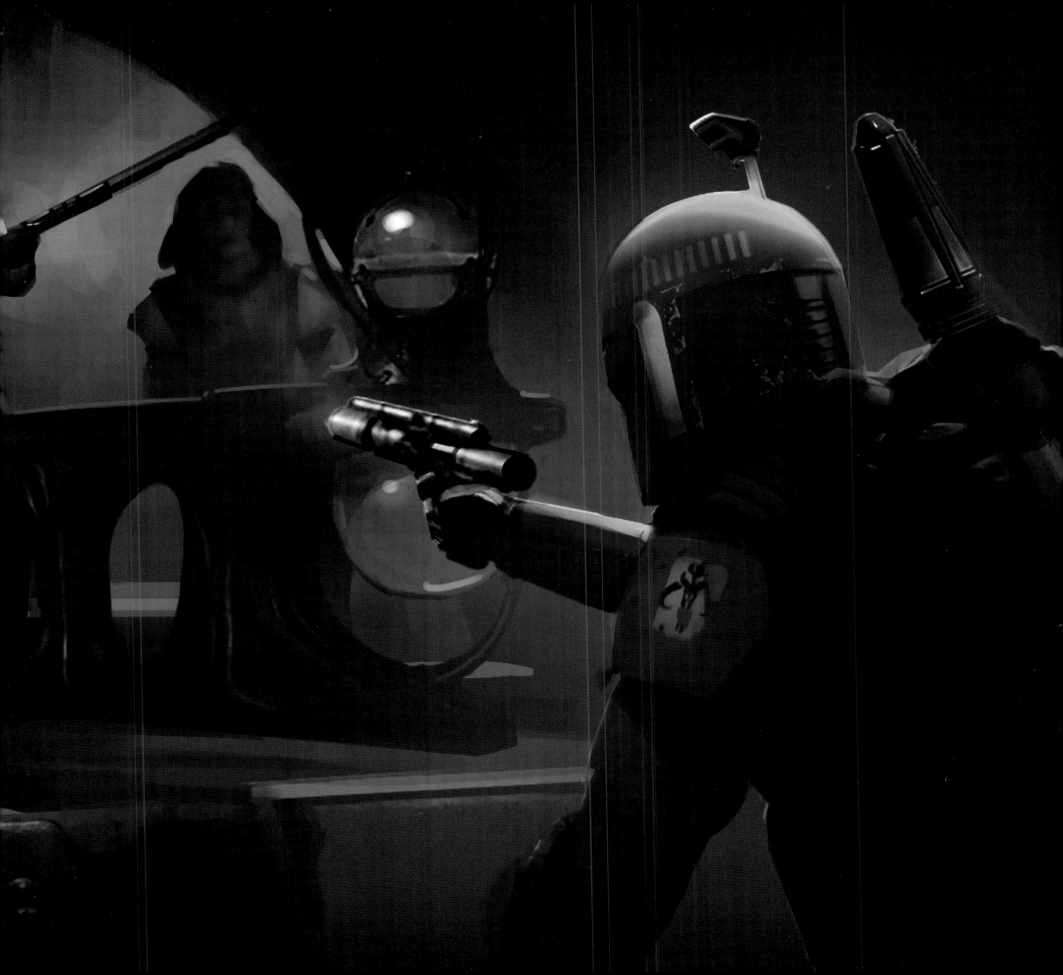